THIS WAS
HOLLYWOOD

TURNER **CLASSIC** MOVIES

THIS WAS
HOLLYWOOD

FORGOTTEN STARS & STORIES

CARLA VALDERRAMA

RUNNING PRESS
PHILADELPHIA

For

JUSTINA MIA ROSE

and ZACK

THIS WAS HOLLYWOOD
FORGOTTEN STARS & STORIES

Movie Stars

Pets

Sex Symbols

Dancers

Singers

Cover design by Paul Kepple and Alex Bruce at HEADCASE DESIGN www.headcasedesign.com. Interior design by Carla Valderrama and Paul Kepple and Alex Bruce

Running Press • Hachette Book Group
1290 Avenue of the Americas, New York, NY 10104
www.runningpress.com • @Running_Press

Printed in Canada • First Edition: November 2020

Published by Running Press, an imprint of Perseus Books, LLC, a subsidiary of Hachette Book Group, Inc. The Running Press name and logo is a trademark of the Hachette Book Group.

The Hachette Speakers Bureau provides a wide range of authors for speaking events. To find out more, go to www.hachettespeakersbureau.com or call (866) 376-6591.

The publisher is not responsible for websites (or their content) that are not owned by the publisher.

Additional copyright/credits information is on page 226.

Library of Congress Control Number: 2020935509

ISBNs: 978-0-7624-9586-3 (hardcover),
978-0-7624-9585-6 (ebook)

FRI

10 9 8 7 6 5 4 3 2

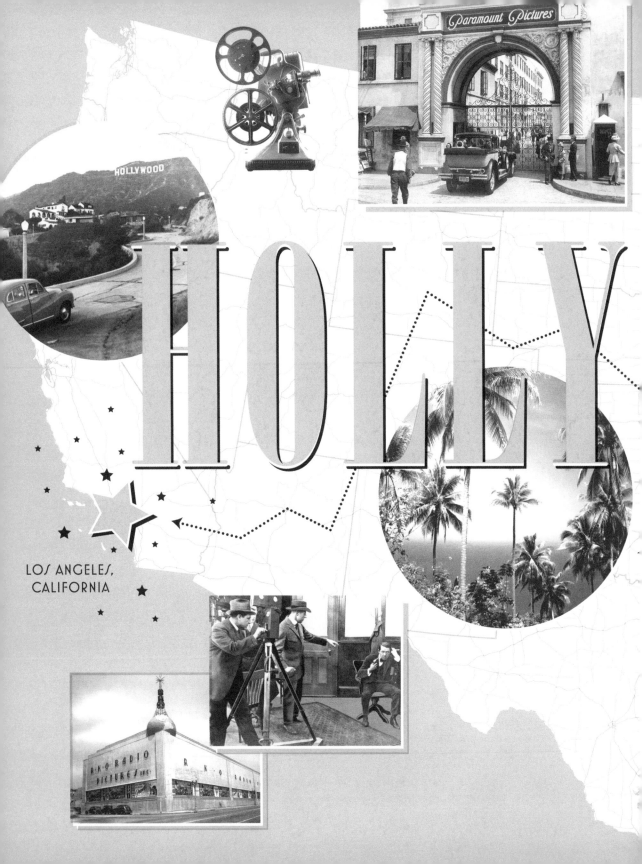

HOLLY

Paramount Pictures

HOLLYWOOD

LOS ANGELES,
CALIFORNIA

R·K·O RADIO PICTURES INC.

THE ROAD TO
WOOD

FORT LEE,
NEW JERSEY

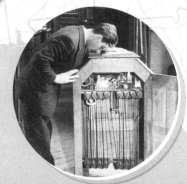

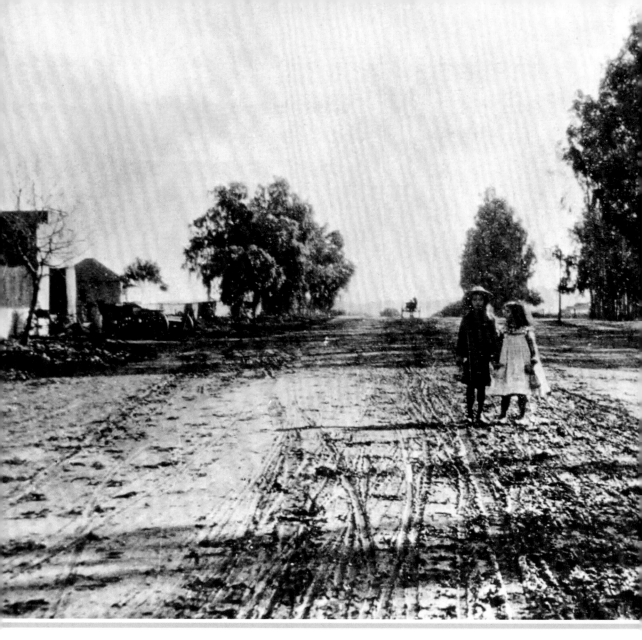

HOLLYWOOD became the film capital of the world through the flip of a coin. In 1911, director Al Christie was making Westerns in New Jersey and had grown tired of the inappropriate landscape there. He wanted to try filming in California. His producer, David Horsley, favored Florida, thinking it would be cheaper. Christie had a silver dollar. "Heads for California and tails for Florida," he declared. It was heads. On the train west, the two met a theatrical producer who told them Hollywood was a pretty place. "None of us had heard of Hollywood before," Christie recalled.

Indeed, in the first decade of the 20th century, it was another city, on the other side of the country, that played host to the film industry, still just in its infancy. It was a boomtown, gloriously diverse in its scenic beauty, an Edenic paradise in which to build America's first dream factory. It was Fort Lee, New Jersey. While there were numerous studios in New York and minor film centers in Philadelphia and Chicago, the New Jersey town

Two girls walking down Sunset Boulevard in 1906.

anyone else. Thomas Edison's Kinetoscope was developed at his laboratory in West Orange, New Jersey, in the early 1890s, where the first motion picture studio in the world was built in December 1892. When Edison unveiled the Kinetoscope, he launched an entertainment revolution, with arcades that played the Kinetoscope films on individual-viewing machines popping up everywhere. Not long after, another revolution began, as newly formed moving picture companies began selling admission to see their products on large screens in theaters. An industry was born.

As it grew, so did Edison's stranglehold on the technological patents that made it all possible. In December 1908, eleven film companies, including Edison's, formed a new organization, the Motion Picture Patents Company, known as the Trust. The companies pooled their patents for essential equipment, from projector machines to cameras to sprocket holes on film. Their plan was simple: Prevent anyone outside the Trust from making motion pictures in the United States. And they went to great lengths to make their plan a reality.

"[W]e were shadowed, harassed, threatened and assaulted," said Carl Laemmle, founder of the Independent Moving Pictures Company (IMP). Edison hired detectives to spy on and harass the independent filmmakers who weren't paying royalties to the Trust. Double agents posed as actors or technicians and gathered information on these "pirates." Once, Laemmle and his cameraman hid all night in a Fort Lee cellar with his camera while sleuths from the Trust scoured the neighborhood. According to Laemmle, "[C]ameramen were selected in the early days not for their artistic ability, but for their fistic prowess."

When surveillance and harassment didn't stop the independent filmmakers, the Trust turned to violence. They hired gangsters to burn down independent studios and destroy their equipment. "They found that by shooting holes through the camera, they could stop their use, and that became their favorite method," filmmaker Allan Dwan said.

Eventually, independent filmmakers hired gangsters of their own. According to Laemmle, today's commonplace industry jargon meant something else entirely on a film set back then. "When the present-day director instructs his cameraman to 'shoot,' he probably does not realize that

on the banks of the Hudson River provided something those larger cities couldn't. As narrative-driven motion pictures became a dominant form, it became clear that audiences preferred scenes set outdoors to be shot outdoors instead of on clumsily painted sets. Fort Lee's proximity to the river as well as to steep cliffs, waterfalls, forests, and farmland made it a natural choice.

And it was only fitting that the movie business set up shop in the home state of the man who had done more to pioneer film technology than

The first motion picture studio, dubbed "The Black Maria" because of its resemblance to the police wagons of the time, which had earned that nickname for reasons still obscure.

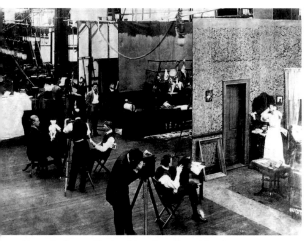

The early days at Thomas Edison's studio in New Jersey.

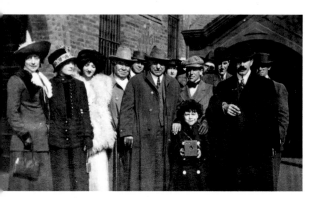

The Nestor Company arriving in Los Angeles in 1911.

a similar order a couple of decades ago may have been taken literally," Laemmle explained. "A six-shooter was part of a cameraman's equipment in the early days."

Independents were now hiring lawyers to beat the Trust in the courts. But all of this was expensive and taking time away from making films. So, many of the independent companies began to search for a new home where they could ply their trade without interference from Edison or the Trust.

"That's one of the reasons most of us went to California, and distant places," Dwan said.

If a Trust representative should happen to make the journey west, Southern California had the added benefit of being close to Mexico, where their patents were meaningless.

Dwan felt secure in California. "I had my three cowboys, the Morrison brothers, arm themselves with Winchesters, hire some other cowboys, and station them outside our area of work. So, if anybody appeared carrying any kind of weapon, they were challenged by our people and disarmed." One day "a sneaky-looking character" got off the train and asked to see the boss. Dwan suspected he worked for the Trust. They walked to an arroyo, a little stream under a bridge, which was full of tin cans. "To impress me, he whipped out a sidearm and fired at one of the tin cans in the arroyo. I immediately whipped mine out and fired," Dwan said. "He missed his, but I hit mine three times. He turned around towards the depot and ran right into the three Morrison brothers with three Winchester rifles aimed at him, and he decided it was about time to leave town." Dwan's company wasn't bothered by the Trust again.

And then there were Al Christie and David Horsley and their fateful coin flip. Other film companies had established studios in downtown Los Angeles as well as neighboring towns like Glendale, Santa Monica, and Long Beach. D.W. Griffith had even made a film in Hollywood: *In Old California* (1910). But there were no studios in Hollywood; it was just a small town of God-fearing folk, once described by the *Los Angeles Times* as a place where "the saloon and its kindred evils are unknown."

The town had been founded by Harvey Henderson Wilcox, a wealthy real estate dealer and prohibitionist from Kansas, who arrived in Los Angeles with his wife, Daeida, in 1883. After the death of

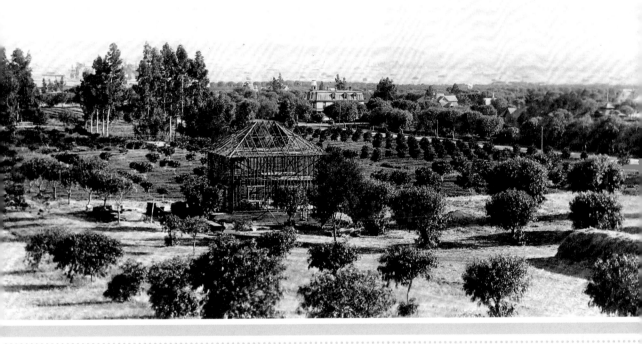

"THERE WERE NO STUDIOS IN HOLLYWOOD:
IT WAS JUST A SMALL TOWN OF GOD-FEARING FOLK"

their nineteen-month-old son, the Wilcoxes tried to console themselves by taking long horse rides throughout the Cahuenga Valley. They fell in love with an apricot and fig orchard and purchased it as well as a few other tracts that brought their property in the area to a total of 160 acres. They called their ranch Hollywood. Expecting a land boom, in February of 1887, Wilcox submitted the plan for a new town to the Los Angeles County Recorder's office. He hoped Hollywood would be a sober and vice-free Christian community, and the Wilcoxes sold parcels of land to vacationers and even gave them away for free to anyone

willing to build a church. In 1903, Hollywood was incorporated as a city, and one of the new municipality's first official acts was to ban the sale of alcohol. But they didn't stop there: The city would soon ban gambling, pool halls, bowling alleys, oil wells, glue factories, bicycle-riding on sidewalks, and speeding by car, bicycle, or horse. There was even a law prohibiting "more than 2000 sheep being driven through the streets of Hollywood at any one time." And they banned a popular new type of entertainment venue: The movie theater. But Hollywood's status as an independent city didn't last long. In 1910, lack

of water forced Hollywood to be annexed into the city of Los Angeles, which brought an end to the movie-theater ban. It didn't take long for a theater called The Idle Hour to spring up on Hollywood Boulevard.

On October 27, 1911, Al Christie and David Horsley made it to Hollywood. They found themselves on a dirt road called Sunset Boulevard, searching for a place to set up their new film studio. At the corner of Sunset and Gower Avenue, Christie saw an abandoned roadhouse with a barn on the same lot. That day, they launched the first movie studio in Hollywood, the Nestor Studio. The very next day, they made their first film, *The Law of the Range*. A week later they placed a help-wanted ad in the *Los Angeles Times* seeking actors. Like many studios in those days, Nestor was built open-air and outdoors, and, with the help of Hollywood's temperate climate, the company began churning out films faster than ever. Their success helped draw other companies, including Carl Laemmle's IMP, west. Within a few months, more than a dozen film companies had arrived and set up shop along Sunset.

In 1913, director Cecil B. DeMille headed to Flagstaff, Arizona to make *The Squaw Man*. But the landscape disappointed him. He had to make a quick decision. He remembered that Los Angeles was on the end of the railroad line and that other filmmakers had gone there.

DeMille and company got back on the train and continued west, and the director eventually sent a telegram to his producer Jesse Lasky:

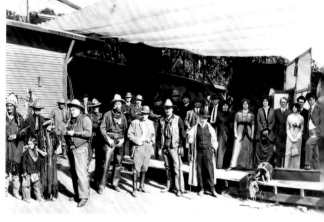

The end of the first day filming Cecil B. DeMille's *The Squaw Man* (1914). You can see DeMille in his signature jodhpurs just left of center.

"The California climate was good, there was a variety of scenery there, and it was that much further away, so we thought, from the minions of the Trust," DeMille said.

Not quite. One night, DeMille's studio was broken into and a negative of *The Squaw Man* was destroyed (fortunately, he had kept another copy at home). Soon after, he began receiving anonymous notes, written with letters cut out of newspapers, telling him "get out of the motion picture business, fold up your studio, or your life won't be worth much." For protection, DeMille brought home a wolf he had purchased for a role in *The Squaw Man*. He also bought a large revolver and began wearing it on his belt. As he was riding home one night through the Cahuenga Pass, he was shot at from the bushes, and a bullet passed by his head. A few days later, in the same location, he was shot at again. "He must have felt terribly frustrated at his two futile attempts at marksmanship," DeMille explained, because the shooter gave up after that.

In October 1915, the federal courts ruled in *United States v. Motion Picture Patents Co.* that the Trust went "far beyond what was necessary to protect the use of patents or the monopoly which went with them." The Motion Picture Patents Company was officially declared a trust under the Sherman Antitrust Act and ordered to disband. An appellate court denied the Trust's appeal, and it officially dissolved in 1918, bringing the Patents War to an end.

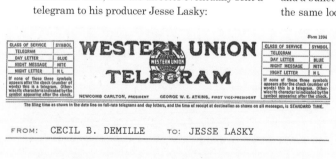

CLASS OF SERVICE	SYMBOL
TELEGRAM	
DAY LETTER	BLUE
NIGHT MESSAGE	NITE
NIGHT LETTER	N L

If none of these three symbols appears after the check (number of words) this is a telegram. Otherwise its character is indicated by the symbol appearing after the check.

WESTERN UNION TELEGRAM

CLASS OF SERVICE	SYMBOL
TELEGRAM	
DAY LETTER	BLUE
NIGHT MESSAGE	NITE
NIGHT LETTER	N L

If none of these three symbols appears after the check (number of words) this is a telegram. Otherwise its character is indicated by the symbol appearing after the check.

Form 1204

NEWCOMB CARLTON, PRESIDENT GEORGE W. E. ATKINS, FIRST VICE-PRESIDENT

The filing time as shown in the date line on full-rate telegrams and day letters, and the time of receipt at destination as shown on all messages, is STANDARD TIME.

FROM: CECIL B. DEMILLE TO: JESSE LASKY

FLAGSTAFF NO GOOD FOR OUR PURPOSE. HAVE PROCEEDED TO CALIFORNIA. WANT AUTHORITY TO RENT BARN IN PLACE CALLED HOLLYWOOD FOR $75 A MONTH.

The winter of 1918 was the death knell for film-making in Fort Lee. Because of a coal shortage brought on by World War I, filmmakers were unable to heat and light their studios—during the coldest winter in decades. At the same time, the deadly Spanish Flu epidemic forced studios to shut down.

And so, the exodus to sunny Southern California quickened. But the "movies," as Hollywood locals called people in the industry, were hardly welcomed with open arms. The movies disrupted the serene, small-town atmosphere of Hollywood. Now, there were gunfights, car chases, and wild animals being filmed in the streets. And film stock in those days had a foul smell, which filled the air and further outraged the locals, who began putting up signs that read: "No Dogs, No Movies."

"We were beneath them," Allan Dwan recalled. "If we walked in the streets with our cameras, they hid their girls under the beds and closed the doors and the windows and shied away. We were really tramps in their eyes."

The new industry was remarkably informal. There were no casting agencies; people simply showed up for work at the gates each day. As stuntman Harvey Parry recalled, "It was a family, a very close-knit group of people. Everybody would help each other. They wouldn't try to hinder you or push you down. Everybody worked. And it was fun, it was real fun."

Although residents complained about the movies, they didn't complain about the value of their real estate, which skyrocketed as the film industry boomed. The Los Angeles Area Chamber of Commerce began advocating for the city as a film-making paradise:

Environment certainly affects creative workers. You realize surely the importance in such essentially sensitive production as the making of motion pictures the vital importance of having every member of an organization awake in the morning and start to work in a flood of happy sunshine. Cold rain and slushy snow do not tend to the proper mental condition for the best creative work.

By 1919, 80% of all films in the world were made in Southern California, and of those, nearly all were made in one town. Once a sleepy and pious hamlet, this town had become the center of a new gold rush, the cradle of a new and exciting art form in its infancy, fast becoming a symbol to the world of the power and magic of the human imagination. This was Hollywood.

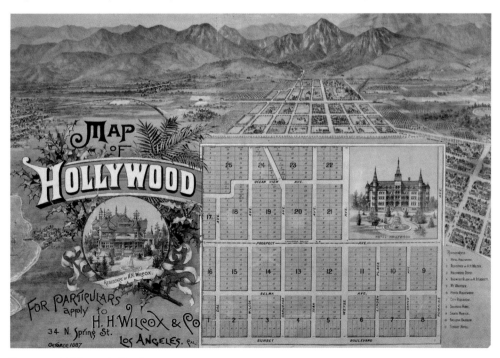

Tract map of Hollywood, October 1887.

T was March 25, 1910, and the train was due into Union Station in St. Louis shortly after 5 p.m. When it pulled in, hundreds of people rushed past the gatemen onto the platform. The throng was there for one reason: To get a glimpse of a brand-new type of American celebrity—the motion picture star. Her name was Florence Lawrence, and she was in a state of shock. After she and her company made their way to their car, the crowd surrounded them and prevented them from leaving. Today, such a scene would be unremarkable. In 1910, it was overwhelming, practically unimaginable. At that time in St. Louis, as in the rest of America, such welcomes were reserved for presidential visits, returning war heroes, and public executions. But this was different.

It was the dawn of a new age, and Florence Lawrence was the rising sun.

She was born Florence Annie Bridgwood ("Flo" for short) on January 2, 1886, in Ontario, Canada. Within a few years, her parents separated, and

her mother, Charlotte, joined the vaudeville circuit, taking the stage name Lawrence. Flo made her debut at the age of three. The act was simple but effective. Flo would meander out onto the stage when her mother was in the middle of a song-and-dance number. The audience would think she was just a lost child until she picked up her mother's dance steps, and they finished the routine together. Crowds went wild and nicknamed her "Baby Florence, The Child Wonder."

By age ten, she was a veteran of the circuit. She and her mother billed themselves as "The Lawrences: Florence and Lottie," "High-Class Vaudeville and Dramatic Artists, warblers (whistlers), vocalists." But Lottie seemed to know her daughter was destined for bigger things. "As a girl she displayed such indomitable ambition," Lottie explained, "that I did not doubt for a minute that she would become a really famous actress."

In the winter of 1906, Flo and Lottie were in New York and out of work. Word had gotten around that

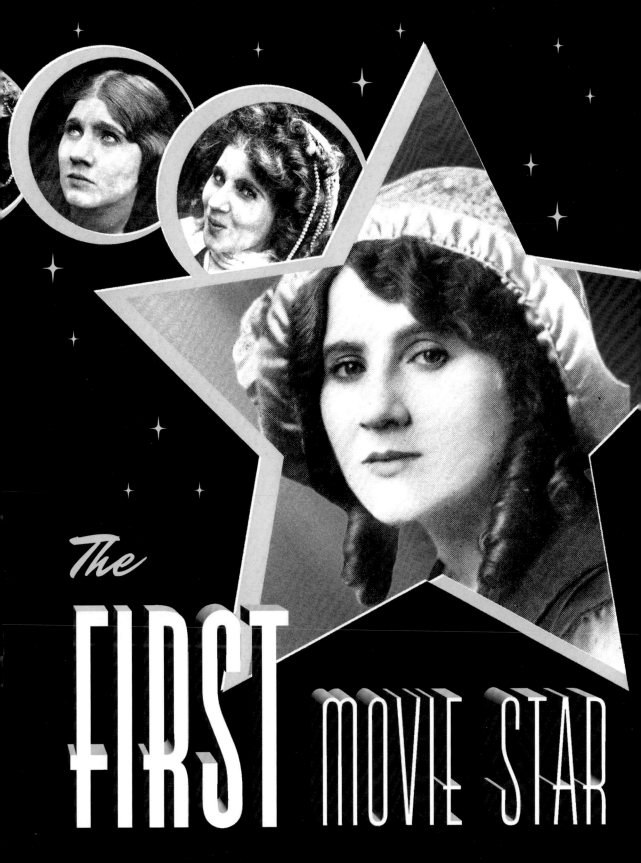

The
FIRST
MOVIE STAR

Edwin S. Porter, production manager of Edison Studios, was hiring actors for a historical picture. On a cold morning shortly after Christmas, Flo and Lottie got in line behind twenty or thirty eager actors outside the Edison Studios building on 21st Street. Porter and his director came out to survey the crowd and hired Flo on the spot—and Lottie too, when they learned she was Flo's mother. The salary was $5 each per day, and no one in the cast even knew the title of the production until they reported for work. The film was *Daniel Boone; or, Pioneer Days in America*. Flo played one of Boone's daughters, and Lottie played his wife.

The movie business wasn't as glamorous as it would soon become. Filming took place in Bronx Park, and the actors had to wait outside for hours in zero-degree temperatures just for the right amount of sunlight for a shot. "We kept a bonfire going most of the time," Flo recalled, "and after rehearsing a scene would have to warm ourselves before the scene could be done again for the camera."

Six weeks later the film was shown and was a success, though Flo was disappointed in her own performance. "I looked so clumsy," she said. And she was irritated at the historical inaccuracy: "Daniel Boone's daughter wearing high-heeled shoes!"

Despite such reservations, Flo wanted to be a motion picture actress and began trying to get work from various companies. She started at Vitagraph, where her equestrian skills eventually landed her the lead in the company's Civil War drama *The Despatch Bearer*.

It was during this production that Flo began to take her craft seriously. Learning that the directors would be reviewing footage, Flo went down to the projection room to join them but was stopped by the studio manager.

"How in the world do you think I can ever improve my work if I never see how I act?" Flo demanded. The manager replied, "My dear little girl, don't worry. [The directors] will tell you all you need to know about your work. If you don't improve they will tell you."

Flo tried her best to improve on her own and went to see as many pictures as she could, often two or three in a single evening. She began to develop her own approach, deciding, for instance, that even though the pictures were silent, "I simply must talk. Otherwise I find myself acting mechanically without spirit or emotion."

At Vitagraph, she churned out approximately fifty films in 1908 alone. She also became friendly with one of the extras, Harry Solter. Harry had spent the greater part of his life in the theater. Productions in San Francisco had left him and his friend David Wark Griffith stranded and broke. The two headed east and wound up entering the growing moving picture business in New York City. Flo's friendship with Harry soon blossomed into romance, and by August of that year, they married. Soon after, Harry was lured to the Biograph company by his old friend Griffith, who had quickly risen to become the studio's top director—and had shortened his name to D.W.

Griffith was looking for a new leading lady, and he was especially keen on one who could ride horses for Western films, which were becoming particularly popular. Harry brought his wife to Griffith, and Griffith decided to roll with it.

Flo immediately rushed into a grueling production schedule: Two pictures a week, many involving horseback. These were her favorite films to work on. "I'd rather ride than eat," Flo declared. "When I am riding before the motion-picture camera, I really forget the picture and everything else. And I always act better in such scenes because I am not acting at all. I am just having fun."

At Biograph, Flo's popularity soared. Millions of Americans knew her face and demanded to see her pictures, but no one knew her name.

In the early days of the movie business, actors were anonymous. When people went to see a movie, all they knew was the title and the studio that made it. No one was credited. This was partly due to the stigma of working in film, which was considered by many to be an immoral industry. But mostly it was financial. Producers feared that if actors became well known to the public, they would demand higher salaries. (They were correct.) It wasn't long before everybody wanted to know the names of their favorite faces on the screen, and no one was more in demand than an actress known to the public only as "The Biograph Girl." Countless moviegoers wrote to exhibitors requesting to know her identity. But their requests fell upon deaf ears.

One producer, Carl Laemmle, had a better idea, one that would make Florence Lawrence a household name and change the movie business forever in the process.

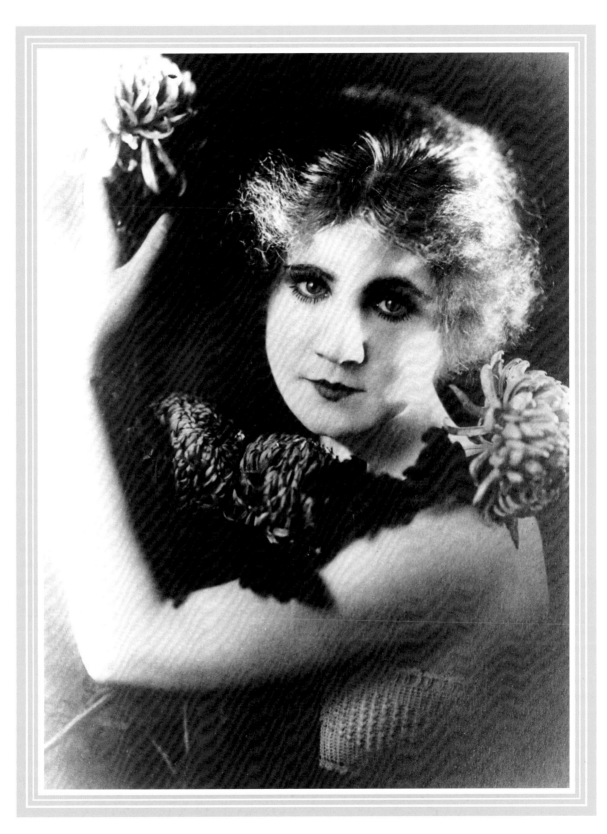

Laemmle had arrived in the United States in 1884 with only $50 in his pocket. Soon he would own the largest movie distributorship in the country as well as a string of nickelodeon theaters. In 1909, he formed his own film company, Independent Moving Pictures Company (IMP).

Meanwhile, Flo had become increasingly unhappy with D.W. Griffith and Biograph. Flo didn't like Griffith's fast direction style, which required her to act "four times the speed of real life." When she asked him to allow her to do "slow acting," he refused. Harry offered his and Flo's services to another studio, and when Biograph found out, the pair was promptly fired.

Laemmle happily signed Flo to a contract with IMP and placed a blurb in *Variety* on October 16, 1909, that would help change the course of film history.

"Miss Lawrence," it read, "the former star actress with Biograph's stock company, has been with the

FLORENCE LAWRENCE NOT DEAD: See her here in today's motion pictures.

Laemmle himself then placed an ad in *Moving Picture* magazine, which featured a picture of Flo and the declaration:

The blackest and at the same time the silliest lie yet circulated by enemies of the "Imp" was the story foisted on the public of St. Louis last week to the effect that Miss Lawrence (the "Imp" girl, formerly known as the "Biograph" girl) had been killed by a street car. It was a black lie because so cowardly. It was a silly lie because so easily disproved. Miss Lawrence was not even in a street car accident, is in the best of health, will continue to appear in "Imp" films, and very shortly some of the best work in her career is to be released.

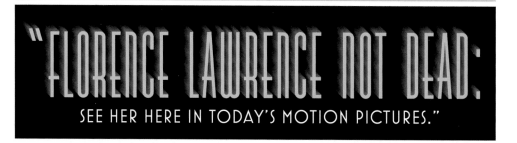

Laemmle firm for the past six weeks. She will appear in the first Laemmle release of October 25."

Three months later, an ad to promote an IMP film included Flo's name. The use of an actor's name to promote a company and its films was a first, and it helped usher in the star system that would serve as the backbone of the industry for the next century.

Someone who took notice was Frank Talbot, who was looking to attract more moviegoers to his Gem Theater in St. Louis. Talbot concocted a wild publicity stunt, claiming Florence Lawrence had died and even telegraphing to request confirmation or denial from Laemmle and IMP. The studio responded, "Report is silly. Miss Lawrence in perfect health and turning out picture today." Talbot then got the rumor of Flo's death and IMP's response published in the St. Louis *Star and Times* on February 21, 1910. He also made sure the paper featured a timely ad for his theater:

Laemmle quickly followed up with arrangements for a personal appearance by Flo at the Gem Theater. Thus ensued the unprecedented mob scene at the St. Louis train station.

"I appreciate this honor," Flo told a reporter that day, "and it seems so strange that so many people would gather at the train to welcome one they had never seen, only in pictures." The press around the country covered the event in typically understated terms. "She's in your life the same as the Goddess of Liberty, and for a time she was just as incognito," wrote one paper. "Her name is Florence Lawrence. There. After two years exercise of sway over the admiration and curiosity of the public, the most popular moving picture star is known."

Flo began receiving screen credits, billing on marquees, and regular promotion in advertisements. The days of the anonymous movie star were over.

In 1912, Laemmle helped Flo and Harry form the Victor Film Company. Flo earned $500 a week

to act, and Harry earned $200 a week to direct. With this new affluence, she was able to fulfill a lifelong dream and purchase a fifty-acre property in River Vale, New Jersey.

Flo had become not only the first movie star but also one of the first women to own her own production company. Briefly. In 1913 the Victor Film Company was sold to Carl Laemmle, who had begun acquiring and merging film studios—a move that launched the now-legendary Universal Studios.

Under the new arrangement, Harry continued to direct his wife, and in 1914, while filming *The Pawns of Destiny*, he directed a scene that ultimately destroyed her career. Flo had to carry a 175-pound actor down a long staircase through flames and smoke. She had to do the scene three times. Afterwards, she found out her back had been injured.

The full extent of her injuries went undetected, and she continued making movies. But as time went on, the pain in her back grew worse. She took almost two years off, an eternity for a movie star. Her comeback was her first feature-length film, *Elusive Isabel*, hyped as "The Return of Everybody's Favorite, Florence Lawrence." It was a failure on all fronts. *Variety* described it as "a very much jumbled up affair that runs along in halting fashion and finally ends up nowhere. The picture is just about a third-rate feature."

Flo's career ground to a halt, and she underwent a series of operations. Out of work and in financial straits, she sent a desperate letter to Carl Laemmle:

This is just a friendly letter to ask you to be fair with me—you know of course the Isabel picture was a great detriment to me and also you remember the offer I had from another concern, but I had given my word to you and couldn't accept . . . the Victor Co. would not be in existance [sic] *today but for me. And you know how (badly) I have been treated in this matter, while you have made a nice little fortune of it. Last but not least my back was injured as you know, while working in a picture which I can prove; and the shock of the unjust, unfair and inhuman way I received my dismissal was the climax to the already very much injured spine. I was hoping against hopes that I would get better so I could work again but I am gradually getting worse and my left side is almost always*

numb and joints are beginning to be enlarged and lameness has set in through favoring my left side. I am telling you all of this now so we can settle out of court. . . . My life and my career have been ruined by the Universal. . . *you didn't seem to care whether I lived or died or any one else in* Universal *for that matter. I will await an early reply and settlement or else.—"*

The studio never paid her a cent.

At the same time, her marriage had been on the rocks for years. After a series of dramatic separations that included threats of suicide and murder, Flo finally hired New Jersey detectives to "obtain the necessary evidence" for a divorce. The proceedings dragged on for years as they split up finances and sold the New Jersey property. Harry died of a stroke in 1920, before the divorce was finalized.

With nothing keeping her in the east, in 1921 Flo headed to Hollywood, where most of the movies were now being made. There, she was quick to note the transformation in her once-humble profession. In her day, she said, actors going on location "would climb aboard a big truck and away we would go. Now our stars travel in their own limousines, thank you. Verily times had changed."

In May, she married Charles Woodring, a soldier she had met while volunteering with the Red Cross during World War I. Woodring took on the role of Flo's "press agent," with disappointing results.

The movie industry had little use for its first known star. Her efforts at a comeback out west were just as futile as in the east, and her Hollywood debut, *The Unfoldment* (1922), opened to little fanfare. Even her friend Mary Pickford, then the biggest movie star in the world, couldn't help her find work. She was forced to work as an extra, but even those jobs were hard to come by, as studios were reluctant to hire former stars for crowd shots because they might distract the audience.

Spurned by the industry she had helped create, Flo was getting desperate. She turned to plastic surgery to revive her career. She underwent sixteen nose operations and invited the *Los Angeles Times* to do a feature on the last one. "I have not been starred for three years," Flo told the *Times* reporter while lying on the operating chair, "and nothing but my nose is responsible. Beauty may be only skin deep, but that's deep enough to make a lot of difference to us who perform before the movie camera."

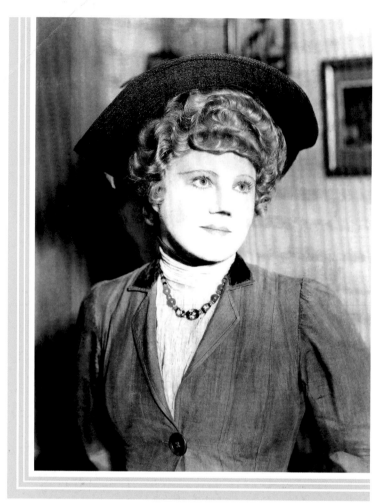

Flo, after her sixteen nose operations.

MGM phoned her home on Westbourne Drive and told her to report to the studio at 1 p.m. for a small part in *Four Girls in White*. Flo told them she was ill and would have to decline. She then wrote out a note addressed to her housemates:

Call Dr. Wilson. I am tired. Hope this works. Good-by, my darling. They can't cure me, so let it go at that. Lovingly, Florence. P.S. You've all been swell guys. Everything is yours.

She swallowed a glass of ant poison and cough syrup but quickly changed her mind about ending her life. Screaming for help, she had her neighbor get a doctor. An ambulance took Flo to Beverly Hills Receiving Hospital, but it was too late. She died shortly thereafter. Her doctor disclosed that for eighteen months Flo had been suffering from "a bone disease which produces anemia and depression."

By 1927, she was a has-been and she knew it. "I don't hope for stardom again," she said. "I know that went glimmering in the years when illness kept me from the camera. But I do want to stay on the screen. I began acting as a child, and the movies I helped build into an industry are my life."

The next ten years were more of a downward spiral. With little film work coming her way, Flo went back to the vaudeville circuit. Her mother died in 1929. She divorced Woodring in 1932, married another man a year later, and was divorced again by 1934. She spent the next few years working as an extra in the MGM Stock Company.

On December 28, 1938, an opportunity for a real role finally arrived. At around 11:00 a.m.,

Two days later, fewer than forty people gathered in the Pierce Brothers Chapel to say farewell to the first film star, a woman who had once feared for her safety from the crowds that turned out just to get a glimpse of her. The Motion Picture Relief Fund paid for her funeral services, casket, and an unmarked grave at Hollywood Memorial Park. Her grave remained unmarked until 1991, when the actor Roddy McDowall purchased a headstone for her. It now reads, simply:

Florence Lawrence
The Biograph Girl
The First Movie Star

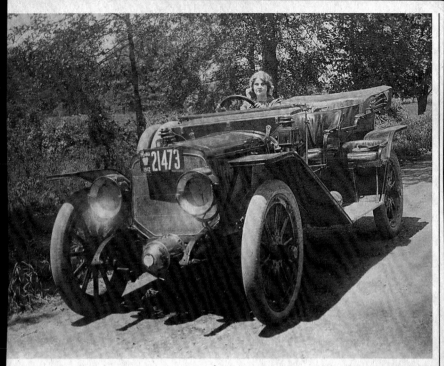

Flo driving a Lozier open touring car in 1912.

FLORENCE LAWRENCE, INVENTOR

FLORENCE LAWRENCE WASN'T just the first movie star; she was also the inventor of the turn signal and brake light. She had a lifelong passion for automobiles and enjoyed doing her own mechanical work and discovering new safety fixtures. "I have invented an 'auto signaling arm', which, when placed in the back of the fender, can be raised or lowered by electrical push buttons, thus indicating the intention of the driver," she told a reporter in 1914. "The one indicating 'stop' works automatically whenever the footbrake is pressed." Unfortunately, she failed to properly patent either of these inventions.

In 1917, Flo's mother, Charlotte Bridgwood, invented and patented the first automatic windshield wiper, the "electric storm windshield cleaner." Mother and daughter joined forces to form the Bridgwood Manufacturing Company, of which Florence was the president, but they weren't successful in selling their inventions.

Within the decade, the automatic windshield wiper became a standard feature on all automobiles, though Charlotte wasn't compensated. In 1930, Florence recovered papers from an old safe that indicated that the patent issued to her mother was in fact "the basic patent" for all the automatic windshield wipers being used on motor cars.

Sadly, neither Florence nor her mother ever received credit for their contributions to the automotive industry.

The Cat
WHO CONQUERED
Hollywood

"Alright, Mr. DeMille, I'm ready for my close-up."

L ONG before the first cat video ever went viral, there was Puzzums. The feline film star was labeled "the most human cat in pictures" and was the first cat to sign a long-term movie contract. His story began in 1926 with two sisters, Nadine and Katherine Dennis, who had come to Tinseltown seeking fame and fortune. They didn't find it, but one night they did find a starving kitten shivering in an alley. The sisters took him in, nursed him back to health, and named him Puzzums. Still waiting for their big break, the sisters began to train Puzzums to do tricks. Soon, he could cross his eyes, lay his ears back, and "laugh" on command. His greatest trick, however, was to feed himself with a baby bottle.

In 1927, Puzzums competed against 155 other cats at the Los Angeles Cat Club show. Puzzums didn't win a prize, but he did get all the press. The following morning, a photo of him sucking on a bottle was featured in the *Los Angeles Times*.

It was Puzzums's big break, and it wasn't long before the Hollywood studios came calling. On July 19, 1927, Puzzums signed (with his paw print) a three-year contract with the "King of Comedy," producer Mack Sennett. The cat was paid $50 a week (more than $700 today), performing a wide variety of feats, like landing a plane, playing checkers, and getting stuck in bunion pads. But the biggest perk of his new gig was making four films with bombshell Carole Lombard. *Meow.*

Puzzums's star was on the rise, and soon he got a massive raise. Unfortunately, financial setbacks forced Sennett to cancel his contract in 1928, but Puzzums wasn't about to let getting laid off hold him back. He was on to someplace even bigger: Paramount Pictures, where he earned $50 *a day* and worked with top-notch directors like Cecil B. DeMille.

The next few years were a whirlwind. On screen, Puzzums started a prison fire in DeMille's *The Godless Girl* and fired a pistol in *Charlie Chan's Chance*. Off screen, like all the biggest stars of the day, he went on a European tour.

After narrowly escaping accidental electrocution on set, Puzzums announced his retirement in April of 1934. But it wasn't long before he was itching for a comeback. When a cat was needed for Will Rogers's *Handy Andy*, Puzzums made his triumphant return to the screen. Alas, like many stars, Puzzums was gone far too soon. He came down with an infected tooth, and on August 18, 1934, this feline gladiator of the silver screen went to the big soundstage in the sky.

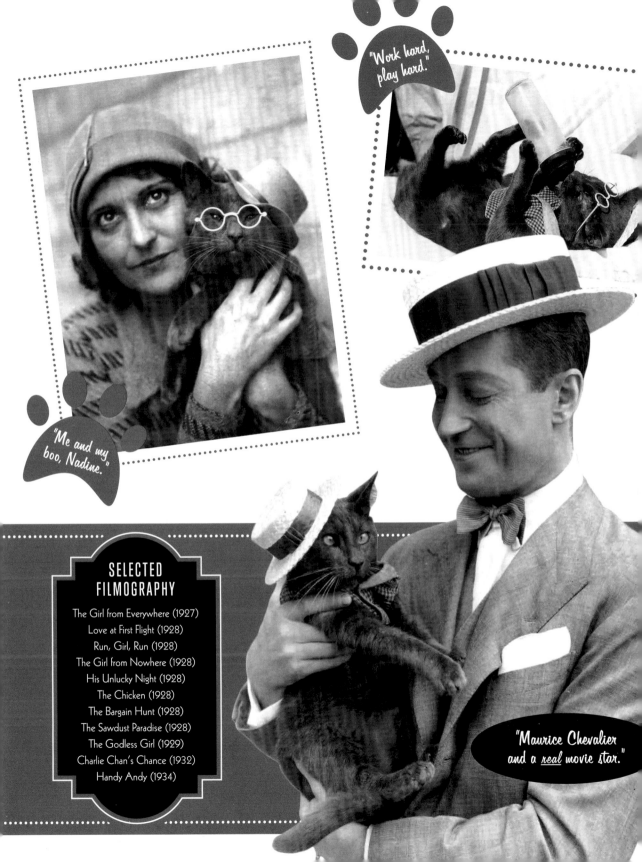

"Work hard, play hard."

"Me and my boo, Nadine."

SELECTED FILMOGRAPHY

The Girl from Everywhere (1927)
Love at First Flight (1928)
Run, Girl, Run (1928)
The Girl from Nowhere (1928)
His Unlucky Night (1928)
The Chicken (1928)
The Bargain Hunt (1928)
The Sawdust Paradise (1928)
The Godless Girl (1929)
Charlie Chan's Chance (1932)
Handy Andy (1934)

"Maurice Chevalier and a _real_ movie star."

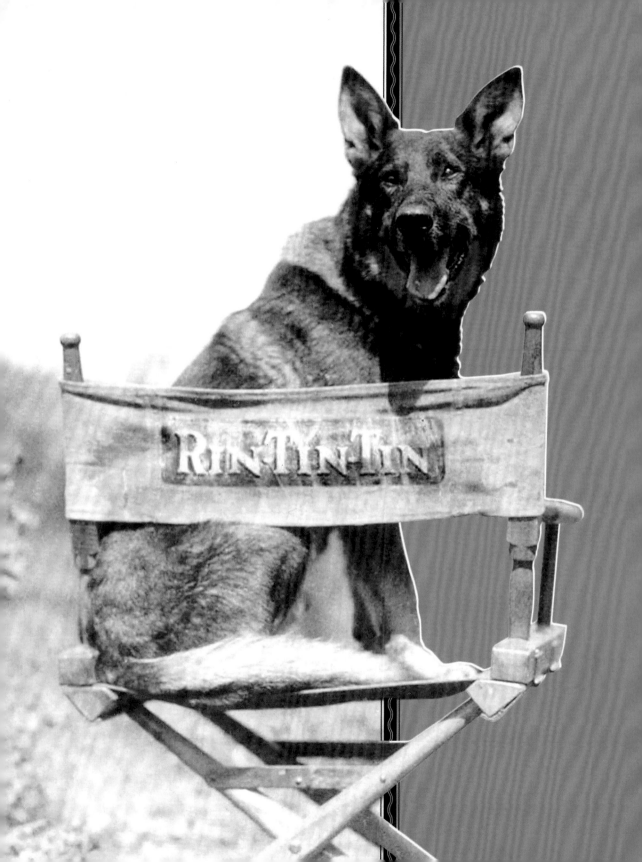

RIN TIN TIN

THE DOG WHO SAVED WARNER BROS.

IT was just after the Battle of Saint-Mihiel in September 1918, and Corporal Lee Duncan was in the frontline town of Flirey, France, searching this no-man's land for a suitable flying field for his unit. He came across a bombed-out kennel once used by the Imperial German Army, and as he walked inside, he saw dogs that had been killed by artillery shells. Making his way through the savagery, he heard whimpering. He followed the sound to a corner in the back of the kennel and found a terrified female German Shepherd with her litter of five puppies.

He brought the dogs back to camp and gave away all but two, keeping the prettiest male and female for himself. He named them Rin Tin Tin and Nanette, respectively, after the good luck dolls French children gave to soldiers in the hopes of keeping them safe on the battlefield.

This was how Lee Duncan, in his unpublished 1933 memoir, described finding the dog who would become an international movie star and an American institution. There are a number of different versions of Rin Tin Tin's origin story, featuring different battlefields and different parentage, many told by Duncan himself. In fact, Duncan never shied away from embellishing the details of his prized dog's biography, from Rin Tin Tin's humble beginnings to tall tales of his heroic war record. But one thing is indisputable: Lee Duncan returned from war with a dog whose incredible athleticism and ability to convey emotion made him one of the greatest stars of the silent era and saved Warner Bros. from financial ruin.

Leland "Lee" Duncan was born in 1892 to a family of farmers in California's Central Valley. When he was five, his father abandoned the family. After spending a few years in an orphanage, he moved with his mother and sister to his grandparents'

ranch. Not long after, Lee was given his first dog, a smooth-haired fox terrier he named Jack. Lee spent his days teaching Jack to climb trees and to run and jump into his arms. He quickly realized that he had a knack for teaching the dog and that the key to his success was "time, patience, sympathy, and affection." One day, his mother announced that the family was moving again and that they had to leave Jack behind. She promised that Jack could come live with them once they settled into their new home. Eventually, she admitted that Jack had been given away. Lee was devastated: "For ten days I was sick of heart and body and made to go to bed. Nothing mattered but my dog."

Lee's early experiences had taught him that people could hurt and betray you. Dogs, however, were different. "In a dog you never see that quality of divided loyalty owned by so many men," he would later say. He dropped out of high school and moved to Los Angeles, taking a job selling guns at a sporting goods store, unsure what direction his life would take.

On April 6, 1917, the United States declared war against Germany, three years after the "Great War" had begun ravaging Europe. Lee enlisted and soon made his fateful discovery on the battlefield. Having Rin Tin Tin and Nanette with him was a great distraction from the horrors of the war.

He disliked the word "training" and began to give the puppies what he called an "education." He treated the puppies as if they were his children. He never used physical force and was adamant that it was "cruel, needless, and stupid to whip or mistreat a dog." He also never raised his voice. The puppies' "first lesson" was to learn to love their teacher. Lee would kneel down, open his arms, and gently call for them to come to him. The goal was to build trust with the puppies so that later they wouldn't question his commands. He quickly taught them simple commands like "come" and "sit" and "heel." Lee grew so attached to them that when he was

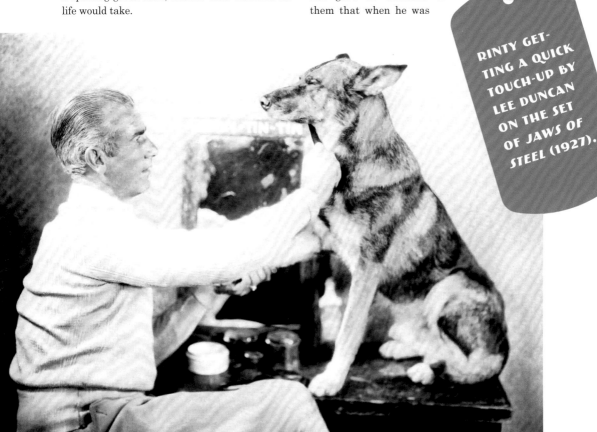

RINTY GETTING A QUICK TOUCH-UP BY LEE DUNCAN ON THE SET OF JAWS OF STEEL (1927).

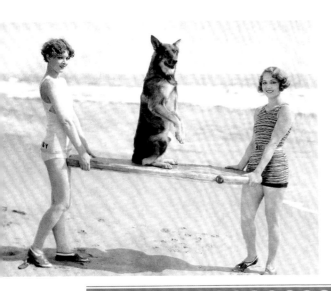

Life's a beach for Warner Bros. biggest star, here with Myrna Loy and Leila Hyams.

the feature-length film *The Man from Hell's River* (1922). As Lee discovered, directing Rinty took "untiring patience and things must be explained to him, very much as you would explain things to a small child working in a scene."

Rinty followed up his debut with a series of small appearances in forgettable films, but he was cast in a small but important role for *My Dad* (1922), which earned him critical praise from the New York *Daily News*: "Rin-Tin-Tin . . . runs off with most of the histrionic honors. The dog stages one of the most realistic and blood curdling fights we have seen recently."

In January 1923, Lee was making the rounds of the studios, trying to get a screenplay he'd written

"THE DAMN DOG IS ALMOST HUMAN."

granted a nine-day leave to go to Paris, he came back after nine hours because he couldn't stand to be apart from them. "I felt there was something about their lives that reminded me of my own life," he recalled. "They had crept right into a lonesome place in my life and had become part of me."

When the war ended, Lee got special permission to bring the puppies home with him, and on April 25, 1919, he and the two puppies departed France aboard the *Huron*.

But by the time they arrived in Brooklyn, Nanette had fallen ill. She died soon after, and he adopted another German Shepherd, whom he named Nanette II. He took the train to California with the new Nanette and "Rinty," as he had nicknamed Rin Tin Tin. Returning to his old job, Lee found himself unable to work with guns after all he had seen and experienced in the war.

He devoted himself to teaching Rinty how to jump and do other parlor tricks, and soon began to enter Rinty in shows. When Lee received a check for $350 for footage of Rinty that was featured in a short film, he decided to get Rinty into the movies. The dog was quickly cast in a small part in

for Rinty produced. He met producer Harry Rapf, who was enthusiastic about the idea and took it to Jack Warner. His timing couldn't have been better.

Warner Bros. was then a fledgling company, named for the four founding brothers: Harry, Albert, Sam, and Jack. Sam and Jack produced the pictures, and Harry and Albert handled the finances and distribution deals. In 1918, the brothers opened the first Warner Brothers Studio on Sunset Boulevard in Hollywood. But as Jack explained, "We had one continuing problem at our new Sunset lot—a persistent lack of money, popular stars, and story ideas." To make ends meet, the brothers often rented out the studio and their equipment.

When Harry Rapf came to Jack's office and pitched him the idea of making a film starring a dog, Jack was skeptical. Rapf told him the dramatic story about how Rinty had been found in a trench in France and about the story Lee had written for him. "It's got a lot of action," Rapf said, "and believe me, the damn dog is almost human."

When Jack met with Lee and Rinty, his doubts quickly vanished. He was impressed with Lee's control over Rinty, who "needed only a word to attack,

Rinty living the dream. At breakfast with his wife and son, 1926.

growl, bare his teeth, jump, climb fences or rock walls, or just sit quietly by a fireside." Furthermore, unlike other actors, as Jack put it, "he didn't ask for a raise, or a new press agent, or an air-conditioned dressing room, or more close-ups." Jack agreed to produce the picture, which would be called *Where the North Begins*, and signed Lee and Rinty to a six-month contract for $150 a week.

The film and its canine star would prove a godsend for Warner Bros. By August 1923, the studio had outstanding loans it couldn't pay. But they were able to convince the Pacific-Southwest Trust & Savings Bank that the just-released *Where the North Begins* would be a box office smash. Instead of calling in the loans and likely forcing Warner Bros. into bankruptcy, the bank agreed to accept the rights to 65% of all gross revenues from the film, plus 5% of the film's gross in perpetuity. The film was a hit, and Rin Tin Tin had single-handedly saved Warner Bros. from collapse. Said Jack Warner, "He kept us from going under during the darkest days of our company history."

Warner Bros. negotiated a new five-year contract with Lee Duncan on August 20, 1923, for $250 a week and 10% of all the net profits from their films.

But Rinty wasn't just a hit at the box office. He was also a critical success.

"A new star has risen. His name is Rin-Tin-Tin," declared the *San Francisco Examiner*.

"Rin-Tin-Tin is practically the whole show and at times his intelligence is almost uncanny," said *Moving Picture World*. "This dog's acting is marvelous in its naturalness."

Twenty-one-year-old Darryl Zanuck was hired to write the script for Rinty's follow-up film, *Find Your Man* (1924). It was a "box office rocket" and a launching pad for Zanuck, who would one day become the head of 20th Century Fox. It also proved that Rin Tin Tin wasn't a one-hit wonder dog. In the words of Jack Warner, "The dog was literally a bonanza, and he kept so many exhibitors out of hock that they gave him the name 'The Mortgage Lifter.'"

Rinty's amazing stunts were one of the keys to his success. In *The Lighthouse by the Sea*, he carries a flaming rag up a staircase to ignite the lighthouse fire, jumps over a 12-foot wall, jumps from a dock onto a moving boat, and digs out a stake he's tied to. In *The Night Cry*, he feeds a lamb with a baby bottle, climbs up and down rock walls, and opens and closes a door. In *Clash of the Wolves*, he climbs up and down trees and leaps across 8-foot-wide ravines. In *A Dog of the Regiment*, he jumps onto a burning plane.

Lee personally supervised all of the stunts to ensure Rinty wouldn't be harmed. "I attribute most of the success I have had in the education of Rinty to the fact that I have never violated his

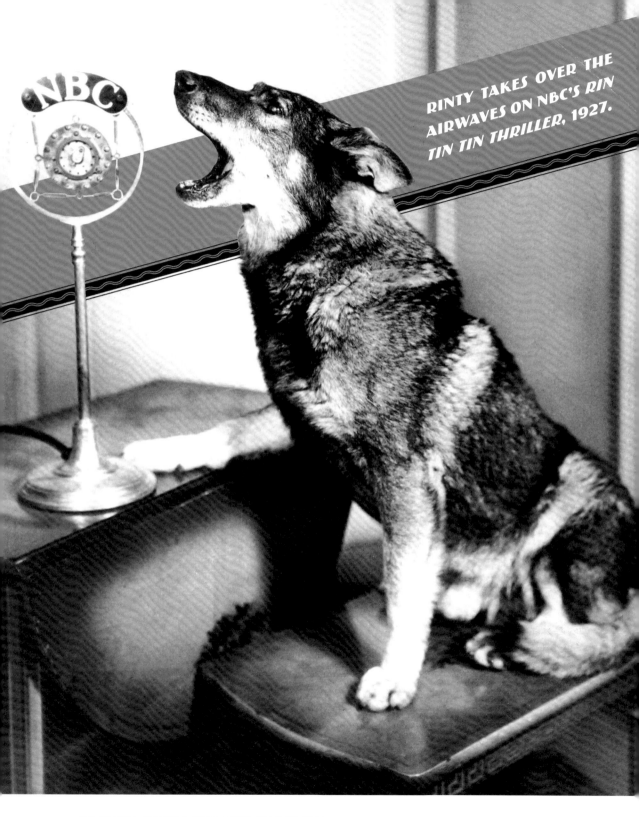

RINTY TAKES OVER THE AIRWAVES ON NBC'S RIN TIN TIN THRILLER, 1927.

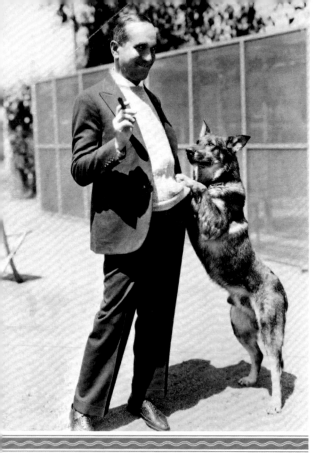

Rinty meeting Al Jolson, the star of the talkie sensation *The Jazz Singer* (1927).

confidence," Lee explained. For truly dangerous scenes, such as falling from a cliff while grasping a condor in *The Night Cry*, a stuffed dog took Rinty's place.

It was important for Lee that people knew Rinty was never abused, even in scenes when the dog was supposed to be hurt. For instance, Lee taught Rinty to limp on command by hooking his leash under Rinty's leg and holding it off the ground. Lee would then walk him on three legs saying "limp." In his personal appearances, Rinty would repeat his on-screen stunts and display his ability to follow direction. At a show in Chicago, Lee told Rinty, "There's a flea in your right ear," and Rinty scratched his right ear. "There he goes to your left side," Lee said, and Rinty immediately switched to the other ear. "Of course, there really isn't a flea at all," Lee told the audience. "But he scratches as if there were. That's education." Lee hoped that Rinty's movies

would help "teach the coming generation a lesson in kindness to animals."

As amazing as his athletic abilities were, Rinty's acting also won the hearts of audiences and critics. As columnist Harry Carr of the *Los Angeles Times* explained, "Rin-tin-tin . . . doesn't know anything about the rules of dramatic technique; yet he can register eagerness or fear or anger as no actor, living or dead, has ever been able to do."

"He was the only leading man in our company history—or hero, if you prefer—who had no flaws whatsoever, and never gave a bad performance," Jack Warner declared. He backed up his statement with action: When it came time to vote for the first Academy Awards, Warner cast a write-in vote for Rinty for Best Actor.*

Rin Tin Tin had arrived. He was living the life of a true Hollywood star, with his own five-room home (kennel) in Beverly Hills, a wife (Nanette II), and a family (lots of puppies). He had his own publicist (future producer Hal Wallis), received tons of fan mail, and had newspapers bragging about their exclusive interviews with him. In typical Hollywood style, Rin Tin Tin even found himself the subject of a divorce: After Lee Duncan's brief marriage to socialite Charlotte Anderson ended, she testified, "Mr. Duncan did not love me. . . . All he cared for was Rin Tin Tin."

But in 1927, at the height of Rinty's fame, a revolution began at Warner Bros. that would have dire consequences for the studio's biggest star.

"Wait a minute, wait a minute, you ain't heard nothing yet!"

These were the first words spoken by Al Jolson in *The Jazz Singer*. Produced by Warner Bros. with its Vitaphone sound-on-disc system, *The Jazz Singer* was the first feature-length film with a synchronized recorded music score as well as lip-synchronized singing and speech. Its success proved to be the death knell for silent films and the end of an era for Rin Tin Tin.

Rinty made several more silent films after *The Jazz Singer*'s premiere, but by the following year, it was clear that sound was here to stay. *Land of the Silver Fox* (1928) was the first Rin Tin Tin talking picture (although most of the film was still silent) and was hyped as a new beginning

*In 2011, major news outlets were quick to jump on a claim from a best-selling author that Rin Tin Tin had actually won the most votes for Best Actor but was passed over because he was a dog. In fact, the actual ballots, which are stored at the Academy's Margaret Herrick Library, proved this story false.

for the canine star: "You've known and rooted for Rin Tin Tin for a good while—but, boy, you've never really known him till you hear him rip off a bark-snort-youk-whimper!"

Rinty made a few more part-talkies for the company, including *Frozen River*, *The Million Dollar Collar*, and *Tiger Rose*. He even appeared briefly in the Technicolor revue *The Show of Shows* (1929), introducing a "Chinese Fantasy" featuring Myrna Loy. Every single one of his talkie pictures made a profit for Warner Bros. In fact, every film he had ever made for the studio made a profit. But as far as Warner Bros. was concerned, their dog days were over.

In early December 1929, Warner Bros. drew up a letter terminating the studio's contract with Lee and Rinty. The letter stated that "the making of any animal pictures, such as we have in the past with Rin Tin Tin, is not in keeping with the policy that has been adopted by us for talking pictures, very obviously, of course, because dogs don't talk." Lee's contract with the studio wasn't set to expire until August 1931, and although Warner Bros. recognized that the contract "does not give us much hope about cancelling it" they decided to try anyway, reasoning "we can always settle with him later."

On December 21, 1929, Lee and Rinty, who some six years before had saved the studio from collapse, were handed their walking papers.

Rinty went to Mascot Pictures to make two serials, then appeared on a radio show called *The Wonder Dog*, eventually retitled *Rin Tin Tin*. But he was getting older now.

On August 10, 1932, Lee realized that Rinty wasn't well. Rinty passed suddenly, and his death made the front page of newspapers across the world.

He was buried in Lee's backyard with a wooden cross. The Depression had hit Lee hard, and when he could no longer afford his mortgage, he sold his house and arranged to have Rinty's body returned to his country of birth. Rin Tin Tin was reburied in the Cimetière des Chiens, located in the Parisian suburb of Asnières-sur-Seine. There the bronze marker on his grave reads:

Rin Tin Tin
La Grande Vedette Du Cinema
[Rin Tin Tin, The Great Film Star]

Rin Tin Tin has lived on for nearly a century. His son Rin Tin Tin Jr. continued to make Rin Tin Tin movies, and Rin Tin Tin III became a spokesmodel for Dogs for Defense, which called for dog owners to donate their quality dogs to the Army's Quartermaster Corps in World War II. After the war, he starred in *The Return of Rin Tin Tin* (1947). The advent of television brought even greater possibilities. In 1954, *The Adventures of Rin Tin Tin* premiered on ABC and was an immediate hit, running until 1959 and spawning a series of books, toys, and memorabilia. Today the show remains in syndication and continues to introduce the wonder dog to a whole new generation of fans. From 1988 to 1993, the Canadian TV show *Katts and Dog* was aired in the United States as *Rin Tin Tin: K-9 Cop*, and the children's film *Finding Rin Tin Tin* was released in 2007. In the words of Lee Duncan: "There'll always be a Rin Tin Tin."

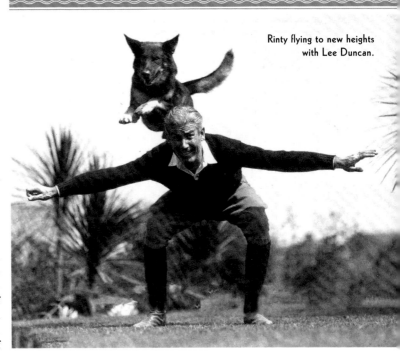

Rinty flying to new heights with Lee Duncan.

THIS WAS HOLLYWOOD...

Pets!

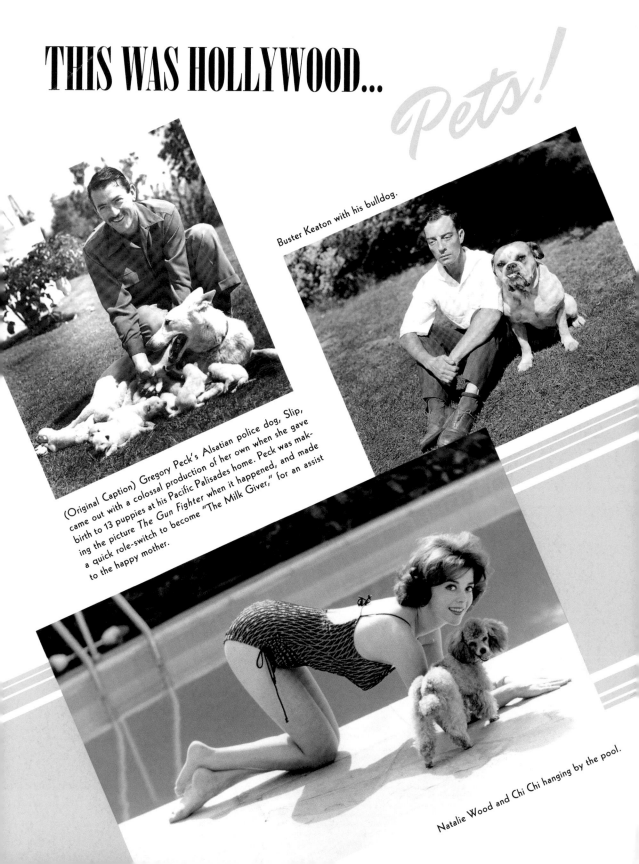

Buster Keaton with his bulldog.

(Original Caption) Gregory Peck's Alsatian police dog, Slip, came out with a colossal production of her own when she gave birth to 13 puppies at his Pacific Palisades home. Peck was making the picture *The Gun Fighter* when it happened, and made a quick role-switch to become "The Milk Giver," for an assist to the happy mother.

Natalie Wood and Chi Chi hanging by the pool.

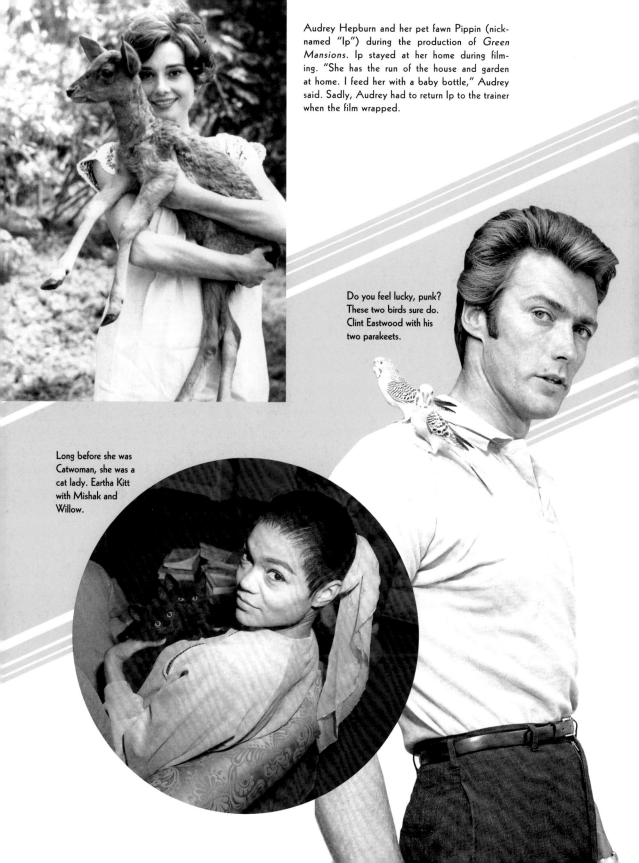

Audrey Hepburn and her pet fawn Pippin (nicknamed "Ip") during the production of *Green Mansions*. Ip stayed at her home during filming. "She has the run of the house and garden at home. I feed her with a baby bottle," Audrey said. Sadly, Audrey had to return Ip to the trainer when the film wrapped.

Do you feel lucky, punk? These two birds sure do. Clint Eastwood with his two parakeets.

Long before she was Catwoman, she was a cat lady. Eartha Kitt with Mishak and Willow.

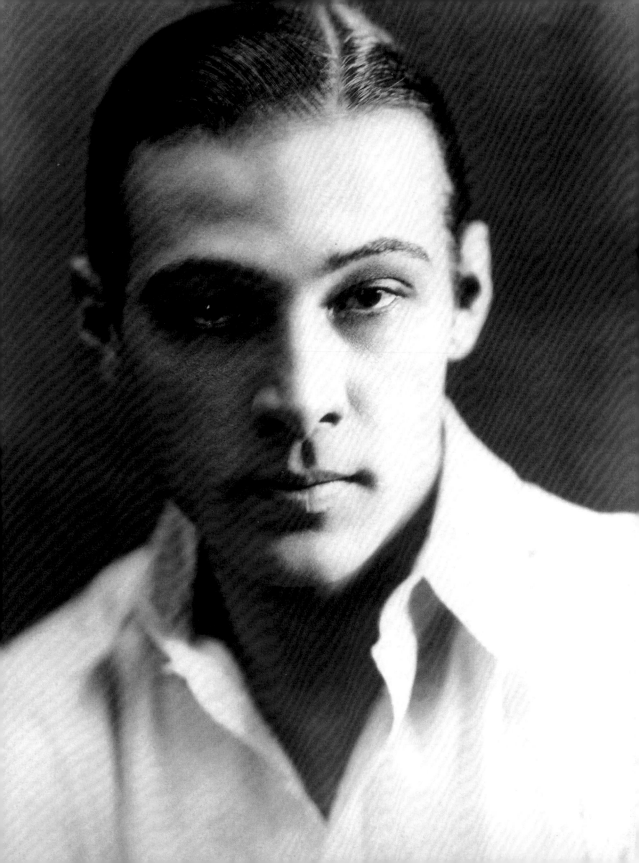

THE DEATH *of*

Rudolph Valentino

and THE BIRTH OF A SCREEN GOD

UNDER clear blue skies on August 30, 1926, more than 100,000 people lined the streets near Broadway and 66th Street in New York City, hoping to catch a glimpse of a silver-gray, rose-covered casket inside Campbell's funeral parlor. Rudolph Valentino, filmdom's "Great Lover," was dead. His death a week earlier, at the age of thirty-one and at the height of his fame, had spurred "grief riots" throughout the world. Now all that was left was mourning. Hollywood royalty like Mary Pickford and Douglas Fairbanks were among the bereaved. So was Valentino's self-declared "fiancée," the Polish film star Pola Negri. As the casket emerged from Campbell's, the funeral procession moved to St. Malachy's

Church. The crowds bid farewell to their beloved idol, whom they had revered in life and whose death would serve as the greatest proof yet of the movies' unique ability to elevate mortal men to the status of ageless gods.

At the time of his death, Valentino (born Rodolfo Pietro Filiberto Raffaello Guglielmi; Rudy to his friends) had squandered a fortune that should have lasted a hundred lifetimes. Profligate spending was a habit he had brought with him when he arrived in New York from his native Italy in 1913. After blowing through his $4,000 nest egg (more than $100,000 today) in a matter of months, he found himself homeless, often sleeping in Central Park. He soon got work

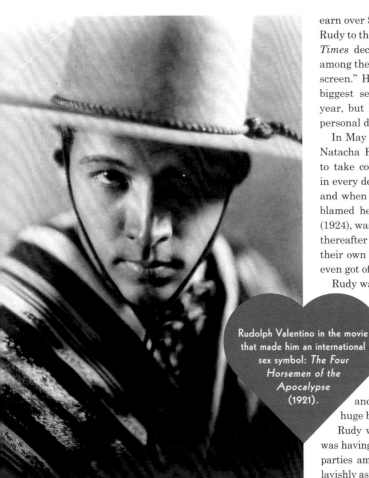

Rudolph Valentino in the movie that made him an international sex symbol: *The Four Horsemen of the Apocalypse* (1921).

earn over $1 million at the box office and vaulted Rudy to the top of the profession. The *Los Angeles Times* declared that he had "assumed a place among the most dominant romantic actors on the screen." He cemented his status as the world's biggest sex symbol with *The Sheik* later that year, but his time at the top was fraught with personal drama.

In May 1922, Rudy married costume designer Natacha Rambova, and she immediately began to take control of Rudy's career. She interfered in every detail of his next film, *The Young Rajah*, and when it bombed at the box office, the studio blamed her. His next film, *Monsieur Beaucaire* (1924), was a commercial and critical flop. Shortly thereafter Rudy and Natacha tried to produce their own film, *The Hooded Falcon*, and it never even got off the ground.

Rudy was in debt and accepted a contract from United Artists on the condition that Natacha have nothing to do with his films. Natacha was furious, and their marriage was soon over. But the end of his marriage would herald a return to his former glory, with Rudy's next two films, *The Eagle* and *The Son of the Sheik*, proving to be huge box office successes.

Rudy was once again on top of the world and was having a ball in New York, attending countless parties among New York society and spending as lavishly as ever. Despite his success, he told a friend that he would hate to live to be an old man and that he knew he would die young. Fate proved him right.

On the night of August 14, 1926, Rudy fell ill. Shortly before noon the next day, he collapsed in his room at the Hotel Ambassador. His manager, George Ullman, called for a doctor. After considerable delay, he underwent a double operation for acute appendicitis and perforated gastric ulcers.

The prognosis after surgery was positive. Peritonitis, a dangerous inflammation of the abdominal wall, had set in, but Rudy's physicians believed they had it under control and everyone thought Rudy would be back on his feet in no time. The next morning, front-page news stories about Rudy's hospitalization sparked mass hysteria. Crowds gathered outside the hospital waiting for an update. When the doors opened, hundreds of people poured into the hospital, and an information bureau was created on the ground floor to

at Maxim's restaurant-cabaret, where wealthy women paid to dance with him. He also began appearing as an extra in films.

He graduated to bit roles after moving to Hollywood in 1917, and four years later he exploded onto the screen in his first starring role, in *The Four Horsemen of the Apocalypse* (1921). June Mathis, one of the most successful and powerful female screenwriters of the era, had seen one of Valentino's performances and hired him for the film, despite the objections of the director and several executives at Metro Studios. Once he had become a star, many tried to take credit for discovering Rudy, but he always gave Mathis her due. "She gave me my start. She first of all people believed in me," he said. "I can only hope I shall have her eternally as my friend."

Four Horsemen was one of the first films to

keep the lobby clear. An armed guard had to be placed outside Rudy's hospital room.

Doctors began releasing updates on Rudy's condition, which were quickly dispatched around the world. Extra telephone operators were hired to answer the influx of calls. A premature report of his death brought in 2,000 calls per hour. The calls came not only from fans but also from New York mayor Jimmy Walker, New York representative Fiorello La Guardia, heavyweight champion Jack Dempsey, and movie stars Gloria Swanson, Marion Davies, and Mae Marsh. Douglas Fairbanks, Mary Pickford, and Charlie Chaplin sent letters and telegrams. Bibles, rosaries, and holy relics arrived en masse. Flowers appeared by the truckload. Even a pet monkey was brought to the hospital to cheer

Some of the tributes that have affected me the most have come from my "fan" friends—men, women, and little children. God bless them. Indeed, I feel that my recovery has been greatly advanced by the encouragement given me by every one.

But soon after, things took a turn for the worse. His temperature skyrocketed, and his doctors discovered that he had developed pleurisy, an inflammation of the lungs. Rudy was deteriorating quickly. In the early morning hours of August 23, he was given a shot to induce sleep. Shortly afterward, Ullman began to pull down the shades in the room, but Rudy cried out, "Don't pull down the blinds! I feel fine. I want the sunlight to greet

"DON'T PULL DOWN THE BLINDS! I FEEL FINE.

I want the sunlight to greet me."

Rudy up. The press dubbed his day nurse "the most envied woman in America."

Rudy had no idea how sick he was. He wasn't told about the peritonitis, and Ullman made sure he never saw a newspaper. He spent his days reading through the mountains of mail he had received. After receiving a telegram from a fan that read, "I need you. Live," Rudy said to Ullman, "They must have thought I was dying."

On August 19, the doctors said he was getting better, and Rudy issued a statement to the public:

I have been deeply touched by the many telegrams, cables, and letters that have come to my bedside. It is wonderful to know that I have so many friends and well-wishers both among those it has been my privilege to meet and among the loyal unknown thousands who have seen me on the screen and whom I have never seen at all.

me." These would be the last recorded words he ever spoke. At 8:00 a.m., he slipped into a coma. At 12:10 p.m., he died with only his doctors and nurses by his side. One of his physicians promptly had a heart attack.

News of his death traveled rapidly through the hospital and into the streets. Crowds gathered outside, blocking traffic until the police came. When the body was moved to Campbell's funeral parlor, the crowd followed. Embalmers worked through the night to restore his dashing film image for a public viewing the next day.

By the next afternoon, a crowd of more than 30,000 had surrounded the building, hoping to get a look at Rudolph Valentino. When the doors opened at 2:00 p.m., all hell broke loose. The crowd surged into Campbell's, knocking down policemen and even pushing a line of them into a window, causing the large plate glass to come crashing

down over their heads. Ambulances rushed to the scene and a hospital room was set up in the funeral parlor to accommodate the growing number of injuries. About an hour after the first window came down, the crowd crashed through the window of a nearby car rental. When the crowd was being driven out into the roadway, it overturned an automobile in the street.

"Feet were trod on, clothes were torn, hats, umbrellas and shoes even were wrenched from their owners, and at one time Broadway, closed to traffic intermittently for several hours along the block between Sixty-sixth and Sixty-seventh street, was littered with torn and battered personal belongings," the *New York Times* reported. "Twenty eight pairs of shoes were gathered up by the police at one time after the crowd had been driven back to the corner."

By the end of the day, at least a hundred people had been injured. Police on the scene declared the rioting was "without precedent in New York."

The following day, the large crowds returned to view Rudy's body. When the doors opened at 9:30 the next morning, a crowd of 10,000 had already assembled, and it continued to grow throughout the day, even as rain began to fall. By the end of the night, police estimated anywhere from 50,000 to 75,000 people had viewed Rudy's body.

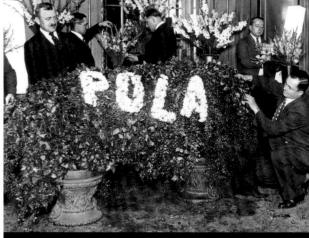

The floral arrangement Pola Negri wanted placed on Valentino's casket. When her request was denied, she promptly destroyed it.

The hysteria wasn't limited to the crowds outside (and within) Campbell's. On August 25, in London, Margaret Murray "Peggy" Scott was found dead after taking poison, leaving letters behind expressing her grief over Rudy's death. Later, in Newark, nineteen-year-old Evelyn Vail turned on the gas in her hotel room and was found dead clutching a photograph of Valentino. In Queens, Angeline Celestina, a mother of two small children, drank iodine and shot herself twice, falling over a pile of Valentino memorabilia. She lived but told police she "wanted to be where he is."

But soon another kind of hysteria would sweep into town as Pola Negri arrived at Grand Central Station. She stepped off the train in widow's garb, weeping and wailing. She became hysterical and collapsed. She was whisked away to the Hotel Ambassador by the nurse, publicist, and secretary who had accompanied her on the trip. Once at the hotel, she promptly fainted again. After crying for several hours in her suite, the real theatrics began.

At Rudy's casket, she knelt and prayed for fifteen minutes. As she began to rise, she suddenly fainted and was unconscious for twenty minutes. She managed to recover herself long enough to make a statement to the press. "We were really engaged to be married but the fact that we both had careers to follow accounts for the delay in our wedding plans," she said. "My love for Valentino was the greatest love of my life; I shall never forget him. I loved him not as an artist might love another but as a woman loves a man."

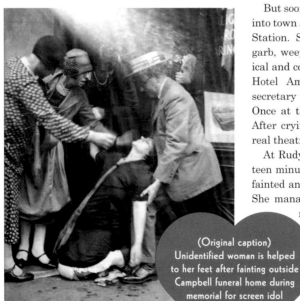

(Original caption) Unidentified woman is helped to her feet after fainting outside Campbell funeral home during memorial for screen idol Rudolph Valentino.

THIS WAS HOLLYWOOD

She had paid for an elaborate floral arrangement to cover his casket: White roses that spelled out "P-O-L-A." One of the ushers at the funeral, the actor Ben Lyon, was enraged at her attempts to turn Valentino's funeral into a "premiere for Pola Negri" and forbid her from bringing the floral arrangement near the casket.

On the day of the funeral, 500 invitation-only guests were allowed inside St. Malachy's Church. Five hundred policemen were ready in the event of another riot, but the crowds that day were subdued. The only disruption came as the casket was being carried out of the church after the service. A man ran up and dropped to his knees wailing, "Good-by, Rudolph. I will never see you again. Good-by, my friend Rudolph."

Immediately after Valentino's death, conspiracy theories swirled: He had been shot during a fight, struck during a brawl, or poisoned by a jealous woman at a party. Ferdinand Pecora, the assistant district attorney, stated that if he received any official reports, he would launch an investigation. Many pressured Rudy's brother, Alberto, to request an autopsy, but he declined and began the

trip to Hollywood with his brother on the funeral train. As the train pulled out of Grand Central Station, Pola was back at it, kneeling beside the casket with tears streaming down her face.

When the train stopped at Chicago's LaSalle Street Station, a crowd of thousands broke through police lines to rush onto the tracks. Twenty-five people were arrested for disorderly conduct. As the train neared Iowa, Pola admitted to reporters that she and Valentino weren't really engaged after all. "We were not formally engaged," she said. "We did not believe in formal engagements. . . . We decided

A very identifiable woman: Pola Negri, being helped after fainting at Valentino's funeral.

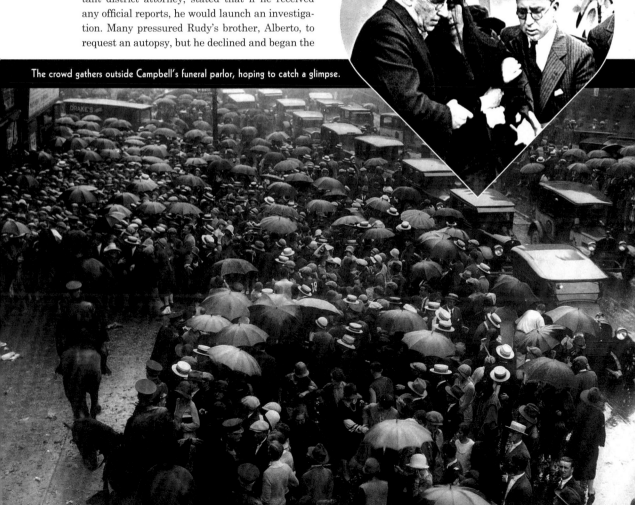

The crowd gathers outside Campbell's funeral parlor, hoping to catch a glimpse.

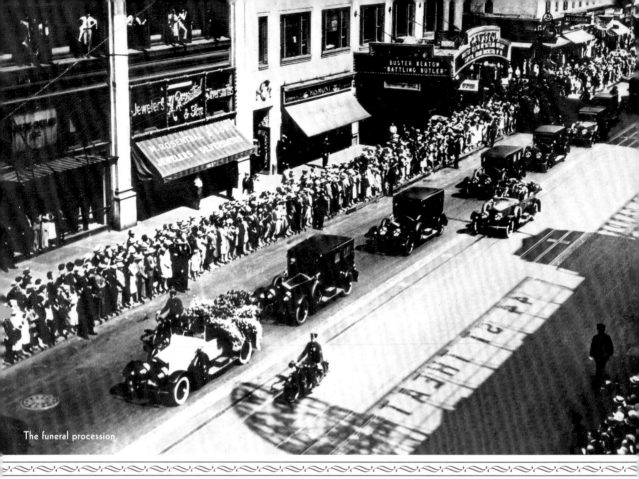

The funeral procession.

that our private lives belonged to us and we did not want to make publicity of it."

Final funeral services were held at 10:00 a.m. on September 7, 1926, at the Church of the Good Shepherd in Beverly Hills. That day, all the studios lowered their flags to half mast, held five minutes of silence, and let production out early.

Charlie Chaplin was among the pallbearers. Mary Pickford, Douglas Fairbanks, Louis B. Mayer, and Cecil B. DeMille were among the 600 mourners. Rudy's dear friend June Mathis was in attendance, as was Pola Negri. Thousands lined Santa Monica Boulevard between the church and Hollywood Memorial Park cemetery.

As the funeral procession made its way to the burial, two airplanes swooped through the sky and rained rosebuds over the mausoleum. Pola went to the casket sobbing loudly. She lifted the coverlet of flowers and began kissing the coffin before fainting one last time. Friends carried her to a divan, where she soon recovered. "The world

does not know my grief," she cried to reporters outside. A few months later, Pola married a prince.

Despite his success, Valentino's estate was such a shambles that it could not even afford to pay for his burial. And despite being loved the world over, nobody else came forward to pay for it either. Finally, June Mathis offered her own crypt in the Cathedral Mausoleum as a temporary resting place for Rudy.

Less than a year later, Mathis had a heart attack and died. Rudy was quietly moved to the crypt adjacent to hers. He has lain there since, next to the woman who launched his movie career and whom he once hoped he would have "eternally as my friend."

Rudy enjoyed an unprecedented level of posthumous success. Typically, films were withdrawn from theaters if their stars died, and it was a shock to exhibitors that, months after Rudy's death, *The Son of the Sheik* was still drawing record-breaking box office returns. The film was

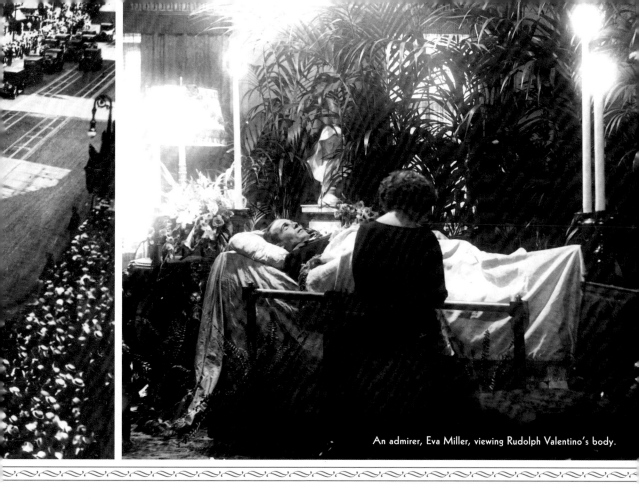

An admirer, Eva Miller, viewing Rudolph Valentino's body.

doing a "turn away" business, and many movie houses were forced to open doors two hours earlier than usual just to keep up. Studios began re-releasing his films, and film houses began digging up old prints of even his most obscure and maligned films to feed the public's demand for more Rudy. "The biggest gross on Broadway last week was attracted by a star who is no longer living," *Variety* wrote in October.

The world went on trying to cash in on his name. His brother underwent seven plastic surgeries to look more like Rudy, hoping to launch a screen career that never materialized. A few months after Rudy's death, George Ullman released his memoir, *Valentino As I Knew Him*. His first wife, Jean Acker, began to credit herself as "Jean Acker Valentino" and wrote a popular song about him called "We Will Meet at the End of the Trail." His second wife, Natacha Rambova, wrote a book about their time together and the ongoing "spirit messages" she claimed to be receiving from the

departed Valentino. Marion Benda, who had been with Valentino on the night before he fell ill, claimed he had fathered two of her children—just one of many women who made such claims.

Fans from around the world visited his crypt, and their antics were such that the caretaker of the Cathedral Mausoleum wrote a book about them. Women tried to sneak through the window of the mausoleum to be with him. Thirteen months after his death, a pregnant woman showed up at the cemetery saying Valentino was the father of her unborn child and asked to have a cot placed beside his crypt so that she could stay until she gave birth.

A year after his death, the first Valentino Memorial Service was held. Today, it is one of the longest continuous annual events in Hollywood and attracts two to three hundred people each August 23. A fitting tribute to a star whose death—and its aftermath—loom even larger than his colossal life.

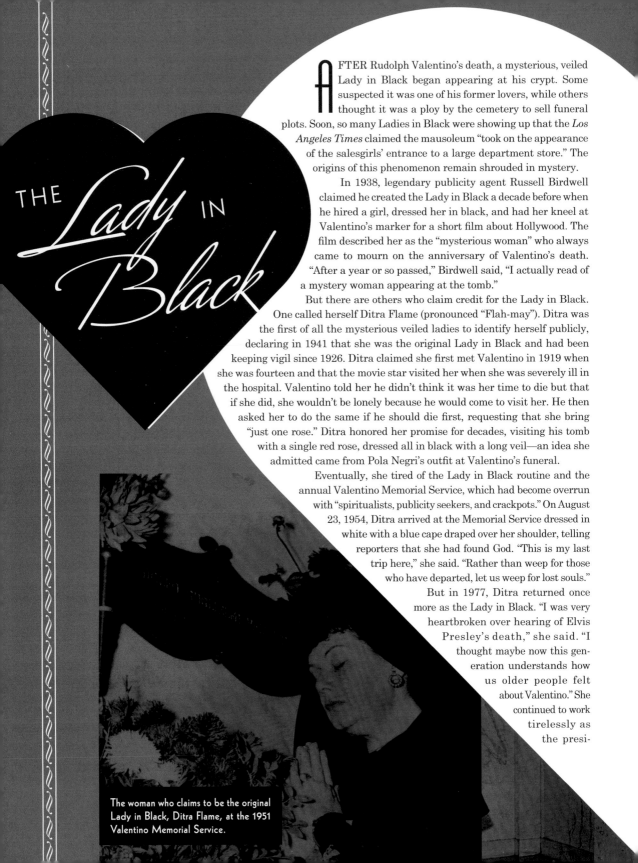

THE *Lady* IN *Black*

AFTER Rudolph Valentino's death, a mysterious, veiled Lady in Black began appearing at his crypt. Some suspected it was one of his former lovers, while others thought it was a ploy by the cemetery to sell funeral plots. Soon, so many Ladies in Black were showing up that the *Los Angeles Times* claimed the mausoleum "took on the appearance of the salesgirls' entrance to a large department store." The origins of this phenomenon remain shrouded in mystery.

In 1938, legendary publicity agent Russell Birdwell claimed he created the Lady in Black a decade before when he hired a girl, dressed her in black, and had her kneel at Valentino's marker for a short film about Hollywood. The film described her as the "mysterious woman" who always came to mourn on the anniversary of Valentino's death. "After a year or so passed," Birdwell said, "I actually read of a mystery woman appearing at the tomb."

But there are others who claim credit for the Lady in Black. One called herself Ditra Flame (pronounced "Flah-may"). Ditra was the first of all the mysterious veiled ladies to identify herself publicly, declaring in 1941 that she was the original Lady in Black and had been keeping vigil since 1926. Ditra claimed she first met Valentino in 1919 when she was fourteen and that the movie star visited her when she was severely ill in the hospital. Valentino told her he didn't think it was her time to die but that if she did, she wouldn't be lonely because he would come to visit her. He then asked her to do the same if he should die first, requesting that she bring "just one rose." Ditra honored her promise for decades, visiting his tomb with a single red rose, dressed all in black with a long veil—an idea she admitted came from Pola Negri's outfit at Valentino's funeral.

Eventually, she tired of the Lady in Black routine and the annual Valentino Memorial Service, which had become overrun with "spiritualists, publicity seekers, and crackpots." On August 23, 1954, Ditra arrived at the Memorial Service dressed in white with a blue cape draped over her shoulder, telling reporters that she had found God. "This is my last trip here," she said. "Rather than weep for those who have departed, let us weep for lost souls."

But in 1977, Ditra returned once more as the Lady in Black. "I was very heartbroken over hearing of Elvis Presley's death," she said. "I thought maybe now this generation understands how us older people felt about Valentino." She continued to work tirelessly as the presi-

The woman who claims to be the original Lady in Black, Ditra Flame, at the 1951 Valentino Memorial Service.

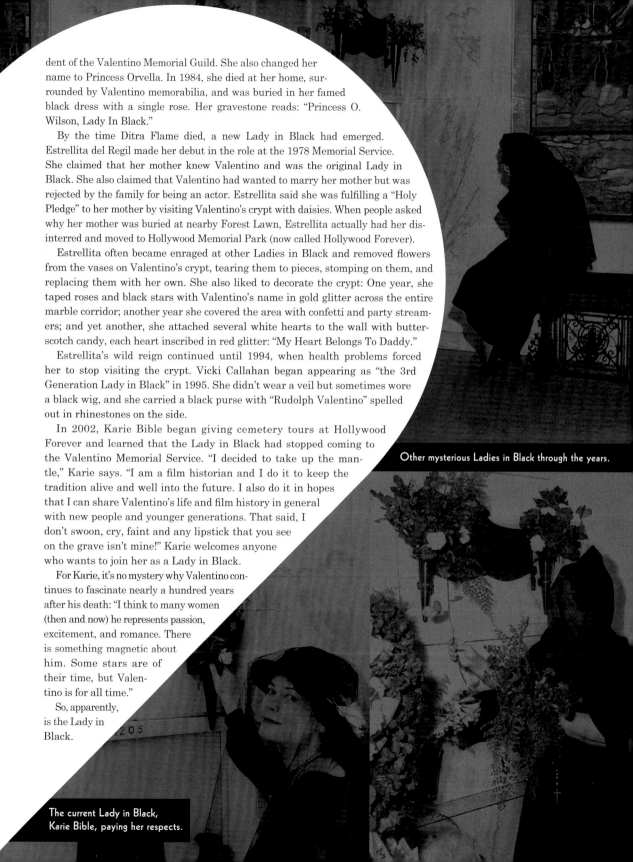

dent of the Valentino Memorial Guild. She also changed her name to Princess Orvella. In 1984, she died at her home, surrounded by Valentino memorabilia, and was buried in her famed black dress with a single rose. Her gravestone reads: "Princess O. Wilson, Lady In Black."

By the time Ditra Flame died, a new Lady in Black had emerged. Estrellita del Regil made her debut in the role at the 1978 Memorial Service. She claimed that her mother knew Valentino and was the original Lady in Black. She also claimed that Valentino had wanted to marry her mother but was rejected by the family for being an actor. Estrellita said she was fulfilling a "Holy Pledge" to her mother by visiting Valentino's crypt with daisies. When people asked why her mother was buried at nearby Forest Lawn, Estrellita actually had her disinterred and moved to Hollywood Memorial Park (now called Hollywood Forever).

Estrellita often became enraged at other Ladies in Black and removed flowers from the vases on Valentino's crypt, tearing them to pieces, stomping on them, and replacing them with her own. She also liked to decorate the crypt: One year, she taped roses and black stars with Valentino's name in gold glitter across the entire marble corridor; another year she covered the area with confetti and party streamers; and yet another, she attached several white hearts to the wall with butterscotch candy, each heart inscribed in red glitter: "My Heart Belongs To Daddy."

Estrellita's wild reign continued until 1994, when health problems forced her to stop visiting the crypt. Vicki Callahan began appearing as "the 3rd Generation Lady in Black" in 1995. She didn't wear a veil but sometimes wore a black wig, and she carried a black purse with "Rudolph Valentino" spelled out in rhinestones on the side.

In 2002, Karie Bible began giving cemetery tours at Hollywood Forever and learned that the Lady in Black had stopped coming to the Valentino Memorial Service. "I decided to take up the mantle," Karie says. "I am a film historian and I do it to keep the tradition alive and well into the future. I also do it in hopes that I can share Valentino's life and film history in general with new people and younger generations. That said, I don't swoon, cry, faint and any lipstick that you see on the grave isn't mine!" Karie welcomes anyone who wants to join her as a Lady in Black.

For Karie, it's no mystery why Valentino continues to fascinate nearly a hundred years after his death: "I think to many women (then and now) he represents passion, excitement, and romance. There is something magnetic about him. Some stars are of their time, but Valentino is for all time."

So, apparently, is the Lady in Black.

Other mysterious Ladies in Black through the years.

The current Lady in Black, Karie Bible, paying her respects.

United States Ⓥ.

"The Spirit of '76"

Robert Goldstein directing the film that would destroy his life.

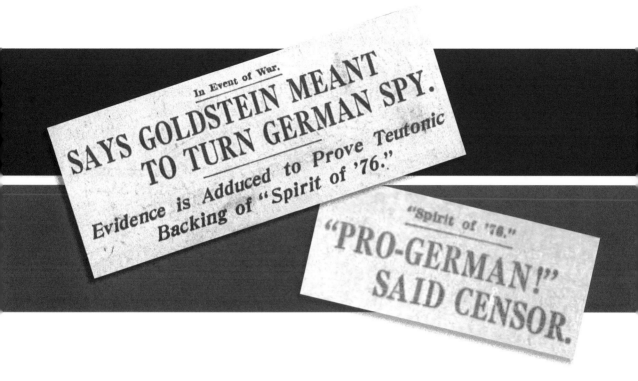

In Event of War.

SAYS GOLDSTEIN MEANT TO TURN GERMAN SPY.

Evidence is Adduced to Prove Teutonic Backing of "Spirit of '76."

"Spirit of '76."

"PRO-GERMAN!" SAID CENSOR.

O N June 23, 1918, prisoner #3180 was being processed at McNeil Island Penitentiary in Washington state. His name was Robert Goldstein, and he was beginning the first day of a ten-year sentence. His crime was violating the recently passed Espionage Act, but he was no spy and certainly no traitor. He was a film producer whose first and only project had aroused such suspicion and outrage that he was branded an enemy of the state. But in truth, Goldstein's biggest crime was making the wrong movie at the wrong time. As a result, he would fall victim to power-hungry censors, a pigheaded Justice Department, and anti-German sentiment roused by World War I. And he, and his film, would come to a tragic end.

Prior to his incarceration, Goldstein was the most sought-after costumer in the film industry, then beginning to boom in Los Angeles. He had provided the costumes for D.W. Griffith's ground-breaking film *The Birth of a Nation* (1915) and earned a small fortune by investing in the picture, which turned out to be one of the most lucrative films ever made. Inspired by that success, the thirty-three-year-old sank $200,000 ($4 million today) into his own film, *The Spirit of '76* (1917), planning to do for the Revolutionary War what *The Birth of a Nation* had done for the Civil War.

For obvious reasons, the British were the villains of *The Spirit of '76*, but by the time filming had wrapped, the United States had entered the Great War, and Britain had become an ally. To acknowledge this, Goldstein ended the film with a tableau of Uncle Sam and his British counterpart, John Bull, hands clasped, with the subtitle, "And now joined together in a still greater fight for the liberty and democracy of the whole world."

Goldstein viewed his film as a patriotic masterpiece and expected it to be a smash at the box office. It was chock full of patriotic scenes of early American glory: Patrick Henry's "Give me liberty or give me death" speech; the midnight ride of Paul Revere; the Battle of Lexington; and the signing of the Declaration of Independence, among others. But it also showed British soldiers committing crimes against civilians.

The trouble began immediately. He had arranged to premiere his film in Chicago, but the head of the Chicago censorship board, Major Metellus Lucullus Cicero Funkhouser, declared that the movie's anti-British sentiment would offend the government of the United States and "had been financed by friends of the German government as a German propaganda to retard the recruiting to America."

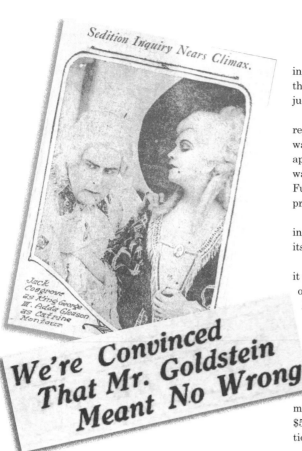

Sedition Inquiry Nears Climax.

Jack Cosgrove as King George III. Adda Gleason as Catrine Montour

We're Convinced That Mr. Goldstein Meant No Wrong

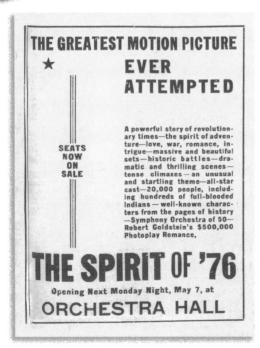

THE GREATEST MOTION PICTURE
★ **EVER ATTEMPTED**

SEATS NOW ON SALE

A powerful story of revolutionary times—the spirit of adventure—love, war, romance, intrigue—massive and beautiful sets—historic battles—dramatic and thrilling scenes—tense climaxes—an unusual and startling theme—all-star cast—20,000 people, including hundreds of full-blooded Indians—well-known characters from the pages of history—Symphony Orchestra of 50—Robert Goldstein's $500,000 Photoplay Romance,

THE SPIRIT OF '76
Opening Next Monday Night, May 7, at
ORCHESTRA HALL

After cutting the offending scenes—and taking legal action—Goldstein was allowed to show the picture to a small private audience, including judges and newspaper reporters.

"The consensus of unofficial opinion expressed," reported the *Chicago Tribune*, "was that there was no pro-German trend to the film. In fact, it appeared to be rather the reverse." Funkhouser was forced to grant the film a permit. (Ironically, Funkhouser himself was soon accused of being pro-German and driven from office.)

On May 28, *The Spirit of '76* premiered to glowing reviews, many of which specifically highlighted its patriotic character.

"Contrary to the opinion of the Chicago censors it contains nothing that would dampen the fervor of America at war now," the *Exhibitors Trade Review* wrote. "Instead it inspires patriotism. It has some truly wonderful moments and should cause the red blood of any American to tingle."

"It is the very heart of what our patriotism is based on," the *Chicago American* exclaimed, "it is The Spirt of '76!"

Despite this enthusiasm, Goldstein estimated that all the delays had cost him around $50,000 (over $1 million today). His next exhibition would prove even more costly.

In November, he premiered the film at Clune Auditorium in Los Angeles to much fanfare. But in the days after the premiere, the U.S. Attorney confiscated the film and arrested Goldstein under the Espionage Act. He was charged with "willfully and unlawfully attempt[ing] to cause insubordination, disloyalty, mutiny and refusal of duty on the part of the military and naval forces of the United States."

Goldstein was baffled. He had set out to make a patriotic film, but just as in Chicago, the government now seized on scenes of British violence against civilians as evidence of pro-German bias. He appeared before Judge Benjamin Bledsoe, who said there was no doubt that "a sedulous effort was indulged in to put [into the film] those things which would tend to create a prejudice against Great Britain."

The publicity around the case meant Goldstein had difficulty securing representation. Most lawyers simply did not want to tarnish their reputations by defending anyone who was "pro-German." Even his attempts to pay his bail were rejected, with the government declaring the various bondsmen

ROBERT GOLDSTEIN

wishes to announce
the completion of his

TWELVE REEL
PRODUCTION

Entitled

THE SPIRIT of '76

A Historical Romance Dealing with the
AMERICAN REVOLUTION and its CAUSES

This film has been in production for over a year and is happily completed at this time to help rouse the patriotism of the country.

CONTINENTAL PRODUCING CO.
650 South Broadway

Los Angeles, California

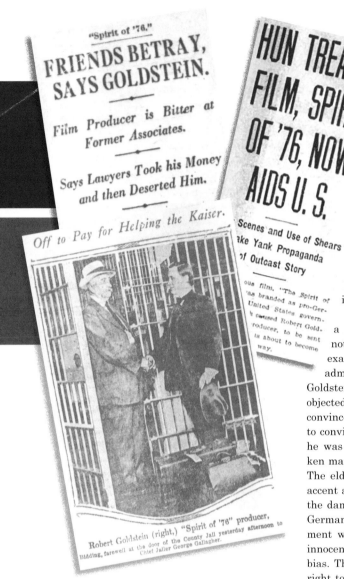

Francisco who had recently been convicted of conspiracy to destroy an American ship. Walter Brock, a researcher, testified that Goldstein ordered "no English be employed about the studio," a curious claim given that British actor Howard Gaye played the leading role.

But the biggest bombshell came from the manager of the Clune Auditorium, Theo M. Newman. Newman undermined the prosecution's entire case, testifying that the public had *never actually seen* any of the objectionable scenes of British violence because he had cut them out himself before exhibiting the film.

Newman's testimony would have been a godsend for most defense lawyers—but not Goldstein's. When his lawyers cross-examined Newman, they pressed him to admit that he had cut the scenes out without Goldstein's authority and that Goldstein had objected. They made several other missteps that convinced Goldstein they were actually working to convict him. They forced him to testify, and he was mocked by the press for his soft-spoken manner. They put his father on the stand. The elder Goldstein spoke in a thick German accent and, under cross-examination, admitted the damning fact that his son had traveled to Germany as a teenager. Their closing statement was less an argument for their client's innocence than an admission of his pro-German bias. They told the jury that "Goldstein had a right to his opinion even if he approved of the sinking of the *Lusitania*" (he didn't) and that he could not be convicted just because "he was pro-German" (he wasn't).

Goldstein was convicted and sentenced to ten years in prison, with a $5,000 fine. At the sentencing, Judge Bledsoe declared *The Spirit of '76* one of the "most potent German propagandas" and told Goldstein he should consider himself lucky that he hadn't committed treason in a country where the penalty would be death.

Interestingly, a mere two months later, Bledsoe announced that he had removed the "pro-German" scenes and changed the title of the film to *The Eternal Spirit of '76*—and that it would be

he secured unsuitable. He languished in jail for months awaiting trial.

When his trial finally began in April 1918, the prosecution's case was long on theatrics but short on evidence. Several prosecution witnesses testified in military uniform. When the film was shown, the scenes of British violence were played at a much slower speed than normal for heightened effect. (The scenes in question amounted to less than one second of screen time in a film that ran well over an hour.) George L. Hutchin, one of the film's scenario writers, claimed that Goldstein had told him the film would be financed by Franz Bopp, former German consul of San

re-released as "patriotic propaganda," sanctioned by the U.S. government.

Robert Goldstein, meanwhile, sat in prison. In March 1919, President Woodrow Wilson reduced Goldstein's sentence to three years, and he was released a year-and-a-half later. But the damage was done. The trial had bankrupted Goldstein, ruined his career, and ostracized him from his friends and family. He began to lose touch with reality, experiencing paranoid delusions that his dentist and doctor were attempting to harm him.

In the spring of 1921, a desperate Goldstein decided the only way to vindicate himself was to exhibit the picture that had caused him so much trouble in the first place. A few months later, *The Spirit of '76* was presented at the Town Hall in New York. This time, with World War I over, nobody thought to accuse the film of being pro-German. Now, some claimed, Goldstein's film was inciting another immigrant group to revolt. "[I]t is intended to stir up pro-Irish feeling against Great Britain," the *New York Times* wrote after the premiere. But that was hardly the paper's biggest complaint. "As a motion picture," the newspaper wrote, "'The Spirit of '76' seems to be of the age 1891." The film ran for three weeks, but when Goldstein was tipped off that he would be arrested if he brought his exhibition across state lines, he closed the show.

Feeling like a pariah in his own country, he tried to get work in the film industry in Europe. When that failed, he went to live with an aunt in Berlin. Goldstein's paranoia increased, especially after D.W. Griffith released his Revolutionary War film *America*. Griffith had worked with Goldstein on the early stages of *Spirit of '76*, and Goldstein became convinced that Griffith had sabotaged him to clear the way for his own film. When Griffith visited Berlin, Goldstein confronted him. Griffith didn't deny there were similarities between the films and even agreed to compensate Goldstein. Upon receiving Griffith's check for a mere $100, Goldstein promptly sent it back.

By 1927, he was "flat broke" and unable to find work even as a "street sweeper." He began sending pleading letters to the recently formed Academy of Motion Picture Arts and Sciences, including a rambling, ninety-two-page manuscript written in the third person. The Academy declined to help. The fact that Griffith, a leading Academy member, was the villain of Goldstein's tale likely didn't help his cause.

He remained in Berlin for several more years, but in 1935, the Jewish Goldstein was growing desperate to leave Hitler's Germany. For a time, he was trapped there. Unable to pay the $9 to renew his American passport, he was fined 75 marks by the American Consulate. When he couldn't pay that, he was jailed for two weeks and appealed to the Academy for help once again, calling it a "swell piece of ironical news" that a man once convicted of aiding Germany was now imprisoned there.

Eventually, he secured passage to New York, arriving in August 1935. By 1938, he was living in a seedy hotel in the city. He sent the Academy a desperate telegram:

And then Robert Goldstein just disappeared. He had no children. His only brother had cut off contact with him years earlier and hid Robert's existence from his children. The last official record of his existence is a Social Security application he made on March 3, 1940. There is no known record of his death.

And just like its creator, *The Spirit of '76* has itself been lost to history, with no known print still in existence.

The
White House
of Hollywood

BEVERLY Hills has long been a symbol of the glamour and excess of Hollywood and the people who made it. But at the turn of the 20th century, the city was known for something else entirely: Beans. Lots of them. Rancho Rodeo de las Aguas, as the area was then known, was just a field of lima beans when a group of investors purchased it on behalf of the Amalgamated Oil Company in 1900. The little oil they struck wasn't enough to commercialize, but the area's vast water resources convinced the investors to reorganize as the Rodeo Land and Water Company. In 1906, they renamed the beanfield Beverly Hills and vowed to make it "one of the world's show places." Beverly Hills aspired to be a utopia for homebuyers of all income levels, but restricted covenants prohibited non-Caucasians and Jews from buying or even living in a property, except as servants. Growth was so slow at first that the company's principal, Henry Huntington, sent in laborers from his Pacific Electric Railway to set up "temporary camps" in order to reach a population of 500, the minimum required to incorporate as a city.

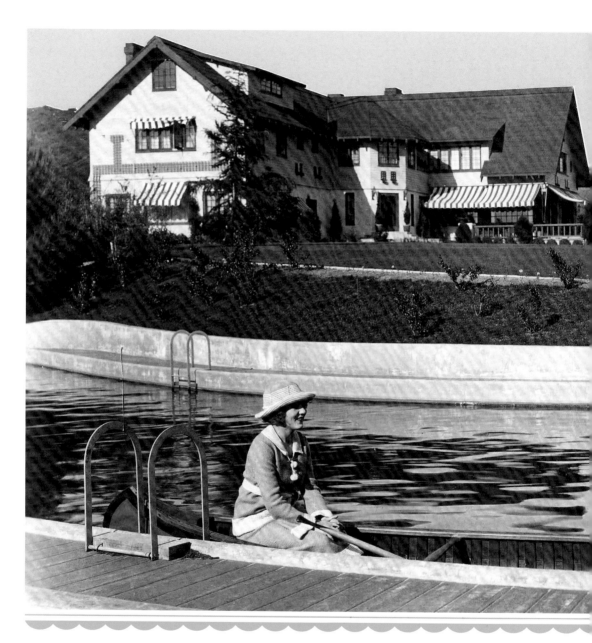

Even after the city was incorporated on January 28, 1914, people were hesitant to live in this "far away, isolated patch." But everything changed in 1920, when a celebrity couple decided to move in. He was Douglas Fairbanks, the first "King of Hollywood." She was Mary Pickford, "Queen of the Movies." Together they were Hollywood royalty and would come to reign over the film colony from their palatial estate, Pickfair, which became the social center of the movie industry and a magnet for tourists from around the world. The estate would earn the nickname "The White House of Hollywood" in tribute to the endless procession of dignitaries—U.S. presidents, foreign heads of state, famous authors, artists, scientists, and heroes—among its guests. Following Fairbanks's and Pickford's lead, movie stars, directors, and producers began to flock to the area, lending

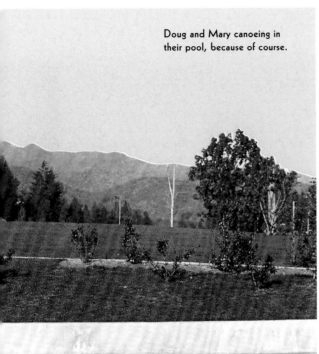

Doug and Mary canoeing in their pool, because of course.

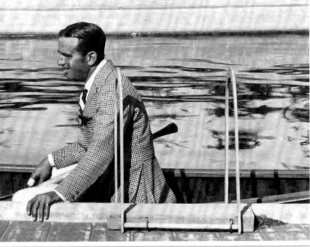

and the leading form of mass entertainment for Americans. Movie stars were now eager to spend their money and build their dream homes, and Douglas Fairbanks was no exception. A larger-than-life personality who reveled in doing his own outrageous stunts, Fairbanks was a sensation. One of the first film superstars, he was also a successful screenwriter and independent producer.

Much like the city it would come to represent, Pickfair sprang from humble beginnings. Built in 1911, the original structure was a hunting lodge without running water or electricity. It sat on a gentle rolling hill over Benedict Canyon with a view of the mountains and ocean. Fairbanks purchased the lodge and the fourteen acres that surrounded it on April 22, 1919. He began remodeling the property in June, and by the end of the year, the hunting lodge had been transformed into an extravagant mansion in the style of an English country house.

The home featured two wings (one 95 feet long and the other 125 feet), each facing the front of the lawn with its view of the canyon below. The first floor of the house had an entrance hall, living room, movie theater, dining room (which led to a glass-enclosed sun porch), breakfast room, kitchen, and servants' quarters. On the second floor was Fairbanks's master suite and five guest bedrooms. The third floor had a bowling alley and billiard room. He built a 55-by-100-foot swimming pool with a slide and even a strip of sandy beach. He used the massive pool and a series of ponds he had constructed for canoeing. There was a six-stall stable on the grounds, with quarters for caretakers, a tea house, and a miniature golf course.

At the time of his purchase, Fairbanks had divorced his first wife and was secretly involved with Mary Pickford, who herself was still unhappily married. If Fairbanks was a sensation, Pickford was a phenomenon. Known as "Little Mary" and "America's Sweetheart" (despite being from Toronto), Pickford played children well into her early thirties. Her charm and comic abilities endeared her to audiences around the world. She was also a brilliant businesswoman. In 1916, she became the highest-paid movie star when she signed a million-dollar contract (plus a percentage of the profits) as an independent producer with Paramount Pictures. She was also one of the founders of United Artists, along with Fairbanks, Charlie Chaplin, and D.W. Griffith.

Beverly Hills its aura of glitz and opulence that endures to this day.

It is hard to believe now, but at the dawn of Hollywood, movie stars lived somewhat modestly. The movies were still a novelty, and it was unclear how long they would remain popular, or if the big salaries they provided would last. But by the time World War I had ended, the motion picture industry was the fifth largest in the United States

After paying $100,000 to her husband not to contest the divorce, on March 3, 1920, she was finally free. On March 28, she and Fairbanks were married by a friend in a small ceremony in Los Angeles. Afterwards, they returned to Fairbanks's new home in Beverly Hills. Upon arriving, Fairbanks told his new bride, "Mary, this house is my wedding present to you."

"No, Douglas," she replied. "I want to feel that this is your home and that I am sharing it with you."

Initially, both Pickford and Fairbanks were concerned that their divorces and quick remarriage would ruin their careers. But when they embarked on a European honeymoon, they were mobbed by fans from London to Paris. Fairbanks had to put Mary on his shoulders to keep her from getting trampled by the crowds who thronged to see them throughout their trip. Upon returning,

they opened up their home to the press, who christened it "Pickfair" and photographed and shared every detail with legions of movie fans. They became known as "Doug and Mary," and Pickfair quickly became one of the world's iconic homes.

The couple had separate adjoining suites. Mary's bedroom was decorated in pastel shades of lavender and green with replica 18th century neoclassical French furniture. Both Mary and Doug's rooms featured a large bathroom and a sleeping porch (very helpful in pre-air-conditioning days).

They rarely dined alone. Doug had a habit of bringing people home for dinner without notice, and Mary instructed her staff always to set the table for fifteen. Fans demanded to know what their beloved stars dined on, so fan magazines began publishing Pickfair menus. A "Typical Family Dinner" menu at Pickfair:

DINNER AT PICKFAIR

Boiled Halibut
with Hot Tartar Sauce
French Fried Potatoes

Filet of Chicken a la Poulet
Sweet Potato Croquettes
Spinach *with Egg Sauce*

Hearts of Lettuce
with French Dressing

Neapolitan Baskets
with Hot Chocolate Sauce

Coffee

One item was never on the menu at Pickfair: Alcohol. Doug was a teetotaler. However, according to his son (and Mary's stepson) Douglas Fairbanks Jr., Mary was "something of a secret drinker" and would often sneak a glass of sherry at dinner. She would also hide it in her bathroom: The hydrogen peroxide bottle was filled with gin, while the Listerine bottle was reserved for scotch. To compensate for the lack of alcohol-fueled levity, Doug would play pranks on his dinner guests. Sometimes he would get under the table like a dog and bite their ankles. He also had a specially wired chair that would send electric shocks to the lucky guest sitting in it.

A flood of movie stars, screenwriters, producers, and directors followed Doug and Mary to the newly trendy city of Beverly Hills, among them Charlie Chaplin, Buster Keaton, Gloria Swanson, Rudolph Valentino, Will Rogers, Jack Warner, and Louis B. Mayer.

"Soon, houses began to spring up on all the hills like gilded monuments," screenwriter Frances Marion recalled. "Every parvenu tried to outdo every other parvenu." With each new resident came a new swimming pool or waterfall, and before long, the once-plentiful water that had put Beverly Hills on the map was running short.

By 1923, the private wells that were providing the water couldn't keep up with demand. The Rodeo Land and Water Company sourced its water supply from the shallow wells in Coldwater Canyon and wanted to annex Beverly Hills to the city of Los Angeles, which had an abundance of water from its own aqueduct. The city's real estate agents supported annexation, and a petition drive put the issue to a public vote. Those in favor of annexation began aggressive campaign tactics, putting bottles of stinking, sulfurous water on doorsteps around the city, with a message: "This is a sample of the water which the Trustees of the City of Beverly Hills propose for our city. Drink sparingly, as it has laxative qualities."

But the pro-annexation campaign was met with a force far more compelling than cheap stunts: Star power. Mary, Doug, and other stars such as Harold Lloyd, Rudolph Valentino, Will Rogers, Fred Niblo, Tom Mix, and Conrad Nagel went door to door campaigning against annexation. If Beverly Hills were to be annexed, the stars said, they could face new taxes and lose

Douglas Fairbanks, Mary Pickford, and Charlie Chaplin at a Pickfair costume party.

control over their schools and police force (the LAPD had already developed a reputation for corruption).

The final vote was 507 to 337 in favor of independence, and the city constructed its own water system. Thirty-five years later, the city erected a 22-foot high marble and bronze monument called "Celluloid" as a tribute to the eight celebrities who vigorously campaigned for the city's autonomy.

Doug and Mary weren't just the saviors of the city; they were also becoming the toast of international nobility. Lord and Lady Mountbatten spent two weeks of their honeymoon at Pickfair, and the home left a distinct impression. "Pickfair was certainly the best taste house—not the biggest but the best taste house—in Hollywood," Lord Mountbatten recalled. "It was like Buckingham Palace in London."

The couple played host to a procession of nobles from around the world, including the King and Queen of Siam, King Alfonso XIII of Spain, the Crown Prince of Japan, Prince George of England, and Prince Wilhelm of Sweden.

Doug being Doug during a story conference for *The Three Musketeers* (1921), with writers Lotta Woods, Kenneth Davenport, and Edward Knoblock.

With all this royalty in the house, Doug felt that Pickfair needed a regal remodeling. In 1925, the dining room took on the theme of 18th century France and featured solid gold dishware, crystal place-card holders, and a set of china that Napoleon had once given to Josephine. For formal dinners, a footman stood behind each chair. Doug even started permitting alcohol: Two "weak mixed drinks" per guest.

A man of boundless energy with a bizarre sense of fun, Doug always kept things interesting for his noble guests. He would wake them up before dawn to ride horses in the dark to a campsite, where breakfast would be waiting for them. He would take them on sightseeing tours to the elaborate Pickford-Fairbanks Studio, where he had a lounge-dressing room, makeup room, barber shop, play room, bar, gymnasium, Turkish

bath, swimming pool, and even an underground trench with a private running track so he could run naked. Once the royals had toured the studio and seen how the movies were made, Doug would take them to his gymnasium for physical activities: The King of Siam rode a mechanical horse; Prince George of England wrestled; the Duke of Alba fenced; and Prince Wilhelm of Sweden did "Swedish exercises."

Afterwards, Doug would invite his guests for a steam bath. Charlie Chaplin recalled that many of his introductions to these titled guests were made in the Turkish bath. "When a man is stripped of all his worldly insignia," Chaplin said, "one can appraise him for what he is truly worth—the Duke of Alba went up a great deal in my estimations."

Doug and Mary were also honored to host presidents (Calvin Coolidge and Franklin Roosevelt), scientists (Albert Einstein), writers (F. Scott Fitzgerald, George Bernard Shaw, Sir Arthur Conan Doyle, and H.G. Wells), and important Americans of all kinds (Amelia Earhart, Helen

Keller, Charles Lindbergh, Thomas Edison, and Henry Ford, among many others).

Doug especially enjoyed befriending his sports heroes. He would play baseball and leapfrog with Babe Ruth and spar with Jack Dempsey and Gene Tunney. One day, when studio head Adolph Zukor came over to talk business, he found Doug in the pool with Ruth and the great Washington Senators' pitcher Walter Johnson, in the midst of a contest to see who could hold their breath the longest.

"People of attainment fascinated [Doug], and he them," Mary said. "He sought them out not because he was a snob, but because of his lively interest in how they made their name, how they accepted their success, how it had influenced them."

But the endless entertaining began to exhaust Mary. According to actress Lillian Gish, Mary called one day to say she was coming to New York to stay in a hotel room "just for the quiet."

As the silent film era gave way to talkies, Doug found his career in steep decline. Mary made a more successful transition to sound films, winning an Academy Award for Best Actress in 1930 for *Coquette*. But she knew her star was also dimming and was able to accept life out of the spotlight, refocusing her energies into her production company. Doug, however, struggled to adjust to the new reality.

He decided to travel the world and make a film about his journey: *Around the World in 80 Minutes with Douglas Fairbanks*, which included footage of him in Japan, China, the Philippines, Thailand, Malaysia, Burma, Mandalay, and India. The film was released to disappointing returns in 1931, and he returned briefly to Pickfair the next year, overseeing the addition of a new wing and guesthouse to accommodate all the guests expected for the 1932 Olympics. He then set out for Tahiti to film *Robinson Crusoe* before embarking on another world tour.

But Doug's travels were creating a rift with Mary. "I found I just couldn't keep up the pace with a man whose very being had become motion, no matter how purposeless," Mary said.

She put her energies into improving Pickfair and making new additions. "It's thrilling," she explained, "to watch one's home grow and grow. No world-wandering could make up for that enormous satisfaction."

By the summer of 1933, their fairytale life was coming to an end. In England, Doug had begun an affair with Lady Sylvia Ashley, an ex-model who had married her way into English nobility. Hollywood's first power couple separated, and Mary was left to tend to their vast estate. Millions of fans were shocked that the "perfect union" of Doug and Mary was no more.

In early 1936, Doug and Mary were divorced, and in March Doug married Lady Ashley. The

The King and Queen of Hollywood.

decline of his career and personal life was matched by a decline in health over the next few years. On December 10, 1939, he suffered a heart attack. Two days later, he died in his sleep. He was fifty-six years old.

Mary found happiness in her new life. In June 1937, she married actor-turned-musician Buddy Rogers, who was twelve years her junior. Buddy purchased a beautiful home near the Riviera Country Club, and Pickfair was put up for sale. "But," he later explained, "I saw Mary's maids keep shuttling back and forth between Pickfair and the house. I realized she wanted to get home. One day I said, 'I give up.'"

Mary's new life at Pickfair with Buddy and their two adopted children was very different from the old days with Doug. The lavish entertaining gave way to more intimate gatherings. When World War II began, soldiers were invited every Wednesday for lunch and swimming. Pickfair played host to charity events during the war for American, British, and Chinese soldiers. After the war, Pickfair hosted a party for disabled veterans

Angeles. But these institutions wanted Mary and Buddy to pay to maintain the property in perpetuity, which they couldn't afford. Eventually, it was decided that Buddy would take a piece of the land and build a smaller place of his own, Pickford Lodge, then sell the rest of the estate.

In 1980, Pickfair was sold in a probate hearing to Los Angeles Lakers owner Jerry Buss, who continued to care for the estate. Buss sold the property to celebrity Pia Zadora and her businessman husband, Meshulam Riklis, in 1988. They announced they were planning $2 million in renovations to "add a little more house" to the forty-two-room mansion because, as they said, their two children, housekeeper, maid, and nanny "have to be put somewhere."

A year later, however, it had become clear that their plans went far beyond adding "a little more house." They were planning to transform Pickfair into an extravagant Venetian palazzo. The City of Beverly Hills didn't seem to care that the estate that had brought the city global recognition (and whose owners had once saved

"People have their illusions — and I want them to keep them."

and their families, which became an annual event and a great source of pride for Mary.

But as the years passed, such events became less and less frequent. Eventually, Mary became a recluse, rarely leaving Pickfair during the last fifteen years of her life. She declined to see those who came to visit her, choosing instead to speak with them by telephone from her room upstairs as they stayed on the ground floor. "People have their illusions—and I want them to keep them," she explained. On May 29, 1979, she died at Santa Monica Hospital from a cerebral hemorrhage suffered the week before.

Before her death, Buddy told Mary that Pickfair was too much for him to handle on his own, and the couple tried to bequeath the home and its land to several institutions, including the City of Beverly Hills, the University of Southern California, and the University of California Los

the young city from being annexed) would all but cease to exist.

The Beverly Hills Planning Commission approved the proposed changes to the property. The Beverly Hills Historical Society, "a non-profit organization dedicated to preserving all things pertinent to the history of the city of Beverly Hills," also raised no objection. The society's president said, "It's nothing spectacular. It's just a house."

In 1990, after seven decades as one of the most renowned estates in the world, Pickfair was demolished. All that remained were the gates, the kidney-shaped pool, the guest wing built in the 1930s, and remnants of Pickford's living room. In response to the news that this Golden Age relic had been razed, the president of the Beverly Hills Historical Society also expressed no regret, dismissing Doug and Mary as nothing more than "highly paid sex symbols."

Doug and Mary catching some rays on Pickfair's "private beach."

Many people were outraged. Headlines singled out Pia Zadora especially: "Pickfair razed to clear the way for Pia's palace;" "Homewrecker Pia;" and "Pia Zadora Trashes Pickfair."

Douglas Fairbanks Jr. was disgusted, saying, "I wonder, if they were going to demolish it, why they bought it in the first place." Faced with harsh criticism, Zadora blamed the demolition on a termite infestation.

In 1993, Zadora and Riklis finally moved into the 35,000-square-foot palazzo that stood on what used to be Pickfair. Just a few months after moving in, the couple split up, and Zadora moved to another of her Beverly Hills mansions.

In 2012, on an episode of *Celebrity Ghost Stories*, Pia Zadora claimed that the real reason she had destroyed Pickfair was because it was haunted by the laughing ghost of a woman in a long white gown who, she claimed, died in the house after

having an affair with Fairbanks. She gave no explanation for her conclusions about the ghost's origins, and there is no record of anyone dying at Pickfair. Zadora said she hired an exorcist, but when the ghost refused to leave, they decided to destroy the home. As she put it: "You can deal with termites. You can deal with plumbing issues. But you can't deal with the supernatural."

Zadora's supernatural fantasies aside, the house that Douglas Fairbanks and Mary Pickford built was far more than just a home. It gave birth to a community, played host to kings and queens, and inspired awe and admiration the world over. Tragically, it proved too good for the ephemeral, make-believe world of the movies and the city that it helped to create.

A TOUR OF *Pickfair*

→

The entrance hall outside the living room.

The living room, with a painting by Philippe Mercier.

The upstairs hall made into a sitting room.

A guest bedroom.

The dining room.

THIS WAS HOLLYWOOD...

at Home!

Table tennis anyone? Bogie and Bacall having a laugh on their ping-pong table.

James Stewart letting it fly! Playing with his beloved model airplanes.

Cary Grant and Randolph Scott battling for bragging rights in a game of backgammon at the house they shared on the Santa Monica beach.

Carmen Miranda matching her furniture.

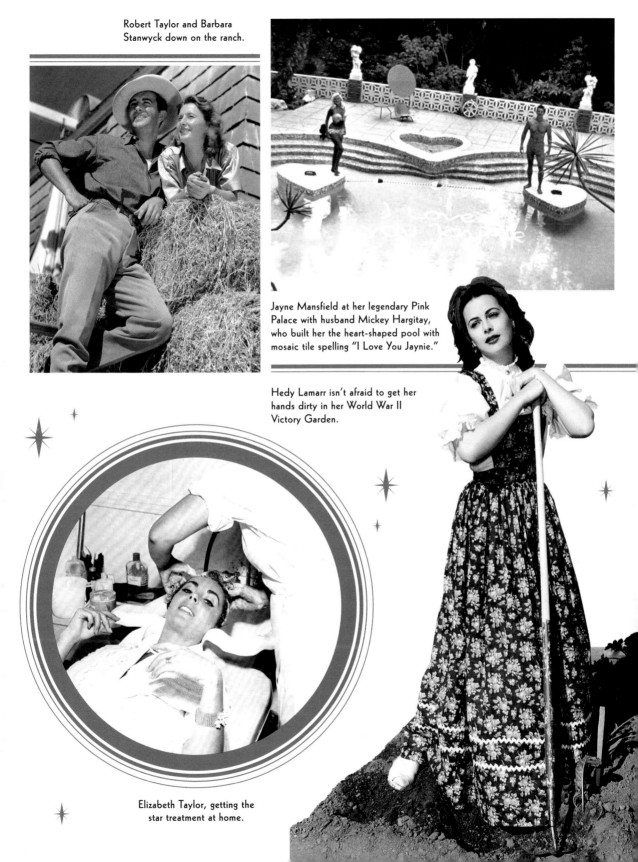

Robert Taylor and Barbara Stanwyck down on the ranch.

Jayne Mansfield at her legendary Pink Palace with husband Mickey Hargitay, who built her the heart-shaped pool with mosaic tile spelling "I Love You Jaynie."

Hedy Lamarr isn't afraid to get her hands dirty in her World War II Victory Garden.

Elizabeth Taylor, getting the star treatment at home.

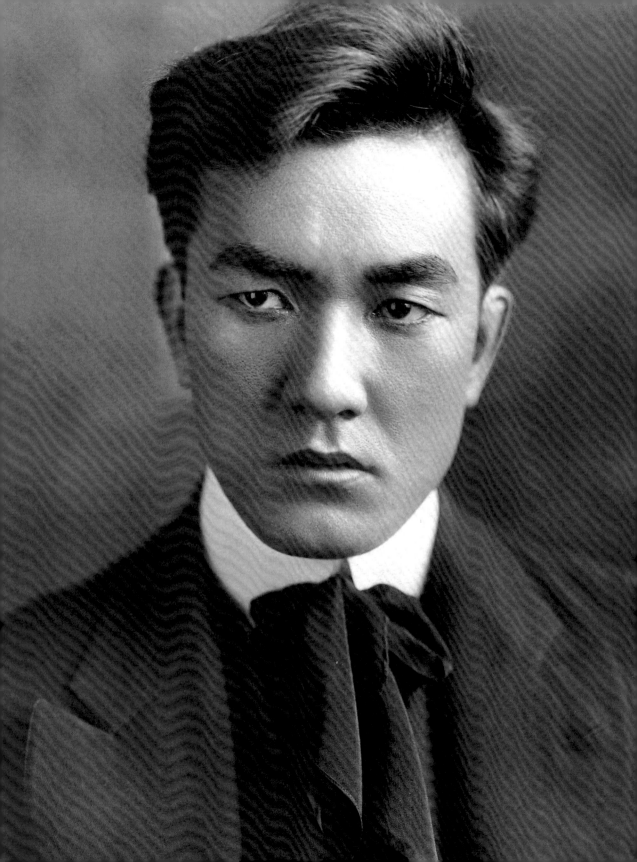

THE
SEX SYMBOL
THAT TIME FORGOT

SESSUE Hayakawa is best remembered for his role as Colonel Saito, the uncompromising prison-camp commandant in David Lean's *The Bridge on the River Kwai* (1957). The role earned him an Academy Award nomination for Best Supporting Actor, and the film has endured as one of the great war movies of the second half of the 20th century.

But in the heyday of the silent film era, Hayakawa was an international sex symbol and one of the biggest movie stars in the world. Years before the debut of the great "Latin Lover" Rudolph Valentino, Hayakawa stirred the longings of women around the globe. And in an industry that to this day rarely elevates nonwhite actors to leading roles, Hayakawa rivaled the likes of Charlie Chaplin and Douglas Fairbanks in popularity and acclaim.

His given name was Kintaro Hayakawa, born in 1886 in Chiba, Japan, to a wealthy, aristocratic family. Kintaro was expected to have a career in the navy, but at eighteen, he ruptured his eardrum during a deep-sea dive. Ineligible for the navy, Kintaro was despondent and his father ashamed. Kintaro decided to commit harakiri: ritual suicide. But his suicide was thwarted by his dog, who alerted the rest of his family that something was wrong. After a hospital stay, Kintaro languished for several years in a deep depression. Then, in March 1907, an American steamship crashed in Tokyo Bay. Kintaro helped organize the rescue effort. His

work with the Americans inspired him, and he set sail for the new world a few months later.

His life changed forever in Los Angeles, where he discovered the Japanese theater scene in Little Tokyo and fell in love with acting. Not long after, he changed his first name to Sessue and began appearing in theatrical productions for Japanese immigrants, staging his own translations of Shakespeare and Ibsen. But acting wasn't the only thing he fell in love with in Little Tokyo.

He met a young actress and was smitten. "Until I met Tsuru Aoki," Sessue later said, "I had not given much thought to marrying, except to make a mental note not to marry a girl who was taller than I was." Fortunately, Tsuru met his height requirement, and the two quickly fell in love.

Tsuru had caught the attention of one of Hollywood's biggest film producers, Thomas Ince. American popular culture was in the midst of an "Eastern craze," and Ince hoped to capitalize with a series of films set in Japan. He signed Tsuru to a five-picture deal, and she pushed for Ince to sign Sessue as well.

"Before we began," Ince recalled, "Miss Aoki brought Hayakawa into my office and introduced us with the remark that he was a very good Japanese actor and would also be a good picture actor. Tsuru was an excellent prophet." Sessue signed a deal with Ince, and his career in Hollywood began. Soon after, Sessue made his first feature-length film, playing Tsuru's father in Ince's volcano-disaster film *The Wrath of the Gods* (1914), based on a real volcanic eruption on the island of Sakurajima in Japan. Ince insisted on authenticity in his films, refusing to cast white actors even as extras, and *The Wrath of the Gods* was advertised as "Japanese Story, Japanese Actors, Volcano in Eruption!" (The film was banned in Japan for portraying the country's people as primitive.)

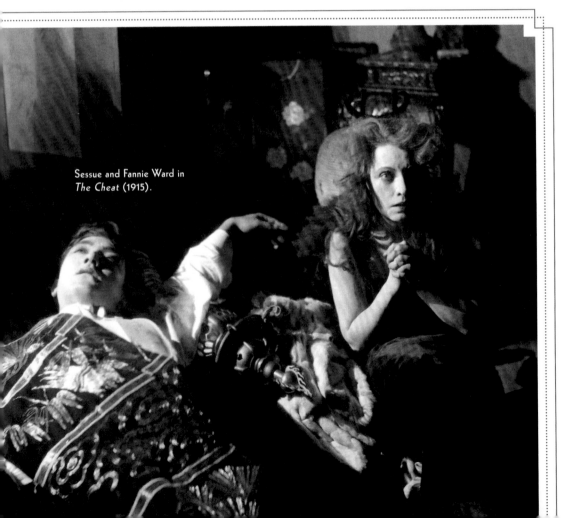

Sessue and Fannie Ward in *The Cheat* (1915).

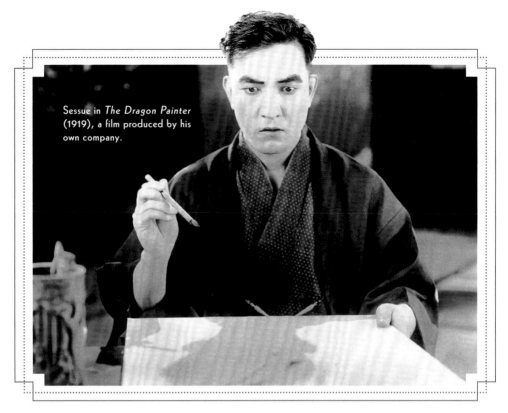

Sessue in *The Dragon Painter* (1919), a film produced by his own company.

Sessue and Tsuru were married on April 14, 1914. Ince continued to cast them in films together, publicizing them as the ideal Japanese-American couple, "a perfect blend of the old and new." He also gave Sessue a raise to $500 a week, making him the highest-paid Asian screen actor in the world.

In March 1915, Sessue's contract with Ince was coming to an end, and Jesse Lasky, head of the Famous Players-Lasky studio, offered him a massive raise. When Sessue asked Ince to match it, Ince thought he was joking and refused. The producer was dumbfounded when his new star bolted for the rival studio.

Sessue's breakthrough came in Cecil B. DeMille's *The Cheat* (1915). "It was a rather daring theme for its time," DeMille recalled, with some understatement. In the film, a society woman gambles away money from the Red Cross. To repay the debt and avoid public shame, she accepts money from a wealthy foreign playboy (played by Sessue) in exchange for implied sexual favors. When she tries to repay him in cash, he brands her on the shoulder with his personal insignia.

The Cheat had been intended as a vehicle for the legendary stage actress Fannie Ward, but when the film was released, Sessue became a sensation. The *Los Angeles Times* declared that Sessue "does one of the best bits of acting seen on the screen." *Variety* agreed, saying, "the work of Sessue Hayakawa is so far above the acting of Miss Ward . . . that he really should be the star in the billing of the film." When the film was reissued a few years later, he was.

Sessue was adamant about acting for the screen as he would in real life, and his understated style was unusual at a time when exaggerated gesticulation was the norm. "I don't understand it," DeMille said. "[I]t is new and strange, but it is the greatest thing I ever saw."

The Cheat was a smash at the box office in America and around the world. It was so popular in France that it was adapted into a play and an opera. But in Japan the film sparked protests, and Sessue was branded as an "unforgiveable traitor" for contributing to anti-Japanese sentiment in America. Sessue wrote a public apology, and when *The Cheat* was reissued in 1918, the nationality of Sessue's character was changed to Burmese.

Despite the controversy, the film cemented Sessue as a major star and as one of Hollywood's first male sex symbols. "White women were willing to give themselves to a Japanese man,"

renowned photographer Toyo Miyatake recalled. "When Sessue was getting out of his limousine in front of a theater of a premiere showing, he grimaced a little because there was a puddle. Then, dozens of female fans surrounding his car fell over one another to spread their fur at his feet."

Sessue was well aware of the cultural significance of his success, even if the industry would only allow him to go so far with his leading ladies. "Public acceptance of me in romantic roles was a blow of sorts against racial intolerance," he explained, "even though I lost the girl in the last reel."

Over the next few years, his star would continue to rise, but he was becoming disillusioned with stereotypical Japanese roles. "Such roles are not

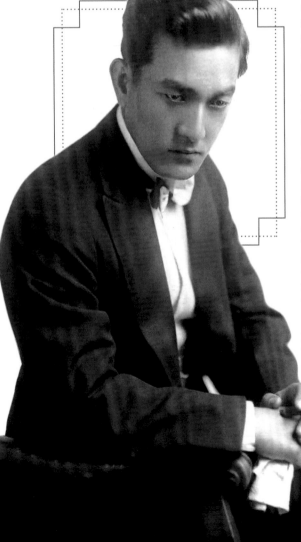

true to our Japanese nature," he told a reporter. "They are false and give people a wrong idea of us. I wish to make a characterization which shall reveal us as we really are."

When his contract with Lasky was up in March 1918, Sessue decided to form his own film company: Haworth Pictures. Over the next four years, Sessue made twenty-three films and earned $2 million a year (approximately $34 million today), making him one of the highest-paid actors in the world. A young actor named Rudolph Valentino applied to work at the company but was rejected. "The atmosphere of his personality was too similar to mine," Sessue explained. "And although his acting ability was less than skin deep, I sensed something of a rival in him."

At Haworth, Sessue was involved in every aspect of production and worked up to twenty hours a day. By 1920, he was exhausted and decided to cut production in half, reorganizing Haworth into the Hayakawa Feature Play Co. He also decided to "live a little."

Sessue and Tsuru moved out of their bungalow and into a thirty-two-room castle on the corner of Franklin and Argyle Avenues in Hollywood. With Prohibition in full swing, Sessue purchased a "railroad carload of liquor" from Chicago and hosted lavish "drunken fury" parties for the film colony. His parties often grew to as many as 600 people and featured multiple orchestras playing around the clock. "They sometimes lasted for days," Sessue recalled. He also lost massive sums at poker and collected automobiles, including two Cadillacs, a Ford, and a gold-plated Pierce-Arrow town sedan. "Defiantly," Sessue said, "I was determined to show the Americans who surrounded me that I as a Japanese could live up to their lavish standards."

In just a few short years, and despite rampant anti-Japanese sentiment in the country, Sessue had risen from total obscurity to become one of the most famous men on earth. He was wealthy beyond measure and adored the world over, even meeting with President Harding and Vice President Coolidge. But by the early twenties, he would soon fade back into obscurity.

The Vermilion Pencil (1922) would be his last Hollywood film for several years. During filming, he was warned of a plot

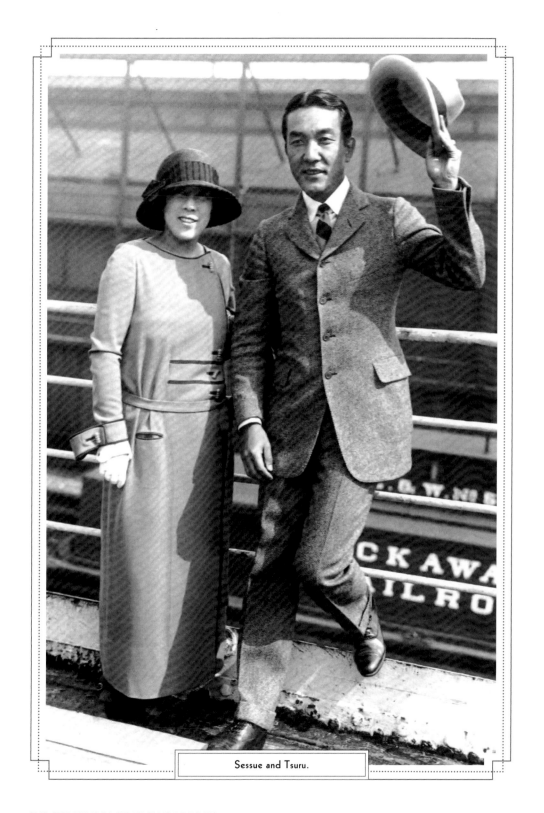

Sessue and Tsuru.

Sessue with the man
who relaunched his career,
Humphrey Bogart, in
Tokyo Joe (1949).

Bandit Prince, which was published in 1926. He adapted the novel into a stage show and returned to the U.S. to tour the vaudeville circuit.

In 1931, he returned to Hollywood to play a Chinese Scotland Yard detective in his first sound film, *Daughter of the Dragon*. "For once I was not the villain," he said. "I have played the villain too many times I think even though I did play romantic roles in my early films. Sometimes, just for once, I would like to play the hero." Sessue realized that wasn't going to happen any time soon, especially with the passage of the Motion Picture Production Code in 1930, which prohibited interracial love scenes.

At the same time, the details of one of Sessue's real-life love scenes were exploding across the front pages of American newspapers.

He had had an affair with the actress Ruth Noble and fathered a son in 1929. In 1931, he and his wife paid Ruth off and formally adopted the boy. Apparently dissatisfied with the agreement—or the amount of compensation—Ruth sued to void the adoption and went to the press with the story. Newspaper headlines read, "Film Star in 'East-West' Love Triangle" and "White Actress Is Suing to Get Back Child from Jap." After receiving $27,000 (almost $500,000 today), Ruth dropped the lawsuit but continued to harass Sessue and Tsuru for decades, even following them to Japan with demands for more money. In 1961, she went so far as to sue Sessue for half a million dollars, claiming he owed support for a child she hadn't seen in nearly thirty years.

by his business partners to kill him for insurance money. On the last day of production, a set director told him that the set was rigged to fall on him. He refused to believe it and was nearly crushed when the set crashed down around him. He wasn't hurt, but he was shaken.

He sold his business interests and his castle, and abandoned Hollywood. During the next few years, he undertook several ventures. He signed with legendary Broadway producer Lee Shubert, but Sessue's first play, *Tiger Lily*, didn't make it past out-of-town previews. Discouraged by his Broadway failure, Sessue went to France to make the film *La Bataille*. He then wrote a novel, *The*

In the meantime, Sessue and Tsuru had returned to Japan, where he appeared in plays and films and built a life for himself and his family in his home country. In 1937, an offer from Pathé Studios would take him to Paris, for what he thought would be only a temporary separation from his family. He spent the next two years making films—until France declared war on Nazi Germany in 1939. The Japanese Embassy issued

a call for all Japanese citizens to return home, but Sessue hated the ruling class of Japan and chose to stay in France. After the country fell to the Germans, the Nazis tried to lure Sessue into their service. "They offered me an automobile—Mercedes—and a big salary to spend for receptions and propaganda," he said. "They wanted me to hold cocktail parties—to establish good understanding between the peoples. I refused. Instead of an automobile, I had a bicycle."

Cut off from his family and unable to work as an actor, Sessue was "a man on a tightrope" who "lived in an atmosphere of indefinable terror." He made his living by painting Japanese watercolors and selling them in the Montmartre district in Paris as he waited for the war to end. After the Japanese surrender, the Allied authorities refused to allow him to return to Japan and limited his

would come to define his career, but his wife urged him to reconsider. He read the script four times and, each time, found the story more interesting.

"From the conflict of two men—Nicholson, the English colonel, and Saito, the Japanese colonel—stems all the power and the compelling emotional impact, the irony, anguish and pathos, the symbolization of the futility of war and the ridiculousness of what men fight for—the whole tragic human comedy encompassed by the film," he said. Of all the roles he played, no character "captivated or challenged" him more than Saito. He was proud to use his immense skill as an actor to defy American stereotypes of Japanese military officers as "personifications of evil" and "caricatures rather than characters."

"I have portrayed Japanese officers, but mine have been men," he explained. "The untrue

"THE UNTRUE STEREOTYPE I FIND DISTASTEFUL...BECAUSE
IT IS NOT TRUE TO LIFE. IT IS NOT HUMAN."

communication with his family to postcards that had to be written in English or French.

Halfway around the world, another star was busy plotting Sessue's Hollywood comeback. Humphrey Bogart was preparing a film set in Japan, *Tokyo Joe*, and he knew exactly who he wanted for the villain. But nobody in the movie business had any idea where Sessue was. Bogart asked Louella Parsons to put a request for his whereabouts in her gossip column, and readers quickly responded. A representative of Columbia Pictures tracked him down in Paris, and in short order Sessue was on a plane back to America.

Tokyo Joe put Sessue in demand again. He was cast as a Japanese colonel in another Hollywood movie, *Three Came Home*, then returned to Tokyo to see his family for the first time in thirteen years. He spent the next few years reacquainting himself with his family and performing in Japanese movies.

Then, in 1956, producer Sam Spiegel offered him the role of Colonel Saito in *The Bridge on the River Kwai*. Sessue nearly turned down the role that

stereotype I find distasteful—not because it insults the Japanese so much, but because it is not true to life. It is not human."

In *The Bridge on the River Kwai*, Sessue reached the apex of his second Hollywood career when he was nominated for the Academy Award for Best Supporting Actor. Sessue would lose to a white actor, Red Buttons, whose character marries a Japanese woman in *Sayonara*, a film arguing for the virtues of interracial marriage. It was an ironic twist, a measure of how far the world had come since Sessue had scandalized audiences with his own interracial love scenes, and a reminder of how far it still had left to go.

After *The Bridge on the River Kwai*, Sessue continued to play supporting roles, usually the villain, in other major Hollywood productions, including *Swiss Family Robinson* and Jerry Lewis's *The Geisha Boy*. Tsuru died in 1961, and Sessue continued to work for several more years before retiring to the suburbs of Tokyo, where he lived modestly and studied Zen Buddhism until his death in 1973.

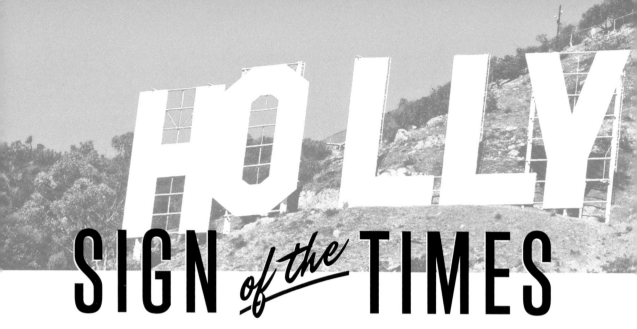

SIGN *of the* TIMES

ONE of the most iconic and recognizable landmarks in the world, the Hollywood sign has stood for decades as a symbol of the glitz and glamour of the movie business. But, like many of the stars who have stood in its shadow, the sign's story is one of great swings in fortune, nearly ending in ruin after fading into obscurity.

It begins in 1923, when a real estate development company erected a temporary billboard in the hills on Mt. Lee, advertising their new development: HOLLYWOODLAND. On December 8, 1923, the sign was illuminated by 3,700 light bulbs and became an instant landmark. It sat mostly undisturbed for a decade, a symbol of the booming young city's promise and opportunity. But on September 16, 1932, the sign, and the town, were struck by tragedy when Peg Entwistle, a Hollywood hopeful despondent at not achieving her dreams of stardom, made the long trek up the canyon, climbed the ladder on the back of the letter H, and jumped to her death.

In 1933, the company that had erected the sign dissolved and stopped paying for the maintenance. Over the next few years, windstorms knocked down letters, and the sign fell into disrepair. Finally, in 1939, the men who had built the sign caved to public pressure and paid to repair it. In 1944, it was donated to the City of Los Angeles, which also failed to maintain it. Soon, residents began protesting that the sign was "an eyesore and a detriment to the community." The city decided to tear it down. Thankfully,

the Hollywood Chamber of Commerce intervened and offered to pay for the costs—provided that the word "LAND" was removed. In October 1949, a groundbreaking ceremony was held for the newly shortened "HOLLYWOOD" sign.

Maintenance lapsed once again, and by 1978 the sign was in its most decrepit state yet— this time beyond repair. All of the letters would have to be replaced. The Hollywood Chamber of Commerce was unprepared to pay the cost and began a campaign to raise funds. Celebrities like rock star Alice Cooper, screen cowboy Gene Autry, singer Andy Williams, and *Playboy* magnate Hugh Hefner joined together with community leaders and saved the sign.

In 2010, it came under a different kind of threat. Developers had purchased 138 acres around the sign and planned to cover the hills with luxury properties. A nonprofit organization, The Trust for Public Land, made efforts to stop the project, but the developers gave them a deadline to come up with $12.5 million to buy the land back. With about a week and a half before the deadline, The Trust was still short of the needed funds. Once again, Hugh Hefner came to the rescue, donating the final $900,000.

"It's like saying let's build a house in the middle of Yellowstone Park," Hefner said. "There are some things that are more important. The Hollywood sign represents the dreams of millions. It's a symbol. It is as the Eiffel Tower is to Paris. It represents the movies."

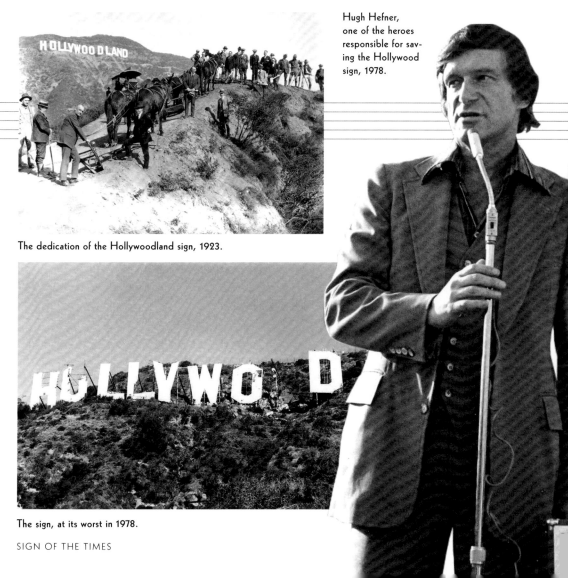

Hugh Hefner, one of the heroes responsible for saving the Hollywood sign, 1978.

The dedication of the Hollywoodland sign, 1923.

The sign, at its worst in 1978.

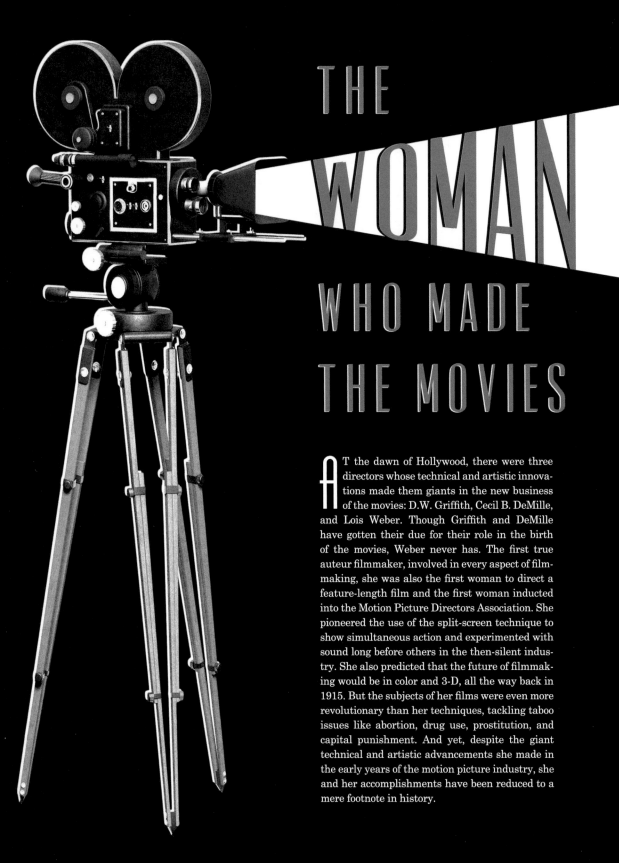

THE WOMAN WHO MADE THE MOVIES

AT the dawn of Hollywood, there were three directors whose technical and artistic innovations made them giants in the new business of the movies: D.W. Griffith, Cecil B. DeMille, and Lois Weber. Though Griffith and DeMille have gotten their due for their role in the birth of the movies, Weber never has. The first true auteur filmmaker, involved in every aspect of filmmaking, she was also the first woman to direct a feature-length film and the first woman inducted into the Motion Picture Directors Association. She pioneered the use of the split-screen technique to show simultaneous action and experimented with sound long before others in the then-silent industry. She also predicted that the future of filmmaking would be in color and 3-D, all the way back in 1915. But the subjects of her films were even more revolutionary than her techniques, tackling taboo issues like abortion, drug use, prostitution, and capital punishment. And yet, despite the giant technical and artistic advancements she made in the early years of the motion picture industry, she and her accomplishments have been reduced to a mere footnote in history.

Florence "Lois" Weber was born to a God-fearing Pennsylvania Dutch family in 1879. Her father spurred her interest in storytelling from a young age. But he did his best to extinguish her desire to be a singer, a profession he considered deeply immoral. He failed, and at twenty-one, she moved to New York City to embark on a singing career. After a few months of performing in small venues, she was forced to return home to help her family after her father fell ill. She tried to join her church choir, but she was forbidden by the deacons because she had sung on stages in New York. To do penance for her sins, Lois joined the Church Army, an evangelical organization dedicated to rehabilitating drug addicts, gang members, alcoholics, and prostitutes. Lois sang in jails, asylums, and the city's red-light districts.

The first few years of their marriage were spent mostly apart because stage productions at the time refused to hire married couples. As her husband performed across the country, Lois put her own career on hold and spent most of her time waiting in a New York hotel room. To keep her mind off their separation, Lois took advantage of the moving picture studios springing up around her and launched a film career. In 1908, she acted in a picture for the Gaumont Company. Gaumont produced primitive "talking pictures," recording the sound on discs, almost twenty years before *The Jazz Singer* unleashed the "talkie" phenomenon. The amount of money she was making at Gaumont convinced Phillips to leave the stage and join what Lois called "the shadowy drama."

"It occured to me that the public would welcome
SOMETHING BETTER."

Three years later, she had become frustrated with the limitations of the Church Army, and her uncle David, a theater owner, suggested a new group to minister to. "If you want to save souls," he told her, "who needs it more than chorus girls?" He secured her a gig with a musical theater troupe that traveled in Pennsylvania and New England. "I joined the chorus for the sole purpose of converting my fellow chorus members," she recalled. But the show people—the kindest and most considerate people she had ever met—quickly converted her instead.

In 1904, twenty-four-year-old Lois joined a touring show in Massachusetts, where she met the stage manager, Phillips Smalley. He was thirty-eight, six feet tall, with dark hair and eyes, and he spoke with a slight English accent. When Phillips offered Lois a drink, she proceeded to lecture him about alcohol. He fell in love with her that night, and the next day he asked her to marry him. On April 29, 1904, Lois and Phillips were married at her uncle David's Chicago home.

Lois quickly became dissatisfied with the scenarios she was given at the studio. "Little thought was accorded to the boundless art essential to the real photodrama," she explained. "The writers were satisfied to keep the characters moving through a thin plot, insipid in conception, and pathetic in sentiment. It occurred to me that the public would welcome something better."

She decided to give the public just that and began writing scenarios with parts for her and her husband. When it came time to produce them, Lois realized that "[n]o one knows more about a scenario worthy of the name than the originator of it: and yet, few scenario writers have the faculty to visualize a scene with every detail polished to a sparkling brilliancy." Lois discovered that she could, and she was constantly asked for her advice on other people's work at Gaumont. It wasn't long before she was a director herself, and Lois threw herself into the art of filmmaking. She wrote the scenarios and cast her pictures, in addition to acting, titling, editing, and directing.

After a few years at Gaumont and a brief stint at Biograph, Lois and Phillips were hired to head the newly formed Rex Motion Picture Company. As Lois described it, "I wrote the scenarios, Mr. Smalley selected the types, assisted in directing, and we both acted." They were officially marketed as a directorial partnership and referred to as "The Smalleys," but the press regarded Lois as the brains behind their pictures. The *New York Dramatic Mirror* asked, "Why the 'and Phillips Smalley' on the producer's line of the announcement? It is said to be almost entirely Miss Weber's creation."

Director Henry Hathaway, who began his career as Lois Weber's prop boy, was blunt about Lois's dominance of the partnership, saying, "Phillips Smalley did nothing—he just sat around the set." Phillips had no illusions about his role. He frequently noted that his wife "personally supervised" their films and deserved most of the credit: "She is as much the director and even more the director of Rex Pictures than I."

Lois set herself apart from her male contemporaries with sophisticated storytelling that usually revolved around controversial social issues and featured women (played by Weber) in unconventional roles. In *The Final Pardon* (1912), she plays a woman on trial for murder; in *The Dragon's Breath* (1913), a woman addicted to opium; and in *Woman's Burden* (1914), a single mother forced to work to support her child and sister.

In her home-invasion film *Suspense* (1913), Lois used camerawork far more technically and artistically innovative than what D.W. Griffith was doing at the time. She pioneered the triple-split effect, showing a wife, husband, and intruder in scenes of simultaneous action, and featured interesting perspective in practically every shot. She also used a natural and understated acting style in an era notable for histrionics, and the ten-minute film remains gripping and suspenseful to this day.

Carl Laemmle bought Rex Pictures in 1912 and merged it with several other independent film companies to form the Universal Film Manufacturing Company. When the company purchased a large parcel of land near Los Angeles and began to construct its own filmmaking city, Lois and Phillips went west to head Universal's Rex Pictures division.

Innovative shots from *Suspense* (1913).

The mirror of truth in *Hypocrites* (1915).

But Lois ended up leading more than just the studio division. On May 20, 1913, the newly formed town of Universal City was having its very first municipal elections. Aubrey M. Kennedy, general manager of Universal Studios, was running for mayor on the Democratic ticket, and he seemed to be a shoo-in—until Lois entered the race. California had just granted women the right to vote, more than six years before the rest of the country, and Lois intended to make the most of it. She ran on an all-female Suffrage ticket, reportedly the first of its kind in the world, and the race made headlines around the country. Lois lost by only fifteen votes. A month later, Kennedy retired from his position at Universal Studios and vacated the mayor's office, and Lois was appointed to replace him.

In 1914, she directed and starred in *The Merchant of Venice*, believed to be the first feature-length film directed by a woman. Its success motivated Lois to make more feature-length films, but to her disappointment, Universal was more interested in producing one- and two-reel shorts. When Bosworth, Inc offered Lois and Phillips the opportunity to produce and direct feature films for $500 a week ($12,848 today) plus half of the profits on their films, the two bid Universal *adieu*.

It wouldn't take long for Lois to make a huge splash at her new studio. In 1915, she shocked the world with *Hypocrites*, about the destruction of a nude statue by an angry mob. The statue was portrayed by a fully nude actress, who unveiled various forms of societal hypocrisy by holding up a mirror to politics, love, modesty, and the home. The film would prove to be a case of life imitating art, as the public reaction to it perfectly mirrored the outraged mob's reaction to the statue.

The film was banned in Chicago, Minneapolis, and the state of Ohio. In San Jose, the mayor and chief of police seized all the prints until a court decision forced them to allow screenings. The mayor of Boston declared it "indecent and sacrilegious," though he sat through less than half of the film.

Lois was encouraged by the response: "*Hypocrites* is not a slap at any church or creed— it is a slap at hypocrites, and its effectiveness is shown by the outcry, amongst those it hits hardest, to have the film stopped."

Along with D.W. Griffith's *The Birth of a Nation*, released a month later, *Hypocrites* helped to transform the motion picture industry into a serious art form. "In a way 'Hypocrites' is daring, but only because no one else has attempted as much or has gone as far," *Variety* wrote. "After seeing it you can't forget the name of Lois Weber." *Hypocrites* was the first film for which she received sole credit as director and writer.

The rapid rise of a woman was made possible, according to Lois, by the infancy of the industry. "Personally, I grew up with the business when everybody was so busy learning their particular branch of a new industry that no one had time to notice whether or not a woman was getting a foothold. Results at the box office were all that counted." And Lois had them. *Hypocrites* earned more than seven times its budget. Six months after its release, the film remained "one of the strongest booking features on the market" and "the most productive money-getting box-office attraction ever shown in the South."

A financial dispute led Lois and Phillips to leave Bosworth, but Carl Laemmle welcomed them back to Universal with open arms and allowed Lois to make feature-length films. Lois was now the highest-paid director at Universal. Laemmle declared, "I would trust Miss Weber with any sum of money that she said she needed to make any picture that she wanted to make. I would be sure that she would bring it back. She knows the motion picture business as few people do and can drive herself as hard as anyone I have ever known."

In addition to her own trailblazing accomplishments as a filmmaker, Lois had a reputation for supporting the careers of other women. Many performers in her films went on to become directors themselves and others became successful

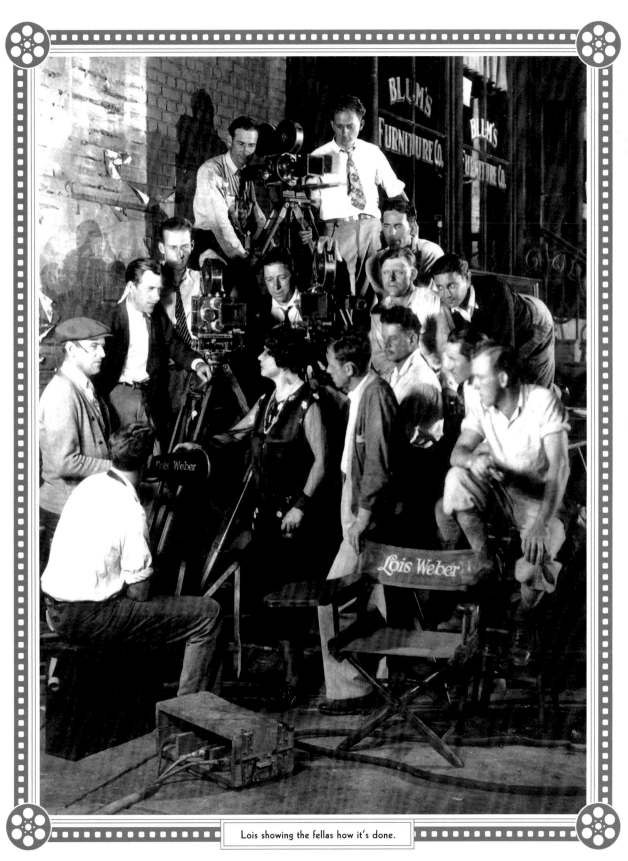

Lois showing the fellas how it's done.

Shoes (1916), starring Mary MacLaren.

screenwriters. She also had an eye for spotting and developing talent, discovering many actors who would become stars of the silent film era, including Billie Dove and Mildred Harris. And she launched the careers of two great male directors: John Ford and Henry Hathaway began their careers as prop boys for Lois at Universal.

Lois was one of the first directors to find herself in constant battle with the motion picture censor boards. She chafed against the "mindlessness"

Next, she set her sights on capital punishment with *The People vs. John Doe*, about an uneducated farm-hand sentenced to die for a double murder he did not commit. The film was based on the story of Charles F. Stielow and followed the plot points of his real-life death penalty case. As soon as Stielow's sentence was commuted, Laemmle rushed the film to release. The *New York Times* called it "the most effective propaganda in film form ever seen."

"IT IS NOT FOR DECENT PEOPLE TO SEE."

of cuts made by Pennsylvania's censor board to her film *Hop, the Devil's Brew* (1916), which dealt with drug trafficking. The board left several scenes of opium smoking in the film, but "the close-up of the dead baby's shoes, which I had put in to accentuate the mother's grief at the loss of her little one," she said, "was ordered to be cut out. I do not know whether babies' shoes are obscene, or merely immoral."

All of this would pale in comparison to the controversy over her next film, *Where Are My Children?* (1916). The topic was birth control and abortion, both illegal in the United States at the time. The film took a strong stance in favor of birth control, with the plot revolving around the fall of a society woman who has several abortions so her social life can go on uninterrupted. One censor declared it "unspeakably vile," "a mess of filth, and no revision, however drastic, could ever help it. It is not for decent people to see."

Decent or not, the masses rushed to see *Where Are My Children?*, making it Universal's highest-grossing film of 1916. A month after its release, Lois turned to advocating for a minimum wage for female workers with *Shoes*, about an underpaid shop girl who ends up prostituting herself for a new pair of shoes. The film was a critical and commercial success and another top moneymaker for Universal.

It had been a big year for Lois, and in December, the Motion Picture Directors Association of America, a precursor of the Directors Guild of America, decided to set aside its ban on women and make her a member.

In 1917, Lois moved on to bigger ventures. She formed her own production company and became the first woman to own her own studio. Lois Weber Productions stood in stark contrast to other studios. One *Motion Picture* magazine reporter wrote:

You would never guess that this is a studio. Nothing suggests business. The beautiful gardens in the front are so shady with palms and loquats, fruit-trees and flowers, that the great house in the rear is almost obscured from first vision. The front door stands wide open; there isn't any peep-hole with a sign over it "Information" and a locked entrance behind it, such as one always finds in Los Angeles studios. You walk right into a huge, cheery room with comfortable divans and rockers and a great log-fire burning and blinking cheerfully at you, while its long fiery arms invite you to draw up a chair and be comfy.

Lois also eschewed traditional studio filmmaking by shooting on location and in narrative sequence as often as possible. Lois Weber Productions released fourteen films, the most successful of which was *The Blot* (1921), about the economic inequality of the middle class. It made the case that teachers "who clothe our souls" deserve pay equal to that of the people "who clothe our bodies." Today it is often cited as her masterpiece.

Within a few years, however, the movie-making landscape changed drastically. Studio conglomerates were edging out independent filmmakers. In

1922, Lois Weber Productions ceased to exist, and her rapid slide into obscurity began.

The end of her production company was followed by the end of her marriage. Phillips's infidelity and drinking had put a strain on the marriage, and the two had been living apart for some time. On the morning of June 23, 1922, Lois quietly filed for divorce. After the split, Phillips never produced or directed another film and was reduced to acting in extra roles. As for Lois, though she didn't rely on Phillips for the making of her films, his presence had provided her with emotional support that was now missing. After almost fifteen years of nonstop work, she plunged into a deep depression.

By early 1925, Lois had begun to come out of her depression, and Carl Laemmle hired her to head his new story-development project adapting popular books for the screen. By the end of the year she had also signed a director contract with the studio and was ready for a comeback. *Film Daily* wrote that after a "noticeable absence" of female directors, Lois's reemergence was likely "to give the Griffiths, von Stroheims, Vidors, and others a run for their money." Others were less complimentary, claiming that "the sentimentalities of her sex" and her "old-fashioned" ways would lead to failure.

The two films Lois wrote and directed for Universal, *The Marriage Clause* and *Sensation Seekers*, were met with critical praise. "She is back again now, near the very top," *Motion Picture* magazine declared. The success of these films proved that Lois could keep up with changing times, unlike D.W. Griffith, whose films had already fallen out of favor. In 1927, Cecil B. DeMille's production company hired her to direct *The Angel of Broadway*. But after she finished the film, DeMille joined MGM, and she was left unemployed.

Just a few years earlier, in 1921, *Motion Picture* had predicted, "When the history of the dramatic early development of motion pictures is written, Lois Weber will occupy a unique position."

But when the first major account of the film industry, Terry Ramsaye's *A Million and One Nights*, was published in 1926, Weber was barely a footnote, earning just three mentions (and not one as a director). Her contemporary D.W. Griffith, by contrast, garnered sixty-seven mentions across dozens of pages. Already history was being written, and it was leaving Lois out.

Her disappearance into the shadows of the industry she helped to create didn't go completely unnoticed. In 1927, *Hollywood Vagabond* magazine asked pointedly: "It is to be wondered why United Artists, Famous Players, Metro-Goldwyn-Mayer, DeMille or one of the other giant companies that are constantly seeking new blood and new perspective for their organizations have failed to avail themselves of the intelligence and experience of Lois Weber."

The answer was simply that she was a woman, and the now-institutionalized sexism of the studio system was driving women out.

"There will be few women directors," Cecil B. DeMille declared in a 1927 interview, adding that directing was too physically demanding and technically complex for a "woman's mind." But DeMille had to concede, "Lois is an exception."

Lois didn't remain silent in the face of sexism. When Jesse Lasky, Paramount's vice president and general production manager, claimed women did not make good directors, Lois fired back with an op-ed in the *San Diego Evening Tribune*:

> In the first place, so small a percentage of women ever get a chance to prove or disprove such an assumption that we have no average by which to judge. Out of the enormous number of men who have been given opportunities as directors, how many brilliant successes result? The number of really fine pictures turned out will give the answer. . . . Women entering the field now find it practically closed. Frequently a male writer is given the directorial chance. . . . But you do not hear of a woman writer being so favored. . . . [M]any a cameraman or gag man or assistant director is given a directorial chance. . . . But women are not given either of those jobs or chances. . . . And so who can say how women would average if given chances in proportion to those given men.

With the coming of sound, Lois took out a full-page ad in an issue of *The Film Mercury* to remind the industry of her experience making sound films for the Gaumont Company. "LOIS WEBER IN TALKING PICTURES," the ad blared. "Author and Director of hundreds of well-remembered screen plays." But no one was interested.

Her career was at a standstill, and her financial situation had seriously deteriorated. Her second

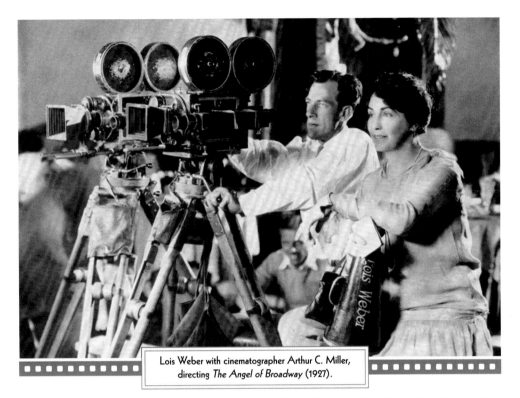

Lois Weber with cinematographer Arthur C. Miller, directing *The Angel of Broadway* (1927).

husband had squandered her vast fortune in a series of horrible investment projects. By 1930, Lois was reduced to managing an apartment building in Los Angeles.

In 1933, she agreed to take on the unsalaried job of talent scout for Universal in the hope of getting the opportunity to direct again. After a few months, Laemmle signed her as a screenwriter, with the possibility of directing. A few projects came and went, but nothing was ever finalized, and Lois left Universal empty-handed. An independent film company hired her to direct her first and only full-length sound film, *White Heat* (1934). The theme was interracial marriage, and it was the first movie to be shot on location in Hawaii. It bombed at the box office, and Lois never directed again.

In November 1939, she entered Good Samaritan Hospital with a stomach ailment that had been plaguing her for years. On November 13, Lois Weber died of a bleeding ulcer. She was sixty years old.

Most of the obituaries focused on her accomplishments as a talent scout, with headlines like "Lois Weber, Who Made Stars, Dies." *Variety*, which had once written that "you can't forget the name of Lois Weber," apparently did and dedicated just eighteen lines to this filmmaking pioneer. Only gossip columnist Hedda Hopper did Lois justice. In her front-page profile, Hopper referred to her as a "film writer, director, producer, and musician" and declared, "I don't know any woman who has had a greater influence upon the motion-picture business than Lois or anyone who has helped so many climb the ladder of fame asking for nothing but friendship in return." Six years later, though, even Hopper asked her readers, "Remember Lois Weber? No, of course you don't."

After Lois's death, her sister donated the 35mm prints of the films Lois had directed to the Academy of Motion Picture Arts and Sciences. Sadly, the films were on nitrate stock and prone to decompose, and the Academy neglected to preserve them. In the 1970s, the Library of Congress was able to salvage some of them and copy them onto safety stock. They are impressive feats of technical innovation and artistic mastery. One can only hope that, while the 20th century went out of its way to forget Lois Weber, the 21st century will find a way to restore her to the position of prominence in film history that she so richly deserves.

And THE FIRST ★ ACADEMY AWARD® ★ Goes To...

I T was just after 8:00 p.m. on May 16, 1929, in the Blossom Room of the Hollywood Roosevelt Hotel, and the first Academy Awards® were being handed out. There was no red carpet, little press, and even less suspense, the winners having been announced three months earlier. The ceremony wasn't even broadcast over radio. After just fifteen minutes, the awards had been handed out, and the guests turned their attention back to their desserts. "Nobody really felt there was any historical significance," Janet Gaynor recalled. Gaynor was there to receive her Merit Award for Best Actress, as it was called then, but she was more excited about meeting Douglas Fairbanks and Mary Pickford.

It's hard to blame Gaynor for being so nonchalant: The awards themselves had been little more than an afterthought, the outgrowth of movie mogul Louis B. Mayer's scheme to manipulate the people who worked for him. As he explained, "I found that the best way to handle [moviemakers] was to hang medals all over them. If I got them cups and awards, they'd kill themselves to produce what I wanted. That's why the Academy Award was created."

That and Mayer's desire to build a beach house.

A Jewish immigrant whose family had escaped the pogroms of the Russian Empire, Mayer had risen to become the cofounder of the most glamorous movie studio of Hollywood's Golden Age: Metro-Goldwyn-Mayer. In 1926, he was looking to build a beach house on the Pacific Coast Highway in Santa Monica. Mayer wanted to skip the months of planning that normally went into building a home and decided to forego hiring an architect. As he told his family:

When we need a set at the studio, we build it overnight. We need a big village, we build it in weeks. Don't be at the mercy of those contractors. Don't start with the architects. With us, it's business, it gets done. I will talk to the people at the studio.

He commissioned the head of MGM's art department, Cedric Gibbons, to design the home and had MGM production manager Joe Cohn wrangle some MGM labor and come up with a schedule. Cohn told him he could have the house built in six weeks, provided that three shifts of laborers worked twenty-four hours a day, seven days a week. However, Cohn also told Mayer that the studio laborers were on the verge of signing an agreement with a union, the International Alliance of Theatrical Stage Employees. As union members, the workers would be entitled to secure rates of pay and higher rates for overtime, which meant the job was going to cost far more than Mayer wanted to pay. Cohn suggested using only a few workers from MGM and getting cheap outside labor for the rest, and Mayer agreed. Six weeks later, he had his beach house, but the unionization of his studio laborers got him worrying: What would happen to his studio when actors, writers, and directors started joining unions?

Mayer decided that the solution was one governing body to unite the film industry, serve his filmmaking needs, and settle labor disputes. One night over Sunday dinner at his newly completed beach house, Mayer met with actor Conrad Nagel, director Fred Niblo, and producer Fred Beetson to lay the foundation for this new organization that would "promote harmony and unity" in the five main branches of film production: producers, actors, writers, directors, and technicians.

On January 11, 1927, thirty-six Hollywood heavyweights dined at the Ambassador Hotel to hear Louis B. Mayer's proposal to create the International Academy of Motion Picture Arts and Sciences (the "International" would soon be dropped). He promised them improved working conditions if they became members of his Academy, and everyone in the room became a founding member.

On May 4, 1927, the group filed for a charter for the Academy of Motion Picture Arts and Sciences. According to the application, the organization intended "to represent to the industry what the Academie Francaise represents to the world of art in Europe."

A week later, 300 prominent figures of the film colony gathered for a banquet in the Crystal Ballroom at the Biltmore Hotel in downtown Los Angeles where, for $100 up front and $5 monthly dues, they could become members of this elite organization.

Newly elected Academy president Douglas Fairbanks outlined the organization's objective to unite all the branches of filmmaking, erect a building for headquarters that would house a laboratory and theater, bestow awards of merit for distinctive and distinguished achievement, and most importantly, elevate the quality of motion pictures.

Mary Pickford told the crowd that the Academy planned to publish a bulletin providing "authentic and constructive news of the industry . . . to offset slanderous and misleading publicity from unfriendly sources."

The censorship czar of the motion picture industry, William H. Hays, described the organization as a new "moral weapon." He explained that "dishonorable or unethical conduct, or the commission of any act involving moral turpitude, shall be sufficient cause for expulsion from the academy." The threat of expulsion from such a distinguished group, he said, would be the best deterrent for "keeping the motion picture house in order."

By the end of the night, the Academy had raised $27,000 in new memberships and had passed their first official act, making Thomas Edison the group's first honorary member.

The ink was barely dry on the organization's founding documents when producers announced a slash in salaries. As Mayer had hoped, the Academy was preemptive in keeping talent from unionizing and quickly established a "standard contract" for freelance actors, which was accepted by both actors and producers.

The Actors' Equity Association called the Academy a "company union" and said if they had been involved, they would have negotiated a much better contract for actors. The Academy countered that "its sole interest in promoting harmonious employment relations has been a desire to pave the way for larger and broader services for all production classes and for the industry."

But the Academy's real purpose, the undermining of labor unions, was made especially clear in a letter from Cecil B. DeMille to Louis B. Mayer.

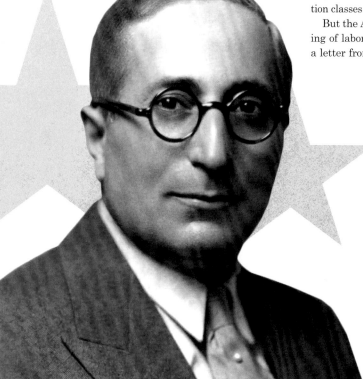

Louis B. Mayer, the man with the plan.

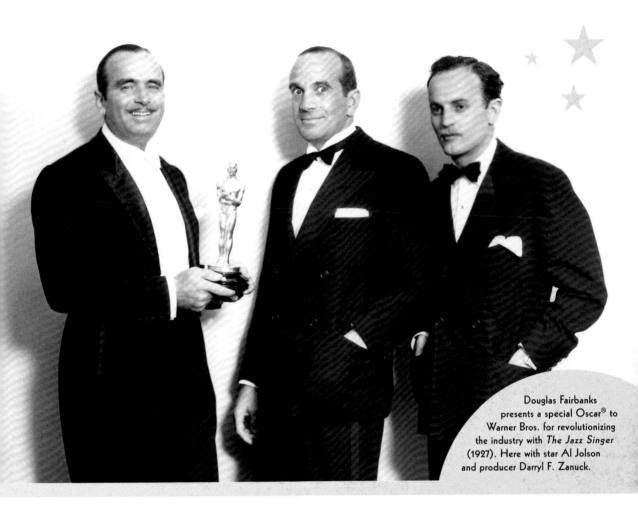

Douglas Fairbanks
presents a special Oscar® to
Warner Bros. for revolutionizing
the industry with *The Jazz Singer*
(1927). Here with star Al Jolson
and producer Darryl F. Zanuck.

DeMille explained that film editors, cameramen, and actors were being wooed by a union and advised Mayer to "explain the situation to the Producers there and let them know the seriousness of the situation and explain to them that if actors are to be kept out of the mess, the Academy must be supported financially and substantially without delay."

At a board meeting on May 28, 1928, a new steering committee was assigned to orchestrate what the Academy predicted would be marks of great value and distinction—awards for "distinguished achievements in production, acting, directing, writing, art and technical work."

Louis B. Mayer put Cedric Gibbons in charge of designing the prize. Gibbons designed a knight holding a crusader's sword, standing on a reel of film with five spokes representing the five branches of the Academy. The Academy

then hired an unemployed art student, George Stanley, to sculpt the statue. By July of 1928, the Committee had established a voting system. "Academy Awards of Merit should be considered the highest distinction attainable in the motion picture profession," the official ballot stated. "[A]nd only by the impartial justice and wisdom displayed by the membership in making their nominations will this desired result be possible."

The actual voting system proved far from impartial. Each Academy member would cast one nominating vote for each category. The top ten of each category would be passed on to a Board of Judges, made up of twenty-five people. They would then pass their top three choices in each category to the smaller Central Board of Judges, who would pick the winners.

On February 15, 1929, the Central Board of Judges had their meeting, and Louis B. Mayer

OUTSTANDING PICTURE
(NOW KNOWN AS BEST PICTURE)

Winner: *Wings* (Paramount Famous Lasky)
Honorable Mention: *7th Heaven* (Fox),
The Racket (The Caddo Company)

Winner: Lewis Milestone (*Two Arabian Knights*)
Honorable Mention: Ted Wilde (*Speedy*)

UNIQUE AND ARTISTIC PICTURE

Winner: *Sunrise* (Fox)
Honorable Mention: *Chang* (Paramount),
The Crowd (MGM)

WRITING
(ADAPTATION)

Winner: Benjamin Glazer (*7th Heaven*)
Honorable Mention: Alfred Cohn (*The Jazz Singer*),
Anthony Coldewey (*Glorious Betsy*)

WRITING
(TITLE WRITING)

Winner: Joseph Farnham
Honorable Mention: George Marion, Jr., Gerald Duffy

BEST ACTOR

Winner: Emil Jannings
(*The Last Command, The Way of All Flesh*)
Honorable Mention: Richard Barthelmess
(*The Noose, The Patent Leather Kid*)

CINEMATOGRAPHY

Winner: Charles Rosher and Karl Struss (*Sunrise*)
Honorable Mention: George Barnes (*Sadie Thompson,
The Devil Dancer, The Magic Flame*)

BEST ACTRESS

Winner: Janet Gaynor (*7th Heaven, Sunrise, Street Angel*)
Honorable Mention: Gloria Swanson (*Sadie Thompson*),
Louise Dresser (*A Ship Comes In*)

ART DIRECTION

Winner: William C. Menzies (*The Dove, The Tempest*)
Honorable Mention: Rochus Gliese (*Sunrise*),
Harry Oliver (*7th Heaven*)

DIRECTING
(DRAMATIC PICTURE)

Winner: Frank Borzage (*7th Heaven*)
Honorable Mention: Herbert Brenon (*Sorrell and Son*),
King Vidor (*The Crowd*)

ENGINEERING EFFECTS

Winner: Roy Pomeroy (*Wings*)
Honorable Mention: Nugent Slaughter, Ralph Hammeras

WRITING
(ORIGINAL STORY)

Winner: Ben Hecht (*Underworld*)
Honorable Mention: Lajos Biros (*The Last Command*)

SPECIAL AWARDS

Warner Bros. for producing the pioneer
outstanding talking picture, *The Jazz Singer.*
Charlie Chaplin for acting in, writing, directing,
and producing *The Circus.*

showed up to "supervise" the proceedings. In the early morning hours of February 16, director King Vidor was told that the judges had planned to give Vidor's film *The Crowd* the Unique and Artistic Picture Award but that Mayer had spent all night fighting their decision. Even though MGM had produced the film, Mayer argued that *The Crowd*, about an average man who worked hard and didn't get anywhere, wouldn't promote the Academy's lofty goal of encouraging "the improvement and advancement of the arts and sciences in the profession. . . ." Mayer believed *Sunrise*, directed by the world-renowned German-expressionist director F.W. Murnau, was a better choice. It also had the added benefit of being produced by Fox Studios, which gave Mayer cover against accusations of rigging the vote. At 5:00 a.m., the exhausted board finally gave in.

The next day, the Academy announced to newspapers the winners and honorable mentions for their first Merit Awards.

Emil Jannings, who won the first Best Actor award, was convinced that he wasn't going to make the transition into talking films due to his limited English and thick accent. He would be moving back to Germany before the award

ceremony and sent the Academy a telegram: "I therefore ask you to kindly hand me now already the statuette award to me." They did, making Jannings the first individual to be presented with an Academy Award. Jannings's next award came in 1939, from Adolf Hitler, who presented him with the Goethe Medal for art and science for a series of Nazi propaganda films. At the end of World War II, Jannings reportedly ran toward the Allied troops marching into Berlin, clutching his gold statuette and yelling, "Please, don't shoot—I vin Oscar." They didn't shoot, but Jannings's reputation was ruined, and he never worked again.

Two hundred and seventy guests were invited to attend the banquet, with one notable exception: William Wellman, the director of the first film to win Outstanding Picture (now Best Picture),

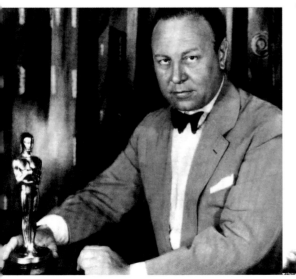

The first person to receive an Academy Award, Emil Jannings, who won Best Actor.

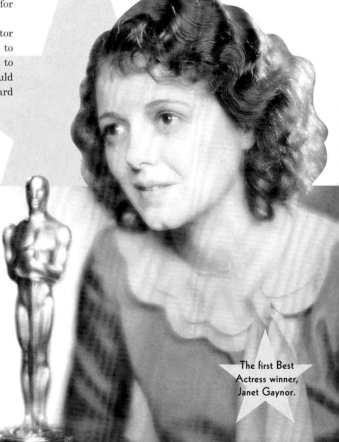

The first Best Actress winner, Janet Gaynor.

Wings (1927). He handled the snub by getting drunk at home, making a speech in his empty living room telling off the Academy.

The festivities began in the Academy lounge room at 7:00 p.m., where a special talking picture exhibition was being shown. At 8:00 p.m., as guests dined on "half broiled chicken on toast," Douglas Fairbanks opened the ceremony and explained the lengthy selection process used to determine the winners, concluding that "it is no mean honor to receive consideration under these conditions."

Fairbanks turned the ceremony over to Academy vice president William C. de Mille, who spoke about the Academy's impartiality in giving awards to people who were not members. "Take Mr. Jannings, for instance, he is not a member of the Academy—he is not even a citizen of our

The second special award went to Charlie Chaplin for writing, directing, acting in, and producing *The Circus*.

A reel of talking film showed Paramount head Adolph Zukor accepting the award for Outstanding Picture for *Wings* from Douglas Fairbanks at Paramount's Long Island studios.

George Stanley, who sculpted the statuette, was called up to receive applause for his work, as Cedric Gibbons was out of town. And, just like that, the ceremony was over.

The evening then switched to speeches by Mary Pickford, Cecil B. DeMille, and representatives from Stanford University and the University of Southern California, who spoke about including film courses in their curriculums. Academy pioneers Conrad Nagel and Fred

"THE ACADEMY IS HERE TO STAY."

country—but it did not prevent the Academy from giving him the award. Miss Gaynor is not a member of the Academy. Why? God knows. I think she has been invited, in fact I know she has had an invitation."

He then asked the winners and honorable mentions to come up and receive their awards and certificates from Douglas Fairbanks.

In addition to the twelve categories, two special awards were presented. One went to Warner Bros. for *The Jazz Singer*, recognized as "the pioneer outstanding talking picture which has revolutionized the industry." Darryl Zanuck accepted the award on behalf of the Warners and made the only acceptance speech of the night:

It is the wish of Warner Brothers that I accept this award in the name of Mr. Sam Warner, who was a pioneer in pictures and who first saw the possibilities and experimented with what is now known as the Vitaphone, and who first saw there was a possibility of making talking pictures. I thank you.

Sam Warner had died the day before the release of *The Jazz Singer*.

Niblo also spoke. Nagel discussed how talking pictures had brought a flood of new actors to Hollywood and turned the industry into "a struggle of the survival of the fittest." Niblo compared doubts about the Academy to those about other innovations: "But the train, the steamship, and the airplane did come and have stayed. I believe the Academy is here to stay."

Louis B. Mayer himself made a speech, extolling the virtues of the organization he had founded (to stop his employees from unionizing), concluding, "Life without service has very little in it. We owe a great debt to the industry that made it all possible."

Al Jolson closed the night and received the first big laughs in Academy Award history. "I notice they gave *The Jazz Singer* a statuette but they didn't give me one," he said. "I could use one; they look heavy, and I could use another paperweight." He added, "For the life of me, I can't see what Jack Warner would do with one of them. It can't say yes."

The crowd burst into laughter and took to the dance floor, blissfully unaware that they had just launched what would become a great American cultural institution.

Who's OSCAR?

The origins of the name of this distinguished symbol are clouded. The iconic statuette was first named the Academy Award of Merit. The Academy didn't officially adopt the name "Oscar" until 1939, but its usage had been around for several years before that. The earliest known reference to "Oscar" in print goes to gossip columnist Sidney Skolsky in his March 16, 1934, column: "To the profession these statues are called Oscars. Here are a few winners who now have a little Oscar in their home."

Skolsky said he came up with the name after attending his first Academy Awards ceremony, which left him feeling underwhelmed. "The snobbery of that particular Academy Award annoyed me. I wanted to make the gold statuette human." He claimed he named it after a popular vaudeville gag in which the name Oscar was the punchline.

Bette Davis once claimed she named the statue for her first husband after she received her Best Actress Award for the film *Dangerous* in 1936:

I finally wheedled out of my husband, Harmon O. Nelson, Jr., the tenaciously guarded secret of his middle name. It was 'Oscar.' To tease him, I began to call my statuette 'Oscar.' Soon 'Oscar' was adopted by the Industry—and that's how the Academy Award statuettes got their name.

However, this would have been two years after Skolsky christened the statuette in print.

Another popular theory is that Academy librarian (and later executive director) Margaret Herrick coined the name in 1931, when she said the statuette reminded her of her uncle Oscar, who was actually her second cousin. Herrick said the moniker was then used casually amongst people in the Academy and Hollywood.

In 2013 the Academy Awards rebranded their entire event to be called *The Oscars®*.

We still have no idea where the name actually came from.

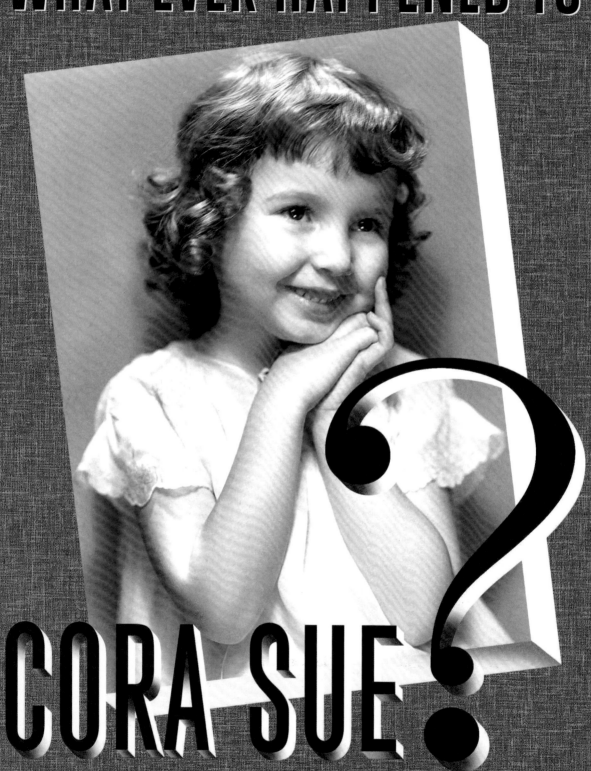
WHAT EVER HAPPENED TO CORA SUE?

A S a child, she rivaled Shirley Temple and starred alongside film giants such as Greta Garbo, Bette Davis, Norma Shearer, and Claudette Colbert. Unlike most child stars, she transitioned successfully to teen roles, and her career was on the rise. And then suddenly, it was over. For years, people asked, "What ever happened to Cora Sue Collins?" For years, she declared that she quit show business for the "luxury of anonymity." But there was actually a much darker reason, which Cora Sue has finally decided to reveal after keeping it secret for more than seventy-five years.

She was born in Beckley, West Virginia, on April 19, 1927. Her father was Young Commodore Collins, a district sales manager of silk hosiery who also bred prize cattle. Her mother was Vella "Clyde" Richardson, "a real beauty" who perhaps would have been a performer herself but for growing up on the farms of North Carolina, where she never had the opportunity. A sister, Madge, had come eight years before. Life was relatively quiet for Cora Sue's first three years on the farm in West Virginia—until her father gave his secretary a mink coat for Christmas.

"My mom just arbitrarily decided that girl was providing other than secretarial services, which she was," Cora Sue says.

Clyde immediately "picked up, packed up," and took Cora Sue and Madge to Hollywood. In classic "only in Hollywood" fashion, Cora Sue was discovered on her third day in town. Clyde had taken the girls to enroll Madge in school, and as they were walking toward the building, a car came screeching up to the sidewalk. A woman hopped out, pointed at Cora Sue, and asked Clyde, "Would you like to put your little girl in pictures?" Clyde said she would. "Good," the woman responded, "there's a casting at Universal. Get in the car, I'll take you."

At the casting call, a director gave Cora Sue a line of dialogue and then asked her, "Can you remember this?" Cora Sue repeated back, "Can you remember this?" She got the job. (Among the competition she topped at the audition was a young girl named Frances Gumm, who would later change her name to Judy Garland.) The film was *The Unexpected Father*, and Cora Sue played the part of "Pudge." Upon release, Cora Sue was a sensation. "ONE IN A MILLION!" declared *The New Movie Magazine*. "She is one of the most amazing combinations of talent, natural acting ability, and beauty that the folks who discover these children

in *Smilin Through* (1932) with the Queen of MGM, Norma Shearer. This was followed by a slew of other films, including *Jennie Gerhardt* (1933) with Sylvia Sidney, *Torch Singer* (1933) with Claudette Colbert, and *The Prizefighter and the Lady* (1933) with Myrna Loy.

One day, Cora Sue was called to a sound stage and asked to stand in front of a big black velvet curtain with a bunch of other girls, lined up according to height. One by one, the girls were sent out until, finally, Cora Sue was the only one left. Then "this very nice blond lady with kind of a funny accent came out from in between the curtains and she chatted with me," Cora Sue recalls. "And then she left, and then they told me I'd gotten the part."

The lady with a funny accent was Greta Garbo, and she had selected Cora Sue to play a younger version of her character in *Queen Christina* (1933).

The notoriously aloof Garbo (still best known for her iconic film line, "I want to be alone!") was in fact quite fond of children. During production of *Queen Christina*, Garbo took a liking to Cora Sue and asked her to call her "GG." Cora Sue could never bring herself to address MGM's biggest star with such informality. "I couldn't say GG. I said Miss Garbo, out of respect," she explains. Garbo began inviting Cora Sue to her dressing room for tea. Clyde was never invited. "My mother wanted to meet her so badly," Cora Sue says.

have presented to date," wrote one critic. "It is really little Cora Sue Collins who proves herself the star of the show and wins the hearts of the audience," wrote another.

She cried her way into her next role in *The Strange Case of Clara Deane* (1932). While waiting in line with scores of other girls to audition, Cora Sue watched the casting director ask a young girl if she could cry. When the girl shook her head, Cora Sue leapt up to volunteer her services. After she took a moment to think of something sad, tears began to stream down her face.

By this time, Cora Sue had caught MGM's eye. She was quickly placed under contract and cast

Clyde begged Cora Sue to tell Garbo that she'd like the great star to meet her mother. But Cora Sue refused. "I don't tell her anything," she explained. "In fact, I don't ask her anything." Cora Sue had seen what had happened to Freddie Bartholomew, another child star at MGM. Bartholomew also had a close relationship with Garbo and was invited for tea in her dressing room—until he asked her to sign a photograph of herself for his mother.

"She autographed the photograph, gave it to him, and never, ever saw him again," Cora Sue says.

Since Garbo avoided public appearances, including her own film premieres, Cora Sue was sent off

to Grauman's Chinese Theatre for the premiere of *Queen Christina*. She arrived in full costume, riding in a replica of the coach from the film, pulled by six Shetland ponies. Standing on an electrician's back so she could reach the microphone, Cora Sue began to address the crowd when suddenly a woman broke through and ran up to her and placed something in her hand: A gold coin that was minted during the reign of the real Queen Christina.

The success of *Queen Christina* fully cemented Cora Sue as a star. She was immediately placed in a series of films alongside William Powell, Myrna Loy, and Loretta Young. Garbo also chose her again for the role of her niece in *Anna Karenina* (1935).

On April 18, 1935, Louis B. Mayer threw a joint birthday tea party for Cora Sue and longtime MGM player May Robson, celebrating Robson's 70th birthday and Cora Sue's 7th. Cora Sue was really turning 8, but Mayer thought 70 and 7 sounded better together. Most of the studio shut down for the day, as 200 of MGM's finest came to celebrate the studio's "oldest and youngest featured players."

"When L.B. Mayer issued an invitation, it wasn't an invitation; it was a command performance," Cora Sue explains. "They were all under contract to him. They didn't dare forget. So, I had the most famous actors, directors, producers, cinematographers, choreographers, whoever because they didn't dare refuse. So, it was really quite a party."

For Cora Sue, MGM was a sort of wonderland, where the biggest film stars in the world were her coworkers, friends, and even babysitters. When

"I *love* this one. It's when I was being coronated. It looks like they're putting the crown on cock-eyed."

"I was playing Garbo's niece in Anna Karenina. She was such a beauty. She just didn't realize how beautiful she was—well, I guess she did."

"They were my buddies. Freddie Bartholomew, Mickey Rooney, and Jackie Cooper. You see Mickey stayed short. He was so much older than all of us, but he stayed short, so he got to play young kids forever and ever."

her mother had to leave town, she left Cora Sue in the care of Lana Turner.

"Oh, Miss Turner, I just love your eyebrows," Cora Sue declared one day. "When I grow up, I want to have eyebrows like that."

"Are you working the next couple of weeks?" Lana asked.

"Not to my knowledge," Cora Sue replied.

Lana promptly tweezed Cora Sue's eyebrows into a thin, dramatic arch. Unfortunately, they never grew back. "Mr. Mayer was furious," Cora Sue says, "because you don't have a six or seven-year-old child with eyebrows that have to be painted on. My mother didn't speak to [Turner] for two months."

One day, Cora Sue and Clyde were sitting in Mayer's office when suddenly the door swung open and a woman, with her back to them, shouted, "Don't tell me that! I've fucked every Jew bastard on the way up!"

With that, she slammed the door and turned around. It was Norma Shearer. Cora Sue turned to Clyde and asked what the word "fucked" meant.

Mortified, Clyde refused to respond to the question. Undeterred, Cora Sue asked Mayer's private secretary, Ida Koverman, who also refused to answer. Finally, she asked Mayer himself. He was flabbergasted. Eventually, she says, "I found out what it was." Shearer's outburst was also Cora Sue's first introduction to the idea of the "casting couch."

"[Norma Shearer] was the biggest, most important star of her time, except for maybe Greta Garbo," Cora Sue explains. "But Norma Shearer was everything. She was a brilliant businesswoman, she was a fine actress, she was everything, and *she* did it on the way up."

It was around this time, at about six or seven years old, that Cora Sue met a man who would change the course of her life. A "little short guy with perfectly round silver rimmed metal glasses," Harry Ruskin was one of MGM's most important screenwriters, but his real talent was in his ability to fix a screenplay. At that time, about half the scripts produced at MGM passed through his hands.

"He was a genius," Cora Sue says. "If they needed thirty-five or forty minutes reduced from the playing time, he could cut it and not lose a bit of the story theme."

For Harry, this came naturally. As he once said,

"Some babies are born with a gold spoon in their mouths. I was born with a typewriter in mine." Harry was born in 1894 in Cincinnati, Ohio. Eventually, he went into the clothing business, setting up shop in Chicago. Harry started to write sketches in order to pass the time when there was a lull in business. In 1923, he sold his first sketch to Florenz Ziegfeld for his famous Follies. Harry would go on to write more material for Ziegfeld's shows, and in 1930 he collaborated with Oscar Hammerstein II to write *Ballyhoo*. From his success on Broadway, Harry was hired as a writer at Fox in 1931. He then went to work at Paramount before ending up at MGM.

"He was a great talent," Cora Sue says. "I don't know of another script author who had ever had the kind of power he had. He was incredible."

Harry began to take a special interest in Cora Sue. He helped her with her schoolwork. He gave her books to read and shared his philosophies of the world with her. Having lived most of her life without a father, Cora Sue reveled in his attention. "He was my mentor," she says. "He was my father image."

As the years passed, Cora Sue grew closer to Harry and found herself joining a crew of MGM players that orbited the powerful writer. These were "players, actors, actresses, producers, writers, choreographers" who "amused him." Harry would invite the group to lunch in his office. "The food was horrible at the commissary so he would send out for food," Cora Sue recalls, "and we would stand around the bookshelves or sit on chairs or on the footstools and eat our lunch." These gatherings became famous about town. "Two hours in his office around luncheon time is entertainment that puts most Hollywood productions in the shade," one reporter wrote.

Lucille Ball was part of the group and someone whom Cora Sue became close with, even giving Lucille the keys to her house so she could come and go as she liked. Often, Lucille would come to tend to Cora Sue when she was sick, bringing "congealed blood" for her to drink as medicine. "She would go to her butcher and have him press beef the way they press duck, squeeze the blood out of it," Cora Sue explains. "And then she would take that and she would cook it. And it would congeal. She would spoon-feed me this stuff and I swear that I got better on my will alone so I wouldn't have to take that."

One afternoon in 1943, Harry called Cora Sue and asked if she would be coming for lunch the following Tuesday. Cora Sue said she didn't know yet. He called the next day and asked again, and she responded that she didn't know. When he called her again the next day, she relented and agreed to be there. But when she arrived on Tuesday, Harry was the only one there. "Where is everybody?" she asked.

"I wrote a synopsis for you, and I wanted you to read it alone," Harry declared. Cora Sue read it and immediately fell in love with the story. "He knew me so well," she recalls. "I still have goosebumps thinking about it. It was so me, it was so perfect, and I would have given my right arm to play it—not my virginity." Harry, the man who she looked up to as a father, told her the part was hers, "but you have to sleep with me." Cora Sue was fifteen years old. Harry was fifty.

She was stunned and refused. Harry was furious. "There are dozens of girls in this town who would *love* to sleep with me to play that part," he told her.

"Let them. Let them," Cora Sue replied.

"And then I realized I was becoming unglued," Cora Sue recalls, "and I was going to start to cry and my mother never let me cry unless it was in front of a camera because *I might get hoarse and not be able to work*."

Cora Sue excused herself, went out into the hall, and began searching for any unlocked door that wouldn't lead into an office. The first one she found was a cleaning supply closet. She went inside, blocked the door, and began to cry in the dark, alongside the buckets and mops.

After crying her eyes out, Cora Sue got herself together and went to see Mayer.

She didn't have an appointment, but Cora Sue waited until Mayer was free. Not long after, he emerged from his office, picked her up, and carried her back inside. Cora Sue was shocked because Mayer was legendary for never getting up from behind his desk. She sat in a large black leather overstuffed chair, as Mayer began to rant in excitement about Harry Ruskin's latest project. "Have you read the synopsis yet? Did you love this? We even have your favorite cinematographer Jimmy Wong Howe! Your favorite producer, your favorite director!"

Cora Sue waited until he was finished and then said, "Mr. Mayer, do you know what Harry wants me to do?" Mayer sat on the arm of her chair.

Pulling her into his arms, he made it clear he knew exactly what Harry wanted, saying simply, "You'll get used to it, darling."

Cora Sue told Mayer she didn't want to get used to it, and after a heated, forty-five-minute-long discussion, Mayer "lunged across his desk," waved his finger under her nose and said, "Cora Sue, you will never work on a sound stage again as long as you live."

"Mr. Mayer, that's my heartfelt desire," she replied.

Her mother was livid. Until the day she died, Clyde thought Cora Sue had misunderstood what Harry had told her. "I didn't misunderstand him," Cora Sue says. "When it was put as succinctly as that, an idiot would understand."

This type of behavior wasn't anything new at MGM. In her autobiography, Shirley Temple recalled that Arthur Freed, the producer of classics like *Singin' in the Rain*, exposed himself to her in his office. "Not twelve years old," Shirley wrote, "I still had little appreciation for masculine versatility and so dramatic was the leap between schoolgirl speculation and Freed's bedazzling exposure that I reacted with nervous laughter. Disdain or terror he might have expected, but not the insult of humor." Freed was furious and ordered her out. Judy Garland said Mayer himself would have her sit on his lap and tell her, "Your talent comes from here," pointing to her heart and groping her breasts. "I often thought I was lucky," Judy would quip, "that I didn't sing with another part of my anatomy."

Cora Sue never spoke to Harry Ruskin again, and she kept silent about the incident for years. "I couldn't tell anybody at the time," she says. "I didn't tell anyone except my mother, and she didn't believe me. I had five girlfriends who had acquiesced to these same kind of propositions because their mothers didn't believe them either." Furthermore, she says, their mothers would tell them, "Do whatever they want because you need that part."

Many years later, she confided in her good friend Lucille Ball. "That son of a bitch!" Lucille remarked. Lucille told Cora Sue "she wasn't the least bit surprised" and then hugged her and said, "Darling, it's not your fault."

"I didn't know enough to take her advice," Cora Sue says. For years, she felt guilty about the incident and thought she must have been responsible.

"What had I done to cause this? Had I dressed provocatively? Had I said something that could be provocative in some way?" Cora Sue says. "You blame yourself. I wasn't capable of realizing it was his problem. Only his problem. Not mine."

Mayer followed through on his threat of a blacklist, and Cora Sue's only role over the next two years was in Columbia's B-picture *Youth on Trial* (1945).

And then, Cora Sue was shocked to receive a phone call from Mayer himself, offering her a role in MGM's upcoming film *Weekend at the Waldorf*. She had heard all about the movie from several of her friends who were starring in it and said, "Mr. Mayer, you just talked me out of retirement."

To this day, Cora Sue doesn't know what prompted Mayer to give her the role. "I'm sure it wasn't his idea," she says, speculating that one of her friends, like Lana Turner, twisted his arm. Either way, she was excited to reunite with her old film family.

Still, it was difficult for her to get past her encounter with Harry Ruskin. "If I could have simply understood it was his fault and not mine," she says. "I kept blaming myself." After *Weekend at the Waldorf*, Cora Sue decided she was done with films for good. "My heart wasn't in it," she says. "I just thought it was such a rotten business that I wondered, 'What's going to happen next?'"

What happened next for Cora Sue Collins was a full life, well lived. She had a family and two fabulous marriages. She traveled the world, living in Paris and Mexico, and learning to speak six languages fluently. For years, she disliked being reminded of her childhood stardom. Whenever someone would bring it up, she would tell them, "That's like yesterday's newspaper, you wrapped the trash in it." But after the fall of Harvey Weinstein and the rise of the #MeToo era, Cora Sue found the courage to speak about what had happened to her. In January 2018, she told part of her story to the *New Yorker* but remained anonymous because she had never told her family what happened. Here, she is sharing her story in full for the first time.

Now, she is enjoying revisiting her work as one of Hollywood's most beloved child stars. As for her decision to stop making movies, she has no regrets, saying, "It's the best single decision of my life."

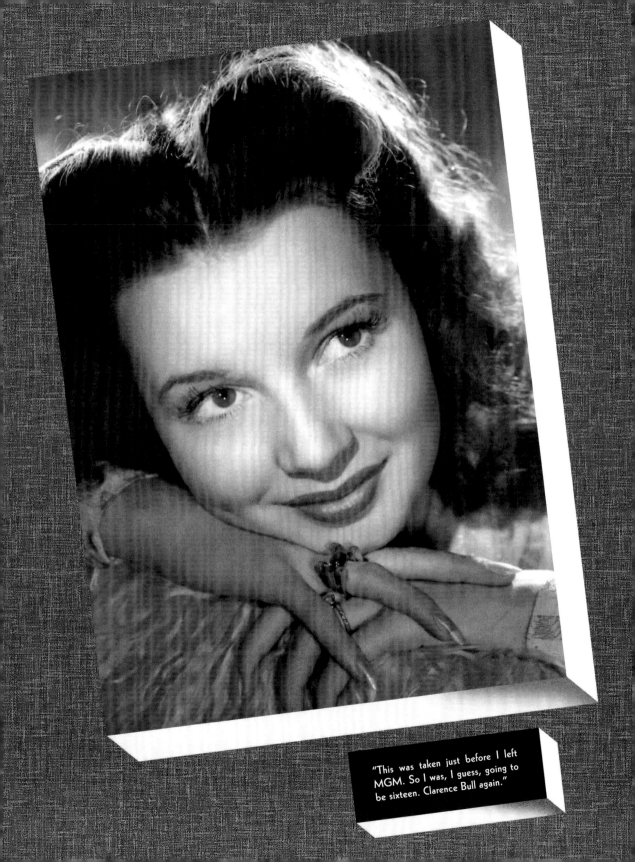

"This was taken just before I left MGM. So I was, I guess, going to be sixteen. Clarence Bull again."

CHATTANOOGA CHOO CH

THE SHOW

STOPPERS

OR decades, an argument has raged about who deserves the title of Greatest Dancer in Film History: Fred Astaire or Gene Kelly? The answer is simple: The Nicholas Brothers. While racism prevented Fayard and Harold Nicholas from reaching the heights of stardom like Astaire and Kelly, the dance numbers they put on film make one thing clear: In the Golden Age of Hollywood musicals, nobody could out-dance the Nicholas Brothers.

Their journey began in Mobile, Alabama, with the birth of Fayard Antonio Nicholas in 1914 to Viola and Ulysses Nicholas. The Nicholases were musicians: Viola played the piano and Ulysses the drums. Shortly after Fayard's birth, the family left the segregated South, and Viola and Ulysses began playing in orchestra pits on the vaudeville circuit up North. After being an only child for six years, Fayard got company when his sister, Dorothy, was born in 1920. A year later, Viola gave birth to another boy. Fayard begged her to name him after his favorite movie star, Harold Lloyd, so she did. The family settled in Philadelphia, and every day after school, Fayard would head over to the Standard Theatre to watch his parents play for artists such as Louis Armstrong. While watching the endless parade of talent that took the stage, young Fayard thought to himself, "Jeepers, they're having fun up there! I'd like to be doing something like that!"

He set out to find his way onto the stage. Fayard taught himself to dance by watching other performers. After watching one tap dancer do a split onstage, Fayard went home and found he could do it better. "I could go down-and-up with-out putting my hands on the floor," he said. Later, when he was outside and saw a fire hydrant, Fayard jumped over it into the splits. He then substituted Harold, who was then only four feet tall. After getting a running start, Fayard leaped over his head and landed in the splits. He never took a lesson and would later quip, "I saved a lot of money, didn't I?"

By the age of eleven, Fayard was choreograph-ing his own dance routines and teaching them to Harold and Dorothy. "It was like a game," Harold said. "But it took a long time. I was determined to learn to dance with both feet. One day, dry-ing the dishes, I finally got into doing a time step on both feet. From then on he had no trouble teaching me." One evening in 1929, when Viola and Ulysses came home from the theater, they noticed all the lights were on in the living room and wondered what the children were doing up on a school night.

"Sit down, we want to show you something," Fayard told them.

The three siblings shocked them with a series of rousing dance routines. Viola and Ulysses were so impressed, they decided to give up their own careers as musicians to manage their children, who soon set forth on the vaudeville circuit as "The Nicholas Kids." Dorothy, who was never as enthusiastic about dancing as her brothers, couldn't handle the late hours and soon dropped out. Though he was not a dancer himself, Ulysses pushed his sons to develop their own style. "Don't do what other dancers do; do your own thing," he told them. "When you're dancing, don't look at your feet, look at the audience. You're not entertaining yourself, you're entertaining the audience."

Equally important for the act was "looking sharp." That was Viola's department. She made sure her sons always had immaculate suits and shoes, even manicured fingernails.

The brothers soon began dancing at the Pearl Theatre in Philadelphia, where they shared the stage with jazz legends like Cab Calloway and Count Basie and his orchestra. It was here that they earned the nickname "the Show Stoppers." "Everywhere we went," Fayard said, "we stopped the show, and nobody wanted to follow us. So they always had us in the closing spot."

The brothers defied gravity with a unique style of tap dancing that blended fast-footed fury with acrobatics, all while dressed in black tie and tails. But their strenuous style was exhausting, so they began to insert songs and comedy bits in between numbers. A popular one involved Harold sing-ing "Lady Be Good" while Fayard conducted the band with his hands, head, feet, and buttocks. The brothers were earning such a name for them-selves that the manager of the Lafayette Theatre in New York made a special trip just to check them out. He signed them on the spot. Not long after, Warner Bros. caught the act and cast the brothers in the all-black musical short film *Pie, Pie, Blackbird* (1932). But their biggest break was about to come at one of America's most legendary venues: the Cotton Club.

Located in the heart of Harlem, the Cotton Club was founded by bootlegger and gangster Owney Madden after his release from Sing Sing in 1923.

"DON'T DO WHAT OTHER DANCERS DO;
DO YOUR OWN THING."

The club quickly became one of the most influential cultural institutions in America, featuring some of the greatest black entertainers of the era, including Duke Ellington, Cab Calloway, Ethel Waters, and Lena Horne. The club's mob connections allowed the Nicholas brothers to circumvent child labor laws and perform at all hours without interference from the police. A typical day for the two brothers involved performing at the club, where the first show didn't begin until midnight, and then returning home anywhere from 3 to 5 in the morning to sleep until 3:00 p.m., when their tutor would arrive. After an hour or two of studies, they would nap, have dinner, and be chauffeured back to the club in a limousine.

The Cotton Club was segregated. The legendary performers were black, but the audience was all white. Blacks were barred from entering by a doorman, who himself was black. The black performers were not allowed to mingle with the white audience. But the Nicholas brothers changed that when an exception was made so they could meet their favorite stars like Charlie Chaplin, the Marx Brothers, Gloria Swanson, and Al Jolson. One night, Harold Lloyd was in the audience, and Fayard told the great comedian that he had named his younger brother after him. Lloyd told him he was honored. Another night, Tallulah Bankhead told Harold how much she had enjoyed the show and asked him which he'd prefer: an autographed photo of her or

a bicycle. He said both if he could have them. The next morning a bicycle and an autographed photo arrived at the Nicholas apartment.

In 1933, Harold was cast alone in a small role in *The Emperor Jones* starring Paul Robeson, but Fayard didn't mind. "My brother let me take all the limelight, because I was the youngest," Harold said. "We always got along." Producer Samuel Goldwyn caught their act at the Cotton Club and cast them in *Kid Millions* (1934). In Hollywood, they got a chance to meet more of their idols, like Fred Astaire, then filming *Top Hat* on the RKO lot. Fred was ecstatic to meet the brothers he had heard so much about and joined them for an impromptu dance on the studio lot that was captured in their home movies. In 1935, the brothers were hired by Paramount to sing and dance in *The Big Broadcast of 1936* and then headed back to New York to make their Broadway debut in the *Ziegfeld Follies of 1936*. The following year they were in another Broadway smash, Rodgers & Hart's *Babes in Arms*. After the play wrapped, they returned to the Cotton Club to perform, and one night at rehearsal they noticed an all-girl singing trio: The Dandridge Sisters. Both of the brothers had their eye on the girl in the middle, the beautiful and reserved teenager Dorothy. Fayard noticed she was paying more attention to Harold, so he got out of the way. Harold began taking Dorothy on chaperoned dates. The romance soon became long distance, as the brothers were booked on a tour in Latin America to perform alongside Carmen Miranda, who was about to make her Hollywood film debut in 20th Century Fox's Technicolor musical *Down Argentine Way* (1940).

At the last minute, studio head Darryl Zanuck added the brothers to the film. They were assigned to work with choreographer Nick Castle, who would become their longtime collaborator. Unlike many film choreographers who balked at working with black dancers (without hesitating to steal their moves), Castle was excited to be working with dancers who had an enormity of talent and ability to bring his visions to reality. At the film's preview, after the Nicholas Brothers' number ended, the crowd went wild and began clapping their hands, stomping their feet, and whistling, so much so that the operator in the projection room had to rewind the film and start it over. Filmgoers had never seen

Looking sharp.

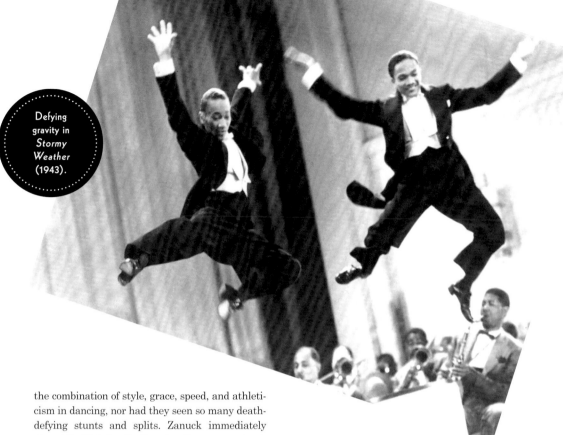

the combination of style, grace, speed, and athleticism in dancing, nor had they seen so many death-defying stunts and splits. Zanuck immediately signed the Nicholas Brothers to a five-year contract.

"So after this sensation of stopping the show like that in the theater we should have been starring in our own movies," Fayard pointed out. "If we were white, you know it would have happened." Instead, they were placed in a series of show-stopping song-and-dance specialty numbers in *Tin Pan Alley* (1940) and *The Great American Broadcast* (1941). "They weren't writing anything for blacks unless it was a shoeshine or something," Harold recalled. "Rather than do that, we just did the dance routine. It would have been difficult, because we weren't brought up to talk like that—that bad English, that Stepin Fetchit talk." In all of these numbers, the brothers never appeared with the white stars of the film. They were filmed separately so that they could easily be cut out by racist exhibitors in the South.

The brothers were banned from dining in the 20th Century Fox commissary and would drive home to eat lunch, until Zanuck found out and insisted they be allowed to eat inside. Zanuck was a fan and champion of the brothers, knowing that just five minutes of the Nicholas Brothers could make any clunker of a film a box-office success. It wasn't uncommon for audiences to

see their films and walk out after their number was over. For black filmgoers especially, used to Hollywood depicting black people as butlers and maids, the Nicholas Brothers were a source of pride. They were superheroes in their musical numbers, and always stole the film from the white stars. Theaters in black neighborhoods across the country would often put "Starring the Nicholas Brothers" above the names of the movie's stars on the marquee, even though they were only in a film for a few minutes.

In 1941, the brothers were filming *Sun Valley Serenade* and rehearsing a number to go along with a new song: "Chattanooga Choo Choo." Hermes Pan was the choreographer for the film, though he never took credit for the number. "Those guys had so many backflips, splits, riffs and steps, and they did them all at the speed of light," Pan explained. "I gave their numbers for that film some cohesion, but I can't do a backflip into a split, so I mostly just let them go." The brothers didn't like the song but convinced the studio to hire Dorothy Dandridge to sing and dance with them to give it something extra.

"Isn't that funny? You never know what's going to be a hit," Fayard said. The song became a classic, and the film launched Dorothy's career. She later went on to make history as the first African American to be nominated for the Best Actress Oscar for 1954's *Carmen Jones*.

While performing in Chicago later that year, Fayard became captivated by a college student, Geraldine Pate, and less than a month later, he married her. A few months later Harold followed his brother down the aisle and married Dorothy.

orchestra, up a white staircase and onto a piano, which they jumped off of, landing into the splits. A few more twists and turns and splits followed, and then they danced back up the staircase. Then came the showstopper: They leap-frogged over each other into the splits all the way down the staircase. "Don't rehearse it," Castle told them. "Just do it." And they did. The result is a number that Fred Astaire would call "the greatest routine I've ever seen on film."

After the success of *Stormy Weather*, the brothers hoped they would begin to get more substantial

"DON'T REHEARSE IT, JUST DO IT."

Both of these marriages were filled with tension due to the brothers' infidelity and would eventually end in divorce. As Fayard put it, "A lot of show people aren't the family type." On screen, however, the Nicholas Brothers could do no wrong.

In *Orchestra Wives* (1942), Nick Castle challenged the brothers for the "(I've Got a Gal in) Kalamazoo" number, suggesting they run up the wall and backflip into the splits. The brothers said it was impossible, but Castle insisted. A special wall was built at the studio and ropes were put on their waists to protect them as they practiced. After a month, they could do it. Years later in *Singin' in the Rain* (1952), Donald O'Connor would make a similar move famous (minus the splits) and would always credit the Nicholas Brothers for having done it first.

In 1943, they were featured in *Stormy Weather*, a showcase for the greatest black entertainers of the day, including Bill Robinson, Cab Calloway, Fats Waller, Lena Horne, and Dooley Wilson, among others. The Nicholas Brothers' number in the film, "Jumpin' Jive," would prove to be the signature performance of their careers. Before shooting, the brothers met with Castle to plan, wondering if it was even possible to top backflipping off of walls. It was.

The number began with them sitting in a nightclub while Cab Calloway performed. They jumped onto the bandstand and danced around the

parts in films, like those that their idol Astaire and rising star Gene Kelly were getting. But the offers didn't come. "They didn't write scripts for us," Harold said. "We couldn't be Gene Kelly or Fred Astaire—all they wanted us to do is dance, and the more spectacular the better. Of course that was disappointing."

In 1943, the brothers were separated for the first time when Fayard was drafted and entered World War II in an all-black unit as part of the laundry company. In between his duties, Fayard entertained the troops to keep up morale. Harold stayed back in Los Angeles, where he performed in *Reckless Age* (1944) and *Carolina Blues* (1944). The brothers reunited and made a film with Gene Kelly, appearing in the "Be a Clown" number from *The Pirate* (1948). Kelly had wanted to perform with the brothers for a long time, and he was the first white person to dance alongside them on film.

"That guy is a perfectionist," Harold would later complain about Kelly. "[H]e and Fayard would be rehearsing this number over and over, as if the camera was running, which means that you're doing it in full force. But I never liked to go all out during the rehearsal." One day, Kelly decided to put Harold on the spot and asked him to do the routine by himself, believing he hadn't gotten it down. Harold did it without missing a step. "Well, I'll be an SOB," Kelly exclaimed. Though the final number in the film is fabulous, it lacked the usual

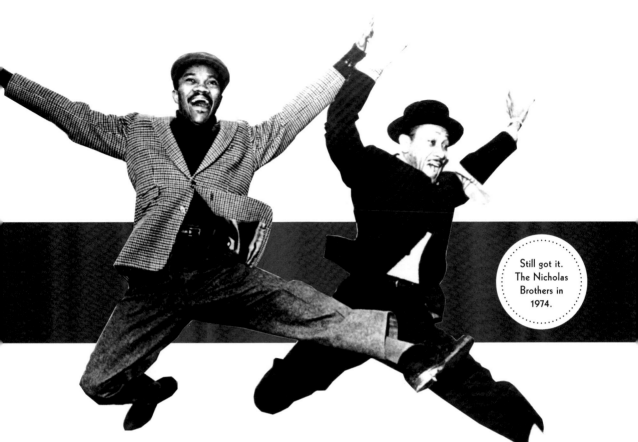

Still got it. The Nicholas Brothers in 1974.

leaps, flips, and splits that the brothers were known for, simply because Kelly couldn't do them.

Realizing their careers would never go further than specialty dances in Hollywood, the brothers decided to travel outside the United States where they would face less discrimination, performing for the Royal family in London and King Farouk in Egypt. Upon returning to the United States in 1953, they performed for President Eisenhower's inauguration. Throughout the 1960s and 1970s the brothers appeared together on television variety shows. They also excelled separately: Harold returned to Europe to record a series of albums, and Fayard received a Tony Award in 1989 for his choreography in the revue *Black and Blue*.

It wasn't until the 1980s and 1990s that the Nicholas Brothers began to get the mainstream accolades they so richly deserved. In 1981, the Academy Awards featured a retrospective of their work, and ten years later, President George H.W. Bush awarded them the Kennedy Center Honor. In 1994, they received a star on the Hollywood Walk of Fame and in 1998 a tribute at Carnegie Hall. Still, it's impossible to know how high their

stars could have soared if not for the racial restrictions of the Jim Crow era. "If we were coming up in this day and age, doing the same things, it would have been completely different," Harold said in 1991. "We would have been two Michael Jacksons."

In the end, the Nicholas Brothers made the success of performers like Michael Jackson possible. Harold passed away in 2000 and Fayard in 2006, but before their deaths, whenever stars like Sammy Davis Jr., Harry Belafonte, Diana Ross, Eddie Murphy, and Denzel Washington saw the brothers, they would thank them for paving the way for their own successful Hollywood careers.

The actor and dancer Gregory Hines once said that if there was ever a biopic about the Nicholas Brothers, the dances would have to be computer generated because no one could ever come close to matching their skills. Decades later, audiences who see their numbers are still in awe. "I can see why people make such a fuss when they see our films," Fayard said. "It is incredible! Nobody did those things before us and nobody has been able to since." As Harold once said, "We top them all now."

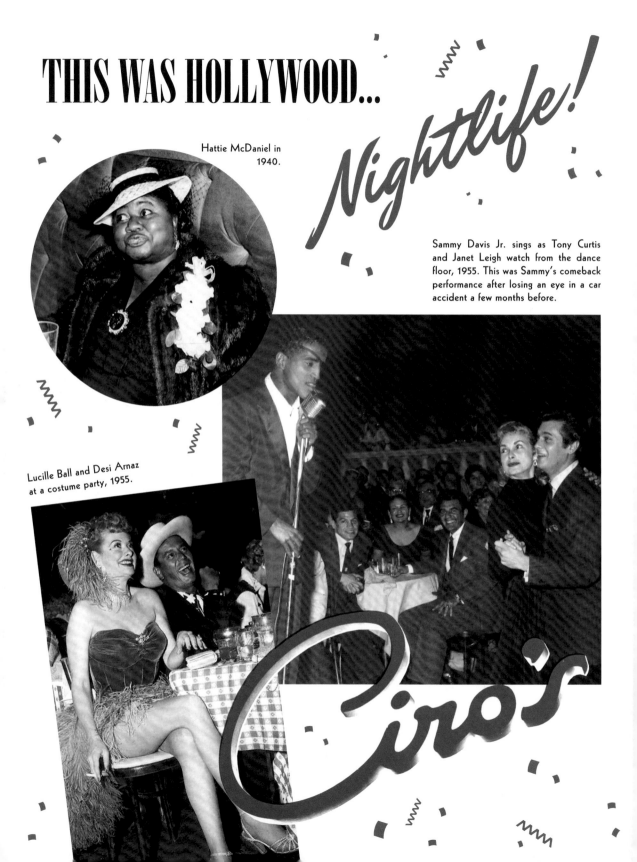

THIS WAS HOLLYWOOD...

Nightlife!

Hattie McDaniel in 1940.

Sammy Davis Jr. sings as Tony Curtis and Janet Leigh watch from the dance floor, 1955. This was Sammy's comeback performance after losing an eye in a car accident a few months before.

Lucille Ball and Desi Arnaz at a costume party, 1955.

Ciro's

AMBASSADOR
Cocoanut Grove

Una Merkel and Anna May Wong, 1937.

Harry Belafonte singing to a crowd in 1959.

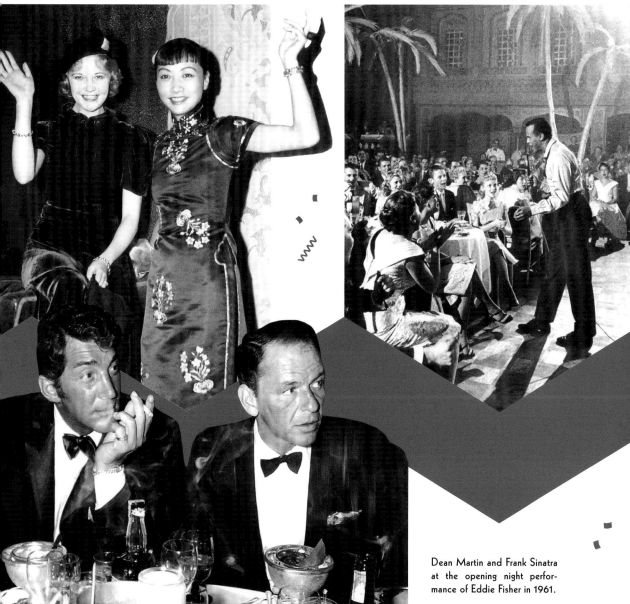

Dean Martin and Frank Sinatra at the opening night performance of Eddie Fisher in 1961.

Mocambo

Ava Gardner dancing with her first husband, Mickey Rooney, in 1943.

Ginger Rogers and Ann Miller doing the Charleston, 1950.

Jayne Mansfield lighting up with actor Lance Fuller, 1955.

Henry Fonda, Virginia Bruce, Madeleine
Carroll, and James Stewart in 1936.

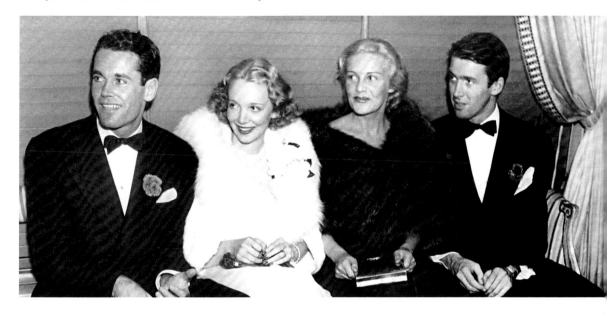

CAFE TROCADERO

Joan Crawford and
Cesar Romero, 1939.

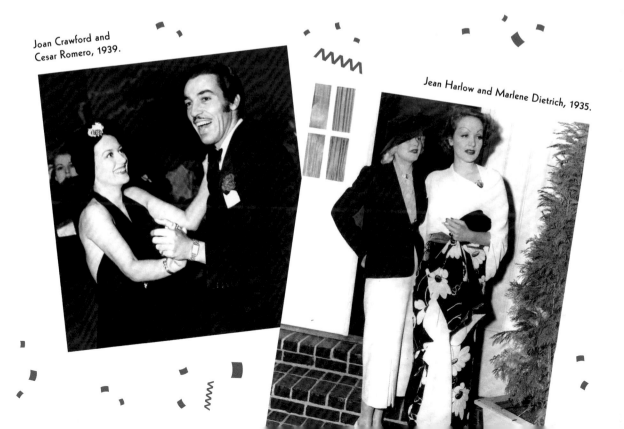

Jean Harlow and Marlene Dietrich, 1935.

AND REBORN...
AND REBORN...
AND REBORN...

I T'S the film about Hollywood that Hollywood can't stop making. One star on the rise, another in decline. They fall in love, but their affair ends in tragedy. Produced for the first time in 1937, *A Star Is Born* has been rebooted for practically every generation since. It is hardly a wonder: A story of hope and aspiration, longing and loneliness, fatal weakness and unbound resilience in the face of despair, its themes are as eternal as some of the stars who have appeared in it. The most recent version, directed by Bradley Cooper in 2018, served as a launching pad for Lady Gaga's acting career, earning her an Oscar nomination for Best Actress in her screen debut. However, the 1937 original and the first remake, in 1954, both served as comeback vehicles for their stars, whose divergent fates closely mirrored those of the movie's protagonists.

Esther Blodgett (Janet Gaynor) on her way to becoming Vicki Lester in the first *A Star Is Born*.

Back in the early days of the movie business, hardly anyone seemed to have much interest in making this timeless Hollywood saga. Director William Wellman had been trying to make a movie about the rise and fall of stars for years. Starting in the late 1920s, he had pitched his idea to several studios, including Paramount, Warner Bros., and MGM. They all passed, but in 1936 it happened that producer David O. Selznick wanted to chronicle a Hollywood rise and fall as well, a theme that resonated with him on a personal level.

He was the son of film pioneer Lewis J. Selznick, who built one of the biggest movie empires of the silent film era. But the elder Selznick made a lot of enemies along the way and lived far beyond his means. At the height of his fortune, Lewis was giving his sons hundreds of dollars a week as allowance and instructing them to "Spend it all. Give it away. Throw it away." Not surprisingly, Lewis went bankrupt in 1923, and the family lost everything.

David's first crack at a film about the "real" Hollywood was 1932's *What Price Hollywood*, directed by George Cukor. It attempted to show Hollywood as it really was, chronicling the fall of an alcoholic director who launches a waitress to stardom. But it was met with a tepid critical response. Still, Selznick was intent on making a successful film that showed the darker side of the industry, and he and Wellman got to work on their project, hiring Wellman's old writing partner Robert Carson.

The Wellman-Carson story was titled *It Happened in Hollywood*. Selznick wanted to avoid using "Hollywood" in the title, as he felt it had come to be identified with "cheap titles of cheap pictures." He asked his business partner, Jock Whitney, for his opinion, and Whitney suggested: *A Star Is Born*. Selznick loved it, and the movie had its title.

According to Wellman, everything in the story "happened to somebody that I knew very well, sometimes a little *too* well." That somebody was Wellman's good friend Barbara Stanwyck. The main model for the story was her relationship with Frank Fay, a comic credited with inventing stand-up comedy. Dubbed the King of Broadway, he was also one of the most hated men

William Wellman, Janet Gaynor, and David O. Selznick at the premiere of *A Star Is Born* (1937) at Grauman's Chinese Theatre.

Janet Gaynor, the original Esther Blodgett, aka Vicki Lester.

in showbusiness. During a time when bigotry was commonplace, Fay was notorious as a particularly unrestrained racist and anti-Semite. He married Stanwyck in 1928, and after moving to Hollywood, Fay became a film star. Stanwyck's career wasn't going anywhere until Fay convinced Frank Capra to cast her in *Ladies of Leisure* (1930). A star was born. Stanwyck's rise to the top coincided with Fay's slide to the bottom. He was fired from his studio contract, his alcoholism worsened, and when he wasn't in the sanitarium, he was getting into car accidents and public brawls. Barbara stood by his side, even walking away from the silver screen for a period to care for him. Whenever reporters addressed her as Miss Stanwyck, she would say, "I am Mrs. Frank Fay," a line famously echoed in *A Star Is Born*'s final scene.

Wellman also used his own experience in the script. Norman Maine's drunken speech interrupting his wife's Academy Award acceptance was based on a speech Wellman made telling off the Academy alone in his living room when he wasn't invited to the first Academy Awards (he had directed the film that won Best Picture). He drew further

inspiration from three silent stars whose alcoholism had derailed their careers: John Barrymore, John Gilbert, and John Bowers.

To play Norman Maine, Selznick hired Fredric March, a top star with a Best Actor Oscar already under his belt. But for the part of Esther Blodgett/ Vicki Lester, Selznick turned to an actress whose career was on the skids.

Janet Gaynor had won the first Best Actress Oscar in 1929 and gone on to make a string of successful films. But a few years later, her career was waning, and in September of 1936, 20th Century Fox issued a statement to the press: Janet Gaynor would no longer appear in starring roles. Hollywood was shocked. Janet told the press she was being punished for refusing to agree to new terms in her contract. In private, she revealed exactly what those new terms entailed: Studio head Darryl Zanuck had locked her in his office, exposed himself, and told her she'd have to sleep with him to continue her career at his studio.

Janet had practically lived the part of Vicki Lester. Just like Vicki, Janet had started in movies as an extra and was helped in her career by a powerful Hollywood figure, Herbert Moulton, dramatic critic for the *Los Angeles Times*. Also, like Vicki, she was the object of a drunken intrusion on the night she received her Academy Award in 1929. As she entered the ceremony, she was accosted by her drunken sister Hilary, a failed actress, who was now hanging on the velvet ropes outside of the event shouting, "There she is! There's my sister!"

Wellman completed the film in under two months, despite endless script rewrites and an

avalanche of memos from Selznick. In early 1937, anticipation for the release was building. Selznick had a private screening of the film and afterward sent a telegram to Janet:

Ran the picture last night for about thirty people all of whom went off their heads about it many being so extravagant in their praise as to call it the best picture in a year. . . . Everyone exceedingly enthusiastic about your appearance and performance and feel it is the best thing you have ever done.

The public agreed. Upon the film's release, newspapers around the country blazed with the headline: "A STAR IS REBORN!" The film was a commercial and critical success and was nominated for seven Academy Awards, including Best Actress for Janet Gaynor. Every major studio began sending her scripts.

Although she lost the Academy Award to Luise Rainer, the film was the crowning achievement of Janet's career. She made two more pictures and then retired. Selznick even begged her to play the role of Melanie in *Gone with the Wind*, but she declined. "The offers poured in but I refused them all," she said. "I think it's better to leave while they still want you instead of the other way around."

It was a lesson the next woman to play Vicki Lester would learn the hard way.

On the morning of October 12, 1953, Judy Garland was facing the movie camera for the first time in three years. Though unquestionably one of Hollywood's most talented stars, Judy's substance abuse and erratic behavior had gotten her fired from MGM back in 1950. Even though she hadn't worked in movies since then, she had been busy. She had divorced her second husband, director Vincente Minnelli, and married B-movie producer and gambler Sid Luft. She had survived two suicide attempts, endured electroshock therapy, and been in and out of several sanitariums. She also nearly died in a fire at her home when she fell asleep with a lit cigarette. Through it all, she had managed to make theatrical history, with a record-breaking nineteen-week run at New York's Palace Theatre, where she performed daily, sometimes twice a day, to capacity crowds. She knew she needed this film to complete her comeback. She had been wanting to make it for a long time.

Judy Garland and James Mason on set.

In 1942, Judy had starred in a radio adaptation of *A Star Is Born*. She told MGM she wanted to remake it as a musical but was shot down by the studio, who said they could never make a tragic film with "our precious Judy." A decade later, when producer Ed Alperson purchased the rights to remake the film, Sid Luft and Judy joined forces with him and set about trying to find a studio to finance the picture.

Fortunately for them, the government had ordered Warner Bros. to sell its theater interests, and the studio had a surplus of cash at the ready. Jack Warner approached William Wellman to direct the film, but Wellman was violently opposed to remakes. "You ought to be able to come up with a different idea or at least a different point of view, not make the same films," he explained. He also disliked the idea of turning his story into a musical and lobbied the Writers Guild to have his name taken off the credits as the original writer, to no avail. Judy had another director in mind: George Cukor. Cukor was known as a "woman's" director, and he had wanted to work with her for years.

The search for a co-star was more challenging. Jack Warner was very keen on Laurence Olivier, who wasn't interested. Everyone else involved wanted Cary Grant, who did a reading at Cukor's house. "He was absolutely magnificent, dramatic and vulnerable beyond anything I'd ever seen him do," Cukor recalled. "But when he finished I was filled with great, great sadness. Because I knew

Judy Garland, reprising the role of Esther Blodgett/Vicki Lester.

"When she was good, SHE WAS VERY, VERY GOOD."

Cary would never do the role. He would never expose himself like that in public." Cukor's suspicions were confirmed when Cary's wife showed up at Sid and Judy's home to inform them that Cary couldn't do the film.

After Cary fell through, the studio persuaded James Mason to take the part. His wife helped by reminding him, "After all, Judy is one of the public darlings."

In private, Judy proved a bit more complicated. She began taking Dexedrine. "[T]he dependency was not about losing weight," Sid said, "it was about keeping her spirits up, giving her an emotional boost. She confessed it was virtually impossible for her to sustain a work mode in front of the cameras without taking some kind of medication."

Principal photography began on October 12, 1953, and Jack Warner marked the occasion by sending Sid and Judy a note:

Now that the picture is underway, we all feel and I know you do, too, that we are embarked upon a very important event—one of which we can all be proud. The culmination will tell its own story. Every good wish to you both.

But it wasn't long before Judy and Sid began to wear on Warner. The costume designer quit because of Judy's fluctuating moods and weight as well as her habit of wearing costumes home and ruining them. Sid charged $75,000 in custom suits to the movie's budget and was constantly borrowing money from Warner without paying it back. Judy began showing up late, calling in sick, or not showing up at all.

Despite the drama, Cukor was impressed by her work. "Judy Garland was a very original and resourceful actress," the director said. Mason, meanwhile, thought the studio had unreasonable expectations. "When she was good, she was very, very good and when she was bad she was predictable," he explained. "Everybody knew about Judy. We all knew about Judy. She had this bad reputation, but instead of getting 100% behind her and just trying to do the best, there was an awful lot of bitching and complaining during the making of that film."

The film went fifty-four days over schedule but still felt incomplete to Jack Warner, who thought it needed one more big musical number. He sank $250,000 more into the already blown budget and

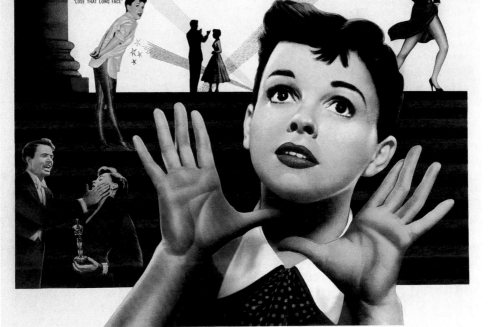

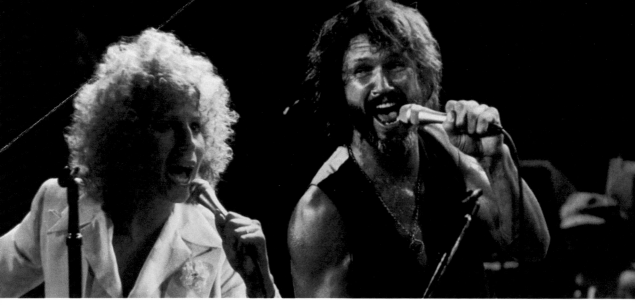

Barbra Streisand and Kris Kristofferson in the 1976 remake.

produced the legendary "Born in a Trunk" number. The scene was shot over three weeks, and Judy was up to her old tricks the entire time, calling in sick, leaving early, and causing drama on set. But she finished the number, which not only justified Vicki Lester's rise to stardom in the film but also announced to the world that Judy Garland was back.

Cukor was excited by the reaction at the first preview. "Judy generates a kind of hysteria from the audience," he said. "They yipped and screamed and carried on about the musical numbers." After the second preview, Jack Warner gave his assessment: "A STAR WAS REALLY BORN AGAIN."

Warner planned the premiere of all premieres. He personally sent out telegrams inviting the biggest stars and arranged for the event to be nationally televised (a first for a movie premiere). An estimated crowd of 20,000 showed up, and so did the stars, including Frank Sinatra, Lauren Bacall, Joan Crawford, Gary Cooper, Elizabeth Taylor, Clark Gable, and Kirk Douglas, among dozens of others.

The acclaim for Judy and the film was unanimous, but, at over three hours, exhibitors complained about how long it was. Warner decided to cut thirty minutes, and with George Cukor in India working on his next project, the cuts were haphazard and caused several story and continuity errors. The recut version underperformed at

the box office. But even this couldn't stop Judy's momentum: She was nominated for an Academy Award for Best Actress.

On March 29, 1955, a day before the Oscars, Judy gave birth to her third child, Joey Luft. The next day, a group of technicians from NBC took over her hospital room, setting up cameras, hanging lights, and wiring Judy for sound to broadcast the moment when she won the award.

Judy thought the fact that they were going to all this trouble meant she might win, and watching the ceremony, her excitement began to build. Finally, the moment came when William Holden announced the winner for Best Actress: Grace Kelly, for *The Country Girl*.

"I didn't have the time to be disappointed," Judy said. "I was so fascinated by the reactions of the men. They got mad at me for losing and started lugging all their stuff out of the room. They didn't even say good night."

Grace Kelly was stunned. Her own father told the press, "We think Grace was very lucky but we are sorry that both she and Judy couldn't have won it."

"I thought Grace Kelly deserved it," Judy told the press. She also said her newborn baby was more important than any award. But Lauren Bacall, who was by her side that night, said Judy "was deeply disappointed—and hurt. It confirmed her belief that the industry was against her. She knew it was then or never."

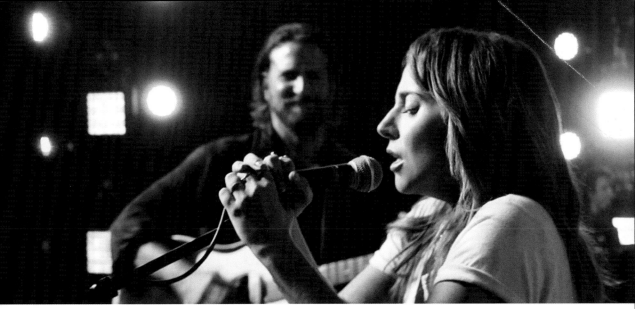

Bradley Cooper and Lady Gaga in the most recent *A Star Is Born* (2018).

Judy never played another leading role. She would earn an Academy Award nomination for Best Supporting Actress for a small role in *Judgment at Nuremberg*. But her film career was in irreversible decline, and she continued her downward spiral into alcoholism and addiction. On June 22, 1969, Judy was found dead in her London apartment of an accidental barbiturate overdose. She was forty-seven years old. Her funeral drew a crowd of 20,000 people in New York, and James Mason delivered the eulogy.

"Her special talent was this," Mason said. "She could sing so that it would break your heart. What is a tough audience? A tough audience is a group of high-income-bracket cynics at a Hollywood party. Judy's gift to them was to wring tears from men with hearts of rock."

After her death, Warner Bros. announced they would re-release the original uncut version of the film. People rushed to the theaters only to discover it was exactly the same as the version they had released back in 1954. The studio eventually admitted they didn't have a print of George Cukor's original cut and had no idea where it was.*

In 1976, Barbra Streisand remade *A Star Is Born* once again, transposing the story from Hollywood to the music industry. Barbra had wanted Elvis Presley to star alongside her, but

he declined, and she cast Kris Kristofferson instead. The film was a success at the box office, but it was panned by critics, one of whom said it should have been called *My Name Is Barbra*.

Even then, Hollywood wasn't done with the story. A version starring Denzel Washington and Whitney Houston was planned in 1993 but never materialized. In 1998, Whitney was rumored to be involved with another attempted remake, this time starring opposite Will Smith, but that too fell apart. For the next fourteen years, Smith tried in vain to produce a remake with Jennifer Lopez. In 2000, Jamie Foxx wanted to remake the film with the singer Aaliyah, but it was shelved following her sudden death in 2001. Clint Eastwood was attached to direct a version starring Beyoncé in 2011 but dropped out after a series of delays and setbacks.

One actor who had passed on the lead role in Eastwood's version was Bradley Cooper, who felt he wasn't mature enough for it at the time. But in 2016, he was ready to star in it and make his directorial debut as well. Cooper heard Lady Gaga sing "La Vie en Rose" at a benefit and was convinced he'd found his leading lady. This time the stars were in perfect alignment, and *A Star Is Born* premiered again in 2018, to great fanfare. The film was a box office smash and was nominated for eight Oscars, winning Best Original Song.

It's safe to say that it's only a matter of time before *A Star Is Born* is reborn once again.

* In 1983, film historian Ronald Haver restored the film to its original version, filling in lost sequences with production stills. It premiered at Radio City Music Hall to an audience of 6,000, including James Mason and Judy's daughters, Liza and Lorna.

Loretta Young

MOTHER of INVENTION

"I HAVE wonderful news for you, Loretta," the doctor said. "You're going to have a baby."

The mother-to-be was Loretta Young, and the news was anything but wonderful. Loretta was a top film star and unmarried. The father was Clark Gable, known as the King of Hollywood and very much married to someone else. Both had signed studio contracts that contained the standard morality clause, which allowed the studio to terminate them for "[a]ny act or thing that would tend to bring the undersigned into public hatred, contempt, scorn, or ridicule, tend to shock, insult or offend the community." In 1935, having a child out of wedlock with a married man would do all of the above. Desperate to save her career, Loretta would take drastic action, and her life would soon come to resemble the plot of a B-movie thriller.

Like many film stars, Loretta began her life as someone else. Gretchen Young was born in Salt Lake City in 1913, the third of Gladys Royal's four beautiful daughters. Her father, John "Earl" Young, was a "time keeper" for the railroads. Neither Earl's young family nor his artificial leg kept him from charming countless women who were not his wife. Gladys reached her limit when she caught Earl with the maid. She told him she wished she never had to see him again. He told her she never would and walked out of his family's life forever. Suddenly a single mother with several mouths to feed, Gladys took a job running a boarding house in Los Angeles.

It was 1917, and the movie business was booming. Gladys's brother worked as a production manager at Famous Players-Lasky and began getting his nieces work as extras. When Gretchen appeared in a small role in *The Primrose Ring* (1917), the film's star, Mae Murray, took such a liking to her that she wanted to adopt her. Gladys refused but allowed Gretchen to live with Mae for a year. At Mae's palatial estate, Gretchen had her own room, a closet full of lavish clothing, and the ballet lessons she'd always wanted. When she got homesick, she would take a limo to visit her family at the boarding house. Although this glamourous lifestyle ended when Mae Murray moved to New York, it fueled Gretchen's ambition to become a movie star herself. A few years and a name change later, Loretta Young was just that.

Her sisters, Polly Ann, Betty Jane (aka Sally Blane), and Georgiana, were also actors, and the Young household became a hangout for the film

colony as well as the local priesthood. Gladys was a Catholic convert. According to screenwriter and family friend Joseph Mankiewicz, when Gladys joined the church, she "took it on like tuberculosis, like infantile paralysis, like the smallpox: it *permeated* that whole family." The children attended convent schools, and priests exerted tremendous influence over the family. When seventeen-year-old Loretta eloped with Grant Withers, a heavy-drinking, twenty-five-year-old divorced actor with a gambling problem, the family was shocked—because he wasn't Catholic. Gladys didn't speak to Loretta for two months. Loretta sought forgiveness from her family priest, Father Ward, but was met with disapproval. Drawing

from the Bible, he told her, "Rather than give bad example, you should have a stone tied around your neck and be thrown into the sea."

The conversation with Father Ward that day was a turning point, and she tried to live by his words. Still, shortly after leaving her husband, Loretta fell madly in love with her co-star in *Man's Castle*, Spencer Tracy. He *was* Catholic, but he was also married with two children. Spencer had just separated from his wife when he and Loretta began a relationship. But Spencer had been married in the Catholic Church, so his union couldn't be dissolved. The relationship had to end. Loretta issued a statement: "Since Spencer Tracy and I can never be married, we have agreed not to see one another again."

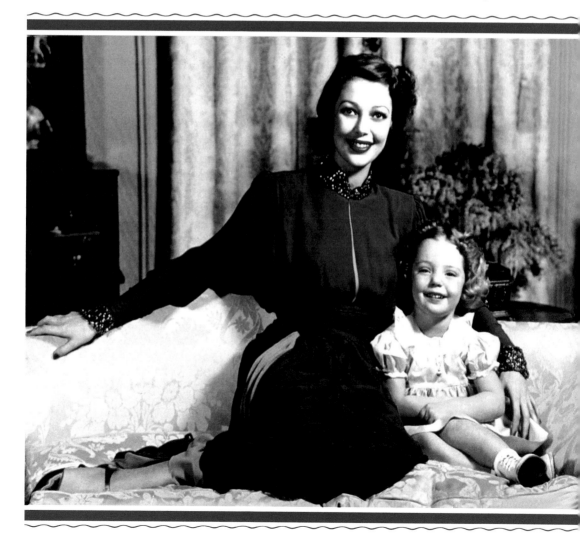

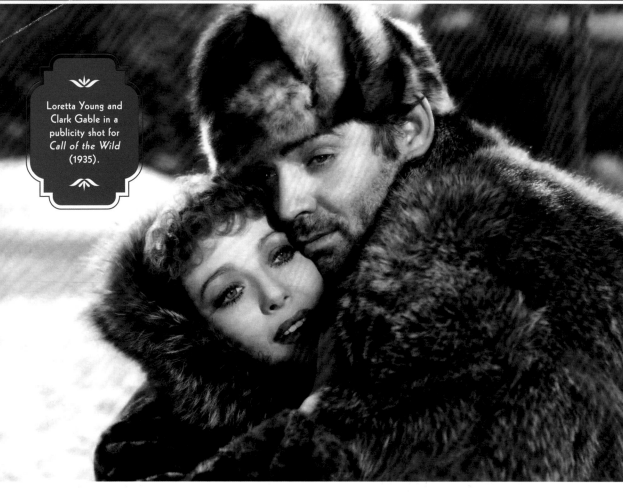

The parting was painful, but she now had another film to preoccupy her, and a king for a co-star.

He was Clark Gable, who had risen from obscurity in just a few short years to become the King of Hollywood. They were cast opposite each other in William Wellman's *Call of the Wild*, and as soon as she met Clark on the train to Mt. Baker, Washington, where filming began, she was smitten. ("I fall in love with all my leading men," Loretta once proclaimed.) There was innocent flirting on both sides, but with Father Ward's chastening words in mind, it never progressed.

What was supposed to be a ten-day location shoot turned into six weeks of plodding work amidst nonstop blizzards, and the company was called back to shoot on the 20th Century backlot instead.

The trip home would change her life forever when Clark Gable came into her train compartment one night. "I allowed him in as I would have any member of the crew, thinking he was there for a visit," Loretta remembered. "He had other intentions. Very persistent intentions. He wasn't rough, but I kept saying no, and he wouldn't take no for an answer."

When it was over, Loretta felt guilty and ashamed. The next morning, when the train pulled into the station, Clark joined Loretta and her mother for breakfast and acted as if nothing had happened. Loretta wasn't exactly sure what had happened herself, except that she had not wanted it. But in 1935, the idea of date rape didn't exist.

She decided to file it away as a "flukey thing." She knew they had to go back to work together for another few weeks and decided to put the incident in "the rear-view mirror."

Several weeks passed, and Loretta's period was late. Finally, she told her mother. After sharing a good cry together, Gladys summoned the family physician, Dr. Walter Holleran. After examining Loretta, he confirmed what she had been dreading: She was going to have a baby.

"Working in the picture business, I knew girls who had abortions," Loretta recalled. "It would not have been hard to find a doctor to perform one, but my religion taught me that I would be taking a human life. I remember thinking if only I had a miscarriage, but again, I wouldn't have done anything to provoke one."

Gladys was extremely understanding. "In those days, unmarried pregnant women were sometimes thrown out of their homes in disgrace,"

Gladys arranged to speak with Clark, who blamed Loretta, saying, "I thought she knew how to take care of herself." Gladys realized that Clark would be no help. Luckily, she knew what to do. Gladys had helped many young people who were in trouble, including a few pregnant high school friends of her daughters. She didn't arrange abortions but instructed them how to act and what to wear to conceal their pregnancies so that they could give birth without anyone suspecting a thing. But it was one thing to hide the pregnancy of a normal high school girl; hiding the pregnancy of a major movie star, who also happened to be her daughter, was a whole other matter altogether. If anyone discovered Loretta's secret, it wouldn't just be the end of her film career; it would be a disaster for the entire family, since Loretta was the breadwinner.

When she completed *The Crusades*, Loretta was about five months pregnant and showing too much to be able to do her next film, *Ramona*.

"I allowed him in ... thinking he was there for a visit.
HE HAD OTHER INTENTIONS."

Loretta recalled. "But Mama was not angry, the way she had been when I married Grant."

Loretta reported for work on her next film, *Shanghai*, and acted as if nothing had happened. When production ended, she began work on Cecil B. DeMille's *The Crusades*. If the costume department noticed her expanding midsection, they said nothing. Instead, they designed loose and flowing gowns that camouflaged her baby bump. During filming one day, Clark showed up and offered to give Loretta a ride home. Driving through the Hollywood Hills, there was a long and uncomfortable silence until Loretta blurted out, "Would it make any difference if I wasn't pregnant?"

Clark turned to her and asked matter-of-factly, "Well, are you or aren't you?"

"I felt like such a fool," Loretta recalled. "I had to tell him I was pregnant. His look toward me was one of total exasperation, and very little was said as he drove me home."

Loretta announced she was exhausted and needed a vacation. It was agreed that she would begin production on *Ramona* when she returned. Loretta and Gladys began their European vacation sailing on the *Ile de France* to England. In order to dispel the rumors about her sudden departure, Loretta embarked on a campaign of public appearances across Europe. She wore loose two-piece outfits the whole way, carrying large coats and holding carefully placed oversized handbags to shield her growing belly from the press. She carried it off perfectly, attending Wimbledon, appearing at dinner parties in London, and going sightseeing with Charles Boyer in Paris.

When Loretta and Gladys returned to Los Angeles at the end of August, Dr. Holleran issued a statement that Loretta was ill and required to be confined at home. Gladys made a statement as well, saying her daughter had been ill for some time and added a nice touch, saying she had "lost considerable weight." A few days later Dr.

Loretta doing her best to hide her baby bump in London.

arm but was actually dispensing liquid to a pan beneath the bed. Gladys had hired a nurse to stand next to Loretta and end the interview by saying Loretta needed rest if the questions ventured into uncomfortable territory.

Loretta, the consummate actress, played the role of a brave, sick young woman, fighting to make it back to the screen for her millions of fans. Manners's article, entitled "Fame, Fortune, and Fatigue: The real truth about the mysterious illness of Loretta Young," began by declaring,

LORETTA YOUNG is not suffering from an incurable illness that will keep her from the screen for a year or more! Her beauty has not been marred in a serious "secret" accident! She is not the secret bride of a secret marriage in retirement to have a secret love child! Nor is she penniless, fundless, existing on the financial help of influential friends in a "pathetic" condition!

Manners blamed Loretta's condition on overexertion but did note that she had not lost any of her "preciously acquired poundage put on during her vacation in Europe." Gladys began making preparations for the big day. She and Loretta had been investing in real estate and owned several rental properties throughout the city. A remote and private two-story house in Playa del Rey was chosen as the location for the birth, and blankets were put over the windows to sound-proof it. On November 6, 1935, Dr. Holleran and a nurse called "Frenchy" joined Loretta for the big day. A backup doctor and nurse sat in a car outside in case there were complications. Loretta was given chloroform to ease her pain during delivery.

But Loretta wasn't out of the woods yet. Just as Loretta's baby girl entered the world, a milk man arrived with his delivery and rang the doorbell. Fearing this was the moment they'd all be exposed, Loretta covered her baby's cries until the milk man was gone. The baby was cleaned and dressed and placed in a dresser drawer in lieu of a crib, the delivery of which could have raised suspicions.

Loretta named her daughter Judith, after St. Jude, the patron saint of desperate and impossible situations. On November 13, Dr. Holleran filled out the birth certificate, naming the mother as Margret Young, a motion picture actress. He listed the father as "unknown."

Holleran issued another statement saying that Loretta was under doctor's orders to "remain away from the movie studios for at least two months." Her condition was not dangerous, he said, but it required a "long rest to avoid a major operation." Studio head Darryl Zanuck didn't want anyone else for *Ramona*, so work on the film was postponed pending Loretta's recovery.

Over the next two months, Loretta left the house only late at night when her family took her to another neighborhood so she could walk without being recognized. When her sister Sally got married at the family home, Loretta had to remain in bed upstairs, and the door to her room was left open so she could hear the ceremony.

Loretta's disappearance from the public eye kept the rumor mills spinning. Some people claimed she had been disfigured in an accident, while others said she was dying. But the most popular rumor had the unfortunate disadvantage of being true: Much of the film world believed she was pregnant with Clark Gable's baby. To dispel the rumors, an exclusive interview was arranged with Dorothy Manners from *Photoplay* magazine a month before Loretta's due date. "I had heard the rumors that the trip to Europe was concocted to conceal a pregnancy, but decided to give Loretta the benefit of the doubt," Manners recalled. When she arrived at the Bel Air home, she found Loretta in bed, buried beneath heavy comforters and carefully placed pillows. An IV was taped to Loretta's

Giving Judy up for adoption was out of the question. "Judy was *my* baby, I loved her." said Loretta. "I didn't have a father, and I got along fine," she later explained. "I believed Judy would too."

Judy remained in the Playa del Rey house for a few weeks, until a Hollywood reporter was spotted nearby. Gladys, whose meticulous planning had anticipated such an event, had a house in Westwood ready, and Judy was quietly moved there. Frenchy the nurse was discharged, and the family's housekeeper, Parsaita, took over her duties. Each day, Loretta would go to the studio to work, return to see Judy in the evenings, and then continue her movie star nightlife to keep up appearances.

At a party one night, she invited Clark to see his daughter. After making careful arrangements, including changing cars multiple times, Clark saw Judy for the first time. When he saw she was sleeping in a dresser drawer, he handed Loretta $400, demanding that she buy a decent bed. This was his only contribution to raising Judy. Loretta had her lawyer set up a bank account in San Francisco so that Clark could deposit funds for their daughter, but he never did. Shockingly, during this first visit with his daughter, Clark tried to have sex with Loretta again. "After all that has gone on," she told her sister, "all that we've gone through, instead of having any interest in his daughter, he tried to knock me down on the bed. . . . That bastard! Who the hell does he think he is?"

Clark's behavior wasn't the only thing creating turmoil. After being dismissed, Frenchy the nurse tried to capitalize on Loretta's secret. Feeling that she would need another individual to corroborate her story, she went to Parsaita with her plan to blackmail the family. Parsaita refused and notified Gladys. Frenchy then went to Dr. Holleran, who also refused. But fearing it was only a matter of time before they were exposed, Gladys and Loretta placed Judy in the St. Elizabeth's Infant Hospital,

"I didn't have a father, and I got along fine...
I BELIEVED JUDY WOULD TOO."

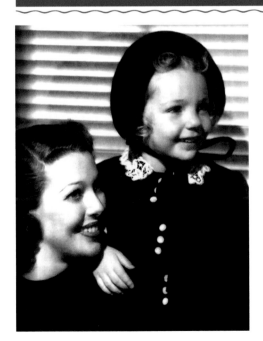

an orphanage run by nuns in San Francisco. Five months later, the baby was discharged to Gladys on December 14, 1936.

In June 1937, Loretta decided to break the news that she was a mother. She contacted gossip columnist Louella Parsons and revealed that she planned to *adopt* 23½-month-old Judy and a 3-year-old named Jane. She added 4 months to Judy's age, in case anyone decided to count backward to what Loretta had been doing 19 months earlier. The other girl she claimed to be adopting never existed. A few weeks later, Loretta told the press that Jane was wanted back by her biological family.

Even as a young child, Judy was very confused by the mystery of her origins. Judy had inherited her father's world-famous ears, and Loretta instructed all of her nannies to keep her ears covered with a bonnet or her hair. Her mother's obsession with

Loretta and Judy, whose ears were often hidden to protect the identity of her famously large-eared father.

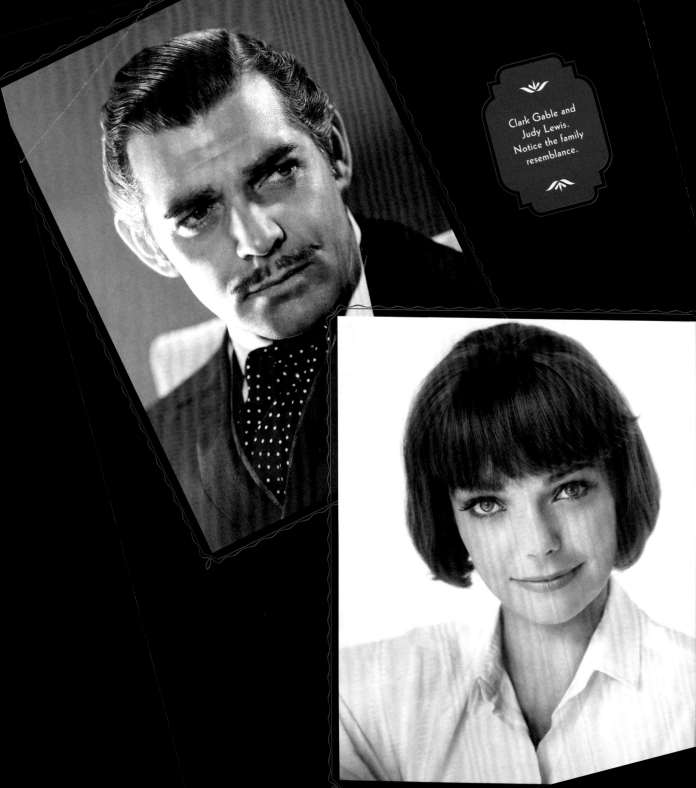

Clark Gable and Judy Lewis. Notice the family resemblance.

covering her ears eventually made Judy think she was deformed. If she didn't have her bonnet on, she would scream and rush to get it. When she was just seven, Judy underwent a painful operation to have her ears surgically pinned back.

Once, the adopted daughter of movie star Irene Dunne asked her, "If you're adopted, why is it that you look so much like your mother?" Judy had no answer. When she asked Loretta if she was her real mother, Loretta was evasive. "I couldn't love you any more than if you were my own child, Judy," she said and left it at that.

When Judy was four, Loretta married producer Tom Lewis, and she soon reached the apex of her career, winning the Academy Award for Best Actress for *The Farmer's Daughter* (1947). In 1949, she found herself working alongside Judy's father once again, starring with Clark Gable in *Keys to the City*. She had agreed to do the film as a favor to Dore Schary, head of production at

Maria Cooper Janis, that her classmate Judy Lewis was the daughter of Loretta Young and Clark Gable and that it would have ended their careers if people found out. Judy's classmate Marlo Thomas said mothers of their friends would whisper about Judy's "Clark Gable ears." Judy's high school boyfriend, Jack Haley Jr., explained, "Our whole group from high school knew who her parents were—and we knew she didn't know. But we thought her mother would tell her." They were wrong.

Not until she was twenty-three years old and engaged to be married did she learn the truth. A few weeks before the wedding, she told her fiancé, Joe Tinney, that she couldn't get married without knowing who she was. She told Joe she suspected Loretta was her biological mother but didn't know who her father was. Her best guess was Spencer Tracy, because she knew her mother had been in a relationship with him years before.

"...the Hollywood rumor mill ensured all of HER FRIENDS KNEW THE TRUTH."

MGM, in return for his having given her the part in *The Farmer's Daughter*. This time her family wasn't going to leave her alone with Gable again, and her mother, sisters, and even her brother-in-law, actor Ricardo Montalban, took turns visiting the set.

Loretta suffered a miscarriage during production, and when she returned to the set, she found flowers in her dressing room from Clark, with a note saying how sorry he was because he knew how much she wanted the baby. "I thought that was very sensitive of him," Loretta later said. The film also gave her the opportunity to introduce Judy to her father—without revealing the truth, of course. Loretta arranged a pool party for the cast and crew, where Judy got to meet the movie star Clark Gable.

As a teenager, Judy still had no idea that he was her father, though the Hollywood rumor mill ensured all of her friends knew the truth. Gary Cooper and his wife told their daughter,

Joe told her the truth. When she asked how he could possibly know, he told her it was common knowledge. Judy was furious at Joe—and everyone else—for not telling her, but she didn't confront her mother. She later explained that she was terrified of forcing Loretta "to confess her 'mortal sin.'"

On November 6, 1960, her twenty-fifth birthday, Judy heard on the radio that Clark Gable had had a heart attack and was in the hospital. She spent the next few days praying for his recovery, but ten days later, he died, and with him went Judy's hope of getting to know her father.

Another six years went by before Judy confronted Loretta about the family secret. Judy was working on a soap opera in New York and took two days off to see her mother in Los Angeles. It took her twelve hours to work up the courage to ask if Clark Gable was her father. Loretta finally admitted the truth. According to

Judy, Loretta told her a somewhat romanticized version of the story—telling her Clark had proposed but that she refused and regretted it for the rest of her life.

Over the years, Loretta worked hard to cement her pious public image. She set up "The Cuss Fund" to which anyone who swore on the sets of her films had to contribute, with the proceeds going to St. Anne's Home for Unwed Mothers. She viewed her successful transition to television with *The Loretta Young Show* as a platform for moral and social good. In 1970, she sued 20th Century Fox for $10 million for featuring footage of her old films in the sexually explicit movie *Myra Breckinridge*. Ironically, the basis for her suit was the same morality clause that had led her to cover up her pregnancy in the first place. Fox removed the footage.

When Judy was asked to write her story for publication in 1986, Loretta refused to give her date rape, still a relatively new concept at the time. Loretta was confused by the term, but when Linda explained what it meant, Loretta responded, "Oh, there's a name for it, okay. That's what happened."

Loretta confessed to her daughter-in-law that that was what Clark Gable had done to her the night Judy was conceived.

Loretta died of ovarian cancer in 2000, without ever publicly admitting that Judy was her daughter. She had given a taped interview about her encounter with Clark Gable to her friend and biographer, Edward J. Funk, with permission to share it after her death. But he and Linda Lewis worried that revealing how Judy was conceived would hurt her because, as Loretta put it, "We all want to be conceived with love."

Judy became a clinical psychologist specializing in foster care and marriage therapy. In her spare time, she appeared in documentaries

"She took the brunt of this her whole life...
SHE TOOK THE RESPONSIBILITY."

blessing, and the two became estranged. Judy's memoir, *Uncommon Knowledge*, was published in 1994. "It's difficult to explain to someone who has not walked in my shoes and has not experienced what it's like to be unacknowledged by your birth parents," Judy said. "My book is an effort to explain what it was like. The damage it did. How I have attempted to be whole in spite of it." Loretta found the book humiliating and refused to confirm or deny its contents. Nevertheless, several months after *Uncommon Knowledge* was published and after eight years of estrangement, Loretta wrote to Judy, asking to "forgive and be forgiven," and they began the slow process of reconciliation.

And several years later, Loretta came to understand what had happened to her that night on the train with Clark Gable. In 1998, she was at her Palm Springs home having dinner with her daughter-in-law, Linda Lewis. The news on television presented a story about

to share her story. She made special appearances at the Clark Gable Museum's annual celebration of the birth of her father. She died in 2011.

It wasn't until the flood of sexual assault allegations surfaced against Bill Cosby that Funk and Lewis decided to tell Loretta's story in an article for *BuzzFeed*. Judy's feelings may have been spared for all those years, but when the story was finally revealed, Loretta's reputation was not. She was criticized by the public as a hypocrite and a liar.

"She took the brunt of this her whole life," Linda Lewis says. "She took the responsibility, as victims do so many times."

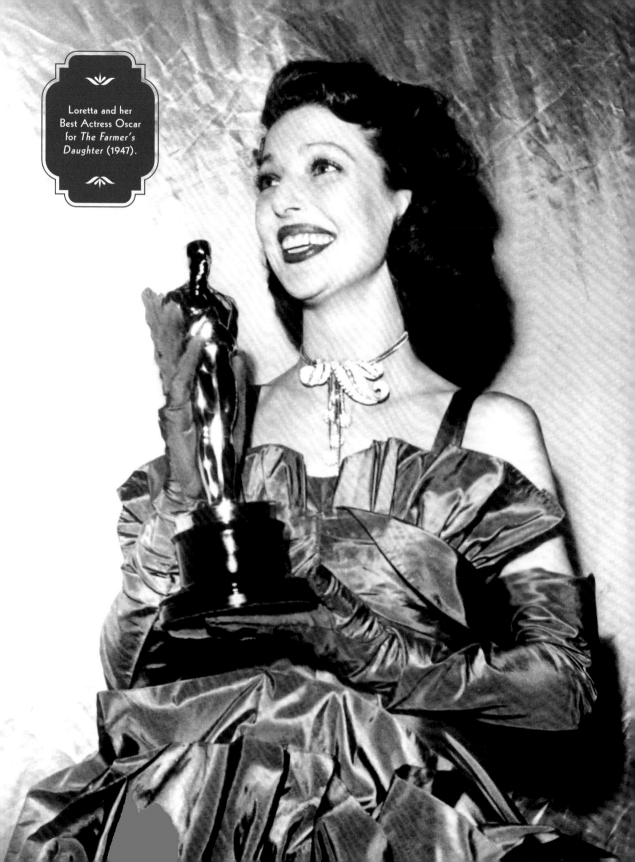

"A VOTE FOR GRACIE

IS A VOTE FOR FUN"

P ICTURE it: America is struggling to emerge from a major economic crisis; foreign threats are looming larger by the day; a deeply divided population is polarized by rapidly changing technology; and an outspoken media star emerges to seize power and upend the political establishment. No, not Donald Trump.

The year was 1940. America's economy was slow to rebound from the Great Depression, and the Second World War was raging in Europe while America's isolationists and interventionists battled at home. Franklin Delano Roosevelt broke with more than a century of tradition and ran for president for a third term. With his fireside chats, Roosevelt had turned radio into the most popular form of home entertainment in America. Amid all this, Gracie Allen, of the popular comedic duo Burns and Allen, was at her Beverly Hills home knitting one night when all of a sudden, she exclaimed to her husband, George, "I'm tired of knitting this sweater. I think I'll run for president this year."

Long before that fateful night, two young comics named Gracie Allen and George Burns met on the vaudeville circuit in 1922. They were wed in 1926 and were not only on their way to one of the great Hollywood marriages of all time but also one of the greatest careers of any comic duo. George played the straight man to Gracie's zaniness and illogical logic. Initially, their roles had been the reverse, until George noticed that audiences were laughing more at Gracie's straight lines than his punchlines. In 1932, the two became regulars on *The Guy Lombardo Show* on CBS, and after Lombardo left the network, they were eventually given their own show, *The Adventures of Gracie*, in 1934. (The title would change to *The Burns and Allen Show* in 1936.) But it was actually before they got their own show that the duo launched the long-running gag that would make them a household name: The hunt for Gracie's "lost brother."

On January 4, 1933, Gracie showed up unannounced in the middle of Eddie Cantor's broadcast. She was in tears, explaining to the audience that she was searching for her missing brother. George and Gracie had been using her "mythical brother" as a part of their vaudeville act for years. As George later explained:

It was Gracie's brother who invented a way to manufacture pennies for only three cents. It was Gracie's brother who marketed an umbrella with holes in it so you'd be able to see when the rain stopped. It was Gracie's brother who first printed a newspaper on cellophane so that he could read it in a restaurant and still keep an eye on his hat and coat. And it was Gracie's brother who broke his leg falling off an ironing board while pressing his pants. Actually, as we discovered, Gracie's brother had been missing for years, but no one noticed it because he'd left a dummy in his place.

The missing brother routine became a cross-network phenomenon, with Gracie taking the search to other shows. It even escalated to the point that CBS received ransom notes from people claiming they were holding the nonexistent brother hostage.

It was in the same spirit of the all-consuming gag that Gracie's presidential candidacy began. On a Wednesday evening in February of 1940, 45 million Americans gathered around the radio as they usually did, only to hear a shocking announcement from Gracie:

GRACIE: *George, I'll let you in on a little secret. I'm running for president.*

GEORGE: *You're running for president?*

GRACIE: *Yes...*

GEORGE: *Gracie, how long has this been going on?*

GRACIE: *Well, for 150 years. George Washington started it.*

GEORGE: *Gracie, why are you running for president?*

GRACIE: *Well, because that's the only way you can get to the White House. You can't just walk in and sit down.*

GEORGE: *The idea is preposterous.*

GRACIE: *Not only that but it pays good money.*

GEORGE: *Look, you don't stand a chance. Gracie, presidents are born.*

GRACIE: *Well, what do you think I was: hatched?*

GEORGE: *Listen, there's nobody who would be happier about your success than I would. But in the entire history of the United States there has never been a woman president.*

GRACIE: *Yeah, isn't it exciting and I'd be the first one.*

Gracie ran as the head of a new party: The Surprise Party. As she later explained, her father was a Republican and her mother was a Democrat, and Gracie had been born a surprise. Because 1940 was a leap year, the party's mascot was a kangaroo, and the campaign's slogan was "It's in the bag!"

The day after her announcement, Gracie sent two professional petition circulators to downtown Los Angeles in the drizzling rain to gather signatures for her campaign. Everyone who signed the petition received a handful of nuts, and within forty minutes Gracie had received 864 signatures. "That's as much support as some of the actual candidates seem to have," she said, "so maybe I should run for president."

She wasn't the first celebrity to run for president. Will Rogers did it as a gag in 1928, and Eddie Cantor followed in 1932. And even though

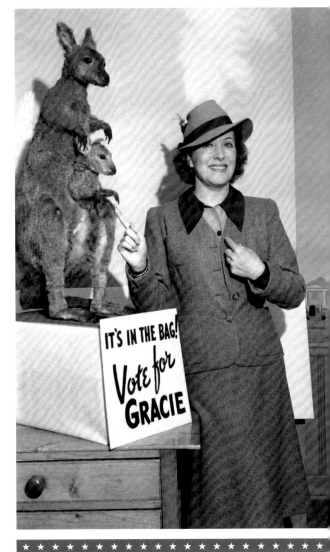

Gracie with the Surprise Party's mascot, Laura the Kangaroo.

Gracie's campaign was as much a joke as her predecessors', she was fully committed. What began as a simple radio publicity stunt quickly took on a life of its own.

As with the lost-brother gag, the "Gracie for President" campaign crisscrossed networks, and Gracie made appearances on other radio shows to talk about her candidacy. She even came up with a platform, one of the main causes being the issue of repealing men. "We don't want to get rid of men entirely," Gracie said. "All we want to do is make

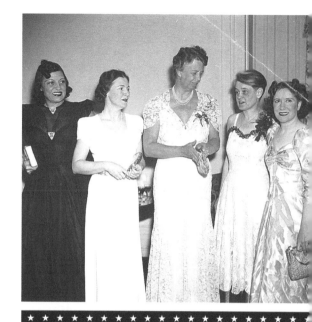

Gracie at the National Press Club's dinner in Washington, D.C., on March 9, 1940. L to R: Rosa Ponselle, who sang for the group; Frances Dewey, wife of Thomas E. Dewey; Eleanor Roosevelt; Ruby Black, president of the Club; and Gracie Allen.

them unconstitutional and keep them out of circulation, but have them handy when there's no place else to go."

Gracie said her platform would be "run up by a movie set designer, so it will be very impressive from the front, but not too permanent." There was no vice presidential candidate because she promised there would be no vice. When asked about the national debt, she said, "We ought to be proud . . . it's the biggest in the world!" She promised to reduce the budget by doing her own washing and ironing in the White House and change Washington from D.C. to A.C. She vowed to ship five hundred ostriches to the White House "just to make it easier for the kiddies" because "[e]very Easter they have an awful time finding those little hens' eggs on the White House lawn." As for foreign relations: "Well, they're all right with me. Only when they come they've just got to bring their own bedding." When asked if she'd recognize Russia, she hesitated and replied, "I don't know. I meet so many people"

Shortly after her whirlwind radio tour, Gracie was invited by Eleanor Roosevelt to be the guest of honor at the Women's National Press Club annual dinner. While in Washington, Gracie announced her plans to hold her own convention and invited the chairmen of the Democratic and Republican parties so they could get some pointers for their own shows. Topeka, Kansas, offered the use of their new $2 million townhall for her convention. But Gracie decided on Omaha, Nebraska, after the city promised to hold a torchlight parade with 25,000 bearded men and to plaster the entire Midwest with "Gracie Allen for President" placards.

The Union Pacific Railroad offered her a campaign train and began erecting billboards with "Vote for Gracie" from Los Angeles to Omaha. Her campaign received endorsements from the students of Harvard, *Variety* magazine, and more than 900 prison inmates from Ramsey State Farm in Texas. The town of Menominee, Michigan, nominated Gracie for mayor during the primary, but she was disqualified for being a nonresident. She even had a campaign song that featured zingers

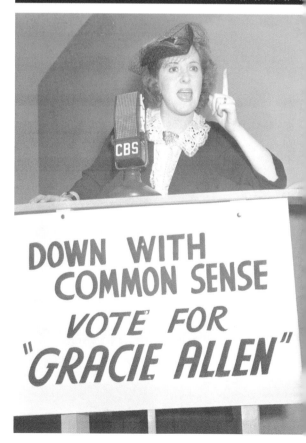

DOWN WITH COMMON SENSE
VOTE FOR
"GRACIE ALLEN"

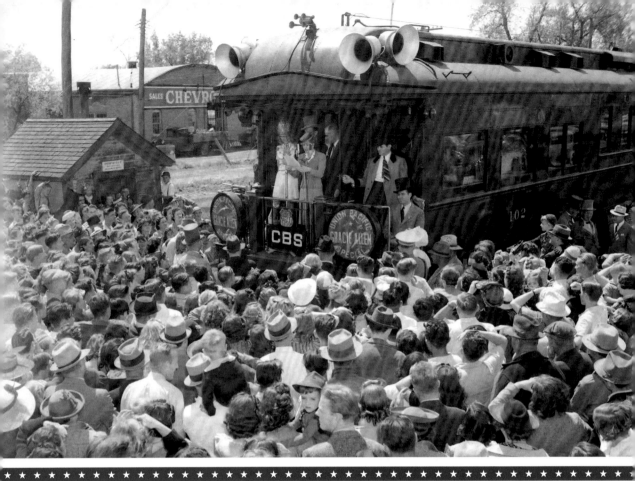

like: "Even big politicians don't know what to do / Gracie doesn't know either / But neither do you / Vote for Gracie!"

On May 9, 1940, Gracie, George, and her entourage—including a full staff of comedy writers, four press agents, a fifty-piece band, and an imitation kangaroo—began a trip aboard a Union Pacific special train to Omaha, and Allen made thirty-one rear-platform speeches along the way. The first stop was outside of Riverdale, California, and as the train got closer, Gracie became nervous and thought about canceling the whole thing. "Suppose nobody comes," she worried to herself. But her worries were unfounded: More than 3,000 people were waiting for her at the station. "As I look around and see all these trusting and believing faces shining up at me with love and respect," Gracie told the crowd, "tears come into my eyes. And do you know why? My girdle is killing me."

Thousands of people and dignitaries greeted Gracie along her whistle-stop tour, and in many

Gracie addressing the crowd in Brighton, Colorado, on May 13, 1940.

cities, schools closed and stores offered "Gracie Allen Specials." When her train stopped in Columbus, Nebraska, she was greeted by twenty times the number of supporters that had greeted Republican candidate Wendell Willkie in the much bigger city of Omaha. In Columbus, two squads of National Guardsmen and the local police came to maintain order. In making the case for her candidacy to the crowd, she declared, "Even the baby needs a change once in a while."

After six days, she arrived in Omaha. At the station, she was presented with a bouquet of flowers and quipped, "These must be Republican blossoms—they look a little Dewey."

On the morning of May 16, an estimated 75,000 people, many in Victorian costumes, packed the streets of downtown Omaha to join Gracie in watching a military parade as planes

THIS WAS HOLLYWOOD

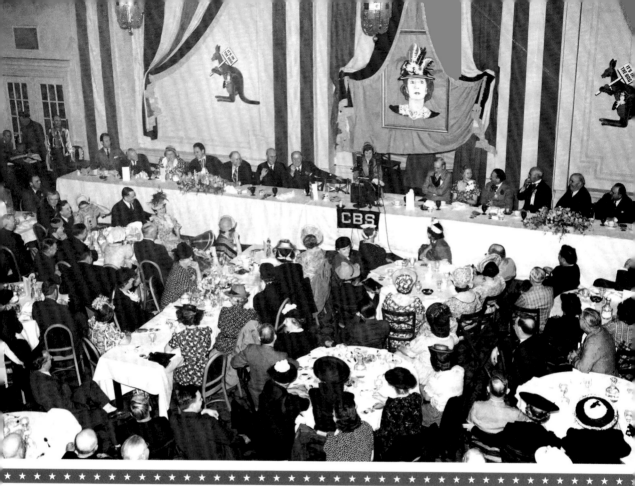

Gracie delivering her keynote speech at the Surprise Party banquet in Omaha, Nebraska.

buzzed overhead. That evening, bearded Omahans marched in a thirty-block-long torchlight parade shouting, "Gracie for President!"

The next day, in front of a crowd of 10,000 packed into Creighton University Stadium, Gracie Allen "won" the Surprise Party nomination unanimously. Every state of the union was represented in the roll call on the convention floor, but Gracie got the most delegates from "the state of confusion."

In her acceptance speech, she declared she "was a better man for the job than many men who aren't even a woman." She added that "anybody knows that a woman is much better than a man when it comes to introducing bills into the house." Her first act as president would be to take Maine and Vermont back into the Union. "Can Roosevelt match that?" She spoke of her experience for the position, saying, "I went to school and learned the politician's three r's: this is ours; that is ours; everything's ours." She scolded Thomas E. Dewey for the surplus cantaloupe problem and swore that her administration would "cover them with toupees and sell them for cocoanuts." Finally, she left her supporters with some sage advice: "Stick with us until we get to Washington. Remember the banana—when it leaves the bunch it gets skinned."

After the convention, Gracie took a step back to let the serious campaigning between Roosevelt and Willkie continue. On November 5, 1940, Gracie received thousands of write-in votes but came up well short, as Franklin Roosevelt won re-election with over 27 million votes. The rest, of course, is history.

When it was all over, Gracie released a book, *How to Become President*, despite the fact that she hadn't. She may not have won, but she was one candidate the whole country could get behind.

GRACIE ALLEN FOR PRESIDENT!

OLIVIA DE HAVILLAND

OLIVIA DE HAVILLAND

 VS.

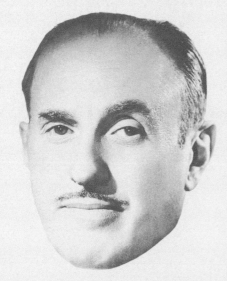

JACK WARNER

WARNER BROS.

HOW ONE WOMAN TOOK ON
THE STUDIO SYSTEM
AND CHANGED
HOLLYWOOD FOREVER

T was a big gamble, possibly even career suicide. It was August 1943, and Olivia de Havilland's future in film was on the line. She was in her agent's office deciding whether or not to sue Warner Bros. According to the California Labor Code, employers could not hold their employees to contracts beyond seven years. Her current contract with Warner Bros. had been up in May, but a "suspension clause" allowed the studio to extend it beyond the legally allowed term. This was par for the course for film actors under contract to major Hollywood studios. No actor had dared to challenge the studios to apply the actual law of the land, and with good reason: If Olivia was to go through with her lawsuit, she wouldn't just be up against Jack Warner; she'd be up against the entire studio system, the foundation of the film industry itself. She was in for the fight of her life.

The story that led to one of the most important contract battles in film history had begun almost a decade earlier, in September 1934, when eighteen-year-old Olivia was the understudy for the role of Hermia in *A Midsummer Night's Dream* at the Hollywood Bowl. Just before opening night, leading lady Gloria Stuart had to drop out, and Olivia took over the part in front of a star-studded crowd of over 15,000, including Bette Davis, William Powell, Jean Harlow, and producer Hal Wallis. Wallis was planning to produce a film version of

the Shakespeare play for Warner Bros., and after the performance he phoned Jack Warner in New York and told him to fly back immediately to see the girl in the show.

"This girl Olivia De Havilland has got something," Wallis told him.

"Yeah. A name nobody can spell," Warner replied. Wallis assured him they could change it. It was the first time, but certainly not the last, that he and Warner would underestimate her willpower.

Warner booked the next flight back to Hollywood, and when Olivia came to the studio for a test, he was mesmerized. "I saw a girl with big, soft brown eyes, like those in a Keane portrait, and a fresh young beauty," Warner would recall. "She had a voice that was music to the ears." He was so taken with her that when Olivia refused to change her name, he decided it had an aristocratic air and let her keep it. Warner Bros. jumped through hoops to get her released from her stage contract so she could do *A Midsummer Night's Dream* and sign long term with the studio. In December 1934, Warner Bros. was finally able to sign Olivia to a seven-year contract starting at $250 per week.

Olivia quickly became popular among filmgoers for her on-screen pairing with Errol Flynn in such blockbusters as *Captain Blood*, *The Adventures of Robin Hood*, and *Dodge City*. Olivia was such a hit that in 1936, with four years still left on her

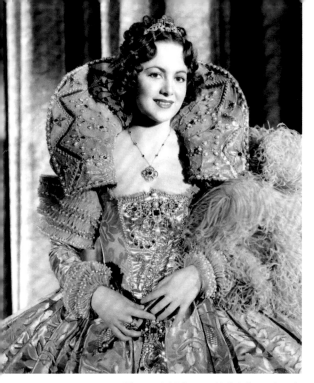

Olivia in A Midsummer Night's Dream *(1935).*

In November of 1938, knowing Warner would never allow it, Olivia tested in secret for the part of Melanie in one of the most anticipated pictures of the era: *Gone with the Wind*. When she won the role, Warner refused to loan her to David O. Selznick. In desperation, Olivia met with Warner's wife, who convinced him to lend Olivia to Selznick in exchange for the services of James Stewart. "Olivia . . . had a brain like a computer concealed behind those fawnlike brown eyes," Warner explained. He warned his wife that there would be trouble if he let her do *Gone with the Wind* and that she would be difficult to handle after. The film earned Olivia her first Academy Award nomination, and Warner's prediction would soon be proven right.

Olivia had seen firsthand the value of a good role in a good film, and she realized that if it were up to Jack Warner, she'd never get either. "I knew that I had an audience," she explained. "I couldn't bear to disappoint them by doing indifferent work at an indifferent film."

Now, when Warner cast her in what she deemed mediocre material, she would refuse and be put on suspension. Her contract not only allowed Warner Bros. to suspend her without pay for the period it took another actor to play the role, but it also allowed the studio to tack that time onto the end of her contract. Olivia began this cycle when she refused to do the film *Married, Pretty, and Poor*. Jack Warner was not happy, as he expressed in a telegram ordering her to answer his phone calls and report for work:

initial contract, she was able to renegotiate a new seven-year deal starting at $500 a week. However, she soon found herself frustrated with Warner, who confined her to ingenue roles that didn't allow her to develop as an actor.

Eventually, Olivia's resentment showed in her behavior on set. During the filming of *Four's a Crowd* (1938), Olivia had her doctor write a note to the studio saying she was "not in good physical condition, and continued overwork might jeopardize her future health irreparably." She showed up late constantly and even walked off set once after only a few hours. Needless to say, the studio wasn't happy.

"For your information," the production manager wrote to Warner, "the girl has not been worked hard I suggest this be turned over to the Guild to have them police Miss De Haviland [*sic*]." Warner ordered his staff to "inform the lady that when she has a noon call we have the right and privilege to work her for eight hours."

FROM: JACK WARNER TO: OLIVIA DE HAVILLAND

AM SURPRISED TO THINK THAT YOU WOULD ENTERTAIN ANY IDEA OF NOT PLAYING IN MAXWELL ANDERSONS PLAY.... PERHAPS I SHOULD NOT BE SURPRISED AT ALL BECAUSE YOUR PRESENT ATTITUDE IS MY ANTICIPATED REWARD FOR PERMITTING YOU TO PLAY IN OUTSIDE PICTURES.

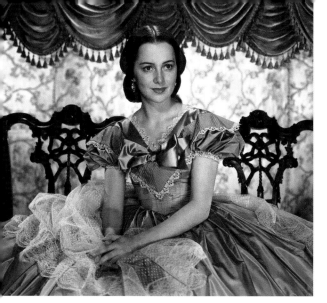

Olivia as Melanie in *Gone with the Wind* (1939).

Undaunted, Olivia did not report. Warner liked to keep his actors on a tight leash and knew Olivia was slipping. Growing more desperate, he tried to find ways to punish her for her refusal, asking his staff, "[C]an we prevent her from going on the radio—even for the Motion Picture Relief Fund? I hope we can. Let me know." But Warner's power play against his young star would prove to be his undoing.

Olivia continued to request more serious and diverse roles, and although Warner Bros. promised them, they assigned her one "little innocent ingenue part" after another.

By January 1942, Olivia was exhausted. She was promised a vacation upon completing *In This Our Life*, but when the film wrapped, she was immediately assigned to another film. She reminded the studio of the promised vacation and how "in spite of an operation and illness I have done five pictures in a year and now need four weeks rest as you I am sure can see and as my doctor . . . has advised." When that failed, she told them she would take a one-month vacation without pay. Jack Warner decided to put her on illness suspension, which, in addition to no pay, would add still more time to her contract.

Olivia was stunned. Even producer Hal Wallis thought Warner was being unreasonable, telling him, "She did do BOOTS, MALE ANIMAL, and IN THIS OUR LIFE consecutively and as a matter of fact, in two of the pictures she overlapped, and I do think it would be fairer to put her on

vacation time rather than to suspend her for the three or four weeks." But Warner wouldn't budge and ordered him to follow through: "We should positively get four weeks extension on her contract and add it on to the present year inasmuch as she will not play the part."

When Olivia was loaned to Paramount for *Hold Back the Dawn* and received her second Academy Award nomination, she tried to renegotiate with Warner Bros. for a deal that would give her more freedom. She wanted to do three pictures a year for Warner Bros., with the right to do one outside film, and she was asking for $75,000 per picture. Warner refused. He renewed the option on her current contract, which was set to expire on May 5, 1943. But with suspension time added on, the deal was extended by at least another six months.

Warner Bros. loaned Olivia to RKO for *Government Girl*, which she didn't want to do but agreed to just to avoid another suspension. Next, Warner loaned her out to Columbia for *First Woman Doctor*. A few days before production, Olivia was frustrated, having received only part of the script and having no idea who the director was. Her concerns fell on deaf ears, and Warner Bros. ordered her to report to Columbia Pictures on August 13, 1943. She had finally had enough and

Olivia looking bored in another movie she didn't want to make, *Government Girl* (1943).

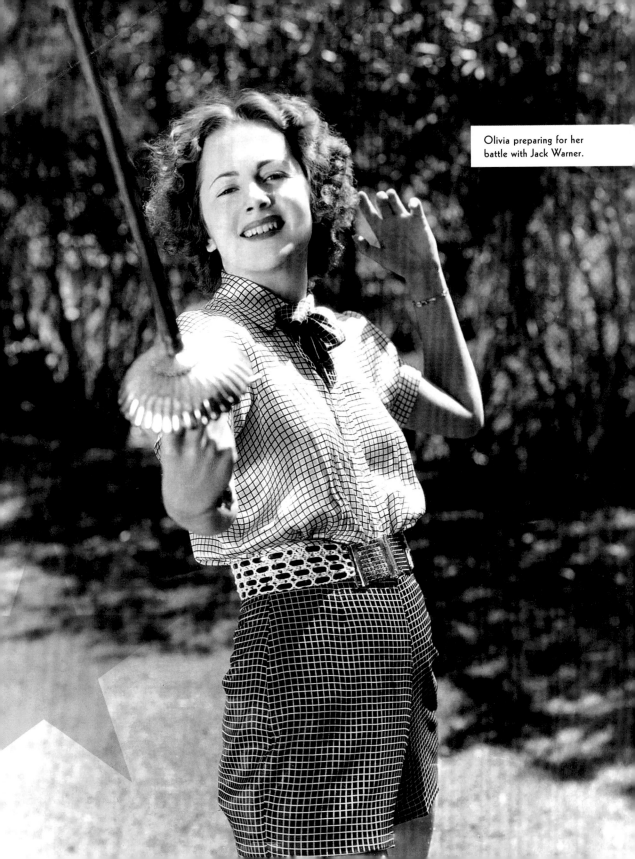

didn't show up, saying she wouldn't appear until she knew who the director was and saw a complete script. Warner Bros. once again immediately put her on suspension, and the legal battle that would change Hollywood was about to commence.

Olivia's agents introduced her to a lawyer, Martin Gang, who told her he might have found a solution to her problems. Gang explained to her that under California Labor Code Section 2855, employers could not hold their employees to contracts beyond seven years. Gang's plan was this: File for declaratory relief with the Superior Court. He was convinced that they would lose there, but he believed a three-judge appellate court would be more sympathetic. If they lost, he vowed to appeal all the way to the U.S. Supreme Court.

On the afternoon of August 19, 1943, Gang phoned Warner Bros. legal counsel Ralph Lewis and requested a letter from the studio freeing her of her contract. Lewis acknowledged the

Judge William S. David, looking over Olivia's first Warner Bros. contract.

"I DIDN'T REFUSE, I DECLINED."

California labor statute meant the contract could not be enforced past seven years but that the studio wasn't going to start a precedent by issuing de Havilland such a letter. Gang told him Olivia would probably sue.

After nearly a decade, Jack Warner knew Olivia as well as anyone, so he knew she meant business. On August 23, 1943, de Havilland filed suit.

Warner was incensed, telling his legal team:

Miss DeHavilland's claim that she did not want to do the pictures because they were not up to her standard is ridiculous. . . . If Miss DeHavilland wants to compare all pictures with GONE WITH THE WIND I will get David Selznick, Daniel O'Shea, and every other top producer to testify that such a comparison would be absurd. We brought her from obscurity to prominence and can show that we made a profit on every picture she has ever been in.

While under contract, Olivia had refused just five films while completing twenty-eight, all of which made a profit.

The trial began on November 5, 1943, and Olivia was required to testify. Gang had warned her that Warner Bros. lawyers would do everything they could to anger her and make her look like a selfish, entitled movie star. He was right. Warner Bros. legal counsel Charles A. Loring pulled no punches and asked in "thundering tones" to admit that she refused to do certain films on certain dates. To each question Olivia calmly replied, "I didn't refuse. I declined."

Loring also asked her to admit that she had refused a part in *Animal Kingdom* because of her love for a man* who had now gone overseas for the war. Olivia, always the consummate actor, calmly answered, "No. . . . I felt that with the interests of the country at heart I should spend as much time with him as possible."

Judge Charles Burnell was amused by the whole proceeding, interjecting, "This testimony isn't pertinent, perhaps, but it's nice to have a little romance in the hearing."

As she waited for the court to decide her fate, Olivia joined forces with the Hollywood Victory

The man, who was not identified in court, happened to be then-married director John Huston.

Committee and went abroad to entertain the troops. When Jack Warner found out, he was livid with the Victory Committee for allowing her to go without his permission. He demanded a letter of apology, which he got. By this time, Olivia had nicknamed him "Jack the Warden."

On March 14, 1944, while she was visiting patients at the military hospital in the Aleutian Islands, Olivia received a telegram from Martin Gang. The message was simple: She had won.

Judge Burnell ruled that Warner Bros.' claim that the statute of seven years meant seven years of "actual service" could result in a contract "being indefinitely extended, even to the point of constituting life bondage for the employee."

Warner Bros. immediately appealed the ruling, arguing that by agreeing to the suspension clause, Olivia had in fact waived her right to end her employment contract at seven years.

Olivia returned from the Aleutians ecstatic to begin her new career as a freelance actor. To her dismay, she found out that her agents were unable to secure her any work because of a telegram sent from the furious Jack Warner:

Olivia in *To Each His Own,* for which she would win the first of her two Oscars.

CLASS OF SERVICE | SYMBOL
TELEGRAM |
DAY LETTER | BLUE
NIGHT MESSAGE | NITE
NIGHT LETTER | N L

WESTERN UNION TELEGRAM

NEWCOMB CARLTON, PRESIDENT GEORGE W. E. ATKINS, FIRST VICE-PRESIDENT

FROM: JACK WARNER

PLEASE BE ADVISED THAT WARNER BROS. PICTURES, INC. TAKES THE POSITION THAT MISS OLIVIA DE HAVILLAND IS STILL UNDER EXCLUSIVE CONTRACT TO IT UNTIL JUDGMENT OF THE COURT IN THE ABOVE REFERRED TO ACTION BECOMES FINAL.

Warner's vengeance was so thorough that the telegram was sent to every production company—major, minor, and even those that were no longer in existence. Warner then followed up by sending the notice to every theater and broadcasting company on both coasts, effectively blacklisting Olivia from any work in the entertainment industry. Warner knew a prolonged absence from the screen was a death sentence to any film actor, and he delayed the release of Olivia's latest film, *Devotion,* to keep her off the screen as long as possible. Olivia was forced to live off her savings and hope that the Appellate Court ruled in her favor.

The case reached the Appellate Court on September 10, 1944. Olivia wasn't required to testify for this round but followed Gang's guidance and sat in the back of the room each day to show how much the outcome meant to her. On December 16, 1944, Gang phoned Olivia to tell her she had won a unanimous decision. Warner Bros.

appealed once more to the California Supreme Court, but the studio was denied a hearing.

"And she licked me," Jack Warner conceded. Years later, he would admit that the case "was probably best for everyone concerned."

It certainly was best for Olivia, who quickly proved that, unencumbered by Warner's casting decisions, there was no limit to how far her star could rise. By 1950, she had won two Best Actress Academy Awards.

But the case had major implications beyond Olivia's career. The labor code law that freed her from Warner Bros. came to be called the "De Havilland Law" and vastly reduced the power of the studio system, while giving greater creative control to actors. Over the years, the law has been invoked by many other actors and artists. James Stewart used it to allow actors who had been serving in the war to renegotiate their contracts. Johnny Carson used it to renegotiate his contract with NBC. Jared Leto credited Olivia de Havilland for saving his band 30 Seconds to Mars from an oppressive contract. And Kanye West filed suit to get out of a never-ending contract with his record company.

On June 30, 2017, Olivia stunned Hollywood once more. The day before her 101st birthday, she filed a lawsuit against the FX network and producer Ryan Murphy for their portrayal of her and for using her likeness without her permission in their series *Feud: Bette & Joan*. Though she had the Screen Actors Guild behind her, Olivia was up against Ryan Murphy and FX, and also the Motion Picture Association of America and Netflix (which had just signed Murphy).

The appellate court threw the case out on First Amendment grounds, but Olivia was undeterred:

I believe in the right to free speech, but it certainly must not be abused by using it to protect published falsehoods or to improperly benefit from the use of someone's name and reputation without their consent. Fox crossed both of these lines with 'Feud', and if it is allowed to do this without any consequences, then the use of lies about well-known public figures masquerading as the truth will become more and more common.

Olivia appealed the decision to the California Supreme Court but was denied a review.

On July 26, 2020, Olivia died peacefully in her sleep at the age of 104, outlived only by her legacy as one of Hollywood's greatest and most determined stars.

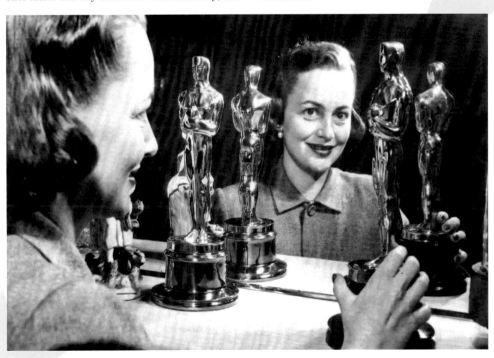

THIS WAS HOLLYWOOD...

Health and Excercise!

It's not a *stretch* to say Marilyn Monroe is in tip-top condition.

En guarde! Rudolph Valentino getting his fence on.

Marie Dressler watching the pounds melt away with a vibrating exercise belt, in a publicity photo for her film *Reducing*.

James Cagney working the pommel horse at the Warner Bros. gym.

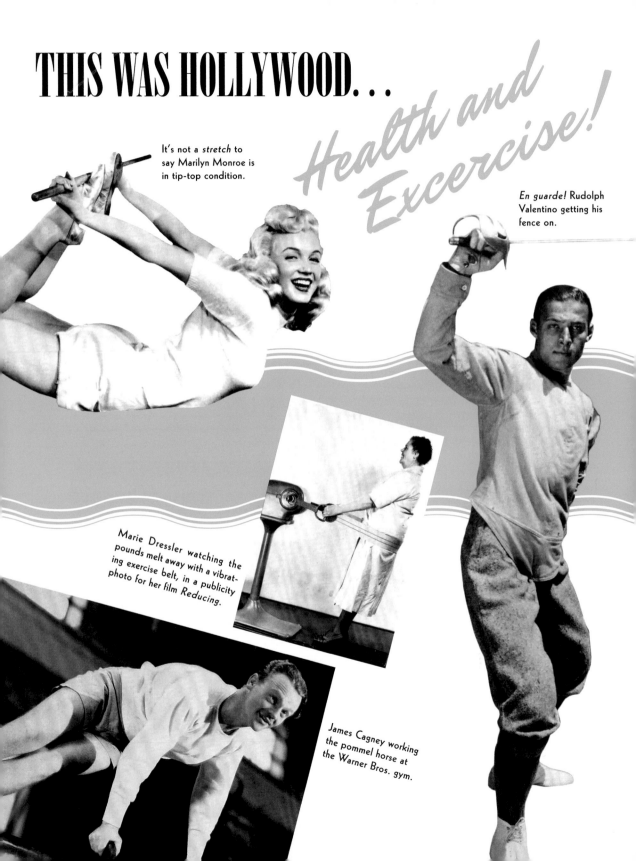

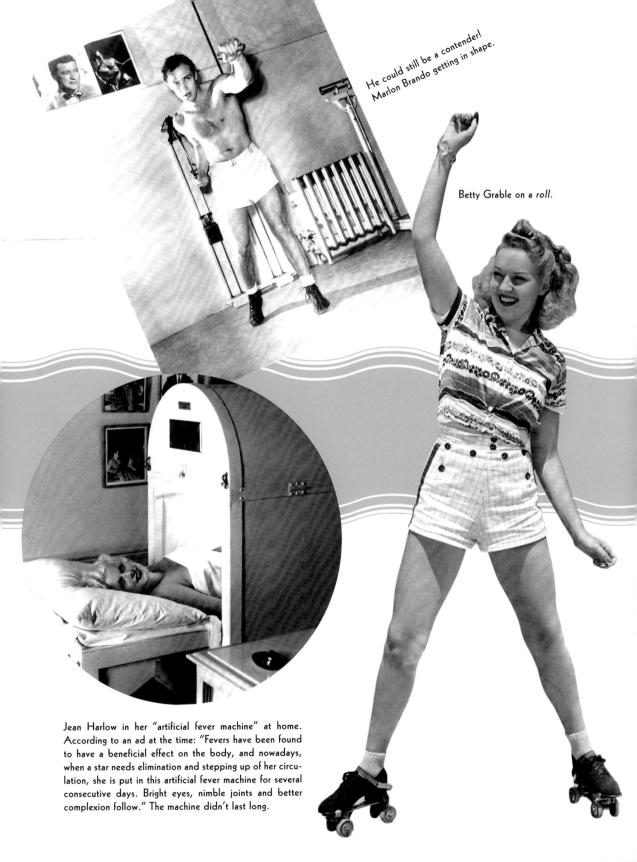

He could still be a contender!
Marlon Brando getting in shape.

Betty Grable on a *roll*.

Jean Harlow in her "artificial fever machine" at home.
According to an ad at the time: "Fevers have been found
to have a beneficial effect on the body, and nowadays,
when a star needs elimination and stepping up of her circu-
lation, she is put in this artificial fever machine for several
consecutive days. Bright eyes, nimble joints and better
complexion follow." The machine didn't last long.

GOLDEN BOY

JOHN GARFIELD

and

THE DEATH

of

AN AMERICAN DREAM

T was the morning of Monday, April 23, 1951, in room 226 of the Old House Office Building in Washington, D.C., and the House Un-American Activities Committee (HUAC) had its prize witness under oath. His name was John Garfield, and for more than a decade he had been one of the most popular and daring movie stars in America. But allegations that he was engaged in Communist activity had landed him on the Hollywood blacklist, and not long after, a subpoena to appear before the Committee had landed in his lap. His career was hanging in the balance, and he hoped his testimony that day would clear his name.

But long before Garfield sat down to face the first question, long before he had even been subpoenaed, long before his name had been dragged through the mud, the Committee had been well aware of a fact of no small importance to the proceedings: John Garfield was not and had never been a Communist. His appearance before the Committee was the result of a coordinated and systematic effort by the HUAC, the FBI, and the Hollywood studios to entrap, intimidate, and ruin him for their own twisted aims.

Garfield had taken Hollywood by storm in 1938, appearing in a supporting role in the Warner Bros. film *Four Daughters*. When the movie premiered, he was an overnight sensation. Handsome and pugnacious, with a naturalistic style and an explosive energy, he was, according to the *New York Times*, "the most startling innovation in the way of a screen character in years." Over the next decade, he appeared in dozens of films, including classics like *The Postman Always Rings Twice* and *Gentleman's Agreement*, and proved to be a bankable star, both for the studios and for the independent production company he went on to found. His fame was part of the reason the Committee had zeroed in on him. But even more than that, it was his background and the arc of his professional career that landed him in the Committee's crosshairs, a hapless target in the government's relentless crusade to rid Hollywood of a supposed Communist plot to subvert the American way of life.

He was the son of immigrants, born in 1913 to Russian Jews recently arrived in Manhattan and living in a tenement on the Lower East Side. His real name was Jacob Garfinkel, but his parents called him Julius, "Julie" for short. He came from nothing and likely would have amounted to as much were it not for the intervention of his junior high school principal, Angelo Patri. Patri was a nationally recognized educator who played a major role in modernizing the public school system. He also ran P.S. 45 in the Bronx, where Julie ended up after being

Julie and Robbe on their wedding day.

expelled from several other schools. After catching Julie trampling flowers on the school grounds, the principal took the troubled boy under his wing.

"Patri talked to me as I had never been talked to before," Julie recalled. "He made me see that flowers are tender, beautiful living things, to be cared for and protected. He gave me the idea that people are like that, too, and hearts, and ideals. And some of the things inside our own hearts and minds that we'd better not trample either."

He helped Julie overcome a stutter and with his support, Julie entered and won the district finals for an oratorical contest conducted by the *New York Times*. It was Patri who suggested Julie pursue acting, although his encouragement might have been more effective than he intended: After his junior year of high school, Julie dropped out to commit himself to acting full time. He made his first appearance on Broadway in 1931, under the stage name Jules Garfield. But his real

objective was to join the revolutionary Group Theatre, whose founders Harold Clurman, Lee Strasberg, and Cheryl Crawford were then pioneering "method acting" in the United States.

He joined the company in 1934. Home to writers like Clifford Odets, whose works mirrored and challenged American society, the Group was a hotbed of left-wing political thinking, producing major works of theater such as Odets's *Waiting for Lefty*.

But his colleagues in the theater weren't the only revolutionaries Julie was growing close to. In early 1935, he married Roberta "Robbe" Seidman, a beautiful and dynamic young woman he had met at a block party a few years earlier. Robbe was a force of nature, a political activist who had cut her teeth in the labor protests then raging across New York City. She was "very Marxist" in her thinking and later explored membership in the Communist Party. Julie, himself a liberal Democrat, shared little of his wife's passion for leftist activism. His passion was acting, and he threw himself into his work with vigor.

He appeared in several productions with the Group, and in 1937, Odets wrote a lead role specifically for him. The play was *Golden Boy*, and Julie was to play Joe Bonaparte, a tragic figure whose fate rests on the choice between true artistry and material success. Julie made a fateful choice of his own, giving up a leading role on Broadway that paid $300 a week and returning to the Group for a fraction of the salary. "That role," he said, "would prove to the world, and to me, that I was a good actor." But he never got to play it. The director cast his soon-to-be brother-in-law instead, and Julie was cast in a comedic supporting role.

The experience left him disillusioned with the Group, so he accepted an offer from Warner Bros. and headed to Hollywood. The first order of business was coming up with a new name. The surname Garfield was good, but Jules sounded too Jewish to studio head Jack Warner (who was also Jewish). He was briefly christened James Garfield, until an executive remembered that a president by that name had been assassinated. The studio settled on John.

His first vehicle was *Four Daughters*, and nobody at the studio seemed aware that a major star was about to be born. When Julie showed up for his first day, he shocked everyone with his acting style. Method acting was still something of a novelty in the film industry, and Julie's co-stars mocked him

for it, as well as for his level of preparation for what they considered a small role. The film's producer fired off a memo saying, "He looks like he's digging a ditch instead of playing the piano." Julie would have the last laugh: Not only did he become an overnight star, he was also nominated for an Academy Award for Best Supporting Actor.

Warner Bros. was anxious to capitalize on their new star and began to typecast him in criminal and tough-guy roles. As fate would have it, *Golden Boy* was now being adapted into a film by Columbia Pictures, and studio head Harry Cohn wanted Julie to play the lead. But he would again be denied the role that had been written for him, this time because Jack Warner was feuding with Cohn and refused to loan Julie out to Columbia. (The role went instead to a then-unknown William Holden.)

Julie grew frustrated with Warner, but the world was now at war, so he threw himself into action. Ineligible for military service due to a chronic heart condition from a bout of typhoid, he found other ways to serve: Entertaining troops in the first USO tour, selling millions of dollars in war bonds, and joining with Bette Davis and musician Jules Stein to launch the Hollywood Canteen, a club free for all servicemen. He even had the opportunity to meet President Roosevelt, who praised his work and personally facilitated a trip to entertain the troops in North Africa and Italy.

But even as he basked in the adulation of the president, the government he believed he was serving was plotting his destruction. As early as 1941, a decade before Julie was ever called to testify before the HUAC, the Committee had listed him as an individual with "subversive tendencies and membership in subversive groups." By early 1943, the FBI had gotten involved, carrying out occasional surveillance of Julie's home. In August 1944, a full investigation into his activities was launched, and by November, the Bureau had prepared its first report.

"While specific information indicating actual Party membership is lacking," the report stated, "the . . . subject has been identified with many Communist front organizations, is closely associated with numerous known Party members including his wife and personal secretary."

Among the evidence cited to support these claims was a 1940 radio broadcast that said Jack Warner once appealed to Julie's "communistic nature" to induce him to work on a movie by pointing out that if he didn't, others would lose their

jobs. Also deemed suspicious was a speech Julie made calling for the democratic rights of black Americans and condemning Jim Crowism as well as his public advocacy for "mixed dancing" between white and black patrons of the Hollywood Canteen. He also sponsored a dinner to finance the *Jewish Black Book*, a publication with the nefarious aim of documenting Nazi atrocities against Jews.

So disturbed was the FBI that, by 1945, the Bureau was collecting fingerprint and handwriting samples from Julie's mail, and J. Edgar Hoover was personally clipping sections out of Communist newspapers that praised Julie's films and celebrated his USO work.

For Julie, life went on as usual, with his career and a growing family to keep him busy. By this time, he and Robbe had two children, six-year-old daughter Katherine and one-year-old son David. But on March 18, 1945, tragedy struck. While on a weekend trip out of town with her nanny, Katherine began to have difficulty breathing. Rather than take her to a hospital, the nanny decided to drive the hundred miles back home. During the drive, Katherine's condition worsened, and she was gasping for air. By the

time she reached home, she was barely breathing. A few minutes later, Katherine died in her mother's arms. Julie was so distraught he shot up the wall in his backyard with his machine gun and then hiked up to the hills and broke down crying. When he returned, he took Katherine's body to the hospital, where he learned she had suffocated from a spasm in her throat caused by staph and strep infections.

Ten months after the death of their first child, the Garfields welcomed a baby girl, named Julie, after her father. The beautiful baby with a vivacious personality instantly became a bright spot in the elder Julie's life.

In 1946, Julie's contract with Warner Bros. was up, and he declined a generous offer from Jack Warner to re-sign, opting instead to form his own production company. "I want to be free to pick stories that I believe fit me," he explained. His words would prove prescient.

Many of the films he would go on to produce centered on men in impossible situations: A boxer blackmailed to throw a fight in *Body and Soul*; a corrupt lawyer whose loyalties are torn between his criminal bosses and his brother in *Force of Evil*; a

Julie in *Force of Evil* (1948).

THIS WAS HOLLYWOOD

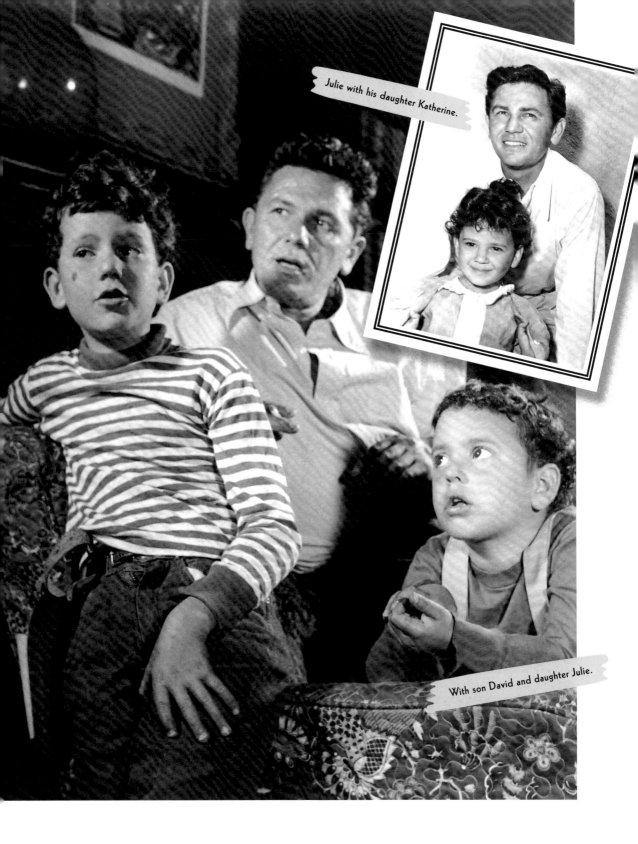

Julie with his daughter Katherine.

With son David and daughter Julie.

hapless stick-up artist trapped in an apartment as the police hunt him down in *He Ran All the Way*. Julie collaborated with the most talented people in the industry, including legendary cinematographer James Wong Howe and acclaimed screenwriters Robert Rossen and Abraham Polonsky. The films are dark, in both theme and aesthetic, and they're among the most sophisticated and powerful works of film noir ever made.

But Julie and many of his colleagues would soon find themselves in an impossible situation of their own, drawn into an ever more perilous game of chicken with the government over their rights of free thought and expression. In 1947, a group of screenwriters known as the Hollywood Ten would be held in contempt of Congress for refusing to answer questions before the HUAC. Julie, though not a Communist, was a firm believer in America and its founding principles and joined the Committee for the First Amendment, headed by director John Huston. He took part in a radio broadcast called "Hollywood Fights Back" along with Judy Garland, Frank Sinatra, and Humphrey Bogart. During the broadcast he advocated fiercely for the right of free speech.

"There is no guarantee that the Committee will stop with the movies," he declared. "If you make a pitch on a nationwide network for the underdog, will they call you subversive? Are they going to scare us into silence? If this committee gets a green light from the American people now, will it be possible to make a broadcast like this a year from today?"

Julie helped organize a meeting to plan a counterattack against HUAC. The group planned to take out full-page ads in major newspapers to make the case to the public that the Ten were being persecuted by the Committee. One attendee, actor Richard Barthelmess, took notes on the meeting and handed them over to the FBI the next day.

HUAC's focus on Julie intensified, and the Committee requested information about him from the FBI. The Bureau forwarded their report but noted that, even after years of investigation, "no documentary proof has been uncovered which would indicate that John Garfield is a member of the Communist Party or was a member of the Communist Political Association."

The FBI continued its investigation, leaving no stone unturned in its efforts to implicate Julie. They recruited the superintendent of his apartment building in New York to report on his every move, while the doorman shared his telegrams and telephone conversations. An FBI informant at a Communist front organization tried to entrap Julie, badgering him about speaking at one of their events while recording the conversation. (Julie refused a half dozen times, before finally saying he'd look into it, and his contact with this organization was later raised against him during his HUAC testimony.)

As the government closed in, Julie continued to work, making films on a freelance basis for the studios. But the stress of his career took a toll, and in 1949, during the production of *Under My Skin* for 20th Century Fox, he suffered a heart attack. He completed the film, then went on to make *The Breaking Point* (1950) for Warner Bros. But before it was released, Julie's name appeared in the anti-Communist pamphlet *Red Channels*, which alleged he was connected to seventeen different Communist organizations. The report made Warner Bros. nervous, and they released *The Breaking Point* with little fanfare in September of that year.

With Julie under fire, Hollywood turned its back on him. Not only was Julie blacklisted, the studios did nothing to stop HUAC's relentless hunt. The Committee was convinced that crucifying a major star would help prove that "Communist infiltration" had penetrated the fabric of American society. Their search for the right star had been ongoing and now narrowed to two actors known for their liberal politics: Julie and Danny Kaye. The studio heads had a choice to make. "I remember talk about having to give them somebody and whether it should be Kaye or Garfield," 20th Century Fox head Darryl Zanuck later admitted. "There were two propositions—that the Committee wasn't fooling anymore, they had to get a big name, and if they had to be fed somebody Garfield made more sense than Kaye."

Kaye was under contract with Warner Bros., which meant the studio lawyers would go to bat for him. Julie, now freelancing and producing his own films, was on his own. "That made him fair game, I guess," Zanuck explained, "especially since certain studio people didn't think too highly of him for turning his back on the studios, maybe were even a little pleased in private to see him getting his. His politics having nothing to do with it."

Determined to continue working, he put his energies into a project for his own production

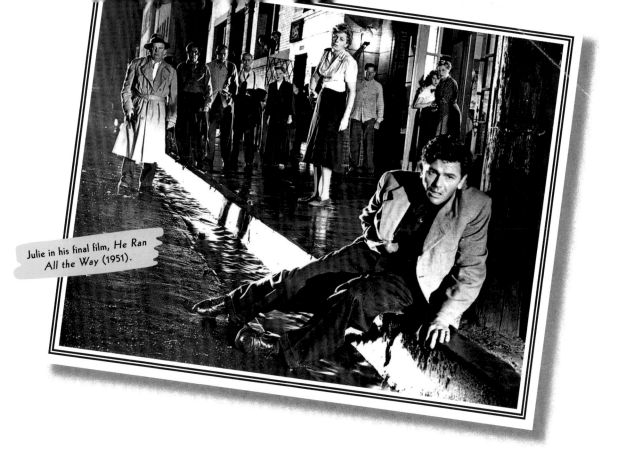

Julie in his final film, *He Ran All the Way* (1951).

company, *He Ran All the Way*. His character, a stick-up artist on the lam, spends the film desperately searching for a way out as the world closes in around him. It was a feeling Julie was becoming far too familiar with himself.

On March 6, 1951, federal agents showed up at his New York apartment and served him with a subpoena to appear before the HUAC. He immediately released a statement.

"I have always hated Communism," he said. "It is a tyranny which threatens our country and the peace of the world. Of course, then, I have never been a member of the Communist party or a sympathizer with any of its doctrines. I will be pleased to cooperate with the Committee."

As the hearing drew near, Julie was a nervous wreck, terrified he would be sent to jail and his acting career would be over.

On April 23, Julie arrived with his lawyers, who were not permitted to give him any counsel throughout the hearing. The Committee grilled him for three hours, poring over minute details of his upbringing and professional career. The questions were by turns hostile and confounding, substituting innuendo for evidence and speculation for fact. But Julie was able to counter the questioning with authority.

One congressman cited positive reviews of Julie's acting published in the Communist *Daily Worker*, adding that anyone praised by such a publication should be under suspicion. When Julie pointed out that the paper had also praised Republican senator Robert Taft, the congressman quickly changed the subject.

Julie's patriotic work during World War II was now being painted as treason, with one congressman implying that Julie's USO appearance in Yugoslavia might have been cover for pro-Soviet activity. He was also grilled about meeting with a Russian diplomat in California but pointed out the man had been invited to the United States by the State Department and that a government translator was present at the meeting because the diplomat didn't even speak English.

But Julie's personal politics aside, the Committee's primary aim was to get him to implicate his friends and colleagues. They asked over and over about various people he had worked with, both at the Group Theatre and in Hollywood. But no matter whom they asked about, no matter how they badgered and intimidated, he would not give in.

Julie concluded his testimony by reading a statement:

> *When I was originally requested to appear before the committee, I said that I would answer all questions, fully and without any reservations, and that is what I have done. I have nothing to be ashamed of and nothing to hide. My life is an open book. I was glad to appear before you and talk with you. I am no Red. I am no "pink." I am no fellow traveler. I am a Democrat by politics, a liberal by inclination, and a loyal citizen of this country by every act of my life.*

The Committee was furious. Before the hearing had begun, Committee members told Julie they had information he and his wife had been members of the Communist Party. They believed their intimidation would prompt Julie to cooperate, but in the end, he had refused to "name names."

A few days later the transcript of his testimony was referred to the Department of Justice, asking for perjury charges. But the assistant attorney general said that a case could only be made if they secured testimony against Julie from "two witnesses or one witness with corroborating circumstances." HUAC and the FBI went back to work.

The Committee subpoenaed Julie's former secretary, Helen Slote Levitt, and her husband, screenwriter Alfred Levitt. Both were active members of the Communist Party, and the Committee offered them a deal: If Helen would testify against Julie, they would cancel Alfred's subpoena, he wouldn't have to testify, and he wouldn't be blacklisted. But she refused. Aside from her belief that what HUAC was doing was unconstitutional, Helen also knew that Julie wasn't a Communist. The Committee's best hope of condemning Julie appeared to be dashed.

Then, on May 1, 1951, a wannabe Hollywood starlet named Jean Carmen Dillow marched into the FBI offices in New York and said she was willing to testify before "any committee, board, or court" that John Garfield had committed perjury.

On June 5, Dillow testified behind closed doors to HUAC, who kept her identity a secret from the press. The FBI followed up with an interview of its own. Her story was outrageous.

She claimed she first met Julie during production of the Warner Bros. film *Daughters Courageous* (1939), when a friend who was the assistant director hired her as a stunt double for one of the female stars. She alleged that Julie made numerous statements praising the Russian peasant way of life and promising "someday this way of life will come to this country." She claimed that he admitted to being a recruiter for the Communist Party, which would assure him a "favored position in the government when we take over." She even claimed to have had dinner with Julie, Paulette Goddard, Burgess Meredith, and Constance Collier at the Ambassador hotel in Chicago, where Julie made several pro-Communist declarations to the table, including that "the only way of life in the world is Communism and this country is going to have it."

It was a dramatic tale, exactly what HUAC and the FBI had been after for years. There was only one problem: None of it appeared to be true. Investigators spent the next several months desperately searching for someone to corroborate her story. But hardly anyone she mentioned even knew who she was, and those who did took issue with her version of events. Her "assistant director" friend from Warner Bros. was actually an extra. The star she claimed to stunt double for had actually done her own stunts. In fact, Warner Bros. had no record that Dillow had ever been employed on any production in any capacity. As for her dinner with the stars at the Ambassador hotel, both Meredith and Goddard denied she was there and had no recollection of Julie's alleged comments about a Communist revolution. Later, the FBI did find someone to corroborate that Dillow was there: A friend who said that Julie, Goddard, and Meredith were in the dining room of the hotel— while she and Dillow were on a double date with two Navy sailors.

At the behest of the attorney general, the FBI redoubled their efforts to corroborate her story. They turned up the heat on Julie, interviewing anyone who came into contact with him, from friends to co-stars, secretaries to old girlfriends, even his maids. They also increased surveillance, tapping his phones and tailing him around New York.

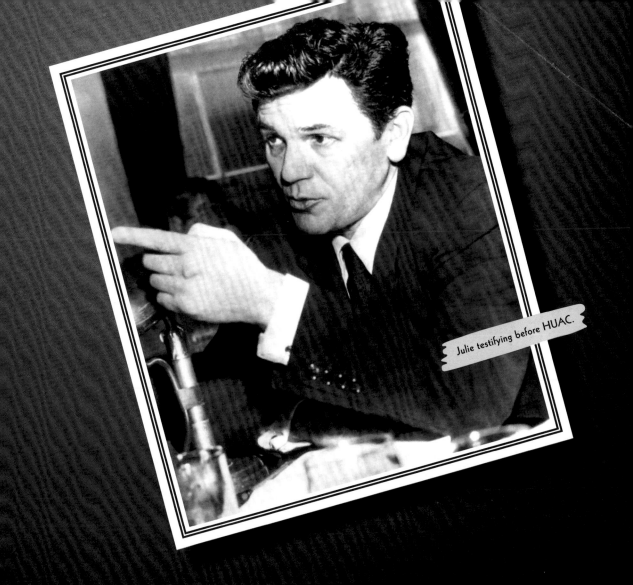

Julie testifying before HUAC.

"I HAVE NOTHING TO BE
ASHAMED OF AND NOTHING TO HIDE.
MY LIFE IS AN
OPEN BOOK."

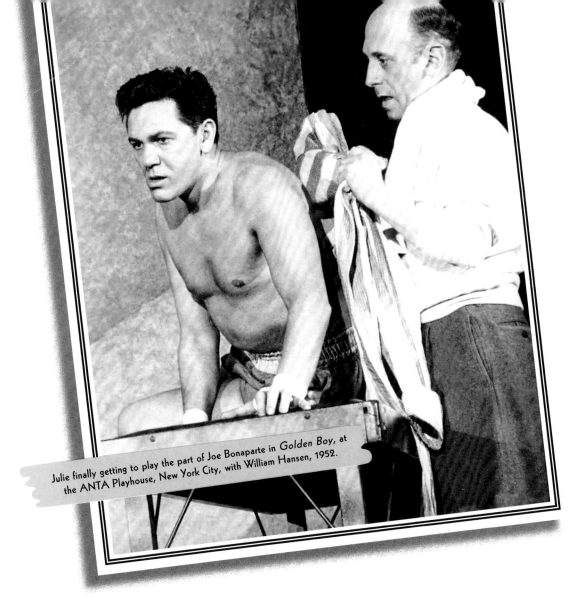

Julie finally getting to play the part of Joe Bonaparte in *Golden Boy*, at the ANTA Playhouse, New York City, with William Hansen, 1952.

While the FBI could find no one to back up Dillow's increasingly dubious story, the Bureau did find more than thirty former Communist Party members, whom they considered highly reliable sources, who repeatedly confirmed that John Garfield was not a member of the Party. In fact, many of them went even further, revealing that the party itself had considered him "anti Party."

Despite the government's increased efforts, by the end of 1951, they had found only one piece of evidence to support one small aspect of Dillow's account: A check from Warner Bros. that indicated she had worked as an extra for one day.

They had also uncovered information that undermined Dillow's claim to be a concerned citizen coming forward to protect her country.

Dillow had had multiple contacts with Boris Morros over a period of several years. Morros was a Communist Party member and Soviet agent who had been turned by the FBI and spent a decade as a double agent informing on Communist activities in America. The FBI simply chose to write this off as innocuous, and Special Agent in Charge Edward Scheidt wrote to J. Edgar Hoover that "No apparent purpose would be served by making mention of these contacts."

Even with the credibility of their only witness in ruins, the FBI's investigation pressed on, and Julie was left to figure out how to pick up the pieces of his shattered career. He was blacklisted in Hollywood but, for now, was still able to work on the stage. In early 1952, he finally got the chance to play the role that eluded him for fifteen years. *Golden Boy* was being revived, and Julie was cast as Joe Bonaparte. The play was one of the few joys left in Julie's life. He thoroughly enjoyed his return to the stage and said he would gladly make a "life's work" of *Golden Boy*.

When Clifford Odets had written the role for him back in 1937, he couldn't have known how closely Bonaparte's fate would come to mimic Julie's own. A gifted violinist and fighter, Bonaparte is forced to choose between a life of integrity as a musician or compromise his principles to achieve material success as a boxer. Ultimately, he chooses the latter and is ruined. Ironically, it was Julie's refusal to compromise his integrity that would prove to be his undoing.

When the final curtain came down on *Golden Boy* in April, Julie was blacklisted from the stage. His livelihood taken away, he was desperate to lift the cloud of suspicion hanging over him. He turned to Arnold Forster of the Anti-Defamation League (ADL) to help clear his name. Forster advised Julie to make a public statement explaining his connection to various leftist organizations. Julie agreed on the condition that no names be mentioned and began to draft an article entitled "Don't Be a Sucker for the Left Hook" to be published in *Look* magazine (it never was).

But shortly after Julie contacted Forster, two FBI agents showed up at Forster's office to question him. Alarmed, Forster contacted FBI Assistant Director Louis B. Nichols and said that if the Bureau asked, the ADL "would wash their hands of Garfield and drop him immediately." Nichols told him the investigation was still ongoing, and Forster secretly sent the FBI a draft of Julie's article. Forster then told Julie that the ADL couldn't be "too active" on his behalf until Julie submitted to an FBI interview. Desperate, Julie agreed.

On May 10, 1952, at 11:00 a.m., Julie walked into the New York FBI office and sat down to meet with Agent Scheidt. For the next three hours, the questioning covered the same ground as his HUAC testimony the year before. Julie was asked about his contact with various Communist front organizations as well as a Communist cell within the Group Theatre. And he was again pressed about alleged membership in the Communist Party of friends and acquaintances. Just as before, he refused to name names. He also did his best to refute Jean Dillow's allegations, insisting that he had no recollection of ever meeting her, even admitting at one point that he "could recall the names of every woman with whom he had slept from Los Angeles to New York, but the name Jean Carmen was completely unfamiliar to him."

But the FBI then turned to an entirely new subject, one not even the HUAC had dared to raise publicly. Julie was asked at length about Robbe's political activities, including allegations that she was a Communist Party member. Julie explained that, from the very beginning of their marriage, he and Robbe had vast political differences. He explained that their differences had resulted in frequent fights, adding that he thought "she was probably the cause of all of my troubles."

Julie was well aware that Robbe had briefly been a Communist and had ended her association with the party after Katherine's death. But that day in Agent Scheidt's office, knowing full well that to sacrifice her might save him, Julie never wavered. No matter how many times Robbe's name came up, no matter what "evidence" the FBI presented about her, he protected her. He refused to admit she had been a Communist, refused to bend, refused to compromise his principles for a chance to return to the life that had been stolen from him. When it was all over, he broke down crying. "She has ruined me," he said. "I am finished."

When J. Edgar Hoover received a copy of the report on Julie's interview, he made one simple note: "Garfield is certainly long on denials."

A few days after his interview, Julie and his lawyers told Robbe that the time had come for her to go to the FBI to clear his name. She refused, and he packed his things and moved out. Julie spent the next week working on his article for *Look* magazine, writing to potential employers, and playing with his children.

On the morning of May 21, six-year-old Julie had a date with her father, and he was late. When a few hours had passed and he still hadn't come, she was sent to a friend's house. There she continued to wait for her father, who would never come.

members. But FBI files reveal that the only statement Julie was writing was a letter to a potential employer describing his statements before HUAC. As Agent Scheidt wrote to J. Edgar Hoover at the time, "NOTHING IN STATEMENT CONTRADICTORY TO HCUA TESTIMONY AND CONTRARY TO PRESS REPORTS ADMITTED NO PERJURY AND NAMED NO CP MEMBERS." Reisel and Sokolsky later admitted to the FBI that they hadn't actually seen the statement but refused to retract their stories. These rumors hung over Julie's name for decades after his death.

But the truth is that John Garfield was a proud American, a staunch defender of the First Amendment, an advocate for civil rights, and a tireless servant of men and women in uniform. In the face of relentless harassment from his own government, incalculable professional and financial loss, and the dissolution of his family, he never provided the names of any Communist Party members to any of the government entities investigating him.

His persecution at the hands of HUAC and the FBI not only robbed him of his career and life; it also robbed his children of their father, and it deprived the public of one of the great film artists of the 20th century. He was one of the most innovative figures in American cinema. His star turns as a method actor blazed a trail for future Hollywood icons like Marlon Brando, James Dean, and Montgomery Clift, among many others. And he succeeded as an independent producer, defying a studio system that then controlled every aspect of production and creating powerful works of cinema.

Before his death, Julie wrote to the highly influential gossip columnist Hedda Hopper, a staunch anti-Communist, asking her to publish a statement he had written. She never did.

Here it is, published for the first time, in its entirety.

The night before, Julie was visiting a friend and began to feel ill. He fell asleep around 11:00 p.m. and never woke up. John Garfield was dead at the age of thirty-nine. The official cause of death was a heart attack. His friends and family believed it was the strain of the government's decade-long crusade against him that did him in.

Despite the government's efforts to destroy his reputation, there was a huge outpouring of love and grief when he died. Ten thousand people lined the streets outside Riverside Memorial Chapel, where he lay in repose. But the harassment and character assassination continued even after his death.

A week later, two FBI agents showed up at his apartment wanting to have a look around.

"What for?" Robbe asked them. "You already killed him! You got what you wanted, now get out of our lives!"

Immediately after his death, columnists Victor Reisel and George Sokolsky fabricated a story claiming that in his final hours, Julie was writing a statement admitting his previous Communist associations and naming names of fellow Party

American citizenship means many things to different people. To me it means a chance to think for myself.

That is the privilege which grows greater every day. Most of the rest of the world is not only told what to do now, it is being ordered to think a certain way, or, in the event the individual can't agree with this mass opinion, not to think at all.

That, it seems to me, is the road back to the dark ages. Admitting the great physical power that a nation can generate by such tactics, such a power as has been demonstrated the last few months, I like to believe that this system carries with it the seeds of its own destruction. I can't believe that one or two men can do all of the thinking for a hundred million men.

It has been well publicized that I come originally from the "under-privileged classes." That is true and yet compared to the youth now growing up in many countries of the world, I was over-privileged. I was hungry at times, ragged often, cold occasionally, but I was never denied the right to think.

I might have grown up in more or less ignorance of the better things of life, in squalor and poverty, had it not been for Angelo Patri, a saint among men, and for the American system that denied no man the right to opinions. Angelo Patri taught me to think straight and changed my way of life from misery to one of opportunity. Of course I am grateful to him, but fundamentally I am more grateful to America where such a change is possible.

I do not think and I do not mean to indicate here that everything in America is as it should be. It would be almost as sad to live in Utopia as in Germany. In Utopia one would have no chance to improve himself or his surroundings. One would not need to think. In Germany one has no right to think. Neither state interests an average young American.

And I am proud to call myself a young American.

Sincerely,
John Garfield

P.S. I know this is too long but it's the way I feel!

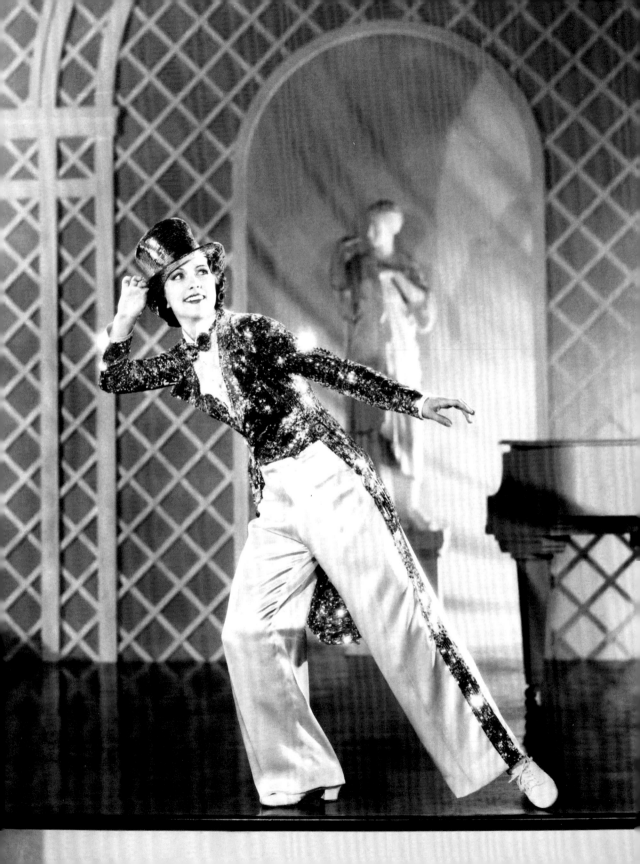

The DANCER
WHO INTIMIDATED
FRED
ASTAIRE

I_N early 1939, Fred Astaire was in producer Mervyn LeRoy's office at MGM, waiting to meet his dancing partner for *Broadway Melody of 1940*. "Boy, I'm so nervous," Fred said. "Do you know how she works? Does she standard record or prerecord? How long does she rehearse?" Fred was used to dancing partners. His partnership with his sister Adele launched his career on Broadway. On film, he had danced with Joan Crawford and Dolores del Rio, until his fateful pairing with Ginger Rogers. This would be his first pairing after Ginger. And Fred was about to meet his match. A dancer so good she rarely had a partner at all.

"Well, why don't you ask her!" LeRoy told Fred. "Eleanor, come out."

In walked Eleanor Powell, who had been hiding behind the door.

"Fred didn't want to do *Broadway Melody of 1940* with Eleanor Powell," dancer and actor Ann Miller said. "He didn't want to tap dance with anyone who could dance as well as him, and of course, she was marvelous."

But the woman who would one day grow up to intimidate Fred Astaire almost didn't survive her own birth.

It was the summer of 1912, in Springfield, Massachusetts, and Blanche Torrey was sixteen years old when she found out she was pregnant after a "tryst in a hay loft." To avoid the shame of having a child out of wedlock, she quickly married the baby's father, seventeen-year-old Clarence "Sonny" Powell. Soon after, Blanche was going through the medicine cabinet when she discovered prescriptions for a venereal disease. The exam she took to learn if her husband had infected her brought on premature labor on November 21. Blanche's baby girl was born without fingernails, toenails, or eyelashes and kept in an incubator as doctors and her family waited to see if she'd survive. Fortunately, Eleanor "Ellie" Torrey Powell was here to stay. Blanche and Sonny would soon divorce, and Blanche took her newborn daughter to live with her parents in Hartford, Connecticut. A few years later, Blanche remarried, but that marriage was short lived as well. For years, Blanche told Ellie her father had died, and it's uncertain if she even knew about her mother's second marriage. Ellie's grandparents were the parental figures in her life, and she described the relationship with her mother as "more like sisters." They were extremely poor, and Blanche worked a series of odd jobs to support the family, including as a hotel maid, bank teller, waitress, and bullet packager for Smith & Wesson.

As a child, Ellie was painfully shy, hiding even when visiting neighbors came to the house. When she was seven, her grandmother took her to a class at the local dancing school to overcome her self-consciousness. The family could barely afford the $1 per lesson. At the first class, Ellie learned the five arm positions of classical ballet. "I just went out of my mind. I wasn't conscious of anybody," she remembered. "This was where I belonged." From then on, Ellie was at dance class every Saturday.

When Ellie was twelve, the family traveled to Atlantic City, where relatives lived and where Blanche got work as a hotel maid. Ellie was doing cartwheels and handstands on the beach when she was approached by Gus Edwards, a show producer, songwriter, and "star maker" who counted Groucho Marx, Ray Bolger, and Eddie Cantor among his discoveries. He hired Ellie for $7 a night to dance in his dinner show revue at the Ritz Grill. Ellie performed the only routine she knew: An acrobatic number she had done for her dancing school recital, which she described as "standing on my head, doing splits, turning round and so forth. Very slowly." Ellie worked three nights a week, and the $21 she earned was more than her mother was making cleaning hotels.

The beginnings of a great career.

After the Ritz Grill, she began appearing at other popular Atlantic City clubs like the Ambassador and the Silver Slipper as well as Martins, where she became the Mistress of Ceremonies. Soon she was making $75 a night and earning praise from famous clientele like Jack Benny and Eddie Cantor, who urged her to go to New York.

In 1927, Ellie and Blanche moved to the city. One day she went over to the William Morris Agency, walked right up to the receptionist, and said, "My name is Eleanor Powell and I'd like to be in the show." After an audition, Bill Grady, the company's top agent and the future casting director of MGM, took Ellie on as a client and convinced her that she could be more than just a specialty dancer. "When you step on a stage, I want you to open your mouth—have a few lines to say—be a personality," he told her. Grady got her a small part in her first Broadway show, the musical novelty *The Optimists*, which opened in January 1928. The show closed less than a month later, but Ellie kept going.

As she made her rounds auditioning, she was constantly asked if she could tap. "I loathed tap," she later admitted, but the fact that she couldn't tap dance was starting to cost her jobs. Ellie begrudgingly enrolled in a beginner's class at Jack Donahue's dance school. She had paid $35 for ten lessons in order to save money, but by the end of her first day she was regretting that decision.

"It was the first thing that had licked me," she recalled. She didn't go to the next class, and the next day Jack Donahue called to ask why she wasn't there. Ellie told him it wasn't his fault but that she just didn't understand tap dancing. Donahue promised to watch her carefully to see if they could figure out the trouble. After her second class, Jack Donahue took her to a private room and told her she was "very aerial" and "too ballet." He put a war surplus belt around her waist and added two sandbags that were used to hold down the curtain at the theater. Donahue taught her the fundamentals for forty-five minutes, and after he left, she stayed behind practicing for another two hours. "It was like an algebra problem you couldn't make out," she said, "then suddenly you see the light and it's like you've always done it."

By the end of the eighth lesson, Ellie was with Donahue in front of the class demonstrating the routine for the rest of the students. It was this routine that got her a spot in the Broadway show

Ellie appearing at Atlantic City nightclubs.

"I WASN'T CONSCIOUS OF ANYBODY, THIS WAS WHERE I BELONGED."

Follow Thru. "Any kid from the class who came to see the show would see me do the class routine on stage because what else did I know?" Calling itself "a musical slice of country club life," *Follow Thru* opened in January 1929 and was a smash, running for 401 performances. During the run, Ellie practiced constantly. After a matinee show, while the rest of the cast would go out to dinner, socialize, and relax, Ellie would grab a sandwich and return to the stage with her hand-cranked Victrola, play her Fats Waller records, and dance until the half-hour call for the next performance. Aside from the first dance numbers she had learned in school, Ellie choreographed all of her own routines. She kept a notebook and pencil by her bedside to record ideas because most of them came while she was asleep. "I used to dream my best ideas," she said. "In my dream I would see it, and I'd wake up . . . and I'd jot the idea down in shorthand—hoofer shorthand— and the next day I'd work out the dance."

She also made her (uncredited) film debut dancing in an obscure Paramount film, *Queen High* (1930), with Ginger Rogers. A slew of Broadway musicals followed, including *Fine and Dandy, Hot-Cha!,* and *George White's Music Hall Varieties.* One night in 1931, Helen Keller came backstage to meet her at Radio City Music Hall. "She had Miss Sullivan, her interpreter, with her," Ellie recalled. "I was just thrilled. She ran her hands all over my face, and I asked if I could have a picture, and she said, yes, if she could have one of me." The picture Helen sent her was one with her two Great Danes and the inscription: "To Eleanor Powell, I would gladly exchange my two dogs for yours, Helen Keller."

When she wasn't on Broadway, she was performing with legendary tap dancer Bill Robinson for private events at the homes of the Astors, the Guggenheims, and other wealthy New Yorkers. Many of them made Robinson, who was black,

use the back door. Ellie would say, "Bill's going through the back door, I'm going through the back door too." Ellie had no patience for racism, and she always credited Robinson and other black dancers for creating the form that she excelled at. She and Bill remained lifelong friends, and he was later the godfather of her only child.

On November 21, 1934, Ellie celebrated her twenty-second birthday on a train to Hollywood to do a specialty dance in *George White's 1935 Scandals*. She was wary about the "wicked place" she had heard such awful things about, and her experience there confirmed her fears. She was the only sober member of the cast. Everyone else was constantly drinking, and a lead actor was once "so stoned" he ate the artificial food in a scene. When production wrapped, she headed back to New York, promising herself she'd never go back to Hollywood. But MGM head Louis B. Mayer was impressed by her number in the film and wanted Ellie for a specialty number in the musical extravaganza *Broadway Melody of 1936*. Ellie told her agent she would do it if they gave her a thousand dollars and an actual role in the film, expecting MGM to tell her to take a hike. They didn't.

Instead, on her first day at the studio, Mayer was so impressed by her dancing that he decided to test her for the lead role. Terrified, she tried to talk him out of it, but Mayer told her he ran the studio and if he wanted her to make a test, she was making a test. She got the part, and the studio set about getting her ready for her close-up.

MGM had her teeth capped and her freckles faded with a series of ultraviolet light procedures. Her hair was given a permanent wave and a lightening rinse. Her eyebrows were plucked, and the ends were shaved so they could be penciled into perfection. She was given daily diction lessons and taught how to handle her hands properly on the screen. The dancing for the film was nearly as grueling as her makeover: By the end of filming she had lost four toenails on her right foot. It was all worth it when the film premiered.

"Chiefly the cinema news this morning concerns Miss Eleanor Powell, a rangy and likeable girl with the most eloquent feet in show business," the *New York Times* raved. "If she is not quite the distaff Fred Astaire, she is certainly the foremost candidate for that exalted throne. . . . Miss Powell's dazzling pedal arpeggios convert the sober art of tap-dancing into a giddy delight." *Screenland* magazine said "not since Fred Astaire's film debut has a movie audience been so electrified." *Variety* wrote, "[I]t's inevitable that she be termed a femme Astaire, for she's possessed of the same nimble tread, finished precision and general adeptness in her stepology."

Mayer signed Ellie to a seven-year contract and gifted her a portrait of himself, inscribed, "You are my lucky star!" MGM built her a special rehearsal hall with two dressing rooms attached, each with its own bath. They also built bleachers on her sets to accommodate the spectators like Greta Garbo, Joan Crawford, Jean Harlow, and Clark Gable, who always dropped by to watch her dance.

Ellie choreographed her own numbers, making her the only female choreographer at MGM. She challenged herself with difficult routines, dancing with a dog she trained herself, tapping with a horse, dancing off a diving board and leaping across a pool, and dancing in the rain (long before Gene Kelly). And she never shied away from outrageous stunts like twirling her way down a sixty-foot-high fire pole and dancing across sixteen-foot-high drums—with plenty of splits, flips, and spins along the way.

But what audiences really wanted was to see her dance with Fred Astaire. She would soon get the chance, with Mayer deciding he wanted to pair her

with Astaire in *Broadway Melody of 1940*. The only thing left was for Ellie and Fred to meet to make sure their height was a match. At their fateful meeting in Mervyn LeRoy's office, Ellie measured in at five feet, six and a half inches in her stocking feet. Fred, whose height (or lack thereof) was often a subject of debate, would find a way to make do.

The two planned to co-choreograph their duet numbers for the film, but their styles were very different, and things started slow. Both were naturally shy and nervous to encroach on the other, and it was unclear who was going to take the lead. Ellie decided to make the first move.

"Mr. Astaire, I have a number and there's something wrong in the middle of it," she said. "If I did it for you, would you please help me with the center part of it?" They began to test out moves for each other. After a few days, they had a breakthrough, and Fred ran over excitedly and lifted her, exclaiming, "Oh, Ellie!" Embarrassed at his forwardness, he quickly put her down and said, "Oh, I beg your pardon, Miss Powell."

"Please, we're just a couple of hoofers," Ellie told him. "Can't I call you Fred?"

Fred smiled, and the ice was finally broken.

Both were perfectionists and often worked straight from 8:00 a.m. to 4:00 p.m. without noticing the time. Ellie later said that they rehearsed as though they were "creating a cure for cancer." Eventually, they had to set an alarm clock so the piano player could take a break. They spent two weeks just rehearsing their arm movements for their nine-minute-long routine to Cole Porter's *Begin the Beguine*, hailed by critics and still regarded as a dance classic.

One day during production, the great conductor Arturo Toscanini came to see Ellie do what he called "the dance with the noise." A week later, she received a letter from him saying the three memories he would take with him when he left this world were the Grand Canyon, the sunset, and Eleanor Powell's dancing.

The film debuted with the tagline "The World's Greatest Dancers In The World's Greatest Musical

Rehearsing, rehearsing, rehearsing... Ellie and Fred's hard work paying off.

Show," and the critics agreed. "Fred Astaire . . . is finally teamed with a dancing partner who is his match as a dancer," the New York *Daily News* declared. "Their work together is so smooth and perfectly timed that watching them together . . . is an esthetic treat of major proportions."

Fred had no illusions about who was the better dancer.

"She 'put 'em down' like a man," he said, "no ricky-ticky-sissy stuff with Ellie. She really knocked out a tap dance in a class by herself." Years later, he would tell her son, "Your mother is a much better dancer than me!"

As Ellie's career blossomed, so did her love life. Blanche had instilled a fear of premarital sex in her daughter, and Ellie remained a virgin until her wedding day, when she was nearly thirty-one years old. One day in May 1942, she met an up-and-coming actor named Glenn Ford. "I had only seen her in black-and-white movies, and in person I was struck by her coloring, her

Ellie and Glenn at Ciro's in 1942.

"SOMETHING HAD TO GIVE, AND IT WAS

MY CAREER."

chestnut hair, worn in soft waves to her shoulders, this glowing complexion, and beautiful cornflower blue eyes," Glenn recalled. "And when she smiled, I was just captivated."

After their first date, at Musso & Frank's on Hollywood Boulevard, they quickly became inseparable. And on Christmas Day, 1942, Glenn got down on one knee and asked for her hand. America was at war, and Glenn enlisted in the Marines. Ellie announced her retirement from show business.

Ellie later explained that the main factor in her decision to retire was her marriage to a man just starting his career when she was at the top of hers. "He had such an inferiority complex, it was sheer hell," she said. Glenn would be told there was a wait at restaurants—until the host would see Ellie and say, "Ah! Miss Powell! But, of course, come right this way. We have your table." Glenn would "die a thousand deaths" and refuse to eat

at the restaurant again. "We were running out of restaurants," Ellie said. "Something had to give, and it was my career."

Glenn and Ellie married at her home on October 23, 1943. Soon after, Ellie was pregnant, and on February 3, 1945, she went into labor. Thirty-two arduous hours later, in the early morning hours of February 5, Ellie gave birth to Peter Newton Ford. Using Ellie's savings, the family moved into a twenty-two-room mansion in Beverly Hills, where husband and wife each had their own lavish bedroom. In between was a bedroom occupied by Glenn's mother.

It wasn't long before Ellie and Glenn's marriage was in trouble. While Glenn was filming *Gilda* (1946), Ellie learned of his affair with Rita Hayworth when a drunken Orson Welles showed up at their house with a gun demanding to know where Glenn was hiding his wife. Not long after, Columbia's notoriously ruthless studio head Harry Cohn warned

her to keep her husband's affair with actress Adele Jergens from causing a scandal for the studio. During the filming of *The Green Glove* in France, when his leading lady, Geraldine Brooks, spurned him, Glenn got so drunk he actually enlisted in the French Foreign Legion. "I guess deep down, in the far pockets of my soul, I knew Glenn and I were mismated," she said. "But I continued to hope things would get better."

In 1947, they needed money, so Ellie dusted off her dancing shoes. "Mamma is off on a three-months tour to pay for the house and the college fund," she announced to the press. Glenn wasn't thrilled about Ellie going off on tour or about the press coverage of his inadequate earnings. But he didn't complain about Ellie's $5,000-a-week paycheck (nearly $60,000 today).

Ellie played to sold-out theaters across the country and in London and Scotland. She performed for President Truman and future president General Dwight D. Eisenhower.

After the tour, Ellie settled back into her domestic routine and devoted herself to raising her son. Peter would later declare that she was a better mother than she was a dancer, high praise for one of the world's most renowned hoofers. She joined the PTA, volunteered with the Beverly Hills Boy Scout Troop, and became the Sunday school teacher at the Beverly Hills Presbyterian Church. In 1953, her class was adapted into a television show, *The Faith of Our Children*, which aired live on KRCA Los Angeles every Sunday. The program promoted itself as a show for children of "any denomination, race or color" and consisted of inspirational religious lessons paired with dramatizations by the children and musical entertainment. Money mailed in from viewers was distributed to charities of all faiths. One day, a well-known minister called Ellie to complain about "the number of dark-skinned youngsters" on her show. She promised to address his concerns in the next episode. That week, the entire cast was black, and the minister never called her again.

The Faith of Our Children won five Emmy Awards. Ellie accepted no salary, and she wrote all the scripts, designed the sets, arranged guest appearances, and provided costumes and props at her own expense. Ellie tried to take the show to syndication, but when NBC wanted to limit the program to one religion and an all-white cast in 1956, she walked away. *The Faith of Our Children* was one effort in a long life of advocacy, and over the years Ellie won awards from a variety of organizations, including the National Conference of Christians and Jews, the Jewish National Home for Asthmatic Children, the Sister Kenny Foundation, the National Council of Negro Women, and the Los Angeles Urban League.

May 1, 1959 was Glenn Ford's forty-third birthday, and Ellie finally gave him the gift he had long deserved: A divorce. Now, she began to crave a comeback.

Ellie said she wanted to do a comeback tour to show her son, Peter, that she was once a star. "That is true, but the real reason is we were broke," Peter says. "My dad didn't give her enough alimony in order to have us survive and so we were eating Hamburger Helper." Ellie even had Peter rationing toilet paper. If she wanted to keep the house, she was going to have to earn some money fast.

Ellie hired ballet instructor David Lichine to whip her into shape. She danced for six hours a day, six days a week, for nine months. She went on a diet and lost thirty-three pounds. On January 24, 1961, she announced her comeback and proved it by launching into a thirty-minute dance routine for reporters. "I know you all want to see if I'm senile or not," she said.

On the night of February 28, 1961, Ellie was at the Sahara in Las Vegas, anxiously awaiting her first performance in fourteen years. She took the stage in the Conga Room and danced for forty-five minutes for a capacity audience of 650 and received three curtain calls and a minute-long standing ovation. "I consider it the highest tribute I ever had," she told the crowd. "When you hear the tap of my feet, it's really the beat of my heart for you."

"Miss Powell . . . is 48. She doesn't look 38, dances as if she were 28, and has all the vim and vigor of an 18-year-old," wrote one Las Vegas critic.

She continued performing over the next few years across the country, and she never lost her commitment to fighting racism. During her run at the Dunes in Las Vegas, the management notified her that her son was having coffee with a black performer named Sammy Yates and that black people were not allowed to eat at the hotel. Ellie was enraged and began entering the hotel through the kitchen until the press got wind of it and the Dunes rescinded the racist policy.

She gave her final performance at the Storrowton Music Fair in her hometown of Springfield, Massachusetts, on June 15, 1964. In the audience that night was her ninety-two-year-old grandfather, her nineteen-year-old son, and a childhood friend she had found by placing a classified ad.

On April 10, 1981, she made a speech at the American Film Institute tribute to Fred Astaire, where she was introduced as "The Queen of Tap" and given a standing ovation. She spoke about how hard they worked on *Broadway Melody of 1940.* "And both of us all would always say, 'Could we do it just one more time?' We would still be there now,

1940–1981, if somebody hadn't been there to say, 'Look, it's just fine. Print it.' But Mr. Astaire, I still wish we could do it just one more time."

A little over a month later, Ellie learned she had uterine cancer. After an operation and a series of tests, a tumor was found on her left ovary. She underwent months of treatment, and through it all maintained her sense of humor. In a letter to a friend she wrote, "I look like a female 'Kojack.'. . . Good thing I look good in turbans."

On the morning of February 11, 1982, Ellie passed away at her home. She was sixty-nine.

On February 15, 1984, Eleanor Powell received a star on the Hollywood Walk of Fame. Though gone two years, she was not forgotten: Among the 250 people in attendance were Gene Kelly, James Stewart, Debbie Reynolds, Fayard Nicholas, and countless other stars who came to pay their respects to the only dancer who ever intimidated Fred Astaire.

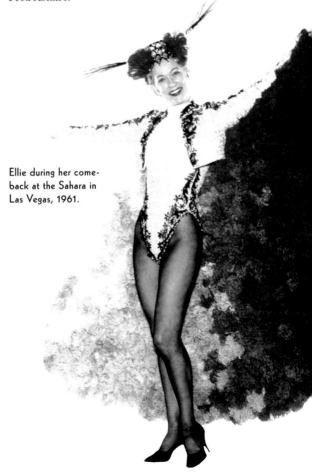

Ellie during her comeback at the Sahara in Las Vegas, 1961.

Becoming

RITA HAYWORTH

"I HAD TO BE SOLD TO THE PUBLIC JUST LIKE BREAKFAST CEREAL OR A REAL ESTATE DEVELOPMENT OR SOMETHING NEW IN LADIES' WEAR."

—Rita Hayworth

Margarita with her father and dancing partner, Eduardo Cansino.

WHEN one thinks of Rita Hayworth, the first image that usually comes to mind is her most iconic role as the ultimate femme fatale, Gilda. So closely would the two be intertwined that years later Rita would quip, "Most men fell in love with Gilda, but they woke up with me." But Rita Hayworth was every bit as fictional as Gilda ever was. In fact, the woman who would one day be known as "The Love Goddess" was just an awkward teenager, dancing with her father in a nightclub act in Tijuana, when Fox production chief Winfield Sheehan happened to walk in one night in 1934.

Her name was Margarita Carmen Cansino, third-generation member of the Dancing Cansinos, a famous Spanish dancing family. She was sixteen, plump, with long black hair that hung almost to her waist. Sheehan couldn't take his eyes off her. "That girl is a great beauty," he told his companions, who included famed gossip columnist Louella Parsons. "She could be a movie star with the right training." Everyone at the table laughed. "When she came to our table," Parsons recalled, "she turned out to be painfully shy. She could not look at strangers when she spoke to them and her voice was so low it could hardly be heard. Hardly, it seemed to me, the material of which a great star could be made." But Sheehan told Parsons, "You wait and see. She'll be a big star."

Sheehan offered Margarita and her father an all-expense-paid trip to Hollywood for two screen tests: One of her diction and another of her physical features. Impressed with the results, Sheehan signed her to a six-month contract and took the first small step on what would be a long and arduous road of transformation, shortening her name to Rita Cansino. He also put Rita on a rigorous regimen that included daily acting lessons, diction classes, and most importantly in Sheehan's thinking, a diet and exercise plan.

"I DEVELOPED A BURNING AMBITION."

"I developed a burning ambition—as only a too-fat seventeen-year-old can burn—to become a good actress," Rita later said. She explained the lengths to which she was willing to go for stardom:

I paid strict attention to my acting coach and to the woman who trained me to project my voice. At home I'd lock myself in the bathroom, stand in front of a mirror over the sink, and practice for hours. I learned to correct my posture and pose for pictures in the studio gallery for hours without complaining. It didn't require my being a genius to realize Fox was spending a great deal of time and money on my behalf and I intended for them to get their money's worth!

On her mother's side, Rita was of Irish and English descent, on her father's, Spanish. Fox decided to play up the latter in the hopes of molding her into the next Dolores del Rio. Rita wasn't too keen on the idea, saying, "I don't want to become another Dolores del Rio. I want to remain Rita Cansino. If I become a star I want to do so in my own right, and not because I imitated somebody else." But Fox cast her in a slew of exotic roles, ranging from a Spanish dancer in *Dante's Inferno* (1935) to an Egyptian servant in *Charlie Chan in Egypt* (1935). She was gearing up to star in a remake of del Rio's silent film *Ramona* when Fox merged with 20th Century Pictures, and everything changed. Darryl F. Zanuck was the new executive producer, and Rita was replaced in *Ramona* by Loretta Young.

Her contract was promptly terminated. "Naturally I cried and I screamed and I vowed I would show those people they'd made a terrible mistake," Rita said. "I would become famous and successful in films without them and they would be sorry."

Around this time, she met Edward Charles Judson, a middle-aged, balding, ex-gambler and car salesman. One day, after a business meeting at Fox with Sheehan, Judson tagged along to the projection room where the color rushes of Rita's tests for *Ramona* were being screened. He immediately saw a potential business opportunity and demanded her number. When he called Rita, he asked to take her out. A few months later, they were married. This was his third marriage, a fact he failed to disclose to Rita. He was forty; she was eighteen. "I married him for love, but he married me for an investment," Rita later said.

Judson would play a pivotal role in Rita's rise to stardom. Upon returning from their honeymoon, Judson got to work capitalizing on his new investment. He put together a business campaign that consisted of two pillars: Self-improvement and self-display.

Since Rita was freelancing, Judson got her parts in films by offering studio executives discounts on cars. And in 1937, Judson secured a deal for Rita with Columbia Pictures. Columbia studio boss Harry Cohn suggested that her last name and exotic looks were keeping her typecast, so Judson put Rita on a course of Americanization, the first step of which was replacing her Spanish last name with her mother's maiden name, Hayworth. Thus, Rita Hayworth was born.

"After I changed my name, I expected wonders to happen," Rita said. "But my roles didn't become any bigger or better." Even after the vigorous acting and voice lessons, dieting, and exercising, Judson still believed Rita needed more polishing. He took her to Columbia's studio hairdresser, Helen Hunt, to see what could be done about her "terrible" too-low hairline.

Rita with her first husband, Edward Judson.

"Her hair was just nothing at all," Hunt said. "She had plenty of hair, but the edges around the front were so bad!" The solution: Electrolysis.

"Achieving a new design for Rita's forehead entailed a long and very painful process," Hunt said. "Each hair had to be removed individually, then the follicle deadened with a charge of electricity." Rita dreaded the agonizing treatments, but Judson insisted she continue. Rita reported to Hunt once a month so that her hairline could be photographed and measured.

After seeing photographs of Rita's new hairline, Harry Cohn agreed to take over the payments for the electrolysis treatments, which would continue for another year. He arranged a screen test for Rita in the latest Howard Hawks film, *Only Angels Have* Wings (1939). "The camera said that her hairline was still too low and too black," said Hunt, "so I suggested putting a bleach streak across her forehead. We tested, it was a success."

Now that she was "self-improved," it was time for self-display. Judson hired a press agent, Henry Rogers, to publicize her as a sex symbol. Rogers began his publicity campaign by approaching *Look* magazine in early 1940, pitching Rita as the actress with the best wardrobe in Hollywood, who spent her entire $15,000 salary on clothing. He sent the magazine a fake telegram signed by the president of the made-up Fashion Couturier's Association of America, attesting that they had voted Rita the year's best-dressed actress. The magazine decided to send someone to photograph her at home. Rogers and Judson had to run all over town borrowing the finest jewelry and evening gowns to produce the wardrobe for the "Best-Dressed Girl in Hollywood." Six weeks later, Rita was on the cover of *Look*.

"Once the ball got rolling, it accelerated itself, it was self-generating," Rogers said. Rita soon found herself appearing in fashion spreads in magazines and newspapers across the country.

Meanwhile, Judson continued taking Rita to all the Hollywood hotspots so she could be seen and photographed. He would buy photographers drinks and invite the press to their home every Sunday. After six months of this "photographic marathon," Rita had become the most photographed and written about girl in the business. Also, the story of Rita's metamorphosis was circulated in the press, a stark contrast to the carefully crafted and curated images of studio stars like Greta Garbo and Marlene Dietrich. Rita's physical transformation

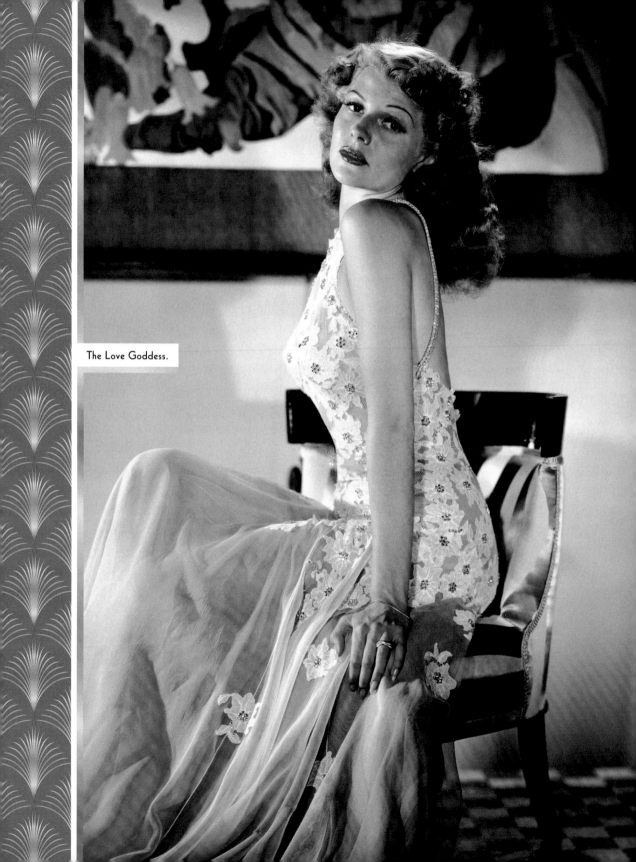

The Love Goddess.

was covered in articles with cringe-worthy titles such as "From Ugly Duckling to Movie Knockout" and "Oomph for Sale." But for movie fans, the idea that the right enhancements could give them a chance at stardom was powerful.

Eventually, Helen Hunt would suggest making Rita's hair red to do away with the streak of bleach on her forehead. "It was the turning point in my career," Rita would later explain. "As soon as I became a redhead things began to happen." Boy, did they.

In 1941, her career took off. She danced alongside Fred Astaire in *You'll Never Get Rich*, followed by *You Were Never Lovelier* in 1942. Throughout the 1940s, she was Columbia Pictures' number-one box-office star and turned the impoverished studio into a major Hollywood player with successful films like *Cover Girl*, *Tonight and Every Night*, and *Gilda*. During World War II, she was a top pinup girl for American GIs, who sent her more than 6,000 letters a week. In 1946, her image was on the fourth atomic bomb ever detonated (christened Gilda, naturally). *Life* magazine dubbed her "The Love Goddess" in 1947,

and her tumultuous love life kept her in the headlines. She divorced Judson, married and divorced Orson Welles, became a princess when she married Prince Aly Khan, and then married and divorced singer Dick Haymes and producer James Hill.

But no matter how big Rita Hayworth or her headlines got, she always saw herself as Margarita. "The screen's Rita Hayworth is a woman entirely apart from me," she explained. She often signed her letters with an "M" and expressed pride in the heritage that Hollywood tried to erase, saying, "I speak Spanish and everything—hell I am Spanish!"

In the end, she was more like her own fans than the mythical love goddess she played in the movies. "I never think of myself as the least bit glamorous," she said. "If I want any glamour, I get it vicariously by reading stories about that other Rita Hayworth."

THIS WAS HOLLYWOOD...

Fashion!

In a design by Helen Rose for
Till the Clouds Roll By (1946).

Perfection in peach, 1947.

Lovely Lena

A look back at the fabulous Forties fashions of
Lena Horne, one of Hollywood's most glamor-
ous and underappreciated movie queens!

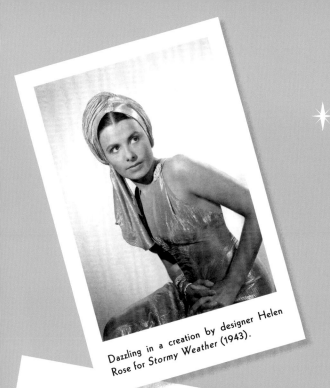

Dazzling in a creation by designer Helen Rose for *Stormy Weather* (1943).

Lena had everyone green with envy in this sophisticated gown, 1947.

Looking snappy in this smart suit for a shoot with the *Daily News*, 1947.

Casual Lena: Lounging in olive-green gabardine slacks, an olive sweater, and brown suede shoes, 1947.

Susan Peters

A RISING STAR WITH
A TRAGIC FALL

I T was New Year's Day, 1945, and Susan Peters was on top of the world. The twenty-three-year-old was one of the film industry's fastest rising stars, with an Academy Award nomination already under her belt. But on that fateful afternoon, in the Cuyamaca Mountains near San Diego, everything changed in the blink of an eye. A gun misfired. A bullet sliced through her stomach and into her spine. And just like that, the life of one of the silver screen's most promising young actresses was changed forever.

She was born Suzanne Carnahan in Spokane, Washington, in 1921. When she was five, her father died in a car accident and she was sent to live with her grandmother, whom she called "Ma Mere," in Los Angeles. Suzanne would spend summers with her mother and brother in Washington state. One summer, she met a young boy paralyzed by polio. "I couldn't understand why he couldn't be cured," Susan later explained. "That's when I was determined to study medicine." But once she enrolled at Hollywood High School, a completely different path would present itself.

Ever since Hollywood High alumna Lana Turner had been discovered, talent scouts had been hanging around the campus on the hunt. During Suzanne's senior year, she decided to take a drama class as an elective. A talent scout sat in on her oral exam at the end of the year, and when she finished her performance, he had just one question: "How would you like to be in pictures?"

Suzanne was stunned. "Acting paid well," she reasoned, "and if I didn't take it too seriously and allowed myself to be hurt by failure, I would at least have money enough for medical school."

The scout was Lee Sholem, who worked for producer Sol Lesser. The very next day, she got her first taste of rejection when Sholem took her to see his boss. The legendary producer wasn't interested. Instead, it was the writer Salka Viertel, a good friend of Ma Mere and an advisor to Greta Garbo, who helped Suzanne get her foot in the door. Viertel took Suzanne to Warner Bros. and also introduced her to director George Cukor, who was casting for the MGM production *Susan and God*.

her to pick one. She chose Susan Peters.

But the new name didn't give her career the kickstart she was hoping for. After a failed engagement and a leave of absence for an "appendectomy,"[1] Susan returned to the studio, only to find out she wasn't getting the role of "Cassie" in *Kings Row*. Not long after, Warner Bros. decided to let her go.

She was two years into her three-year deadline, and she was seriously considering going back to pursue a medical career until she was offered a substantial part in the MGM production *Tish*. During filming, Susan met actor Richard "Dick" Quine, and the two quickly fell in love. There was just one small obstacle to her new romance: Dick was already married to another MGM actress named Susan—Susan Paley.

In June of 1942, director Mervyn LeRoy and producer Sidney Franklin were having difficulty

"Heart and sympathy

WERE ALL WE WERE LOOKING FOR. SHE HAD BOTH."

Before she heard back from Cukor, she reported to Warner Bros. for a screen test on March 22, 1940. The next day, the studio offered her a contract. She also found out that Cukor had cast her in a bit part in his film. Her career appeared to be off and running. Suzanne gave herself a deadline to make it as an actress, promising that she would quit if she hadn't made good after three years.

At Warner Bros., Suzanne spent her time in the studio's school of dramatics, elocution, and dance, and she continued to make screen tests. *Lots* of screen tests. "For some reason, I was the 'official test girl,'" she said. Whenever a potential male star tested for a part, Suzanne invariably appeared with him. In between tests, she was put in bit parts and small speaking roles in a few forgettable films. After a year at the studio, executives told her that her name was no good and that they were changing it to one more fit for a movie marquee: Sharon O'Keefe. Suzanne hated it, so the studio sent her a list of fifty names and told

casting the crucial supporting role of Kitty in *Random Harvest*. After testing a dozen actresses, they began to search through old footage. When they got to Susan, they knew they had found their girl. "Heart and sympathy were all we were looking for. She had both," LeRoy said. "We looked no further. We had a new star." Susan was offered the role on the spot, without even having to test. MGM also signed her to a long-term contract. LeRoy then telephoned his father-in-law, Jack Warner, to brag about the new star Warner had let slip through his fingers.

The first day on the set, Susan was starstruck and "scared to death" by her superstar colleagues Greer Garson and Ronald Colman. After the first take, LeRoy took her aside and told her, "I'm afraid you haven't got what it takes. Kitty is a girl with poise and dignity. You're playing her like a timid

[1] *The nature of the actual procedure remains unclear, but "appendectomy" was a popular studio code word for "abortion." Taken at face value, Warner Bros. studio memos would indicate there was an appendicitis epidemic among female actors at the time.*

school girl." The criticism drove Susan to improve. When the film wrapped, she waited anxiously for the first preview. Finally, it came. "I sank lower and lower into my seat, afraid to look when the moment came for my entrance," Susan recalled. "The moment arrived, and with it I departed. I was just too frightened to sit there and watch. Mother stayed and I spent the next hour sitting in the car in the parking lot, waiting for her to come with the verdict." The verdict was unanimous: Susan was a hit, and MGM knew it. Before the picture was even released to the general public, the studio began discussions to give her a raise and a bonus of $2,500.

Susan didn't see *Random Harvest* until two months after its release, going by herself to a small neighborhood theater. By then, she had already been nominated for an Academy Award for Best Actress in a Supporting Role. She lost to Teresa Wright of *Mrs. Miniver* (1942), but her performance was a breakthrough, and MGM immediately put her into starring roles.

In early 1943, MGM was preparing one of its most important productions of the year, *Song of Russia*. Many major actresses, including Greta Garbo and Hedy Lamarr, were considered for what was being called "the plum feminine role of the year." By March, Louis B. Mayer had made up his mind: He wanted Susan Peters.

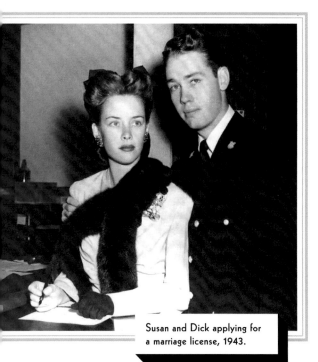

Susan and Dick applying for a marriage license, 1943.

She got some good news in her personal life as well: Dick had gotten a divorce. On November 7, 1943, he and Susan married. They had a small reception and five-day honeymoon before Dick returned to his wartime duties in the Coast Guard.

Song of Russia, released in February 1944, was a critical and box-office hit. Bosley Crowther of the *New York Times* loved it so much he reviewed it twice. *Variety* was effusive:

> *Song of Russia . . . establishes the stellar value of a comparative newcomer: this is Susan Peters' most important role to date. It reveals her as one of the finest young dramatic actresses to emerge from Hollywood in some time. The word-of-mouth on her performance, beauty, and expressive underplaying should make her a "must" in any future Metro plans.*

Susan's star continued to rise. Her next major role was to be in MGM's *The Outward Room*. But good news soon turned to bad. On March 21, 1944, Susan's beloved Ma Mere passed away. Just a few weeks later, Susan was rushed to Santa Monica Hospital for what the press called "an emergency abdominal operation" but that Susan later revealed was a miscarriage. Susan spent weeks recuperating and trying to regain the eighteen pounds she had lost so she could film her remaining scenes for *The Outward Room*. Ultimately, her prolonged illness caused MGM to shelve the film.

And even greater tragedy lay just around the corner. As 1944 came to a close, Susan, Dick, and one of his cousins went duck hunting near Lake Cuyamaca, outside San Diego.

On New Year's Day, as the party went off for a hike, Dick's cousin left his rifle under a bush. Upon returning, Susan went to retrieve the gun. The trigger caught on a branch, and she was shot in the upper abdomen. "I felt I was spinning for five minutes," Susan recalled, "then came wonderful peace."

At the hospital, an emergency operation was performed to remove the bullet lodged in her spine. But the bullet had destroyed her lower spinal cord, leaving Susan paralyzed from the waist down. Initially, her physicians believed this was only temporary. "The doctors say that although paralysis is there now, Susan is improving rapidly and eventually will be able to walk again," her mother said while keeping a bedside vigil for her daughter at the hospital.

By June 1945, Susan was trying to learn how to walk again. Every afternoon she would put seven pounds of braces on her legs and try to walk holding on to a set of bars. "I took three steps in my braces," she told one reporter proudly. "I think I ought to be walking pretty well in three months."

Three months later, she still wasn't walking, but she had returned to acting, this time on the radio. In September, she appeared on a radio broadcast with Van Johnson and declared to the press she could take eight steps in her leg braces now. During an interview in November at her Malibu home, a reporter asked Susan if she thought she would walk again. Susan replied, "I firmly believe that if you try hard enough and want something, you will do it. If you hold bad thoughts, nothing will happen. I'm trying. . . . But someday I think I will get up out of a chair under my own steam."

But Dick discouraged her, saying, "Let's not be too sure, darling." The reporter was taken aback. "He doesn't want me to be disappointed," Susan replied. When Dick left the room, Susan told the interviewer that the accident was actually "toughest on the one who isn't hurt."

Susan had much adjusting to do after the accident and after the sudden death of her mother from a heart attack in December 1945. She faced difficulties navigating a world that made little accommodation to those in wheelchairs. "Just as soon as I admitted the wheelchair had become part of my life and accepted it," she said, "things became less gloomy and my interest in life picked up." In due time, Susan was driving her own specially equipped car, horseback riding, swimming, taking flying lessons, and even hunting again. She adopted a son, Timothy, in 1946, and was ecstatic at the thought of having a big family.

Even as her spirits picked up, her career didn't. MGM had kept Susan on salary and was paying to cover her medical bills as she recuperated. They were also sending her countless scripts, but she rejected all of them, feeling they were trying to capitalize on

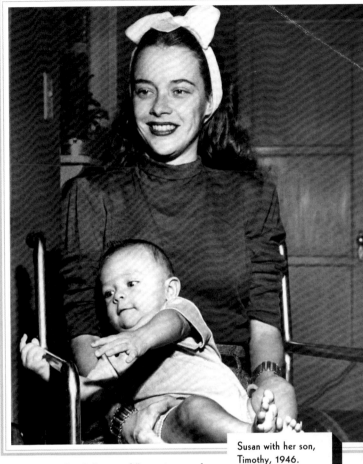

Susan with her son, Timothy, 1946.

her injury and "were too saccharine." MGM then wanted to dig up *The Outward Room*, which had been shelved a few years earlier. "They planned to write in a scene with a balcony collapsing, film it with a double, and have me play the rest of the part in a wheelchair." Susan refused and decided to end her contract with MGM. "I wasn't a God-is-love girl before my accident," she explained. "And I'm not going to be one now. I want to be a hellcat in a wheelchair."

Finally, she found a story that allowed her to be just that. Margaret Ferguson's best-selling novel *The Sign of the Ram* is the story of a woman confined to a wheelchair who uses her disability to manipulate and destroy the lives of those around her. The character presented a strong dramatic role that was a major departure from the ingenue types Susan had portrayed at MGM. "Leah is a completely domineering woman," Susan said. "But

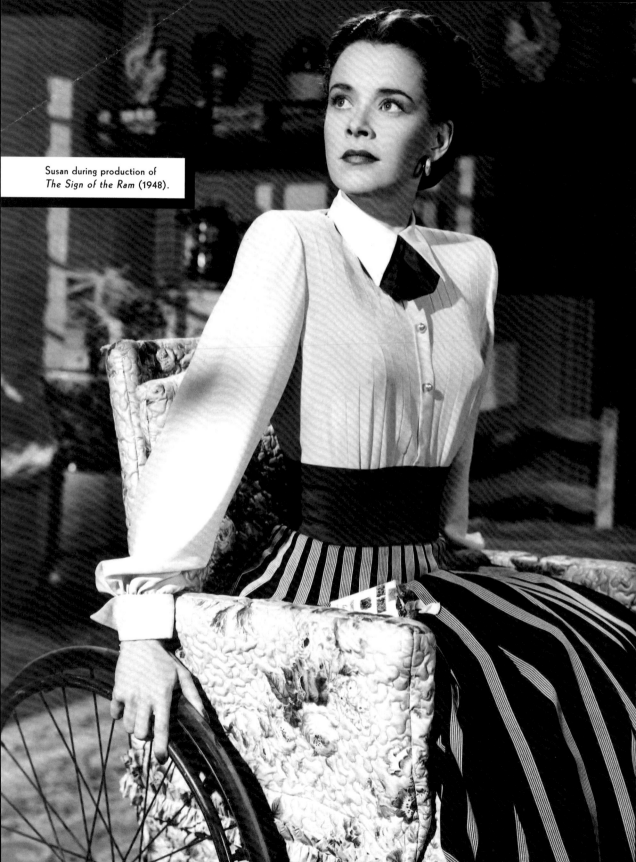

Susan during production of
The Sign of the Ram (1948).

I know what makes her that way. It is the fear of being alone."

Susan was ready to return to the screen, not as a victim but as a villain, and she would produce her comeback film herself. She formed a production company and signed a distribution deal with Columbia Pictures, which provided the production facilities. Charles Bennett was brought on to adapt the book for the screen, and John Sturges was hired to direct.

Columbia took every care to make Susan's return a welcoming one. Not even Rita Hayworth was allowed to drive on the studio lot, but the rule was waived for Susan. The workday was shortened, Susan's dressing room and the entire set were air conditioned, and the studio hired her relatives to assist her daily.

Plainly the story is claptrap. And the direction of John Sturges is such that the illogic and the pomposity are only magnified. By showing Miss Peters, in her wheelchair, as though she were an alabaster doll, with just about as much personality, he has completely denatured her role.

The film was equally disappointing at the box office. "It was one of those kinds of pictures that nobody particularly wanted to see," Charles Bennett explained. "But it was a good picture."

As her comeback faltered, so did her marriage. By March 1948, she and Dick had separated, and rumors were swirling that they would divorce. Afraid people would think that he walked out on Susan in her time of need, Dick ran to gossip columnist Louella Parsons to get ahead of the story.

"I KNOW WHAT MAKES HER THAT WAY. IT IS *the fear of being alone.*"

On July 16, 1947, Susan reported to Columbia to film her first scene in over two years. Her dressing room was flooded with flowers and congratulatory telegrams, and stars like Ginger Rogers and Glenn Ford dropped in to wish her well.

Susan was ecstatic to be back on set. "Taking greasepaint away from an actress is like crossing off lollipops from a kid's diet," she said. "Life just doesn't seem the same. Now that I'm back at work, life again is interesting and complete."

Throughout filming, Susan was clear about what she wanted out of her performance. "I know they will come in to see how I look in a wheelchair," Susan said. "If I can send them out thinking I'm an actress, I'll be satisfied. This is my great opportunity." She was feeling confident enough that, just a few weeks into filming, she was already taking steps to produce her next film.

Unfortunately, *The Sign of the Ram* was not the comeback picture she had hoped for. When the film premiered in March 1948, critics panned the "unhappy and dreary" tone of the film.

Bosley Crowther, once her champion, was especially brutal:

"This divorce is her idea," he explained. "She has said again and again she is much happier alone."

Susan responded, saying Dick "was entitled to a normal life, which he can't have with me. . . . I want him to be free to have his own career which has been sadly hampered."[2] Despite his public protestations about the divorce, Dick was already openly dating the actress Virginia Grey. Susan filed for divorce on the grounds of extreme cruelty, accusing Dick of "grievous mental and physical suffering."

Also upsetting was Susan's difficulty finding work in Hollywood. She decided to turn her eyes to the stage, making her debut at the Norwich Summer Theatre in Connecticut in the role of Laura in Tennessee Williams's *The Glass Menagerie*. Williams allowed the play to be changed so that Susan could act the part from her wheelchair. She followed this with the role of Elizabeth Barrett Browning in *The Barretts of Wimpole Street*.

[2] *Norman Lloyd, an actor at MGM at the time, recalls that one of the reasons Dick had trouble getting work was because people around town suspected that he had shot her. Susan was emphatic that she alone was to blame.*

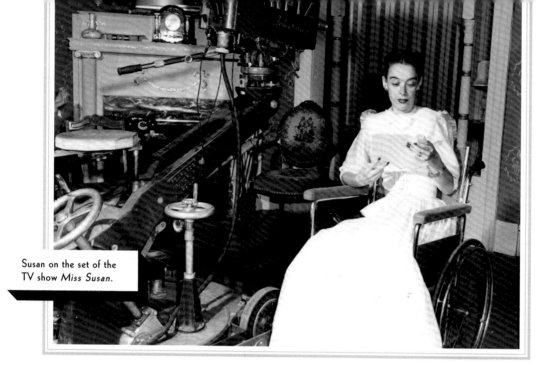

In January 1951, Susan starred in NBC's first daily serial program, *Miss Susan*. The fifteen-minute live daytime drama, about an attorney who moves back to her hometown after a car accident, was the first television program to star a person with a disability.

When the groundbreaking show premiered, it was panned, although Susan was praised. "In view of Miss Peter's marked acting ability, plus a sensitive clean-cut facial beauty and appealing sincerity, it's difficult to understand why the producers of this across-the-board series didn't come thru with adequate production and scripting," *Billboard* wrote. "*Miss Susan* has nothing to offer beyond the personal magnetism of its star."

Outside of work, Susan spent her time as an advocate for people with disabilities. She visited paraplegics and war veterans and appeared in revue shows for organizations that raised funds to help people with disabilities.

After the cancellation of *Miss Susan* and with no projects on the horizon, Susan's optimism about life was beginning to wane. For the first time, she admitted no hope of ever walking again. "How can I—I have no spinal cord," she said. "It will take longer than I live for doctors to find a cure."

By March 1952, Susan was living with her brother Bob and his wife in Lemon Cove, California. "She had to come live with me, which probably hurt her pride," Bob said. "She just didn't have any place else to go at the moment . . . she was a paraplegic alone in the world. She had horrendous bills and her income was going downhill."

Her health was also deteriorating rapidly, and a kidney infection caused her to become severely ill with bronchopneumonia. On October 23, 1952, she entered Visalia Municipal Hospital in what doctors described as a "terminal state of illness." At 5:40 p.m., with her brother and his wife by her side, Susan passed away. She was thirty-one years old.

Her personal physician believed Susan had "lost the will to live." He said that in the last few months of her life, Susan had refused to allow anyone to help her and had lost interest in eating and drinking. "She often spoke to me of dying, saying it was probably the answer to her problem."

Susan was laid to rest after a small service at Forest Lawn Memorial Park in Los Angeles, attended by just a few close friends and family.

Susan's life, though cut tragically short, is more than just a story of what could have been. She was nominated for an Academy Award, broke ground for people with disabilities in the entertainment industry, and did her best to brighten the lives of those in pain. And her films, though few, remain as a legacy of one of Hollywood's most promising young stars.

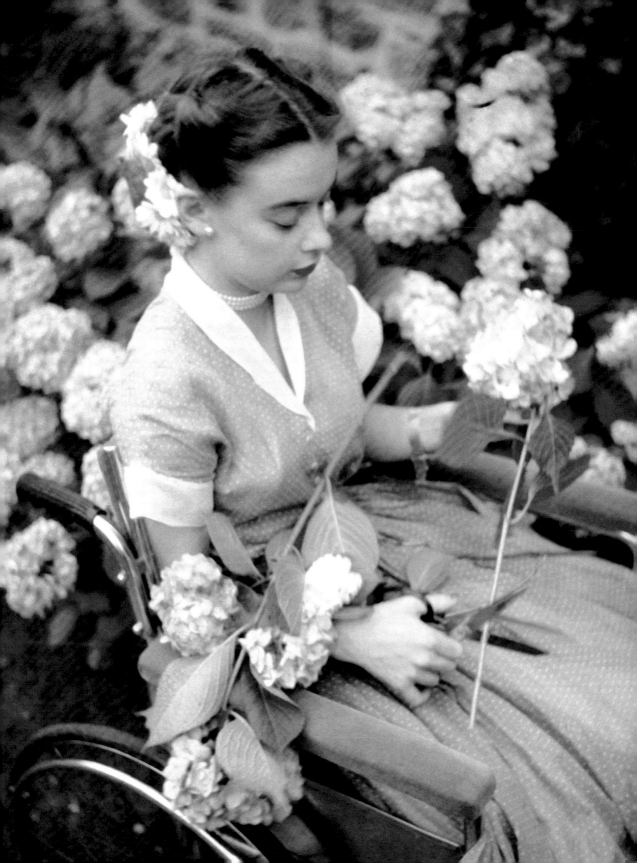

MARNI NIXON:

YOU may never have heard the name Marni Nixon, but you've most definitely heard her voice. She was an accomplished concert and opera singer, recording artist, and stage performer, and she even had her own local television show. But her greatest role was recording iconic numbers in many of the most acclaimed musicals of all time as the ghost singer for some of Hollywood's most beloved stars.

Her ghost-singing career began shortly after she was hired as a "messenger girl" at MGM.

She was taking free voice lessons at the studio and was asked to dub a lullaby for Margaret O'Brien in *The Secret Garden* (1949). Over the next few years, she did a few more dubbing jobs: For Jeanne Crain in *Cheaper by the Dozen*; Ida Lupino in *Jennifer*; even Marilyn Monroe's high notes in "Diamonds Are a Girl's Best Friend" from *Gentlemen Prefer Blondes*.

And in 1955, her career as Hollywood's "ghostess with the mostest" took off. Here are just a handful of the legendary roles she lent her voice to.

UNSUNG HERO

DEBORAH KERR IN *THE KING AND I* (1956)

I N August of 1955, Marni received a phone call from 20th Century Fox asking her to audition for the singing voice of Deborah Kerr. She won the role, but when she was presented with the contract, she was aghast. She would receive no royalty for the recording and, worse, no on-screen credit. "I was torn," Marni said, "but the studio had made the choice clear: either I do the job anonymously, with no credit at all, or walk away." Reluctantly, she agreed to their terms.

Deborah and Marni worked hard to get in sync. They began by rehearsing each song together. "By doing this we each began to see how the other breathed and phrased the lyric," Marni said. Then when Deborah would rehearse the blocking of the scene, Marni would join her and follow her every movement "down to the angle of her head."

"I would listen closely, trying to understand each of her acting intents so that I might absorb them into the way I was singing," she explained. When it came time to record, Marni imagined she was in Deborah's body, while Deborah studied Marni closely so she could incorporate Marni's body language and breathing into her performance.

During production, 20th Century Fox told Marni that if word got out about her role, they'd make sure she never worked in Hollywood again. But word did get out—from Deborah Kerr herself, who told a columnist *part* of the story, claiming that Marni had sung the high notes for her. From that point on in Hollywood, the name Marni Nixon was "forever synonymous with 'ghost.'"

NATALIE WOOD IN *WEST SIDE STORY* (1961)

N ATALIE Wood didn't exactly welcome Marni's help the way Deborah Kerr had. Natalie had worked hard with a vocal coach and was led to believe that her recordings would be used in the film. In fact, she had been told that Marni was just there to assist with some of the high notes in her numbers. Even so, there was plenty of tension, thanks in part to how the studio sessions were organized. Natalie would record a song on her own, then Marni would record the same song immediately afterward.

Furthermore, because the musicians knew Natalie's recordings wouldn't be used, they played half-heartedly during her recording sessions but went all out for Marni and even applauded when she finished a take. "I was both very embarrassed and disgusted at their rudeness to poor Natalie," Marni said.

After the recordings were done, it was decided that Natalie would perform the lip synching on screen to her own recordings, not Marni's. "This kept Natalie happy," Marni recalled, "but also built up her hopes that her voice would be retained in the final cut of the film." Director Robert Wise waited until the final day of shooting before he told her the truth. "He must have known for months," Natalie recalled, "but what really hurt was the fact that he didn't feel I could take a blow and get over it, so he postponed the bad news." Marni was called in to dub all of Natalie's songs, and she also provided dubbing for Rita Moreno's voice in the "Tonight Quintet."

AUDREY HEPBURN IN *MY FAIR LADY* (1964)

WHEN Jack Warner got the rights to adapt the successful stage musical for the screen, everyone assumed he'd also get the woman who originated the role of Eliza Doolittle: Julie Andrews. But Warner dismissed her as "just a Broadway name" and decided to cast Audrey Hepburn instead. Audrey's star power was unquestioned, but her limited vocal range left a lot of people wondering how she was going to pull off the musical's demanding numbers.

Audrey prepared extensively with a vocal coach and prerecorded all the songs, but the studio felt her voice wasn't strong enough. Top-secret auditions were held for someone to ghost Audrey. Marni auditioned for director George Cukor and lyricist Alan Jay Lerner, but they thought she was "trying to imitate Audrey" and weren't impressed. Luckily, her friend, the composer André Previn, helped get her a second audition. The role was hers.

Audrey had hoped they would be able to use a majority of her voice and some blend of Marni's for the more difficult notes. For the songs "Just You Wait" and "The Rain in Spain," it was possible. But for all the other songs, including the popular "Wouldn't It Be Loverly" and the legendary "I Could Have Danced All Night," the studio wanted one voice and one voice alone: Marni's.

George Cukor broke the news to Audrey, and she walked off the set. The next day, she apologized profusely to everyone for her self-described "wicked behavior."

The studio hoped to keep the dubbing a secret, but the press wasn't fooled and wrote extensively about it. In the end, many believed that Marni's exquisite singing might have actually cost Audrey an Oscar nomination for Best Actress. The award that year went to Julie Andrews for *Mary Poppins*.

GRANDMOTHER FA IN *MULAN* (1998)

ALTHOUGH she had turned down offers to ghost since *My Fair Lady*, when she got the call from Disney to audition for the singing voice of Grandmother Fa, she couldn't resist. She was up against some stiff competition, including Lauren Bacall. Marni warned Disney that the person they had hired to voice Grandmother Fa's dialogue was obviously a heavy smoker and there was no way she could match the timbre of her voice.

At the audition, Marni was given the music to "Honor to Us All" and shown a drawing of Grandmother Fa's face. "She had the cutest old lady face I had ever seen. . . ." When it came time to sing, Marni tried to "bring out the twinkle in those eyes and not forget that she had no teeth!"

Marni won the role, and Disney liked her singing so much that they fired the original voice actor and hired someone who sounded more like Marni: June Foray of *Rocky and Bullwinkle* fame. But Marni was disappointed that she hadn't been given a chance to play the role herself. "Since they fired the first actress," she lamented, "why hadn't they even considered the fact that I might be the perfect 'acting' voice for the role as well?" For Marni, it was a disappointment she had come to expect. "In Hollywood," she said. "I was still pigeonholed as a 'singer' . . . or, even worse, a ghost singer."

Dancing

of the

Silver
Screen

SHE had the athleticism of Gene Kelly and the grace of Fred Astaire, and she matched them step-for-step dancing alongside them on the silver screen. She was a master of tap, toe, ballet, ballroom, and acrobatic. She was equally captivating dancing with a partner and without. But she wasn't just a dancer. She could act, bringing charm and vitality to any role she played, and could hold her own playing comedy opposite legends like Danny Kaye, Red Skelton, and the Marx Brothers. She had a meteoric rise, from Broadway specialty dancer, to Hollywood ingenue, to full-fledged movie star. And then, at the age of thirty-six, her career was suddenly over. Her life, once so promising, was marked by personal struggles and family tragedy. She descended into darkness, disappeared from public life, and all but vanished from Hollywood's collective memory. She was one of the silver screen's greatest dancers and one of its brightest stars, burned out too soon. Her name was Vera-Ellen.

She was born without the hyphen. The only child of Alma and Martin Rohe, Vera Ellen was born just outside of Cincinnati, Ohio, on February 16, 1921. She was so tiny as a child that her music teacher made a special wooden stool for her because her feet didn't touch the ground in a normal chair. But

what she lacked in size, she made up for in talent and drive. An honor-roll student, Vera excelled at most everything she did. She won a certificate in Latin and became the director of her elementary school band. Her teachers and classmates marveled at the star pupil, but Alma was concerned that she had "drawn a book worm" in her only child. She decided to enroll her nine-year-old daughter in a ballet class so that she could get some exercise. "From then on ballet was my life," Vera said.

Dance lessons were difficult for Vera's parents to afford, but given her immense passion and talent, they always found ways to make it work. And Vera wasn't the only major talent in her class: She trained alongside another young prodigy named Doris Kappelhoff. The two developed a rivalry, but it came to an end in 1937, when Kappelhoff was injured in an automobile accident. Her dancing career ended, so she turned to singing, later making a name for herself as Doris Day.

When Vera was twelve, Alma thought she was gaining too much weight and put her on the first of a long series of fad diets. One was the "iriology diet," invented by a man calling himself Dr. J.D. Levine. Not a doctor at all, Levine believed that blue eyes signified perfect physical condition. He claimed that "other colors are caused by various toxins and poisons in the body" and that he could change the color of 80% of all eyes through diet. Vera had brown eyes, so according to the good doctor, she should avoid "any meat, milk, or eggs until the eye becomes lighter in color."

Alma's obsession with dieting caused Vera to develop her own unhealthy food obsessions, which plagued her all her life. By high school, Alma's rigid regimen had reduced Vera to an emaciated state. But none of this could hold back the irrepressible Vera.

"When I found out I liked to dance and people seemed to like to watch me, I was determined to go places," Vera said. And places she went. In 1936, at fifteen, Vera was already a teacher at her dancing school and soon traveled to New York City for a dancing teachers' convention. There she learned new dances, but more importantly, she fell in love with the city and with the idea of having her own dancing career. She and her mother moved to New York in October to pursue it. Her first break came on *Major Bowes Amateur Hour* radio show, where she tap-danced and sang "When You're Smiling at Me." Vera was selected to be in Bowes's "All Girl Unit,"

which performed in movie theaters across the country. After the tour, she returned to New York.

But she hadn't grown for two years, and at the age of sixteen she was only four feet, six inches tall. Despite her obvious talent as a dancer, her height was costing her jobs. She was turned down for *Leave It to Me!* on Broadway because she looked so small next to the other dancers. Vera knew if she was ever going to make it, she was going to have to start growing, and quickly. She devised a series of strenuous stretching exercises, including bending backward and trying to touch her elbows to the floor, putting her feet above her head against a wall, and swinging side to side while hanging from a bar in a doorway. In a few years, she grew to be five-foot-four (the role that stretching played in her growth is up for debate).

The day after her eighteenth birthday, she answered a casting call for a show for producer and club owner Billy Rose. At the audition, she noticed all the other girls were auditioning for chorus work. When Rose asked her to do a few time steps, she told him she wasn't interested in dancing in the chorus. Taken aback, Rose asked her what she thought she could do. "A specialty," she told him. Rose laughed but let her show him what she could do. She performed a routine that included tap, toe, ballet, and acrobatic dancing. Three weeks later, she was performing as a specialty dancer at Rose's Casa Mañana night club.

Vera eventually danced her way from night clubs to Broadway musicals. She danced in the chorus line of two flops. She danced at the New York World's Fair in 1940. She danced briefly with the Rockettes. In 1941, she was featured in four dance numbers in *Panama Hattie*, starring Ethel Merman. It was a smash hit. During its run, Vera married an acrobatic dancer, Robert (Bob) Hightower. Time, and his wife's success, would reveal his true colors.

In 1942, Vera landed a featured role as the goddess Minerva, dancing alongside Ray Bolger in the Rodgers and Hart show *By Jupiter*. The *New York*

> "When I found out I liked to dance . . . I was *determined* to go places."

World Telegraph wrote, "The neatest trick of the week . . . is a petite dancing doll named Vera-Ellen, who stole her way into Broadway's heart last evening. She is a gem."

Vera hyphenated her name because, she later said, "I wanted to be different, and the only difference between me and other girls that I could think of was that hyphen. In those days, my single dream was to see that hyphenated name in lights." It was a good move. Show business already had "The Voice" (Frank Sinatra) and "The Look" (Lauren Bacall), and now it would have "The Hyphen" too. (Vera preferred "The Dash," but that never gained any traction.) Vera and Alma would later claim that the hyphen came to Alma in a dream, when she saw the name Vera-Ellen in lights on a marquee before her daughter was even born.

Her next musical was the Broadway revival of Rodgers and Hart's *A Connecticut Yankee*. During the preview runs in Philadelphia, movie scouts began to make her offers, but Vera decided

"She dances with *captivating rhythm.*"

to wait until they got to New York. "You're always worth more when you're a hit on Broadway." When the show premiered on November 17, 1943, Vera-Ellen was a hit, and Samuel Goldwyn was watching. The next day, he sent for her. "She didn't know how to walk and she talked through her nose, but she was charming, highly individual," he said. "I knew that training would take care of her speech, but her personality was heaven sent." Without making a screen test of her, Goldwyn signed her to a one-year contract beginning when her run with *A Connecticut Yankee* was over.

But the more success Vera had, the more troubles Bob created. "He had an overestimated opinion of himself," she said. "I had to remind him that I earned more money than he did." Bob was jealous over her career and had a violent temper. He "always used physical force to make me sign written statements," Vera said. He humiliated her in front of her friends and started fights with strangers. He once tore Vera's engagement ring off her finger and pawned it. She was afraid for her life, and finally, she got the courage to leave him.

With Bob out of the picture, Vera and Alma moved to Hollywood in 1944 to work with Danny Kaye on *Wonder Man*. Vera quickly found that she liked the town and the business. She enjoyed the daily routine of getting up at 5:30 a.m. and heading to the studio far more than the late-night lifestyle of the New York theater world.

She also enjoyed the star treatment. In a letter to her New York acting coach, she wrote:

Movie work is fun so far. They just take ooooo-dles of pictures and I like that. The first day on the picture was quite a thrill. My dressing room on the set was filled with flowers it almost felt like opening night. . . . One just gets so much attention out here. I have a hairdresser, make-up man, body make-up girl and wardrobe lady. It's kinda fun.

After *Wonder Man* premiered in 1945, Vera was a rising star. *Variety* wrote, "Vera-Ellen is a fine young hoofer who can handle lines well too." The *New York Times* called her "a pert and chic new dancer . . . she dances with captivating rhythm." She followed it up the next year with another Danny Kaye film, *The Kid from Brooklyn.* Although she was a hit with audiences and was

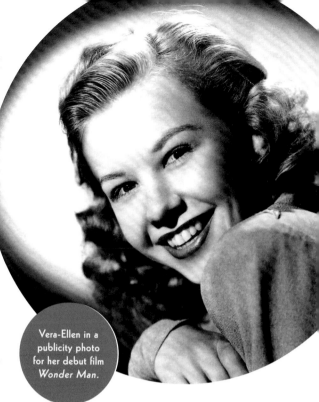

Vera-Ellen in a publicity photo for her debut film *Wonder Man.*

soon receiving 600 fan letters a week (more than any other star at Goldwyn Studio, including Danny Kaye), Samuel Goldwyn didn't see her as a leading lady. He loaned her to 20th Century Fox, where she shined in specialty numbers in the films *Three Little Girls in Blue* and *Carnival in Costa Rica.* But when her contract was up with Goldwyn and he asked her to renew at a lower rate, she declined.

"I took stock of everything. Above all I tried to learn what Hollywood was really like," she said. "Postwar setbacks were beginning to evidence themselves in the films. I realized that I had to get out of the class of being a specialty artist. . . . They do not sign people under long-term contracts who can supply just a single ingredient for a picture." Vera set upon developing herself into a leading lady by taking lessons in acting, voice, singing, and different forms of dance. She appeared in the Laguna Beach summer stock production of *A Highland Fling,* "just to show them I could act as well as sing," she explained. She spent her summer taking courses at UCLA in public speaking, Spanish, Gregg shorthand (for taking notes on dance steps), and typing (so she could answer fan mail faster).

When she was offered the lead role in the

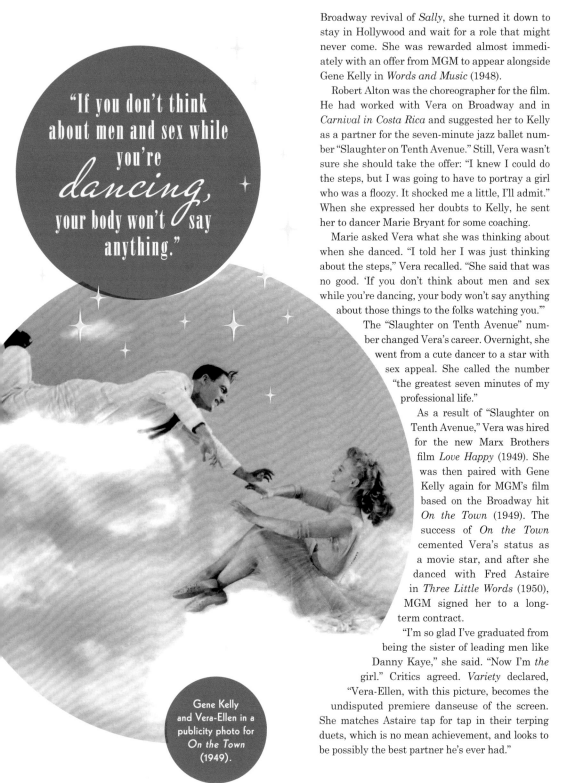

"If you don't think about men and sex while you're *dancing,* your body won't say anything."

Broadway revival of *Sally,* she turned it down to stay in Hollywood and wait for a role that might never come. She was rewarded almost immediately with an offer from MGM to appear alongside Gene Kelly in *Words and Music* (1948).

Robert Alton was the choreographer for the film. He had worked with Vera on Broadway and in *Carnival in Costa Rica* and suggested her to Kelly as a partner for the seven-minute jazz ballet number "Slaughter on Tenth Avenue." Still, Vera wasn't sure she should take the offer: "I knew I could do the steps, but I was going to have to portray a girl who was a floozy. It shocked me a little, I'll admit." When she expressed her doubts to Kelly, he sent her to dancer Marie Bryant for some coaching.

Marie asked Vera what she was thinking about when she danced. "I told her I was just thinking about the steps," Vera recalled. "She said that was no good. 'If you don't think about men and sex while you're dancing, your body won't say anything about those things to the folks watching you.'"

The "Slaughter on Tenth Avenue" number changed Vera's career. Overnight, she went from a cute dancer to a star with sex appeal. She called the number "the greatest seven minutes of my professional life."

As a result of "Slaughter on Tenth Avenue," Vera was hired for the new Marx Brothers film *Love Happy* (1949). She was then paired with Gene Kelly again for MGM's film based on the Broadway hit *On the Town* (1949). The success of *On the Town* cemented Vera's status as a movie star, and after she danced with Fred Astaire in *Three Little Words* (1950), MGM signed her to a long-term contract.

"I'm so glad I've graduated from being the sister of leading men like Danny Kaye," she said. "Now I'm *the* girl." Critics agreed. *Variety* declared, "Vera-Ellen, with this picture, becomes the undisputed premiere danseuse of the screen. She matches Astaire tap for tap in their terping duets, which is no mean achievement, and looks to be possibly the best partner he's ever had."

Gene Kelly and Vera-Ellen in a publicity photo for *On the Town* (1949).

Professionally, Vera was at her best, but in her private life, she had begun to fight a battle that few knew about or understood. While performing on the stage, Vera had never worried much about her appearance because the audience was always twenty-five feet away. But Hollywood was the land of close-ups and the old adage that the camera adds ten pounds.

According to Debbie Reynolds, Vera's troubles really began when MGM ordered her to lose weight. "Vera-Ellen was told that she was too fat, that her top thighs were too heavy," Reynolds explained. "Vera-Ellen was never fat, but she was insecure and wanted to please so she believed them. Which

was the worst thing she could have done. She cut way back on her food intake. After that she drank coffee all day and ate only a steak and vegetable at night. Her legs became absolutely angular."

Dancer and choreographer David Lober recalled, "It was her habit to eat one soda cracker and drink coffee during the day. Then she would eat at night. She was concerned with her legs appearing heavy . . . between her willingness to work and self-destructive diet she ran herself into the ground."

Betty Garrett, who had known Vera since the Broadway production of *A Connecticut Yankee*,

noticed a change in Vera when they worked together in *Words and Music* and *On the Town*. "She did little socialization and had an obsession about her weight. When I knew her she was determined to lose weight and there was no necessity for her to diet. She worked hard all day. And she got so thin. I think now that she may have been suffering from anorexia."

This view seems to be borne out by one of Vera's rationalizations for her restrictive diet: "I like to feel fragile and undernourished when I work."

Her close friend and producer A.C. Lyles said Vera thought it made her dance better. "Nobody knew what anorexia was in those days," Lyles explained. "We didn't know about eating disorders." Most people at the time simply thought Vera had peculiar eating habits. But that would soon change.

The most important picture of her career was *The Belle of New York* (1952) with Fred Astaire, the first and last time she would receive star billing in a major production. The film used trick photography to show the stars "floating on air," dancing above the New York skyline. Robert Alton began rehearsing the dance numbers with Vera and Astaire three months before principal photography began.

The shoot was a struggle, with script edits and new dialogue arriving each day. Producer Arthur Freed was preoccupied with his work on *Singin' in the Rain*, and according to one of Freed's staffers, "there were no story conferences; there were no set meetings, nothing. It just sort of wandered along." And Vera's weight was starting to become an issue. Astaire spoke to the producers of his concerns and even told Vera, "Honey, you have to eat. Your bones are showing." When they were working out the lifts in one dance, she was sometimes so weak she couldn't assist in propelling herself up into Astaire's arms.

In its initial release, the film lost over $600,000. And though Vera was singled out for praise by critics, she lost

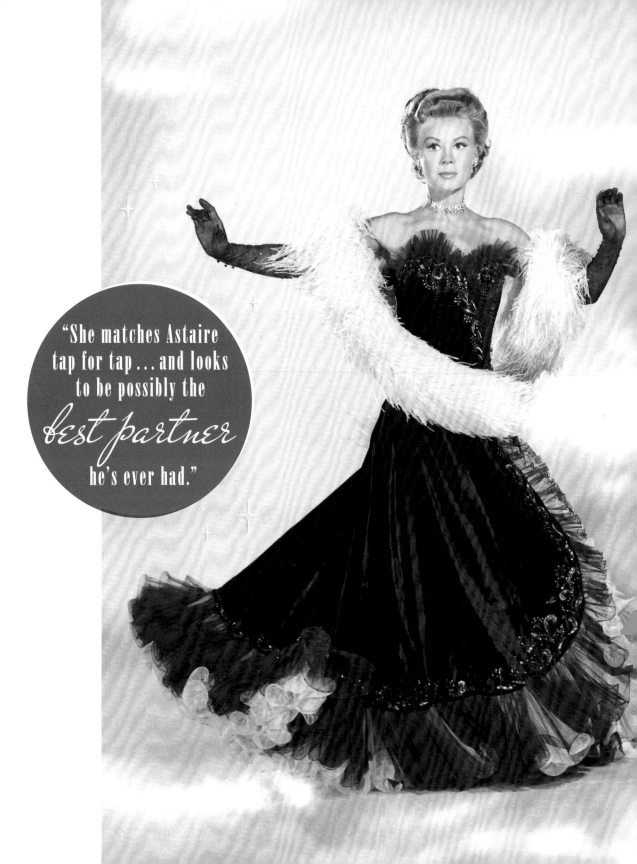

"She matches Astaire tap for tap ... and looks to be possibly the *best partner* he's ever had."

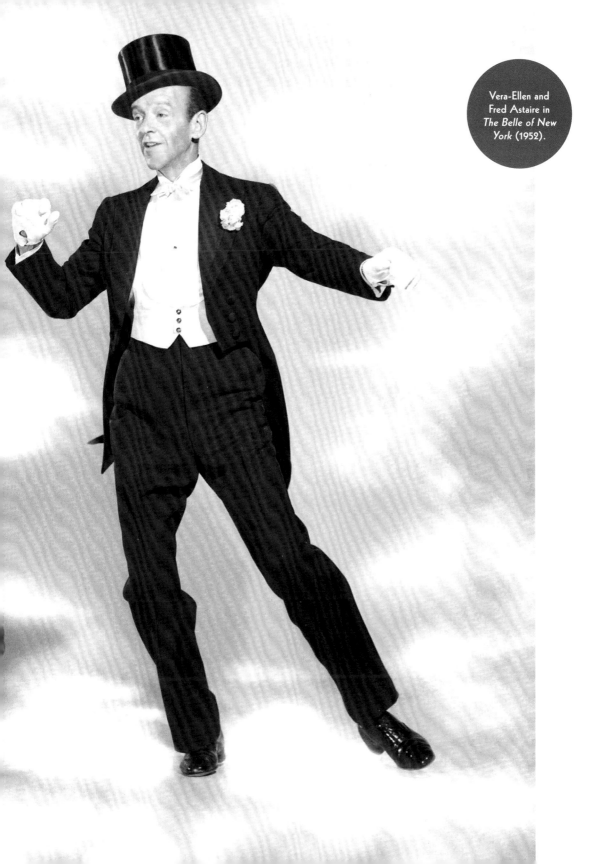

Vera-Ellen and Fred Astaire in *The Belle of New York* (1952).

her shot at a future in starring roles. Before *The Belle of New York*, she had been slated to star in several films at MGM. But once the movie bombed at the box office, the roles were reassigned. With the exception of B-movies, she would appear only in supporting roles for the rest of her career.

For her next project, she was loaned out to 20th Century Fox for *Call Me Madam* (1953), starring Ethel Merman. Vera was excited to work with choreographer Robert Alton again and be paired for the first time with Donald O'Connor. O'Connor considered their dancing duet "It's a Lovely Day Today" "one of the greatest dance numbers ever put on screen." According to him, Vera was beloved. "All the dancers adored her," he said. "She was so nice and concerned about everyone's health and happiness."

Around this time, the press began to report their concerns about her own health and happiness. They claimed that photographers were nervous to take photos of her and that the film industry was launching a "Save Vera-Ellen Campaign." Vera didn't see what the fuss was about. "Everybody was worried when I weighed 90. They thought I was sick, but I never felt better!"

After *Call Me Madam*, producer-writer Matthew Rapf came to her with a script for the MGM B-movie *Big Leaguer*. "I read it and liked it," Vera said. "Then it dawned on me that there wasn't a musical number in the entire production. I read it again. I still liked it." She got the part, and it was the only film in her career in which she did not dance. Although the film came and went with little fanfare, for Vera, holding her own in a dramatic film was a personal achievement.

She was teamed with Donald O'Connor again in *White Christmas* (1954). Robert Alton had already choreographed several numbers when O'Connor suddenly became very ill. He was replaced by Vera's old co-star Danny Kaye, and they played supporting roles to the film's leads, Bing Crosby and Rosemary Clooney.

"She was disciplined . . . she was patient with me. I would make mistakes," Clooney recalled of her attempts at dancing in the film. "I felt very inadequate and indeed I was. There was one thing though that kind of evened out the situation which was that she couldn't sing so that her voice was dubbed. If they could have dubbed my dancing now, we would have had a perfect picture."

Vera pushed herself hard and was eating so little that costume designer Edith Head repeatedly

had to take in her costumes. All of Vera's costumes covered her neck, which led to a nasty rumor that her dieting had ravaged her skin. This was untrue. The real reason was stylistic: It extended her frame and torso, which had been padded as well.

When *White Christmas* was previewed, audiences were shocked at how thin Vera's legs appeared during the "Abraham" dance. Vera shrugged off the feedback, explaining that "men who saw the picture commented on how sexy that scene was." She also added, "There's a sexiness about slimness. You know, the skin fits over the bones more tightly, look at Katharine Hepburn and Audrey Hepburn. They're very appealing."

One reporter tagged along with Vera for a typical day's workout, writing that she began with a

"She was so nice and *concerned* about everyone's health and happiness."

two-hour ballet lesson, followed by a tap-dancing workout, and then went on to play several rounds of tennis. She wound up her day swimming a hundred laps in her pool. "I think I get the energy from my diet," Vera told the stunned reporter. "I eat only eggs, meat, raw vegetables, and juices. No sugar or starches."

After the release of *White Christmas*, Vera hit another lull in her career. Newcomers like Debbie Reynolds and Jane Powell were getting roles that normally would have gone to her. The roles she did land were on loan-outs to other studios. She didn't want to return to Broadway or do the nightclub circuit, and her MGM contract didn't allow her to do television work. Vera was stuck. But she did have one thing going for her: She was about to fall in love.

In the summer of 1954, actor Robert Stack invited Vera to play tennis with him and his wife.

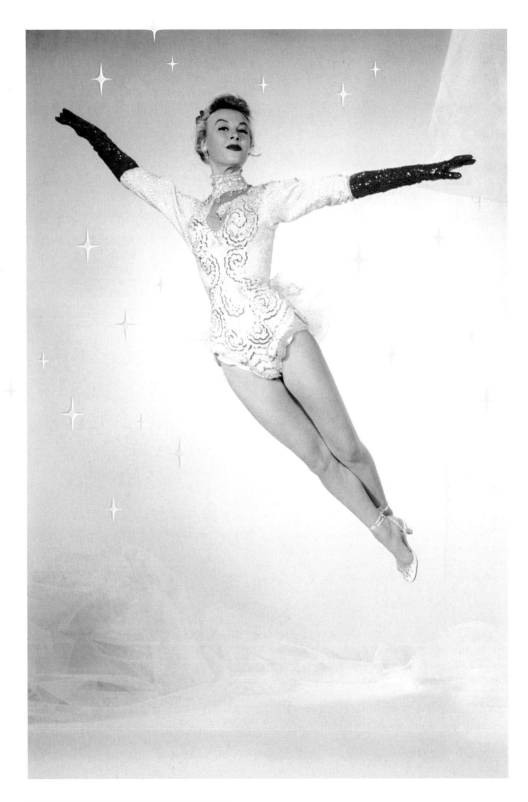

DANCING QUEEN OF THE SILVER SCREEN

Her partner that day was Victor "Vic" Rothschild. Vic and Vera began dating immediately. "Nothing serious at first," Vic recalled, "but then I got ill with the flu and she came around to see me and she was so kind and . . . our serious relationship grew out of that visit." Their love blossomed quickly, and in November, they were married. They honeymooned for a week in Palm Springs, followed by a cruise to Acapulco that extended into the New Year. Eventually, they settled down in a home overlooking the Hollywood Hills.

When her MGM contract expired in 1955, Vera launched a successful Las Vegas show and began appearing on television. After a two-year absence from the screen, Vera returned for what would be her final film: *Let's Be Happy*. The film was a failure. After a few more guest spots on television, Vera's appearance on *The Dinah Shore Chevy Show* on February 15, 1959, was her final professional performance.

Vera decided to close the book on show business and start a new one focused on family. After almost nine years of marriage and at the age of forty-two, Vera gave birth to a daughter, Victoria Ellen, on March 3, 1963.

But just a few months later, her young family was struck by tragedy. On June 20, 1963, Vera brought Victoria to Alma's house so she could attend a dance class. When she returned, she noticed Victoria had stopped breathing. She quickly phoned for emergency help, and Victoria was taken to the hospital, where she was declared dead. The autopsy revealed she died of "acute interstitial pneumonitis," a rare and fatal lung disease. Victoria's lungs had filled up with fluid, and she had suffocated.

"You can't expect to do such *strenuous* things to the body.... Even a machine wears out."

The child was quietly buried in a plot Vera had secured for her mother and herself at Glen Haven Memorial Park. After Victoria's death, Vic distanced himself from Vera, and forty years later, he was embarrassed to find out the baby had been buried without a headstone. "I think Vera just did not want to deal with the death," Vic explained, "because it was a reminder of all the pain it had caused her." Vera kept Victoria's crib, baby clothes, and cloth diapers until the day she died.

She was never the same after her daughter's death, and her marriage with Vic fell apart. It was a bitter divorce, with charges of cruelty and infidelity against Vic, who refused to pay alimony. It dragged on for three years until the court ruled in Vera's favor in 1969.

For the next decade, Vera spent her days playing tennis, swimming, exercising, and taking ballet lessons, despite developing crippling arthritis. "I still go [to dance class] every day, it's part of my life," she said. "It's good for me physically and mentally and everything." She downplayed the excruciating pain and stiffness of her arthritis, saying, "You can't expect to do such strenuous things to the body as I did, year after year, without some wear and tear. Even a machine wears out." When she discovered a knot in her neck, she very reluctantly agreed to see a doctor. Vera was diagnosed with cancer and opted not to pursue treatment.

In late August 1981, Vera's neighbors noticed newspapers piling up in front of her house. After managing to enter, one neighbor recalled staring at "a living skeleton." Vera told them she had cancer and didn't want to go to the hospital. For the next few days, neighbors brought her meals and recalled that, even as she was facing the end, Vera refused to eat anything sweet, "claiming that it was not good for her diet!" Eventually she was taken to UCLA Medical Center. On the evening of August 30, Vera died alone in her hospital room. She was sixty years old.

Despite the circumstances of her life after show business, Vera-Ellen continues to live on in her films. In classics like *On the Town* and *White Christmas*, Vera-Ellen's immense talents and carefree spirit jump off the screen, and she remains one of Hollywood's greatest dancers and irrepressible stars.

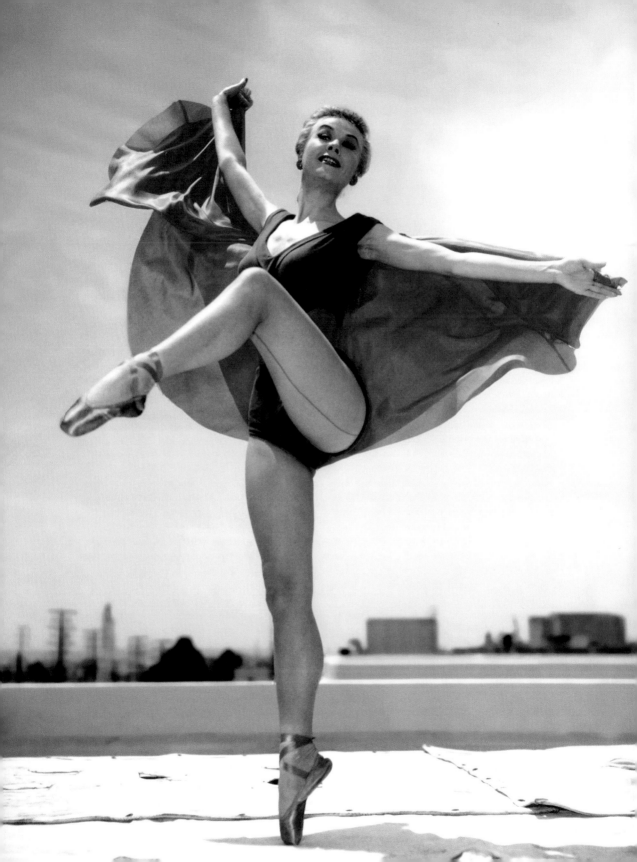

PAUL NEWMAN'S

"Paul Newman Apologizes Every Night This Week—Channel 9."

SO claimed a series of newspaper ads across Los Angeles in January of 1963. The ads were paid for by Newman himself, intended as a "community service" to prevent people from watching the television debut of his 1954 film *The Silver Chalice*, a movie so hilariously bad it nearly derailed the career of one of Hollywood's greatest stars before it even began.

Unfortunately for Newman, his ads backfired. "Everybody watched the picture to see what I was apologizing about," Newman said. "[I]t had the highest rating of anything on TV that week." *The Silver Chalice* was Newman's first film, and after its release, he didn't think he'd get to make another.

Newman's nightmare began on April 8, 1954, when he signed a contract with Warner Bros. He had already appeared in several TV programs and on Broadway in the featured role of Alan Seymour in William Inge's *Picnic*. A few weeks after signing, Newman was cast in his very first film role as Basil, the hero of *The Silver Chalice*.

The film was based on the best-selling novel by Thomas B. Costain about the effort to preserve the cup from which Christ drank at the Last Supper. Jack Warner spared no expense and assembled a team of Hollywood heavyweights to deliver a blockbuster biblical epic. Producer-director Victor Saville, a distinguished veteran in the film industry and former head of MGM's British division, owned the film rights and partnered with Warner Bros. Cinematographer William V. Skall, who won an Academy Award for *Joan of Arc* (1949), was brought on to film in CinemaScope and WarnerColor. The score was composed by Franz Waxman, who had just scored *Rear Window* and already won two Academy Awards for his work on *Sunset Boulevard* (1950) and *A Place in the Sun* (1951). The script was written by Lesser Samuels, who had received Academy Award nominations for two screenplays, *No Way Out* (1950), which he co-wrote with Joseph L. Mankiewicz, and *Ace in the Hole* (1951), on which he collaborated with Billy Wilder. Rolf Gerard was borrowed from the Metropolitan Opera to design the sets.

Saville put Warner Bros.'s research department to work, submitting hundreds of questions about

UNHOLY GRAIL

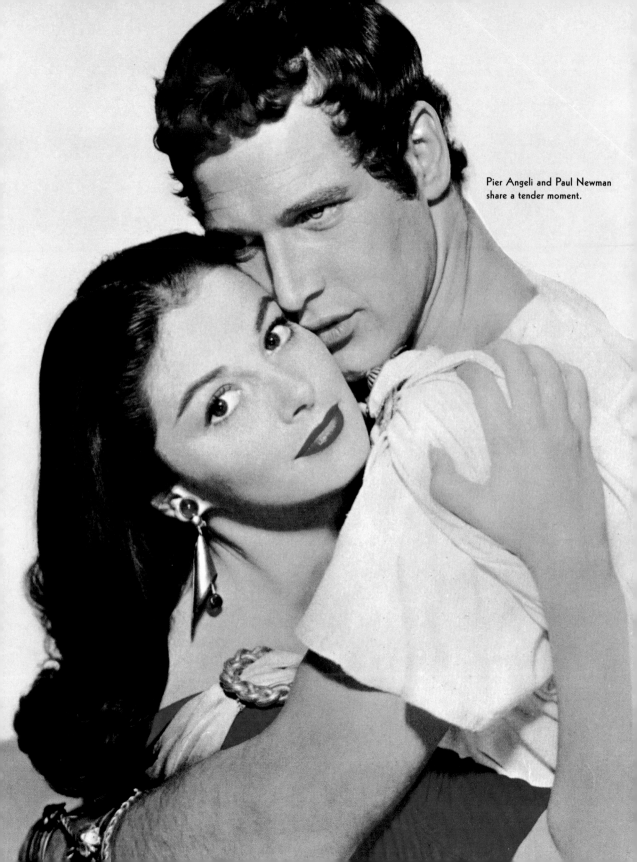

Pier Angeli and Paul Newman
share a tender moment.

the customs and manners of biblical times, demanding to know the most minute details of ancient life: "What were Civil Guards like in Antioch?"; "Did Romans have napkins & if so what kind?"; "Could swans be shown on a lake near Jerusalem?"

With all this talent and hard work, what could go wrong?

As it turned out: Everything.

Production began on location in Palm Springs in June 1954, resuming on the Warner lot for the next few months. The schedule was grueling, with filming often continuing until four in the morning. Paul Newman became ill during shooting, and he and Saville clashed on set over his approach to his character.

It didn't take Newman long to realize that the movie was headed for disaster. "Three weeks after

exterior walls that ring hollow when struck by various characters; the strangely tidy streets of ancient urban locations like Rome and Jerusalem. Jack Warner was less than thrilled with Saville's pet obsession and demanded to see more of his stars.

The problems didn't end there. Despite the film's massive budget and obsession with historical accuracy, the costumes are cheap looking and bizarre: Paul Newman is clad in what he called "my cocktail dress" for most of the movie; Virginia Mayo's wardrobe looks like it was pulled from a sci-fi version of *I Dream of Jeannie*; Jack Palance wears a cape with a red unitard covered in designs shaped like sperm. The props are equally amateurish: Swords and shields have a distinctly plastic sheen; food is spray painted gold; a stone

With all this talent and hard work,
WHAT COULD GO WRONG?

we started shooting," he said, "I called up my agent in New York screaming desperately for him to get me a play. I figured the picture would kill me. I wasn't really convinced that I would survive as an actor." Before filming had completed, Newman was cast in his first starring role on Broadway in *The Desperate Hours*.

But Newman wasn't the only one having issues with the film's director. Jack Warner wasn't satisfied with Saville's dailies, telling him repeatedly "we need to see the people." Despite Saville's twenty-seven years' experience as a director, Jack Warner's memos to him read like a crash-course in basic filmmaking, offering recommendations on the types of lenses to use, asking for "some over-the-shoulder shots," and explaining how "in small cuts we must have more flow in the picture by that I mean staging and direction."

Saville was more focused on technical innovations, using what he claimed was "filmdom's longest camera boom" to capture wide shots of his elaborate but unconvincing sets: Interior walls decorated with blinding geometric patterns;

statue is thrown to the ground, breaks in half, and bounces across the floor like a rubber ball.

Saville was as myopic about his actors as he was about everything else, calling the absurd Jack Palance "impressive as Simon" while issuing a personal attack against Newman: "The only thing that Paul had in common with his role in *The Silver Chalice* was that they were both Jews. . . . Try as I did I could not woo the bravura performance from Newman that the part demanded."

But with a script as confusing as it is melodramatic, it's hard to imagine that even Paul Newman could have saved it. The plot, such as it is, centers on Basil's attempt to sculpt a silver chalice to hold Jesus's sacred cup, while being caught in a love triangle with his childhood sweetheart (Mayo) and a devout Christian woman (Pier Angeli). At the same time, he is seeking the missing witness to his adoption so he can recover an inheritance stolen from him when he was sold into slavery years earlier. Into this ancient soap opera walk the Sicarii, a religious group who hire Simon the Magician (Palance) to stomp out Christianity.

Paul Newman in one of his "cocktail dresses."

Virginia Mayo and Jack Palance in one of the film's more subtle sets.

Jack Palance as Simon the Magician in all his glory.

FROM WARNER BROS. COMES ONE OF THE GREATEST BEST-SELLERS OF MODERN TIMES! READ BY OVER 25 MILLION PEOPLE TO DATE!

HELENA THE SEDUCTRESS
who embarked on a wanton life of abandon!

DEBORRA THE INNOCENT
whose virtue tempted the tyrant legions

SIMON THE MAGICIAN
who brought the world to the brink of chaos

BASIL THE DEFENDER
the slave who became the fighting champion of the Sacred Cup

THOMAS B. COSTAIN'S

THE SILVER CHALICE

CINEMASCOPE
WarnerColor

VIRGINIA MAYO · PIER ANGELI · JACK PALANCE · and introducing PAUL NEWMAN

A VICTOR SAVILLE Production · WALTER HAMPDEN · Written for the Screen by LESSER SAMUELS Associate Producer · Directed by VICTOR SAVILLE · Presented by WARNER BROS.

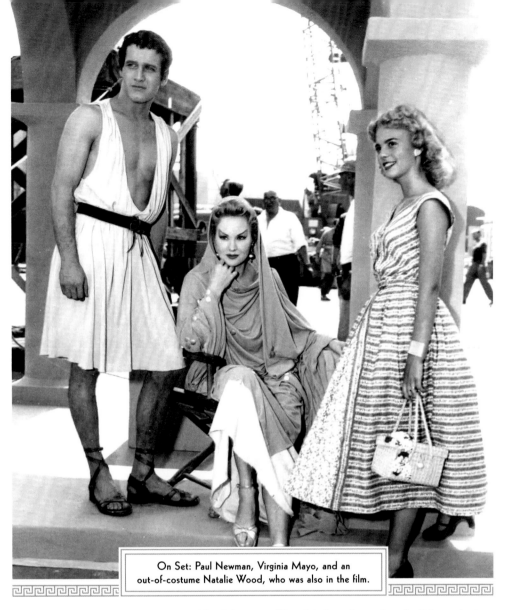

On Set: Paul Newman, Virginia Mayo, and an out-of-costume Natalie Wood, who was also in the film.

He fools people into thinking he is a god by doing magic tricks like pulling a rabbit out of a hat, pulling coins out of ears, and making fire appear. He also fools himself into thinking he can fly (spoiler: he can't). He is obsessed with finding and crushing Jesus's cup and also happens to be dating Basil's old flame. Suffice to say, things get complicated. In the end, good triumphs over evil, but the cup ends up lost to posterity.

This plot is served throughout by comically bad dialogue ("There's no place like Rome. . ."), culminating in a speech about the missing cup delivered by the Apostle Peter just before the credits roll:

When it is brought out into the light again there will be great cities, and mighty bridges and towers higher than the tower of Babel. It will be a world of evil and long bitter wars. In such a world as that, the little cup will look very lonely. But it may be in that age, when man holds lightning in his hands and rides the sky as Simon the Magician strove to do, it will be needed more than it is needed now.

Despite all of this, when shooting wrapped on August 26, 1954, Warner Bros. actually seemed to think they had a hit.

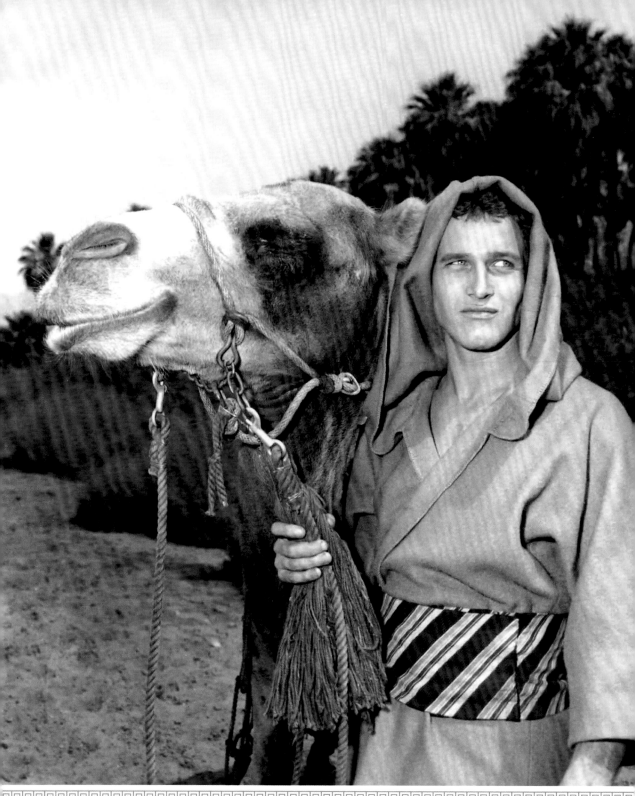

The film premiered at the winter festival at Saranac Lake, New York, on December 17, 1954. The Adirondack mountain community of seven thousand won the opportunity to host the premiere by selling the largest number of Christmas Seals per capita in a nationwide contest conducted by the National Tuberculous Association and TV/radio personality Art Linkletter. Two showings of the film sold out forty-eight hours in advance, and Warner Bros. was expecting "tremendous box office." The traditional red-carpet was swapped out for "white carpet snow," and Saranac Lake celebrated with an Ice Carnival and parade featuring dog teams, horse-drawn sleighs, and Virginia Mayo as the Queen of the Carnival, riding in a 1910 automobile with Santa Claus. Victor Saville was overjoyed, telling the press, "Show business is always so generous."

Paul Newman did not attend.

appears on the screen," wrote the *Boston Globe*. "However, he does not match Mr. Brando when it comes to acting ability." The *Saturday Review* referred to him simply as "a poor man's Marlon Brando."

The film lost money at the box office but, incredibly, was nominated for two Academy Awards, for cinematography (color) and score. But the effects of *The Silver Chalice* were felt by many associated with it: Victor Saville's career as a director was all but over, as he made only one more film, under the pseudonym "Phil Victor." Lesser Samuels wrote just one more screenplay. It would be another two years before Paul Newman made another film, returning to star as Rocky Graziano in *Somebody Up There Likes Me* (1956). That film launched one of the greatest movie careers of all time, with Newman becoming a veritable god of the cinema, starring in countless classic films and winning numerous awards.

The *Saturday Review* referred to him simply as

"A POOR MAN'S MARLON BRANDO."

In fact, he didn't even see the film until January, when he was in Philadelphia performing in a preview of *The Desperate Hours*. Newman and ten of his friends smuggled four cases of beer into an all-night movie house to see his film debut. "I was horrified and traumatized when I saw the film," Newman recalled. "I was sure my acting career had begun and ended in the same picture." Many critics agreed.

The *New York Times* called it "a cumbersome and sometimes creaking vehicle" and singled out Newman, saying his acting was "barely better than wooden." *New Yorker* critic John McCarten went even further, writing, "Paul Newman . . . delivers his lines with the emotional fervor of a Putnam Division conductor announcing local stops."

Many critics unfavorably compared Newman to the era's most celebrated actor, Marlon Brando. "Paul Newman looks so much like Marlon Brando that you blink a couple of times when he first

But no matter how big he got, Newman never forgot *The Silver Chalice*. In the late 1970s, he acquired a print of the film and showed it to friends in the screening room of his Westport home, giving everyone metal pots and wooden spoons to beat on them with. "It was fun for about the first reel," he said, "and then the awfulness of the thing took over."

Years later, Newman summed up his feelings about his first foray into the film business:

When I think about the picture, I feel like a juvenile delinquent. You know the meanest kid on the block has status just like the smartest kid on the block does. Well, The Silver Chalice *gives me block status. I can say I was in the worst picture made in the 1950s.*

Fortunately for all of us, Newman's first film wouldn't be his last.

LETTER *from* *the* AUTHOR

W E forget history, but sometimes history forgets us too. It records some stories and buries others. Prevailing narratives shape our knowledge and understanding of the past. *This Was Hollywood: Forgotten Stars & Stories* is a collection of discarded narratives. But my fondest hope is that years from now, its subjects will be remembered by history once again.

And I have similar hopes for the industry from which these stars and stories sprang. Hollywood is dead, we are told. That may be true, but Hollywood has already died a thousand deaths: with sound in the 1920s, television in the 1950s, the collapse of the studio system in the 1960s, the blockbuster revolution in the 1980s, and CGI in the 2000s. Yet, somehow, after each demise, it has always risen again, often soaring to new heights of possibility.

Hollywood may again be at death's door, threatened by a technological revolution and global pandemic it was helpless to anticipate or avoid. But there is a reason it has persevered through all its earlier trials, not to mention through world war and financial catastrophe and global unrest. Hollywood, the world of the movies, has always been more than just an industry. It is a state of mind, offering escape to endless worlds of wonder through the power of the moving image. And that will never die.

As Ever,

Carla Valderrama

SOURCE NOTES

The Road to Hollywood

"Heads for California": Eugene Brown, "Chesterton Hay Chases Comedy," *Los Angeles Times*, April 2, 1916, p. 29.

"None of us": "Remembrance by Al Christie," 1928. Reprinted in Allan R. Ellenberger, *Hollywood at 100!*, October 27, 2011. Retrieved on December 1, 2019 from http://allanellenberger.com/filmmaking-in-hollywood-approaching-100-years/.

"[W]e were shadowed": "This Business of Motion Pictures," by Carl Laemmle, unpublished manuscript, 1927. Reprinted in Richard Koszarski, *Fort Lee: The Film Town (1904–2004)*.

"[C]ameramen were selected": Ibid.

"They found that by shooting": Allan Dwan to Kevin Brownlow, *Hollywood: The Pioneers*.

"When the present-day": "This Business of Motion Pictures."

"That's one of the reasons": Allan Dwan to Kevin Brownlow, *Hollywood: The Pioneers*.

"the saloon": "Unique Young Hollywood and Her Charming Environs," *Los Angeles Times*, February 4, 1905, p. 1.

"more than 2000": Laurance Landreth Hill, *In the Valley of the Cahuengas: The Story of Hollywood*.

The Idle Hour: 1912 Los Angeles City Directory.

"FLAGSTAFF NO GOOD": A. Scott Berg, *Goldwyn: A Biography*.

"The California": Cecil B. DeMille, *The Autobiography of Cecil B. DeMille*.

"get out": Ibid.

"far beyond": United States vs. Motion Picture Patents Co, District Court E.D. Pennsylvania, October 1, 1915, No. 889.

"No dogs": Gregory Paul Williams, *The Story of Hollywood: An Illustrated History*.

"We were beneath": Allan Dwan to Kevin Brownlow, *Hollywood: The Pioneers*.

"It was a family": Harvey Parry to Kevin Brownlow, *Hollywood: The Pioneers*.

"Environment certainly affects": Wid Gunning, *Wid's Year Book*, 1919.

The First Movie Star

the train was due: "Ovation for Film Star at Union Station," *St. Louis Times*, March 26, 1910, p. 3.

"Florence Annie Bridgwood": 1891 Canadian Census.

"Baby Florence": Florence Lawrence, Growing Up with the Movies, *Photoplay*, November 1914.

"High-Class Vaudeville": Florence Lawrence Papers, Seaver Center, Box 3, Folder 49.

"As a girl": Florence Lawrence, "Growing Up with the Movies."

Daniel Boone; or, Pioneer Days in America: Some online databases such as IMDB have listed *The Automobile Thieves* as Florence Lawrence's first film. Author has seen a print at UCLA and can confirm that Florence Lawrence is not in the picture.

"We kept a bonfire": Florence Lawrence, "Growing Up with the Movies."

"I looked so clumsy": ibid

"How in the world do you think": Ibid.

"I simply must talk": "The Girl of a Thousand Faces," *St. Louis Post-Dispatch*, March 20, 1910, p. 5.

they married: August 30, 1908, State of New Jersey Marriage Certificate No. 484.

"I'd rather ride": "The Girl of a Thousand Faces," *St. Louis Post-Dispatch*, March 20, 1910, p. 5.

"four times": Florence Lawrence, "Growing Up with the Movies."

"slow acting": Ibid.

"Miss Lawrence": "Has Star Actress," *Variety*, October 16, 1909, p. 13.

ad: *Show World*, January 22, 1910, p. 27.

"Report is silly": "Film Poser Is Not Dead," *St. Louis Star and Times*, February 21, 1910, p. 1.

"The blackest": *Moving Picture World*, March 10, 1912, p. 365.

"I appreciate this honor": "Ovation for Film Star at Union Station," *St. Louis Times*, March 26, 1910, p. 3.

"She's in your life the same as the Goddess of Liberty": "You've Seen Her Face So Often! Now You Know Who This Girl Is," *Times-Democrat* (New Orleans, Louisiana), May 26, 1910, p. 30.

"The Return of Everybody's favorite": "Elusive Isabel," *Altoona Times*, May 25, 1916, p. 5.

"a very much jumbled up affair": "Elusive Isabel," *Variety*, May 5, 1916, p. 26.

series of operations: Letter from Dr. Charles Gottlieb to Dr. William J. Jones, April 3, 1916; Payment from Florence Lawrence to Dr. Charles Stephen Baker, September 12, 1916, Seaver Center, Florence Lawrence Papers, Box 2, Folder 16.

"This is just a friendly letter": Letter from Florence Lawrence to Carl Laemmle, October 15, 1916, Seaver Center, Florence Lawrence Papers, Box 1, Folder 1.

threats of suicide and murder: Letter from Florence Lawrence to Charlotte Bridgwood, October 25, 1912, Seaver Center, Florence Lawrence Papers, Box 1, Folder 1; Letter from Harry Solter to Florence Lawrence [undated], Seaver Center, Florence Lawrence Papers, Box 1, Folder 1; Telegram from Harry Solter to Florence Solter, August 26, 1912, AMPAS.

"obtain the necessary evidence": Agreement between New Jersey Rangers Detective Association and Florence A. Solter, November 11, 1916, AMPAS, Florence Lawrence Papers, Folder 1.

died of a stroke: Harry Lewis Solter died on March 2, 1920 in El Paso, Texas. Certificate #10133, Texas Department of Health.

"would climb aboard": Henry E. Dougherty, "Florence Lawrence Returns to the Screen," December 17, 1920, Seaver Center, Florence Lawrence Collection, Box 3, Folder 48.

Charles Woodring: "Florence Lawrence, Film Star, SF Bride," *San Francisco Examiner*, June 27, 1921, p. 13.

"press agent": Letter from William Francis Mooney to Florence Lawrence, 1924, Seaver Center, Florence Lawrence Collection, Box 2, Folder 21.

Mary Pickford . . . couldn't even help: Letter from Mary Pickford's secretary, Elizabeth Carmen, to Florence Lawrence, January 7, 1924, AMPAS, Florence Lawrence Papers, Folder 1.

"I have not been starred for three years": "Tries Sixteenth Surgeon," *Los Angeles Times*, June 12, 1924, p. 26.

"I don't hope for stardom": "Producers Blast Comeback Ambitions of 'First Star,'" *Star Tribune* (Minneapolis, Minnesota), October 2, 1927, p. 6.

Westbourne Drive: 532 Westbourne Drive.

Four Girls in White: "Ex-Film Star Poisons Self," *Pittsburgh Press*, December 29, 1938, p. 2.

"a bone disease": "Biograph Girl Dies of Poison," *Salt Lake Telegram*, December 29, 1938, p. 4.

Fewer than forty: "Biograph Girl Laid to Rest," *Los Angeles Times*, December 31, 1938, p. 34.

"I have invented": "A Film Favorite Who Is an Inventor?," *Green Book Magazine*, May 1914, p. 844.

US Patent #1274983: C.A. Bridgwood, Cleaning Device, Application Filed October 16, 1917, Patented August 6, 1918, Serial No. 196,879.

"electric storm windshield cleaner": Seaver Center, Florence Lawrence Papers, Box 3, Folder 35.

"the basic patent": "Old Papers, May Bring Wealth," *Spokane Chronicle*, December 11, 1930, p. 3.

The Cat Who Conquered Hollywood

"the most human": Jimmy Hazelwood, "Kiddies," *Hollywood Filmograph*, October 21, 1933, p. 5.

Los Angeles Times: "Only an Alley Cat's Daughter," *Los Angeles Times*, January 23, 1927, p. 11.

paw print: Contract between Nadine and Katherine Dennis and Mack Sennett Productions, July 19, 1927, Mack Sennett Collection, Folder 1291, AMPAS.

raise: Letter from Mack Sennett Inc. to Nadine and Katherine Dennis, November 30, 1927, Mack Sennett Collection, Folder 1291, AMPAS.

cancel his contract: Letter from Mack Sennett Inc. to Katherine and Nadine Dennis, January 20, 1928, Mack Sennett Collection, Folder 1291, AMPAS.

European tour: "Puzzums and Tien Chin Ho," *Cincinnati Enquirer*, June 28, 1931, p. 91.

infected tooth: "Puzzums Rites Set for Today," *Los Angeles Times*, August 19, 1934, p. 5.

Rin Tin Tin: The Dog Who Saved Warner Bros.

unpublished 1933 memoir: Lee Duncan, Mr. Duncan's Notes, unpublished manuscript, Box 8, Folders 31–33 (June 21, 1933), Rin Tin Tin Collection, Riverside, California. Local History Resource Center; Ann Elwood, *Rin-Tin-Tin: The Movie Star*.

different versions: Letter from Otto Sandman [Lee Duncan's Commanding Officer] to Eva Duncan, September 21, 1960; "Famous War Dog to Be Exhibited Here," *Los Angeles Times*, October 13, 1919, p. 14; "Movie Man Espouses Cause of All Dogs," *Billings Gazette*, September 30, 1923, p. 15.

born in 1892: October 1, 1892: U.S. Social Security Death Index, 1935–2014; California Death Index, 1940–1997; World War II Draft Registration Cards, 1942.

farmers: George Grant Duncan, California Voter Registration, Tulare, 1866–1899

"time, patience": Sue Bernardine, *San Bernardino County Sun*, July 4, 1948, p. 30

"For ten days": Ann Elwood, *Rin-Tin-Tin: The Movie Star*.

"In a dog you never": "Lee Duncan: Movie Man Espouses Cause of All Dogs," *Billings Gazette*, September 30, 1923, p. 15.

Lee enlisted: U.S. World War I Draft Registration Cards, 1917–1918, National Archives.

"education": "New Dog Star, Son of the Old, Ready to Begin His Hollywood Career," *Messenger* (Madisonville, Kentucky), August 29, 1932, p. 6.

"cruel, needless": "For Television's Canine Stars Pay Is More Than Dog Biscuits," *San Bernardino County Sun*, May 19, 1957, p. 87.

"first lesson": Lee Duncan folder, Warner Bros. Archive, USC.

"I felt there was something": Ann Elwood, *Rin-Tin-Tin: The Movie Star*.

"untiring patience": "Lee Duncan: Directing Animals in Pictures," Laurence A. Hughes, ed., *The Truth About the Movies by the Stars*, p. 169.

"Rin-Tin-Tin . . runs off": "Twas About Time They Gave a Thought to Father," *Daily News* (New York), August 10, 1922, p. 17.

"We had one continuing problem": Jack Warner, *My First Hundred Years in Hollywood: An Autobiography.*

"It's got a lot of action": Ibid.

"needed only a word": Ibid.

"he didn't ask for a raise":

$150 a week: Contract between Warner Bros. and Lee Duncan, July 2, 1923, Warner Bros. Archive, USC.

outstanding loans it couldn't pay: Agreement between Warner Bros. Pictures, Inc., Warner Brothers, and Pacific-Southwest Trust & Savings Bank, August 1923, Warner Bros. Archive, USC.

"He kept us": Jack Warner, *My First Hundred Years in Hollywood: An Autobiography.*

$250 a week and 10%: Letter from Warner Bros. to and signed by Lee Duncan, August 20, 1923, Warner Bros. Archive, USC.

"A new star": Buford Gordon Bennett, "Rin-Tin-Tin, Dog Actor, Latest Find," *San Francisco Examiner*, August 13, 1923, p. 7.

"Rin-Tin-Tin is practically": Charles S. Sewell, "Newest Reviews and Comments," *Moving Picture World*, August 25, 1923, p.657.

"box office rocket": Jack Warner, *My First Hundred Years in Hollywood: An Autobiography.*

"The dog was literally a bonanza": Ibid.

"I attribute": "Rinty's Faith Made Training Possible," *Visalia Times-Delta*, May 29, 1930, p. 2.

"limp": Lee Duncan. *The Rin-Tin-Tin Book of Dog Care.*

"There's a flea": "Rin-Tin-Tin Hunts Fleas in Chicago Education Test," *Daily News* (New York), March 5, 1926, p. 41.

"teach the coming generation": Lee Duncan Transcript, undated, Warner Bros. Archive, USC.

"Rin-tin-tin . . . doesn't know": Harry Carr's Page, *Los Angeles Times*, September 24, 1924, p. 46.

"He was the only leading": Jack Warner. *My First Hundred Years in Hollywood: An Autobiography.*

write-in vote: [also the only vote] Louise Hilton, AMPAS to CV; Bruce Davis (former executive director of AMPAS). "No, Rin Tin Tin Didn't Really Win the First Best Actor Oscar." *The Wrap*, February 15, 2017. Retrieved on October 12, 2019 from https://www.thewrap.com/rin-tin-tin-oscar-win-first-best-actor/.

"Mr. Duncan did not love me": A.L. Wooldridge, "It's the Little Things That Count When Movie Stars Fall Out," *St. Louis Post-Dispatch*, February 28, 1928, p. 33.

"You've known and rooted": "Rin-Tin-Tin Appears in Talking Film at Strand," *Reading (Pennsylvania) Times*, December 28, 1928, p. 16.

"the making of any animal pictures": P.A. Chase to Ralph E. Lewis, Freston and Files, December 6, 1929, Warner Bros. Archive, USC.

"we can always settle": Interoffice Memo from W.M. Koenig to Jack Warner, December 16, 1929, Warner Bros. Archive, USC.

walking papers: Notice of Termination, Warner Bros. to Lee Duncan, December 21, 1929, Warner Bros. Archive, USC.

Rin Tin Tin was reburied: Cimetière des Chiens et Autres Animaux Domestiques lost records when ownership changed; however, they mentioned that someone else, paid for Rinty's transport and burial, and that it was sometime before World War II. [Thank you, Emily Byron.]

"There'll always be": "There'll Always Be a Rin Tin Tin: Picking Up in France Lucky for Lee," *Birmingham News*, August 7, 1955, p. 85.

The Death of Rudolph Valentino and the Birth of a Screen God

"100,000": Mark Hellinger, "Good-by, Rudolph: 100,000 Attend Valentino Rites," *Daily News* (New York), August 31, 1926, p. 3.

Rodolfo Pietro Filiberto Raffaello Guglielmi: Birth Extract #182, Archivio di Stato di Castellaneta / States Archives in Castellaneta, dated May 9, 1895.

arrived in New York: December 23, 1913 on the SS *Cleveland*, Ellis Island Passenger Records, Passenger ID: 100823030192.

sleeping in Central Park: Alberto Valentino to Kevin Brownlow, *Hollywood* (1980 Documentary TV Series by Thames Television).

"She gave me my start": Gladys Hall and Adele Whitley Fletcher, "We Discover Who Discovered Valentino," *Motion Picture*, June 1923, p. 22.

"assumed a place": Edwin Schallert, "Reviews," *Los Angeles Times*, March 10, 1921, p. 32.

told a friend . . . he knew he would die young: [he told John W. Considine Jr., producer of *The Eagle* and *The Son of the Sheik*] Allen R. Ellenberger, *The Valentino Mystique: The Death and Afterlife of the Silent Film Idol.*

double operation: "Valentino Stricken; Goes under Knife," *New York Times*, August 16, 1926, p. 1.

information bureau: "Valentino's Fate Is Still in Doubt," *New York Times*, August 18, 1926, p. 1.

2,000 calls an hour: "Valentino Is Still in Serious Condition; Rumor of Death Swamps Hospital Phones," *New York Times*, August 19, 1926, p. 1.

"the most envied": "Has Pretty Little Nurse," *News-Herald* (Franklin, Pennsylvania), August 21, 1926, p. 1.

"I need you.": "Valentino Gaining; Asks to Leave Bed," *New York Times*, August 21, 1926, p. 3.

"They must have": Ibid.

"I have been deeply touched": "Valentino Better; Passes the Crisis," *New York Times*, August 20, 1926, p. 2.

developed pleurisy: "Valentino Is Worse: Pleurisy Sets In," *New York Times*, August 22, 1926, p. 1; "Valentino Sinking; Second Crisis Near, Pleurisy Spreads," *New York Times*, August 23, 1926, p. 1.

"Don't pull down": George Ullman, *Valentino: As I Knew Him.*

One of his physicians promptly had a heart attack: [Dr. Paul Durham] "Valentino's Doctor III," *New York Times*, August 24, 1926, p. 3.

blocking traffic: "Valentino Passes with No Kin at Side; Throngs in Street," *New York Times*, August 24, 1926, p. 1.

30,000: "Thousands in Riot at Valentino Bier; More Than 100 Hurt," *New York Times*, August 25, 1926, p. 1.

"Feet were trod": Ibid.

"without precedent": ibid

50,000 to 70,000: "Public Now Barred at Valentino's Bier," *New York Times*, August 26, 1926, p. 1; "Crowds Still Try to View Valentino," *New York Times*, August 27, 1926, p. 3.

'Peggy' Scott: "Girl Takes Life over Valentino," *San Francisco Examiner*, August 27, 1926, p. 2.

Evelyn Vail: "Girl Dies Grasping Valentino Picture," *New York Times*, September 22, 1927, p. 14.

"wanted to be where he is": "Tries to Join Valentino," *New York Times*, October 31, 1926, p. 18.

Pola Negri arrived: "Pola, in Collapse, Awaits Rites," *New York Daily News*, August 30, 1926, p. 4.

"We were really engaged": "Miss Negri Swoons at Valentino's Bier," *New York Times*, August 30, 1926, p. 3.

"premiere for Pola Negri": Ben Lyon to Kevin Brownlow, *Hollywood* (1980 Documentary TV Series by Thames Television).

"Good-by, Rudolph": Mark Hellinger, "100,000 Attend Valentino Rites," *Daily News* (New York), August 31, 1926, p. 3.

conspiracy theories: "Stories of Arsenic Revenge Told; Pecora Ready to Act," *Daily News* (New York), August 24, 1926, p. 77.

LaSalle Street Station: "Crowds Wait in Vain," *New York Times*, September 4, 1926, p. 3.

"We were not formally engaged": "Valentino Was Not Engaged to Pola," *Gazette* (Cedar Rapids, Iowa), September 4, 1926, p. 1.

Final funeral services: "Last Services for Valentino," *Los Angeles Times*, September 8, 1926, p. 17.

"The world": "How Pola's Prince Was 'Certified,'" *Salt Lake Tribune*, August 21, 1927, p. 59.

Pola married a Prince: Prince Serge Mdivani.

"record-breaking box office": $28,500 Last Week for Sheik's at Loew's Aldine, *Variety*, October 6, 1926, p. 44.

"turn away": "Valentino-Reid-Lockwood Picture Changes Vividly Brought Out Now," *Variety*, September 1, 1926, p. 1.

"The biggest gross": "Valentino Reissue, 'Horsemen' at Capitol, $68,738, First Week," *Variety*, October 6, 1926, p. 43.

Alberto underwent seven plastic surgeries: Emily Leider, *Dark Lover: The Life and Death of Rudolph Valentino.*

"spirit messages": "Count Salm Back; To Seek Citizenship," *New York Times*, November 26, 1926, p. 21.

caretaker . . . wrote a book: Roger C. Peterson, *Valentino: The Unforgotten.*

asked to have a cot: Roger Peterson, "My Strange Experiences at Valentino's Grave," *New Movie Magazine*, April 1932, pp. 88–90.

200 to 300 people: Karie Bible to CV, October 17, 2019.

The Lady in Black

"took on": "Scores Visit Actor's Tomb," *Los Angeles Times*, August 24, 1938, p. 5.

"After a year": "Mystery Mourner at Valentino's Grave Proves to Be Hoax," *St. Louis Star and Times*, August 24, 1938, p. 10.

"Flah-may": Peter J. Boyer, "After 50 years, Valentino's 'Lady in Black' Reveals Who She Is," *Reno Evening Gazette*, August 26, 1977, p. 13.

"just one rose": Ditra Flame, *Red Roses at Noon.* Reprinted in Tracy Ryan Terhune, *Valentino Forever.*

"spiritualists, publicity seekers . . .": Letter from Ditra Flame to Philomena Rose Miller, October 1, 1954. Tracy Ryan Terhune, *Valentino Forever.*

"This is my last trip": "Color Change Confuses," *Rochester Democrat and Chronicle*, August 24, 1954, p. 15.

"Rather than weep": "Lady in Black in Last Visit to Valentino Tomb," *Los Angeles Times*, August 24, 1954, p. 2.

"I was very heartbroken": "51st Anniversary of Death," *Los Angeles Times*, August 24, 1977, p. 42.

Princess Orvella: Princess Orvella Wilson, February 23, 1984, San Bernardino. California Death Index, 1940–1997. Sacramento, California.

"My Heart Belongs to Daddy": Tracy Ryan Terhune, *Valentino Forever.*

"the 3rd Generation Lady in Black": Ibid.

"I decided to take up": Karie Bible to CV, October 17, 2019.

United States v. "The Spirit of '76"

"#3180": McNeil Island Penitentiary Records of Prisoners Received.

"And now joined": "Spirit of 76 Movie Fails to Move Its Critics," *Chicago Tribune*, May 16, 1917, p. 17.

"had been financed": "The Spirit of '76 Emerges Safely from Censorship Fight," *Billboard*, June 9, 1917, p. 66.

"The consensus": "Spirit of 76 Movie Fails to Move Its Critics", AMPAS clippings.

Funkhouser . . . accused of being pro-German: [This happened after he banned Mary Pickford's *The Little American* on the basis that it was anti-German.] "Anti-German Film Rejected by Funkhouser," *Chicago Tribune*, June 30, 1917, p. 17.

"Contrary to the opinion": *Exhibitors Trade Review*, June 9, 1917.

"It is the very heart": *Chicago American*, AMPAS clippings.

U.S. Attorney confiscated: "War Film Seized," *Los Angeles Times*, November 30, 1917, p. 8.

"willfully and unlawfully": "Film's Called Part of Plot," *Los Angeles Times*, December 5, 1917, p. 14.

"a sedulous effort": "Original 'Spirit of '76' Film to Be Seized," *Los Angeles Herald*, December 1, 1917, p. 4.

George L. Hutchin: "U.S. to Launch Bitter Attack in Film Suit," *Los Angeles Herald*, April 3, 1918.

"no English": Ibid.

Theo M. Newman: "'I Cut '76 Film Myself,' Says Theater Head," *Los Angeles Herald*, April 9, 1918, p. 12.

"Goldstein had a right to his opinion": Robert Goldstein manuscript, AMPAS.

"he was pro-German": Ibid.

"most potent": "Ten Years for Film Producer," *Los Angeles Times*, April 30, 1918, p. 13.

"patriotic propaganda": "Hun Treason Film, Spirit of '76, Now Aids U.S.," *Los Angeles Herald*, August 29, 1918, p. 1.

President Woodrow Wilson reduced Goldstein's sentence: McNeil Island Penitentiary Records of Prisoners Received.

he was released: October 13, 1920.

"[I]t is intended to stir up": "The Screen," *New York Times*, July 19, 1921, p. 18.

"As a motion picture": Ibid.

Griffith's check: Robert Goldstein manuscript, AMPAS.

"flat broke": Letter from Robert Goldstein to Frank Woods, August 18, 1927, AMPAS.

"street sweeper": Ibid.

pleading letters: Letter from Robert Goldstein to the Academy of Motion Picture Arts and Sciences, May 31, 1927, AMPAS.

The Academy declined: Letter from Frank Woods to Robert Goldstein, September 13, 1927, AMPAS.

"swell piece of ironical news": Letter from Robert Goldstein to AMPAS, May 10, 1935.

arrived in New York: SS *Albert Ballin*, sailing from Hamburg August 8, 1935 and arriving in New York on August 16, 1935.

"THERE MUST": Western Union Press Message from Robert Goldstein to AMPAS, June 30, 1938.

Social Security application: National Archives, Washington D.C.

hid Robert's existence from his children: Richard Levin (grand-nephew of Robert Goldstein) to CV, October 17, 2019.

The White House of Hollywood

"one of the world's": Beverly Hills [ad], *Los Angeles Daily Times*, November 7, 1906, p. 27.

"temporary camps": "Small Business for Big Business," *California Outlook*, vol. 16, May 30, 1914, p. 16.

"far away": Beverly Hills [ad], *Los Angeles Times*, September 20, 1907, p. 27.

The home featured: "Film Star's Home at Beverly Hills," *Los Angeles Times*, July 6, 1919, p. 74.

March 28, 1920: Marriage of Douglas E. Fairbanks and Gladys M. Moore, Los Angeles, California, County Birth, Marriage, and Death Records.

"Mary, this house": Mary Pickford, "My Whole Life," *McCall's*, 1954, p. 128.

"No, Douglas": Ibid.

"Typical Family Dinner": Charles Lockwood, *Dream Palaces*.

"something of a secret drinker": Tracey Goessel, *First King of Hollywood: The Life of Douglas Fairbanks*.

"Soon, houses began": Frances Marion, *Off with Their Heads!*

"This is a sample of the water": "Beverly Hills' Thirst for Autonomy Saves the Day," *Los Angeles Times*, January 30, 1994, p. 200.

507 to 337: Ibid.

"Pickfair was certainly the best taste": Jeffrey Vance, Tony Maietta, *Douglas Fairbanks*.

"weak mixed drinks": Charles Lockwood, *Dream Palaces*.

private running track so he could run naked: Tracey Goessel, *First King of Hollywood: The Life of Douglas Fairbanks*.

"Swedish exercises": Richard Schickel, "Superstar of the Silents," *American Heritage*, December 1971.

"When a man is stripped": Charles Chaplin, *My Autobiography*.

"People of attainment": Mary Pickford, "My Whole Life," *McCalls*, 1954.

"just for the quiet": Charles Lockwood, *Dream Palaces*.

"I found I just couldn't keep up": Mary Pickford, *Sunshine and Shadow*.

"It's thrilling": "Doug and Mary Plan Separation," *Philadelphia Inquirer*, July 3, 1933, p. 5.

Pickfair was put for sale: Brochure for the sale of Pickfair. Brochure is by Coldwell, Cornwall & Banker & Times-Mirror Printing & Binding House: Los Angeles.

"But. . . . I saw Mary's maid": Malcolm Boyd, "Rogers Remembers Pickfair Days," *Los Angeles Times*, October 19, 1980, p. 333.

"People have their illusions": "Pickford: America's Sweetheart Dead at 86," *Hanford Sentinel*, May 30, 1979, p. 2.

"add a little more house": "Homes: Big is Better, Say Many Buyers of Real Estate," *Los Angeles Times*, September 18, 1988, p. 3.

"have to be put somewhere": Ibid.

"a non-profit organization": The Beverly Hills Historical Society. Retrieved on November 16, 2019 from http://www.beverlyhillshistoricalsociety.org/about.

"It's nothing spectacular": Mathis Chazanov, "Pickfair: Famed Hollywood Mansion Will Get an Italian Look," *Los Angeles Times*, July 28, 1989, p. 3.

"highly paid sex symbols": Mathis Chazanov, "Pickfair, Relic of Golden Age of Hollywood, Razed," Los Angeles Times, April 20, 1990, p. 3.

"Pickfair razed": John Antczak, "Pickfair razed to clear the way for Pia's palace," *South Bend Tribune*, April 21, 1990, p. 12.

"Homewrecker Pia": "Names in the News," *Vancouver Sun*, April 21, 1990, p. 2.

"Pia Zadora Trashes": "Pia Zadora Trashes Pickfair," *Gazette* (Montreal, Quebec, Canada), April 24, 1990, p. 21.

"I wonder": Mathis Chazanov, "Pickfair, Relic of Golden Age of Hollywood, Razed."

Zadora moved: "Renovated Pickfair for Sale after Zadora-Riklis Split," *Palm Beach Post*, November 28, 1993, p. 117.

"You can deal with termites": *Celebrity Ghost Stories*, Season 4, Episode 4, Episode aired September 15, 2012.

The Sex Symbol That Time Forgot

decided to commit harakiri: Sessue Hayakawa, *Zen Showed Me the Way*.

American steamship crashed: "Wreck of Steamship 'Dakota' As Given by Japanese Paper," *Evening Star* (Washington, District of Columbia), April 14, 1907, p. 11.

he set sail: On the *Aki Maru* arriving in Seattle in on July 25, 1907. Kintaro Hayakawa, National Archives and Records Administration; Washington, D.C.; Index to Aliens, *Not Including Filipinos, East Indians, and Chinese, Arriving by Vessel or at the Land Border at Seattle, Washington*.

"I had not given much thought": Sessue Hayakawa, *Zen Showed Me the Way*.

"Before we began": Thomas H. Ince, "The Early Days at Kay Bee," *Photoplay*, March, 1919, p. 45.

"Japanese Story": *Reel Life*, November 1914, p. 28.

Sessue and Tsuru were married: Marriage of Tsuru Aoki and Kinto S. Hayakawa, Los Angeles, California, County Birth, Marriage, and Death Records, 1849–1980.

"It was a rather daring theme": Cecil B. DeMille, *The Autobiography of Cecil B. DeMille*.

"does one of the best bits": "At the Theaters," *Los Angeles Times*, December 22, 1915, p. 18.

"the work of Sessue": "The Cheat," *Variety*, December 17, 1915, p. 18.

"I don't understand": Edward Jewitt Wheeler and Frank Crane, "Is the Higher Art of Movies to Come from Japan?," *Current Opinion*, vol. 64, 1918, p. 30.

"unforgiveable traitor": Daisuke Miyao, *Sessue Hayakawa: Silent Cinema and Transnational Stardom*.

"White women": Ibid.

"Public acceptance": Sessue Hayakawa, *Zen Showed Me the Way*.

"Such roles": Grace Kingsley, "That Splash of Saffron," *Photoplay*, March 1916, p. 139.

"The atmosphere": Sessue Hayakawa, *Zen Showed Me the Way*.

"live a little": Ibid.

"drunken fury": "He's a Villain At Heart, Millard Alexander," *Pacific Stars And Stripes*, October 3, 1958, p. 9.

"They sometimes lasted": Ibid.

"Defiantly": Sessue Hayakawa, *Zen Showed Me the Way*.

warned of a plot by his business partners: Ibid.

"For once I was not": Ibid.

fathered a son: Alexander Hayes: Born January 30, 1929, New York, New York Birth Index, Certificate Number 4187.

"Film Star in 'East-West' Love Triangle": *Oakland Tribune*, October 16, 1931, p. 4

"White Actress is Suing to Get Back Child from Jap," *Tyler Morning Telegraph*, October 17, 1931, p. 4

following them to Japan: [Ruth Noble went to Japan in 1934, traveling second class as Ruth Darby.] SS *M.S. Chichibu Maru* arriving in Kobe, Japan, 1934. National Archives and Records Administration (NARA); Washington, D.C.; Passenger Lists of Vessels Departing from Honolulu, Hawaii.

sue Sessue for half a million: "A Bridge for Hayakawa to Cross," *Daily News* (New York), January 5, 1961, p. 4.

"They offered me an automobile": Peter Kihss, "Hayakawa Returning to Hollywood," *St. Louis Post-Dispatch*, January 11, 1949, p. 26.

"a man on a tightrope": Sessue Hayakawa, *Zen Showed Me the Way.*

"lived in an atmosphere": Ibid.

Louella Parsons: Louella O. Parsons, "N.Y. Mob Cleanout Theme for New Thriller," *San Francisco Examiner*, November 4, 1948, p. 21; Louella O. Parsons, "Rosalind Russell Returns to Comedy in Latest," *San Francisco Examiner*, November 9, 1948, p. 17.

"From the conflict": Sessue Hayakawa, *Zen Showed Me the Way.*

"captivated or challenged": Ibid.

"personifications of evil": Ibid.

Sign of the Times

December 8: "Huge Electric Sign Blazons, Name of District Across the Sky," *Los Angeles Evening Express*, December 8, 1923, p. 25.

3,700: "Saga of the Sign," Hollywood Sign Trust, p. 14. Retrieved on December 14, 2019 from http://www.hollywoodsign.com.

letter H: "Girl Leaps to Death from Sign," *Los Angeles Times*, September 19, 1932, p. 11.

"an eyesore": "Ruling Asked in Case of Hollywoodland Sign," *Los Angeles Times*, January 25, 1949, p. 21.

tear it down: "Hollywoodland Sign to Be Torn Down," *Los Angeles Times*, January 7, 1949, p. 10.

raise funds: "Derelict Hollywood Sign May Be Restored to Life," *Californian*, June 15, 1978, p. 32; Lynn Simross, "Last Story on Hollywood Sign (Maybe)," *Los Angeles Times*, July 10, 1978, p. 49.

"It's like saying": Ching-Ching-Ni, "Hefner's $900,000 Ensures Protection for Hollywood Sign," *Los Angeles Times*, April 27, 2010. Retrieved on December 14, 2019 from https://www.latimes.com/archives/la-xpm-2010-apr-27-la-me-hollywood-sign-20100427-story.html.

The Woman Who Made the Movies

color and 3-D: Mark C. Larkin, "Sacrifice Price of Success in Photoplay Art," *Des Moines News*, December 26, 1915

Florence Lois Weber: 1880 United States Federal Census, Allegheny, Pennsylvania.

The Church Army: "Salvation Signer Now Directs Film Actors," *Los Angeles Herald Examiner*, July 14, 1913.

"If you want to save souls": Charles S. Dunning, "The Gate Women Don't Crash," *Liberty* 4, no. 2, May 1927.

"I joined the chorus": Frankie Lynne, "What's the Matter with Marriage?," *Movie Weekly*, April 23, 1921.

Lois and Phillips were married: Florence L. Weber to Phillips Smalley, April 29, 1904, Cooks County, Illinois Marriage Index, 1871–1920.

"Little thought": Lois Weber, "How I Became a Motion Picture Director," *Static Flashes*, April 24, 1915, p. 8.

"shadowy drama": Ibid.

"No one knows": Ibid.

"I wrote the scenarios": Shelley Stamp, *Lois Weber in Early Hollywood.*

"Why the 'and Phillips Smalley'": *New York Dramatic Mirror*, December 8, 1917.

"Phillips Smalley did nothing": Henry Hathaway to Anthony Slide, April 18, 1983, AMPAS.

"She is as much the director": Shelley Stamp, *Lois Weber in Early Hollywood.*

mayor: *Variety*, May 30, 1913.

fifteen votes: *Los Angeles Times*, May 21, 1913, p. 16.

Kennedy retired: *Variety*, June 27, 1913, p. 16.

"indecent and sacrilegious": *New York Dramatic Mirror*, April 4, 1915, p. 24.

"Hypocrites is not": *Marlborough Express*, June 18, 1917.

"In a way 'Hypocrites'": "The Hypocrites," *Variety*, November 1914, p. 23.

"Personally, I grew up with the business": Martin F. Norden, ed., *Lois Weber: Interviews.*

"one of the strongest: *New York Dramatic Mirror*, June 30, 1915, p. 25.

"I would trust Miss Weber": Charles S. Dunning, "The Gate Women Don't Crash."

"mindlessness": "The Greatest Woman Director in the World," *Moving Picture Weekly*, May 20, 1916.

"the close-up of the dead baby's shoes": Ibid.

"unspeakably vile": "Pennsylvania Turns Down 'Where Are My Children?,'" *Motion Picture News*, October 7, 1916.

set aside its ban: "Lois Weber Honored by Body of Directors," *Post-Star* (Glens Falls, New York), December 7, 1916, p. 10.

"the most effective propaganda": "Capital Punishment Film Play's Theme," *New York Times*, December 11, 1916, p. 7.

"You would never guess": Fritzi Remont, "The Lady Behind the Lens," *Motion Picture*, May 1918, p. 59.

"who clothe our souls": Anthony Slide, *Lois Weber: The Director Who Lost Her Way in History.*

Phillips's infidelity and drinking: "Lois Weber's Divorce Bared," *San Francisco Examiner*, January 12, 1932, p. 15.

"noticeable absence": Anthony Slide, *Lois Weber: The Director Who Lost Her Way in History.*

"the sentimentalities": "The Years Sensation," *Motion Picture Director*, October 1926.

"She is back": *Motion Picture*, 1926, AMPAS clippings.

"When the history": Aline Carter, "The Muse of the Reel," *Motion Picture*, March 1921.

"It is to be wondered": "Lois Weber: An Asset," *Hollywood Vagabond*, 1927.

"There will be few women directors": Charles S. Dunning, "The Gate Women Don't Crash."

"In the first place": Lois Weber, "'Many Women Well Fitted by Film Training to Direct Movies,' Lois Weber Claims," *San Diego Evening Tribune*, April 24, 1928.

"LOIS WEBER IN TALKING PICTURES": *Film Mercury*, July 6, 1928.

Her second husband: Harry Gantz. Florence Weber and Harry Gantz, June 30, 1926, California County, Birth, Marriage and Death Records.

Lois Weber died: Death of Lois W. Gantz, November 13, 1939, California Death Index, 1905–1939.

"Lois Weber, Who Made Stars, Dies": *Daily Mail* (Hagerstown, Maryland), November 14, 1939, p. 12.

"*Variety*": "Obituaries," *Variety*, November 15, 1939, p. 62.

"film writer": Hedda Hopper, "Death Takes Lois Weber," *Los Angeles Times*, November 14, 1939, pp. 1–2.

"Remember Lois Weber?": "Hedda Hopper on Hollywood: Producer Joan Harrison Wins Filmdom's Respect," *Baltimore Sun*, October 14, 1945, p. 28.

And the First Academy Award Goes To . . .

"Nobody really felt": Bob Thomas, "First Actress To Win Oscar Is Honored," *Lancaster New Era* (Lancaster, Pennsylvania), March 2, 1978, p. 23.

"I found that the best way": "What Makes a Star," *American Weekly*, June 8, 1958, AMPAS; Scott Eyman, *Lion of Hollywood.*

"When we need a set": Irene Mayer Selznick, *A Private View.*

"promote harmony and unity": "Motion Picture Academy of Honor Launched at Banquet," *Exhibitors Herald*, May 21, 1927, p. 9

"to represent to the industry": "Film Academy Organizing," *Los Angeles Times*, May 5, 1927, p. 19.

$100: "Lay Foundation for Academy of Film Art," *Santa Ana Register*, May 12, 1927, p. 1.

"authentic and constructive": "Movie Artists to 'Spank' Own Scandal Tainted," *Oakland Tribune*, May 12, 1927, p. 23.

"moral weapon": "Anti-Scandal Weapon Bared," *San Francisco Examiner*, May 12, 1927, p. 13.

"dishonorable or unethical": Ibid.

"keeping the motion picture house": Ibid.

$27,000: "Motion Picture Academy of Honor Launched at Banquet," *Exhibitors Herald*, May 21, 1927, p. 9.

"standard contract": Academy of Motion Picture Arts and Sciences Annual Report, 1929, p. 5, AMPAS.

"company union": *Bulletin*, no. 9, April 2, 1928, AMPAS.

"its sole interest in promoting harmonious": Ibid.

"explain the situation": Letter from Cecil B. DeMille to Louis B. Mayer, November 25, 1929, DeMille Papers, BYU; Scott Eyman, *Lion of Hollywood.*

"distinguished achievements": *Bulletin*, no. 11, June 4, 1928, p. 2, AMPAS.

"Academy Awards of Merit": Official Nomination Paper, 1927/1928, AMPAS.

voting system: *Bulletin*, Number 11, July 16, 1928, p. 2, AMPAS.

King Vidor was told: King Vidor, *A Tree Is a Tree*; Scott Eyman, *Lion of Hollywood.*

Academy announced to newspapers: "Film Efforts Rewarded," *Los Angeles Times*, February 18, 1929, p. 17.

"I therefore ask you": Mason Wiley and Damien Bona, *Inside Oscar: The Unofficial History of the Academy Awards.*

Goethe medal: "Hitler Honors Jannings," *Boston Globe*, March 18, 1939, p. 1.

"Please, don't shoot": Peter Bogdanovich, *Who the Hell's in It: Conversations with Hollywood's Legendary Actors.*

handled the snub by getting drunk: William Wellman, Jr. to CV, January 24, 2019.

"half broiled chicken on toast": 1929 Academy Awards Menu, AMPAS.

"it is no mean honor": *Bulletin*, no. 22, June 3, 1929, AMPAS.

"Take Mr. Jannings": Ibid.

"the pioneer outstanding talking picture": Ibid.

"a struggle of the survival of the fittest.": Ibid.

"But the train": Ibid.

"Life without service": Ibid.

"I notice they gave *The Jazz Singer*": Scott Eyman, *The Speed of Sound: Hollywood and the Talkie Revolution 1926–1930.*

"To the profession": Sidney Skolsky, "Films Crown Hepburn, Laughton Year's Best," *New York Daily News*, March 17, 1934, p. 99.

"The snobbery": Sidney Skolsky, *Don't Get Me Wrong—I Love Hollywood.*

"I finally": "Sidney Skolsky's Oscar Predictions," *Modern Screen*, April, 1956, p. 50

Uncle Oscar: Gilbert Kanour, "For Film Fans," *Evening Sun* (Baltimore), September 2, 1947, p. 20.

What Ever Happened to Cora Sue?

"rivaled Shirley Temple": George Shaffer, "Theater Polls Youngsters on Child Players: Cora Sue Collins Leads the Hollywood Vote," *Chicago Tribune*, September 28, 1934, p. 23.

"luxury of anonymity": "Cora Sue Collins: 'It's fun to be a housewife from Phoenix,'" *Film Talk*, December 13, 2014, Retrieved from https://filmtalk.org/2014/12/13/cora-sue-collins-its-fun-to-be-a-housewife-from-phoenix/.

district sales manager": 1930 United States Census, Clarksburg, West Virginia.

"a real beauty": Cora Sue Collins to CV, November 21, 2018.

"my mom just arbitrarily decided": Cora Sue Collins to CV, November 21, 2018.

"picked up": Ibid.

"Would you like to put your little girl" Ibid.

"Can you remember": Ibid.

Frances Gumm: Cora Sue Collins to CV, November 21, 2018; Randy L. Schmidt, *Judy Garland on Judy Garland: Interviews and Encounters.*

"ONE IN A MILLION!" *New Movie Magazine*, March 1932, p. 118.

"She is one": "'The Unexpected Father' at Paris, Beginning Tomorrow," *Greenville News* (Greenville, South Carolina), July 9, 1933, p. 18.

"It really is little Cora Sue": "Unexpected Father by O.P.L.," *El Paso Times*, August 30, 1932, p. 12.

"this very nice blond lady": Cora Sue Collins to CV, November 21, 2018.

"I couldn't say GG.": Cora Sue Collins to CV, December 11, 2018.

"My mother wanted": Cora Sue Collins to CV, November 21, 2018.

"I don't tell her": Ibid.

"She autographed": Cora Sue Collins to CV, December 11, 2018.

"oldest and youngest": George Shaffer, "May Robson 70: Studio Gives Surprise Party," *Chicago Tribune*, April 19, 1935, p. 28.

"When L.B. Mayer issued": Cora Sue Collins to CV, November 21, 2018.

"Oh, Miss Turner": Cora Sue Collins to CV, November 21, 2018.

"Mr. Mayer was furious": Ibid.

"Don't tell me that!": Cora Sue Collins to CV November 21, 2018 and December 11, 2018.

"fucked": Ibid.

"I found out": Ibid.

"[Norma Shearer] was the biggest": Ibid.

"a little short guy": Cora Sue Collins to CV, December 11, 2018.

"He was a genius": Ibid.

"Some babies are born": Time Inc., New York biography files f. 7228, AMPAS.

Harry Ruskin: 1900 U.S. Federal Census (Ohio); 1915 U.S. City Directory (Cincinnati, Ohio); World War I Draft Card; 1920 United States Federal Census, Cook (Chicago).

"He was a great talent": Cora Sue Collins to CV, November 21, 2018.

"He was my mentor": Cora Sue Collins to CV, December 11, 2018.

"players, actors . . .": Ibid.

"The food was horrible": Cora Sue Collins to CV, November 21, 2018.

"Two hours in his office": Hope Ridings Miller, "Capital Chatter," *Waco News-Tribune*, September 2, 1946, p. 4.

"congealed blood": Cora Sue Collins to CV, December 11, 2018.

"She would go to her butcher": Ibid.

"Where is everybody?": Cora Sue Collins to CV, November 21, 2018.

"I wrote a synopsis": Ibid.

"He knew me": Ibid.

"but you have to sleep with me": Cora Sue Collins to CV, November 21, 2018.

"There are dozens of girls": Ibid.

"Let them": Ibid.

"And then I realized": Ibid.

"Have you read": Cora Sue Collins to CV, November 21, 2018.

"Mr. Mayer, do you know": Ibid.

"You'll get used to it darling": Ibid.

"lunged across": Ibid.

"Cora Sue, you will never work": Ibid.

"Mr. Mayer, that's my heartfelt desire": Ibid.

"I didn't misunderstand": Ibid.

"Not twelve": Shirley Temple Black, *Child Star.*

"I often thought": Gerald Clarke, *Get Happy: The Life of Judy Garland.*

"I couldn't tell anybody": Cora Sue Collins to CV, December 11, 2018.

"I had five girlfriends": Cora Sue Collins to CV, November 21, 2018.

"That son of a bitch!" Cora Sue Collins to CV, December 11, 2018.

"I didn't know enough": Ibid.

"What had I done to cause this?": Cora Sue Collins to CV, November 21, 2018.

"Mr. Mayer, you just talked": Cora Sue Collins to CV, December 11, 2018.

"That's like yesterday's": Ibid.

New Yorker: Dana Goodyear, "Can Hollywood Change Its Ways?," *New Yorker*, January 1, 2018.

"It's the best single": Cora Sue Collins to CV, November 21, 2018.

The Show Stoppers

Fayard Antonio Nicholas: Birth Certificate #101-14-48057.

Viola and Ulysses Nicholas: Marriage of Ulysses Nicholas and Viola Harden on January 8, 1914 in Mobile Alabama, Film Number 001550513, Alabama County Marriage Records, 1805–1967.

sister Dorothy: Dorothy Berenice Nicholas, born January 8, 1920, Cook County Birth Certificates Index, 1871–1922, Certificate #1309356.

Harold Lloyd: Fayard Nicholas to Theresa Renee White, UCLA Oral History, 2003.

"Jeepers": Fayard Nicholas to Sylvia Shorris, Sylvia Shorris Interview Transcripts, f.28, AMPAS.

"I could go down-and-up": Constance Valis Hill, *Brotherhood in Rhythm.*

"I saved a lot of money": "The Prince Salutes Nicholas Brothers' Dizzying Dancing," *Philadelphia Inquirer*, February 6, 2003, p. E06.

"It was like a game": Jennifer Dunning, "Harold Nicholas: Still Dancing and Stealing the Show," *South Bend Tribune*, March 30, 1988, p.40.

"Sit down": Fayard Nicholas to Sylvia Shorris.

"Don't do what other dancers do": Bob Thomas, "Nicholas Brothers' Pioneering Style Gave Hollywood Musicals of Flair," *Times and Democrat* (Orangeburg, South Carolina), January 22, 2000, p. 20.

"the show stoppers": Fayard Nicholas to Sylvia Shorris.

Tallulah Bankhead: Jennifer Dunning, "Harold Nicholas: Still Dancing and Stealing the Show."

"My brother let me take all the limelight": Mary Campbell, "PBS Series in High Cotton Tonight," *Times* (Shreveport, Louisiana), July 10, 1987, p. 54.

"So after this sensation": Carla Hall, "Class Acts at the Kennedy Center," *Washington Post*, January 8, 1991.

"They weren't writing anything for blacks": Ibid.

"Starring the Nicholas Brothers": Jennifer Fisher, "Nicholases," *Los Angeles Times*, July 2, 2010, p. 278.

"Those guys had so many backflips": Hermes Pan to David Fantle, *Hollywood Heyday: 75 Candid Interviews with Golden Age Legends.*

"Isn't that funny?": Fayard Nicholas to Sylvia Shorris.

"A lot of show people aren't the family type": *The Nicholas Brothers: We Sing and We Dance* (1992).

"Don't rehearse it": Fayard Nicholas Interview, National Visionary Leadership Project, Retrieved on December 1, 2019 from http://www.visionaryproject.org/nicholas-fayard/.

"the greatest routine I've ever seen on film": "The Prince Salutes Nicholas Brothers' Dizzying Dancing."

"They didn't write scripts for us": Jennifer Fisher, "Nicholases."

"That guy is a perfectionist": Howard Reich, "Those Dapper Tappers," *Chicago Tribune*, December 22, 1991, p. 226.

"Well, I'll be an SOB": Ibid.

"If we were coming up in this day": "Class Acts at the Kennedy Center."

"I can see why people make such a fuss": Jesse Hamlin, "As the Nicholas Brothers Danced, the Audiences' Hearts Would Leap Along," *Orlando Sentinel*, June 8, 1989, p. 48.

"We top them all now": "Dynamic Duo Still Perform," *Nanaimo Daily News*, January 24, 1992, p. 22.

"A Star Is Born" . . . and Reborn . . . and Reborn . . . and Reborn . . .

pitched his idea to several studios: William Wellman Jr. to CV, November 4, 2019.

"Spend it all": David Thomson, *Showman: The Life of David O. Selznick.*

It Happened in Hollywood: Wellman-Carson Script, July 22, 1936, David O. Selznick Collection, Harry Ransom Center, University of Texas at Austin.

"cheap titles": Memo from David O. Selznick to Katherine Brown, September 28, 1936. Rudy Behlmer, *Memo from David O. Selznick.*

"happened to somebody": Frank T. Thompson, *William A. Wellman.*

Wellman's good friend Barbara Stanwyck: William Wellman Jr. to CV, November 4, 2019.

Frank Capra: Frank Capra, *The Name Above the Title.*

"I am Mrs. Frank Fay": "Rumor Given Lie," *Los Angeles Times*, June 21, 1931, p. 37.

speech Wellman made telling off: William Wellman Jr. to CV, January 24, 2019.

20th Century Fox issued a statement: 20th Century-Fox Press Statement, September 25, 1936, 20th Century-Fox Legal Files, UCLA; Sarah Baker, *Lucky Stars: Janet Gaynor & Charles Farrell.*

Darryl Zanuck had locked: Paul Gregory (Janet Gaynor's husband) to Sarah Baker, *Lucky Stars: Janet Gaynor & Charles Farrell.*

"There she is": Ibid.

"Ran the picture": Telegram from David O. Selznick to Janet Gaynor, March 3, 1937, David O. Selznick Collection, Harry Ransom Center, University of Texas at Austin.

"A STAR IS REBORN!": Sidney Skolsky, "A Star Is Reborn," *Daily News* (New York), May 2, 1937, p. 62.

role of Melanie: Memo from David O. Selznick to Daniel O'Shea, October 10, 1938; David O. Selznick Collection, Harry Ransom Center, University of Texas at Austin.

"The offers poured in": "Gaynor: A Waif Recalls Her Life and Loves," *Daily News* (New York), February 3, 1980, p. 167.

"our precious Judy": Ronald Haver, *A Star Is Born*.

"You ought be able": William Wellman Jr. to CV, January 24, 2019.

Laurence Olivier: Telegram from Jack Warner to Laurence Olivier, December 2, 1952, Warner Bros. Archive, USC.

"He was absolutely magnificent": Ronald Haver, *A Star Is Born*.

"After all, Judy": Sid Luft, *Judy and I*.

"[T]he dependency": Ibid.

"Now that the picture": Jack Warner to Sid Luft and Judy Garland, October 12, 1953, Warner Bros. Archive, USC.

$75,000 in custom suits: David Shipman, *Judy Garland: The Secret Life of an American Legend*.

borrowing money from Jack Warner: Letter from Jack Warner to Sid Luft, April 24, 1954, Warner Bros. Archive, USC; Jack Warner, *My First Hundred Years in Hollywood*.

"Judy Garland was a very original": Gavin Lambert, *On Cukor*.

showing up late: Production Daily Progress Reports, *A Star Is Born*, Warner Bros. Archive, USC.

"When she was good": James Mason Interview with Arena: A Star Is Born, 1977. Retrieved on October 30, 2019 from https://www.youtube.com/watch?v=0v9zh-baTvJY.

"Judy generates a kind of hysteria": Ronald Haver, *A Star Is Born*.

"A STAR WAS REALLY BORN AGAIN": Telegram from Jack Warner to Moss Hart, August 3, 1954, Warner Bros. Archive, USC.

"I didn't have time to be disappointed": "The Real Me," Judy Garland as told to Joe Hyams, *McCall's*, April 1957, p. 175.

"We think Grace was very lucky": "Kelly Sorry about Judy," *Philadelphia Inquirer*, March 31, 1955, p. 18.

"I thought Grace Kelly": "Has Her Own Oscar, Says Judy Garland," *Los Angeles Times*, March 31, 1955, p. 2.

"was deeply disappointed": Lauren Bacall, *By Myself and Then Some*.

"Her special talent": Sid Luft, *Judy and I*.

My Name Is Barbra: Bob Lundegaard, "There's only one star in 'A Star is Born,'" *Minneapolis Star*, December 30, 1976, p. 13.

Denzel Washington: Army Archerd, "WB hopes to deliver Denzel, Whitney for 'Born,'" *Variety*, April 19, 1993.

Will Smith: "Star May Be Reborn; Pics' Urban Renewal," *Variety*, November 18, 1998.

Jennifer Lopez: "Smith Considers Remake of A Star is Born," *Ottawa Citizen*, August 5, 1999, p. 59.

Jamie Foxx: Sandra P. Angulo, "Jamie Foxx Is Planning to Remake 'A Star Is Born,'" *Entertainment Weekly*, September 15, 2000. Retrieved on December 1, 2019 from https://ew.com/article/2000/09/15/jamie-foxx-planning-remake-star-born/.

Clint Eastwood: Nikki Finke, "Exclusive: Clint Eastwood to Direct Beyonce in Musical of 'A Star Is Born,'" *Deadline*, January 20, 2011. Retrieved on December 1, 2019 from https://deadline.com/2011/01/exclusive-clint-eastwood-to-direct-beyonce-in-musical-version-of-a-star-is-born-98720/.

"La Vie en Rose": Lynn Hirschberg, "Bradley Cooper on Making *A Star Is Born*, Against the Odds," *W Magazine*, October 1, 2018. Retrieved on December 1, 2019 from https://www.wmagazine.com/story/bradley-cooper-a-star-is-born-interview.

Loretta Young, Mother of Invention

"I have wonderful news": Sally Young (Loretta's sister) to Edward J. Funk, *Behind the Door*.

"time keeper": 1910 U.S. Federal Census, Census Place: Salida Ward 3, Chaffee, Colorado.

"boardinghouse": 1920 U.S. Federal Census, Census Place: Los Angeles, California.

"took it on like tuberculosis": Joseph L. Mankiewicz Interview with Ms. Seldon West, September 16, 1991, Joseph L. Mankiewicz Papers, AMPAS.

eloped: Marriage Certificate of Gretchen Young and Granville G. Withers, January 26, 1930, Yuma County, Arizona.

"Rather than give bad example": Linda Lewis (Loretta Young's daughter-in-law) to CV, September 23, 2019; Joan Wester Anderson, *Forever Young*.

"Since Spencer Tracy": Jack Grant, "Why Loretta Young Broke Up Her Romance," *Movie Mirror*, October 1934, p. 8.

"I fall in love with all my leading men": "I Have Been in Love Fifty Times!" said Loretta Young to Gladys Hall, June 24, 1933; Gladys Hall Collection, Folder 506, AMPAS.

"I allowed him in": Loretta Young to Edward J. Funk, *Behind the Door*.

"He had other intentions": Ibid.

"flukey thing": Linda Lewis to CV, September 23, 2019.

"the rearview mirror": Ibid.

"Working in the picture business": Loretta Young to Edward J. Funk, *Behind the Door*.

"In those days": Loretta Young to Joan Wester Anderson. *Forever Young*.

"Would it make any difference": Loretta Young to Edward J. Funk, *Behind the Door*.

"Well are you, or aren't you?": Ibid.

"I felt like such a fool": Ibid.

"I thought she knew": Judy Lewis, *Uncommon Knowledge*.

Ile de France: UK Incoming Passengers List, 1878–1960, National Archives of the UK; Kew, Surrey, England.

Dr. Holleran issued a statement: "Loretta Young Is Ill on Her Return from Europe," *Chicago Tribune*, August 22, 1935, p. 11.

"lost considerable weight": "Loretta Young, Home, to Rest," *Los Angeles Times*, Augusts 22, 1935, p. 27.

"remain away from the movie studios": "Loretta Young Is Ordered to Rest," *Times* (Hammond, Indiana), August 29, 1935, p. 17.

"long rest to avoid a major operation": "Loretta Young Illness Delays Making of Film," *Los Angeles Times*, August 28, 1935, p. 25.

"I had heard the rumors": Edward J. Funk, *Behind the Door*.

"LORETTA YOUNG is not suffering": Dorothy Manners, "Fame, Fortune—and Fatigue," *Photoplay*, January 1936, pp. 32–33, 107.

"preciously acquired poundage": Ibid.

Playa del Rey: 8612 Rindge Avenue [The family always remembered the house as in Venice, but it was located in Playa del Rey.]

"Frenchy": Linda Lewis to CV, September 23, 2019.

named her daughter Judith: Judith Young, November 6, 1935, California Birth Index, 1905–1995, State of California Department of Health Services.

milkman arrived: Judy Lewis, *Uncommon Knowledge*.

"Judy was *my* baby": Loretta Young to Joan Wester Anderson, *Forever Young*.

"I didn't have a father": Ibid.

$400: Judy Lewis, *Uncommon Knowledge*.

set up a bank account: Linda Lewis to CV, September 23, 2019.

"After all that has gone on": Sally Young to Edward J. Funk, *Behind the Door*.

plan to blackmail: Linda Lewis to CV, September 23, 2019; Edward J. Funk, *Behind the Door*.

contacted gossip columnist: Louella O. Parsons, "Loretta Young Now a Mother By Adoption, She Confesses," *Courier-Journal* (Louisville, Kentucky), June 11, 1937, p. 38.

"If you're adopted": Judy Lewis, *Uncommon Knowledge*.

"I couldn't love you any more": Ibid.

Loretta married: Marriage of Tom Lewis and Gretchen Y. Withers, August 2, 1940, California, County Birth, Marriage, and Death Records, 1830–1980. California Department of Public Health.

favor to Dore Schary: Linda Lewis to CV, September 23, 2019.

"I thought that was very sensitive": Loretta Young to Edward J. Funk. *Behind the Door*.

Maria Cooper Janis: Ruth Stein, "Gary Cooper's Daughter Protects Legacy," *SF Gate*, September 2, 2012. Retrieved on October 29, 2019 from https://www.sfgate.com/movies/article/Gary-Cooper-s-daughter-protects-legacy-3828615.php.

"Clark Gable ears": Marlo Thomas, *Growing Up Laughing: My Story and the Story of Funny*.

"Our whole group": Bettijane Levine, "I Always Felt Half a Person," *Los Angeles Times*, May 8, 1964, p. 72.

"to confess her 'mortal sin.'": Judy Lewis, *Uncommon Knowledge*.

"The Cuss Fund": Bob Thomas, "Loretta Young's Fines Have Actors Watching Language," *Boston Globe*, January 22, 1949, p. 14.

she sued 20th Century Fox: "Young Clips Deleted from Film 'Myra,'" *Los Angeles Times*, August 20, 1970, p. 78.

"It's difficult": Lisa Faye Kaplan, "Author Wrote Book 'to Prove My Identity,'" *Springfield News*, May 8, 1994.

"forgive and be forgiven": Edward J. Funk, *Behind the Door*.

"Oh, there's a name": Linda Lewis to CV, September 23, 2019.

"We all want to be conceived with love": Ibid.

BuzzFeed: Anne Helen Petersen, "Clark Gable Accused of Raping Co-Star," *BuzzFeed News*, July 12, 2015. Retrieved on October 29, 2019 from https://www.buzzfeednews.com/article/annehelenpetersen/loretta-young.

"She took the brunt of this": Linda Lewis to CV, September 23, 2019.

Gracie Allen For President!

"I'm tired of knitting this sweater": *Independent Woman*, National Federation of Business and Professional Women's Clubs, 1939.

wed in 1926: Marriage of Grace C. Allen to Nathan Birnbaum on January 6, 1926 in Cuyahoga, Ohio. Ohio, County Marriage Records, 1774–1993.

"mythical brother": George Burns, *Gracie: A Love Story*.

"It was Gracie's brother": Ibid.

45 million: Briton Hadden and Henry Robinson Luce, *Time*, vol. 56, 1950, p. 75.

Wednesday evening: [ad] *Des Moines Tribune*, February 21, 1940, p. 8.

"That's as much support": "Gracie Allen Enters Presidential Picture," *Daily Item* (Sunbury, Pennsylvania), February 23, 1940, p. 3.

"We don't want to get rid of men entirely": "Gracie Allen Campaigning on Nutty Pine Platform: Gives Garner Big Boost," *Quad-City Times*, April 21, 1940, p. 28.

"run up by a movie set designer": "Gracie Allen for President," *Akron Beacon Journal*, June 30, 1940, p. 51.

"We ought to be proud": Jas. S. Coleman, "Stuff—About People and Stuff," *Greene County Democrat* (Eutaw, Alabama), March 27, 1940, p. 1.

"just to make it easier for the kiddies": Harrison Carroll, "Behind The Scenes In Hollywood," *Evening Independent* (Massillon, Ohio), March 11, 1940, p. 4.

"Well, they're all right": "Gracie Allen Has Platform You Can't Beat," *Times Herald* (Port Huron, Michigan), May 15, 1940, p. 9.

invited by Eleanor Roosevelt: Louise C. Marston, "The Women's National Press Club: Gracie Allen, 'Capital Beauties,' Attend Press Dinner in Washington," *Wisconsin State Journal*, March 11, 1940, p. 9.

some pointers: "Invite Party Chairman," *Nebraska State Journal*, March 8, 1940, p. 4.

Harvard: "Harvard for Gracie," *Lansing State Journal*, March 18, 1940, p. 10.

Variety: *Miami News*, April 6, 1940, p. 5.

Ramsey State Farm: Jimmie Fidler, *Pittsburgh Press*, May 3, 1940, p. 34.

Menominee: "Gracie Allen Runs Third in Primary Test at Menominee," *Green Bay Press-Gazette*, March 20, 1940, p. 4.

May 9, 1940: Gracie Allen on 'Whirlwind Campaign' to Win Nomination of Surprise Party," *Marysville Journal-Tribune*, May 9, 1940, p. 1.

"Suppose nobody comes": George Burns and Gracie Allen, February 18, 1953, Hedda Hopper Papers, f.841, AMPAS.

"As I look around": George Burns, *Gracie: A Love Story*.

"Gracie Allen Specials": [ads] *Columbus Telegram*, May 11, 1940, p. 5.

twenty times: "Twenty Times," *Columbus Telegram*, July 12, 1940, p. 4.

National Guardsmen: "Gracie Allen Charms Us All, Wins Many Votes, and Takes Shine to Reeder," *Columbus Telegram*, May 14, 1940, p. 1.

"Even the baby": Ibid.

"These must be Republican blossoms": "This Doesn't Make Sense; How Could It?," *Great Falls Tribune*, May 15, 1940, p. 12.

thirty-block-long: "Golden Spike Days Closing," *Beatrice Daily Sun*, May 17, 1940, p. 2.

"Gracie for President!": "Parade for Gracie Allen," *Sioux City Journal*, May 17, 1940, p. 7.

10,000: "Gracie Allen Nominated During Mock Convention," *San Bernardino County Sun*, May 18, 1940, p. 1.

"the state of confusion": "Gracie Accepts Her Nomination," *Nebraska State Journal*, May 18, 1940, p. 1.

"was a better man": "Gracie Allen's Three R's," *Lincoln Star*, May 19, 1940, p. 5.

"Can Roosevelt match that?": "Extra! Gracie Allen Wins Surprise Party Nomination," *Salt Lake Tribune*, May 18, 1940, p. 2.

"I went to school": "Gracie Accepts Her Nomination."

"cover them with toupees": Ibid.

"Stick with us": "She Out-Promises Everyone," *El Paso Times*, May 18, 1940, p. 14.

Olivia de Havilland vs. Warner Bros.

"suspension clause": Clause 25: "The Producer, at its option, in the event of the failure, refusal or neglect of the Artist to perform her required services hereunder to the full limit of her ability, and as instructed by the Producer, shall have the right to refuse to pay the Artist any compensation during the period of such failure, refusal, or neglect on the part of the Artist, and shall, likewise, have the right to extend the term of this agreement and all of its provisions for a period equivalent to the period during which such failure, refusal, or neglect shall have continued." Contract Agreement between Warner Bros. Pictures, Inc. and Olivia De Havilland, April 14, 1936, Warner Bros. Archives, USC.

15,000: Edwin Schallert, "Stars Play Brilliantly," *Los Angeles Times*, September 18, 1934, p. 25.

"This girl": Jack Warner, *My First Hundred Years in Hollywood: An Autobiography*.

"Yeah. A name": Ibid.

"I saw a girl": Ibid.

December 1934: Telegram from Olivia De Havilland to Warner Bros. Studio, December 3, 1934, USC Warner Bros. Archive.

$250 per week: Contract Agreement between Warner Bros. Pictures, Inc. and Olivia De Havilland, November 12, 1934. Effective date: February 28, 1935.

$500 a week: Contract Agreement between Warner Bros. Pictures, Inc. and Olivia De Havilland, April 14, 1936, Warner Bros. Archives, USC.

"not in good physical": Letter from Robert W. Meals, M.D. to Hal Wallace, February 23, 1938, Warner Bros. Archive, USC.

"For your information": Memo from T. C. Wright to Jack Warner, February 28, 1938, Warner Bros. Archive. USC.

"inform the lady": Ibid.

James Stewart: Letter from Jack Warner to Roy Obringer, January 12, 1939, Warner Bros. Archive, USC.

"Olivia . . . had a brain like a computer": Jack Warner, *My First Hundred Years in Hollywood: An Autobiography*.

"I knew": Dame Olivia De Havilland, Academy of Achievement (April 10, 2018). Retrieved on July 8, 2019 from https://www.achievement.org/achiever/olivia-de-havilland/#interview.

"AM SURPRISED": Telegram from Jack Warner to Olivia De Havilland, December 18, 1939, Warner Bros. Archive, USC.

"[C]an we prevent": Memo from Jack Warner to Roy Obringer, December 28, 1939, Warner Bros. Archive, USC.

"little innocent ingenue part": Memo from Steve Trilling to Jack Warner and Hal Wallis, January 5, 1941, Warner Bros. Archive, USC.

"in spite of an operation": Telegram from Olivia De Havilland to Hal Wallis, January 5, 1942, Warner Bros. Archive, USC.

"She did do BOOTS": Memo from Hal Wallis to Jack Warner, January 6, 1942, Warner Bros. Archive, USC.

"We should positively": Memo from Jack Warner to Roy Obringer, January 6, 1942, Warner Bros. Archive, USC.

asking for $75,000: Memo from Steve Trilling to Jack Warner, February 20, 1942, Warner Bros. Archive, USC.

Warner Bros. ordered her to report: Straight Wire from Roy Obringer to Olivia De Havilland, August 12, 1943, Warner Bros. Archive, USC.

didn't show up: Interoffice Memo from Steve Trilling to Roy Obringer, August 13, 1943, Warner Bros. Archive, USC.

Gang phoned Warner Bros.: Interoffice Memo from Mary Lou Mitchell, Roy Obringer's Office to Jack L. Warner, August 19, 1943, Warner Bros. Archives, USC.

"Miss DeHavilland's claim": "Olivia De Havilland Case," undated, Warner Bros. Archives, USC.

"thundering tones": Dame Olivia De Havilland, Academy of Achievement.

"I didn't refuse. I declined.": Ibid.

"No. . . . I felt": "Olivia DeHavilland Testifies about Romance at Hearing," *Central New Jersey Home News*, November 6, 1943, p. 2.

"This testimony isn't pertinent": Ibid.

Hollywood Victory Committee: Letter from Hollywood Victory Committee to Jack L. Warner, March 16, 1944, Warner Bros. Archives, USC.

"being indefinitely extended": Charles Burnell, "Opinion," De Havilland v. Warner Bros., No. 487685, Los Angeles County Superior Court, March 14, 1944.

"PLEASE BE ADVISED": Telegram to [various studios] from Warner Bros., March 15, 1944, Warner Bros. Archives, USC.

"no longer in existence": Returned Telegram from Warner Bros. to Mayfair Pictures, March 15, 1944, Warner Bros. Archives, USC.

California Supreme Court: Warner Brothers' Petition for Hearing, Ev. No. 14643 De Havilland, California Supreme Court, filed January 16, 1945.

"And she licked me": Jack Warner, *My First Hundred Years in Hollywood: An Autobiography*.

"I believe in the right to free speech": Eriq Gardner, "Supreme Court Denies Review of Olivia de Havilland's 'Feud' Lawsuit," *Hollywood Reporter*, January 7, 2019. Retrieved on July 23, 2019 from https://www.hollywoodreporter.com/thr-esq/supreme-court-denies-review-olivia-de-havillands-feud-lawsuit-1174078.

Golden Boy: John Garfield and the Death of an American Dream

room 226: United States. Congress. House. Committee on Un-American Activities, Communist infiltration of Hollywood Motion Picture Stars, 1951, p. 327

"the most startling": "The Screen: Warners' 'Four Daughters,' a Sentimental Comedy, at Music . . .," *New York Times*, August 19, 1938, p. 13.

Jacob Garfinkel: Born on March 4, 1913. Certificate #15813, New York, New York, Birth Index Records.

Russian Jews: The Garfinkels came from Zhitomir, Russia. Petition #175909, Petitions for Naturalization from the U.S. District Court for the Southern District of New York, 1897–1944; Series: M1972; Roll:736, David Garfinkel, January 6, 1931; Chane Garfinkel Arrival, September 19, 1911, Philadelphia, Pennsylvania.

"Patri talked": John Garfield, "Speaking of Garfield," *Photoplay*, May 1943, p. 53.

oratorical contest: "Win District Finals in Oratory Contest," *New York Times*, April 19, 1928, p. 13; "Bronx Picks Three in Oratory Contest," *New York Times*, May 3, 1928, p. 13.

he married: Jules Garfield and Rose Zeidman married on January 27, 1935 in the Bronx, New York, Certificate #1062, New York, New York, Extracted Marriage Index.

"very Marxist": Julie Garfield (John Garfield's daughter) to CV, December 12, 2018.

"That role": Patrick J. McGrath, *John Garfield: The Illustrated Career in Films and on Stage*.

accepted an offer from Warner Bros.: Contract between Jules Garfield and Warner Bros. Pictures Inc., April 15, 1938, Warner Bros. Archive, USC.

new name: Memo from Maxwell Arnow to Robert S. Taplinger, May 3, 1938, Warner Bros. Archive, USC.

James Garfield: Julie Garfield to CV April 25, 2019.

"He looks like he's digging": Memo from Hal Wallis to Henry Blanke, May 10, 1938, Warner Bros. Archive, USC.

feuding with Cohn: Bob Thomas, *King Cohn*.

bout of typhoid: Julie Garfield to CV, December 12, 2018.

"subversive tendencies": B.E. Sackett to J. Edgar Hoover, FBI, September 29, 1941, FOIA.

occasional surveillance: March 2, 1943, FBI Report, FOIA.

"While specific": FBI Report, File No. 100-22503, to director from SAC Los Angeles, November 24, 1944, FOIA.

"communistic nature": Ibid.

"mixed dancing": Ibid.

Hoover personally clipping: J. Edgar Hoover to SAC Los Angeles, April 10, 1945, FOIA.

"no documentary": Office Memo from D. M. Ladd to J. Edgar Hoover, October 18, 1947,100-50870; Office Memo from D. M. Ladd to the Director, FBI, March 15, 1951, FOIA.

During the drive: Hilda Wane (nanny) to Edward Medard, *Julie*, Unpublished Manuscript, Private Collection of Julie Garfield.

shot up: Robert Nott, *He Ran All the Way*.

spasm in her throat caused by staph and strep infections: Certificate of Death for Katherine Hannah Garfield, Los Angeles County Registrar-Recorder/County Clerk.

"I want to be free": "Actor John Garfield Dies of Heart Ailment." *St. Louis Post-Dispatch*, May 21, 1952, p. 3B.

"There is no guarantee": Robert Nott, *He Ran All the Way*.

Richard Barthelmess: Office Memo from D. M. Ladd to J. Edgar Hoover, October 18, 1947,100-50870; Office Memo from D. M. Ladd to the Director, FBI, March 15, 1951, FOIA.

An FBI informant . . . tried to entrap Julie: The organization was the Joint Anti-Fascist Refugee Committee. Letter from Edward Scheidt to J. Edgar Hoover, October 24, 1947, Communist Activity in the Entertainment industry, File 100-138754, Volume 15, AMPAS.

"I remember talk": Darryl Zanuck to Edward Medard, *Julie*, Unpublished Manuscript, Private Collection of Julie Garfield.

"That made him fair game": Ibid.

"I have always hated": Office Memo from D. M. Ladd to the Director, FBI, March 15, 1951, FOIA.

"When I was originally requested": United States. Congress. House. Committee on Un-American Activities, Communist infiltration of Hollywood Motion Picture Stars, 1951.

Committee members told Julie they had information: Office Memo from L.B. Nicholson to Mr. Tolson, May 24, 1951, FOIA.

"two witnesses": Letter from James M. McInerney, Assistant Attorney General, Criminal Division to Director, FBI, May 25, 1951, FOIA.

offered them a deal: Helen Levitt to Larry Ceplair, March 8, 1988, UCLA Oral History.

"any committee": Teletype from Ed Scheidt to Director, FBI, May 2, 1951, FOIA.

FBI followed up with an interview: Letter to Director from SAC, New York 100-69074, July 14, 1951, FOIA.

"someday this way of life": Ibid.

"favored position in the government": Ibid.

"the only way of life": Ibid.

At the behest of the Attorney General: Letter from A.H. Belmont to D.M. Ladd, FBI, October 12, 1951, File 100-335707, FOIA.

multiple contacts with Boris Morros: Letter from SAC New York to Director, FBI, June 21, 1951, FOIA.

"No apparent purpose": Letter from SAC New York to Director, FBI, October 27, 1951, FOIA.

"life's work": Robert Wahls, "Any Role in 'Golden Boy' Keeps Garfield Happy," *Daily News* (New York), April 27, 1952, p. 28.

"Don't Be a Sucker for the Left Hook: Although many publications have referred to the article Julie wrote as "I Was a Sucker for a Left Hook," the article sent to the FBI was entitled "Don't Be a Sucker for the Left Hook."

"would wash their hands": Office Memo from L.B. Nichols to Mr. Tolson, April 23, 1952, FOIA.

secretly sent a copy: Letter from Arnold Forster to Louis Nichols, April 23, 1952, FOIA.

"too active": Office Memo from L.B. Nichols to Mr. Tolson, May 7,1952, FOIA.

May 10, 1952: Letter from SAC New York to Director, FBI, May 14, 1952, FOIA.

"could recall the names of every woman": Ibid.

"she was probably the cause": Ibid.

"She has ruined me": Ibid.

"Garfield is certainly": Hoover's handwritten note on the Teletype from Edward Scheidt to J. Edgar Hoover, May 10, 1952, FOIA.

10,000 people: "10,000 Line Streets for Garfield's Rites," *New York Times*, May 24, 1952, p. 19.

"What for?": Julie Garfield to CV, April 25, 2019.

"NOTHING IN STATEMENT": Edward Scheidt to J. Edgar Hoover, June 11, 1952, FOIA.

"American citizenship": Letter from John Garfield to Hedda Hopper, Hedda Hopper Papers, f.1402, AMPAS.

The Dancer Who Intimidated Fred Astaire

"Boy, I'm so nervous": John Kobal, *People Will Talk*.

"Well, why don't you ask her!" Ibid.

"Fred didn't want to": Ann Miller to David Fantle, *Hollywood Heyday: 75 Candid Interviews with Golden Age Legends*.

"tryst in a hay loft": Peter Ford (son of Eleanor Powell and Glenn Ford) to CV, October 21, 2019.

quickly married: Marriage of Blanche Helen Torrey to Clarence Gardner Powell on August 29, 1912 in Hartford, Connecticut; Massachusetts Marriage Records.

prescriptions for a venereal disease: Peter Ford to CV, October 21, 2019.

premature labor . . . born without fingernails: Peter Ford to CV, October 21, 2019; Charles Darnton, "What Eleanor Powell Has Lost!," *Screenland*, March 1938, pp. 64–65.

Blanche remarried: Marriage of Galen Atherton and Blanche Powell, January 3, 1916, Bridgeport, Connecticut Vital Records.

"more like sisters": Eleanor Powell to John Kobal, *People Will Talk*.

"I just went": Ibid.

"star maker": "Gus Edwards, 'Star Maker,' Is Dead at 66," *Courier-News* (Bridgewater, New Jersey), November 8, 1945, p. 21.

"standing on my head": Eleanor Powell to John Kobal, *People Will Talk*.

"My name is Eleanor": Eleanor Powell Interview by Robert. W. Chatterton at the Variety Arts Theatre in Los Angeles, 1981.

"When you step on a stage": "There's Only One Eleanor Powell—and Here's Why!," *Movie Classic*, January 1936, p. 54.

"I loathed tap": Eleanor Powell Interview by Robert. W. Chatterton.

"It was the first thing": Ibid.

"very aerial": Ibid.

"It was like an algebra problem": Eleanor Powell to John Kobal, *People Will Talk*.

"Any kid from the class": Eleanor Powell Interview by Robert W. Chatterton.

"a musical slice": *Follow Thru* Musical Program, 1929.

"I used to dream": Alice B. Levin, *Eleanor Powell: First Lady of Dance*.

"She had Miss Sullivan": Ibid.

"Bill's going through the back door": Peter Ford to CV, October 21, 2019.

"wicked peace": Eleanor Powell Interview by Jane Ardmore, October 29, 1975, Jane Ardmore Papers, AMPAS.

"so stoned": Ibid.

MGM had her teeth capped: Mary Watkins Reeves, "The Glorifying of Eleanor Powell," *Photoplay*, December 1935, pp. 70, 98–99

"Chiefly the cinema": Andre Sennwald, "The Broadway Melody of 1936, with Eleanor Powell at the Capitol Theatre," *New York Times*, September 19, 1935, p. 28.

"not since Fred": "Screenland Honor Page," *Screenland*, December 1935, p. 10.

"You are my lucky star!": Peter Ford, *Glenn Ford: A Life*.

"Mr. Astaire, I have a number": Eleanor Powell to John Kobal, *People Will Talk*.

"Oh, Ellie!": Eleanor Powell to Miles Krueger, in Alice B. Levin, *Eleanor Powell: First Lady of Dance*.

"Please, were just": Ibid.

"creating a cure": Eleanor Powell Interview by Jane Ardmore.

"the dance with the noise": Ibid.

"Fred Astaire . . . is finally teamed": Kate Cameron, "40 Broadway Melody on Screen at Capitol," *Daily News* (New York), March 29, 1940, p. 213.

"She put 'em down": Fred Astaire, *Steps in Time*.

"Your mother is a much better dancer than me!": Peter Ford to CV, October 21, 2019; *Peter Ford: A Little Prince* (2012).

"I had only seen her in black-and-white": Peter Ford, *Glenn Ford: A Life*.

"He had such an inferiority": Florabel Muir, "Eleanor Powell's Amazing," *Daily News* (New York), February 12, 1961, p. 604.

"Ah! Miss Powell!": Lloyd Shearer, "Eleanor Powell," *Tampa Bay Times*, January 22, 1961, p. 162.

"die a thousand deaths": Ibid.

"We were running": Eleanor Powell Interview by Jane Ardmore.

"Something had to give": Florabel Muir, "Eleanor Powell's Amazing."

drunken Orson Welles: Eleanor Powell to Peter Ford, *Glenn Ford: A Life*.; *Peter Ford: A Little Prince* (2012).

Harry Cohn warned her: Peter Ford, *Glenn Ford: A Life*.

enlisted in the French Foreign Legion: Ibid.

"I guess deep down": Lloyd Shearer, "Eleanor Powell."

"Mama is off": Marjory Adams, "Eleanor Powell Back at Work to Pay off Mortgage on Home," *Boston Globe*, October 4, 1947, p. 12.

"any denomination": Harold Heffernan, "Ford 'Up to Neck' in TV But Not Facing Camera," *Valley Times* (North Hollywood, California), November 9, 1954, p. 9.

"the number of dark-skinned youngsters": Alice B. Levin, *Eleanor Powell: First Lady of Dance*; Peter Ford to CV, October 21, 2019.

"That is true": Peter Ford to CV, October 21, 2019.

"My dad": Ibid.

rationing toilet paper: Ibid.

"I know you all want": "Eleanor Powell Plans Comeback," *Tampa Times*, January 25, 1961, p. 4.

"When you hear the tap": Robert W. Flick, "Eleanor Powell Returns to Thunderous Applause," *Record* (Hackensack, New Jersey), March 1, 1961, p. 53.

"Miss Powell . . . is 48": Ibid.

uterine cancer . . . left ovary: Eleanor Powell Certificate of Death, February 11, 1982, County of Los Angeles, Registrar-Recorder/County Clerk.

"I look like a female": Letter from Eleanor Powell to Mille Beck Baron, Alice B. Levin, *Eleanor Powell: First Lady of Dance*.

Becoming Rita Hayworth

"I had to be sold": James Reid, "Oomph for Sale," *Modern Screen*, December 1941, p. 36.

"Most men": Jeff Jarvis, "Now Rita Sits in Silence," *People*, November 7, 1983.

"The Love Goddess": Winthrop Sargeant, "The Cult of the Love Goddess in America," *LIFE*, November 10, 1947, p. 81.

Margarita Carmen Cansino: Born on October 17, 1918, Certificate #49015, New York, New York, Birth Index, 1910–1965.

"That girl is a great beauty": Louella Parsons, "Cinderella Princess," *San Francisco Examiner*, May 30, 1949, p. 12.

"When she came to our table": Louella Parsons, *Tell It to Louella*.

"You wait and see": Louella Parsons, "Cinderella Princess."

"I developed a burning ambition": John Kobal, *Rita Hayworth: Portrait of a Love Goddess*.

"I don't want to become another Dolores Del Rio": Gelal Talata, "Dancers Can Act," *Oakland Tribune*, September 29, 1935, p. 55.

"Naturally I cried": John Kobal, *Rita Hayworth: Portrait of a Love Goddess*.

they were married: Marriage Certificate of Margarita Cansino and Edward Charles Judson, Yuma County, Arizona, May 29, 1937. Arizona, County Marriage Records, 1865–1972.

third marriage: Marriage to Dorothy Oliver, March 8, 1921, Marriage Certificate, Lake County, Illinois; and Marriage to Hazel Forbes, January 4, 1929, Record of Marriage, Town of Mamaroneck, Westchester County, New York.

He was forty: Edward Charles Judson Birth Record, County of Santa Clara, California, May 4, 1896.

"I married him for love": Barbara Leaming, *If This Was Happiness*.

"After I changed": James Reid, "Oomph for Sale."

"Her hair": Helen Hunt to Barbara Leaming, *If This Was Happiness*.

"Achieving a new design": Letter from Helen Hunt to John Kobal, December 10, 1974. John Kobal, *Rita Hayworth: Portrait of a Love Goddess*.

"The camera said that her hairline": Ibid.

"Best-Dressed Girl in Hollywood": *Look*, February 27, 1940.

"Once the ball got rolling": Henry Rogers to Barbara Leaming, *If This Was Happiness*.

"photographic marathon": Virginia Irwin, "She's the Picture Editors' Darling," *St. Louis Post-Dispatch*, September 26, 1940, p. 42.

"From Ugly Duckling to Movie Knockout": Gene Schrott, "From Ugly Duckling to Movie Knockout," *Hollywood*, February 1941, p. 21.

"Oomph for Sale": James Reid, "Oomph for Sale."

"As soon as I became a redhead": Lydia Lane, "Rita Hayworth Tells Her Beauty Secrets," *Oakland Tribune*, November 9, 1952, p. 65.

fourth atomic bomb: The image was by Bob Coburn and featured in *Esquire*, June 1946, p. 78.; "Widespread Precautions Advocate Against Danger of Atomic Attack," *Los Angeles Times*, June 30, 1946, p. 3.; "Atomic Goddess Revisited: Rita Hayworth's Bob Image Found!," Conelrad Adjacent, August 19, 2013. Retrieved on October 14, 2019. http://conelrad.blogspot.com/2013/08/atom-ic-goddess-revisited-rita-hayworths.html.

"The Love Goddess": Winthrop Sargeant, "The Cult of the Love Goddess in America."

"I speak Spanish": John Hallowell, "Who'll Hire Rita?," *Akron Beacon Journal*, July 7, 1968, p. 117.

"The screen's Rita": Rita Hayworth, "Glamour Is Just Business with Me," *Boston Globe*, August 10, 1932, p. 27.

Susan Peters: A Rising Star with a Tragic Fall

her father died in a car accident: Robert Houston Carnahan died on July 25, 1926 in Leavenworth, Chelan, Washington; Washington State Select Death Certificates, Washington Department of Health.

"Ma Mere": Susan Peters, "Meet Susan Peters," *Boston Globe*, April 6, 1943, p. 18.

"I could understand why": Ibid.

Hollywood High School: 1939 Hollywood High School Yearbook, p. 32.

"How would you like to be in pictures?": Susan Peters, "Meet Susan Peters," *Boston Globe*, April 7, 1943, p. 28.

"Acting paid well": Susan Peters, "Meet Susan Peters," *Boston Globe*, April 8, 1943, p. 13.

screen test: Letter from Warner Bros. to Suzanne Carnahan, March 23, Warner Bros. Archive, USC.

contract: Contract Agreement between Suzanne Carnahan and Warner Bros., April 10, 1940, Warner Bros. Archive, USC.

"For some reason,": Susan Peters, "Meet Susan Peters," *Boston Globe*, April 8, 1943, p. 13.

failed engagement: [Susan was engaged to actor Phillip Terry] "Young Film Pair Engaged, Hollywood Friends Learn," *Los Angeles Times*, June 3, 1941, p. 5; Frederick C. Othman, "Hollywood," *Hanford Morning Journal*, June 30, 1942, p. 2.

"appendectomy": Interoffice memo from Steve Trilling to R.J. Obringer, July 15, 1941, Warner Bros. Archive, USC.

"Cassie": Letter from Jack Warner to David Lewis, August 20, 1941; Interoffice Memo from Hal Wallis to David Lewis, August, 26, 1941, Warner Bros. Archive, USC.

Warner Bros. decided to let her go: April 11, 1942, Warner Bros. Archive, USC.

Tish: MGM Legal Department Records, Folder 361, AMPAS.

"Heart and sympathy": Mervyn Leroy, "Behind the Scenes in Hollywood," *Morning Herald*, August 17, 1942, p. 6.

"scared to death": Susan Peters, "Meet Susan Peters: Frightened to Death of Ronald Coleman," *Boston Globe*, April 9, 1943, p. 31.

"I'm afraid": Ibid.

"I sank lower": Ibid.

give her a raise: Memo from Loew's Incorporated, December 9, 1942, MGM Legal Records: 1941–1943, AMPAS.

Susan married: Suzanne Carnahan and Richard H. Quine, Certificate of Marriage, November 7, 1943, California Department of Public Health.

Ma Mere passed away: Death of Marie Dorila Patteneaude, March 21, 1944, California Death Index.

"an emergency abdominal operation": "Susan Peters Has Sudden Operation," *Los Angeles Times*, April 5, 1943, p. 13.

"miscarriage": Louella O. Parsons, "Courage Is a Girl Named Susan," *Photoplay*, May 1945, p. 28.

shelve the film: Louella O. Parsons, *San Francisco Examiner*, April 29, 1944, p. 18.

retrieve the gun: Shannon Quine (Susan Peters's granddaughter to CV), February 13, 2019; "Hollywood Actress Seriously Shot in Hunting Accident," *Boston Globe*, January 2, 1945, p. 10.

"I felt I was spinning": Sidney Fields, "Courage in a Wheelchair," *Mirror*, March 15, 1948.

"The doctors say although paralysis": "Hunting Accident Shot Paralyzes Susan Peters," *Los Angeles Times*, January 9, 1945, p. 2.

"I took three steps": Bob Thomas, "Six Months Ago Doctors Said Susan Peters Couldn't Live," *Daily Tribune* (Wisconsin Rapids, Wisconsin), June 22, 1945, p. 7.

"I firmly believe that if you try hard": Mary Morris, "Susan Fights Back," *PM*, November 4, 1945.

"Let's not be too sure, darling": Ibid.

death of her mother: Death of Abby Carnahan, December 4, 1945, California Death Index.

"Just as soon as I admitted": Sheilah Graham, "A Little Thing Like Inability Can't Keep Susan Peters from Acting," *Courier-Journal* (Louisville, Kentucky), September 7, 1947, p. 57.

"They planned to write": Sheilah Graham, "A Little Thing Like Inability Can't Keep Susan Peters from Acting."

"I wasn't a God-is-love": Erskine Johnson, "Miracle of Susan Peters: She's Going to Act Again," *New York World-Telegram*, January 22, 1947.

"Leah is a completely domineering": Philip K. Scheurer, "Wheel-Chair Filmmaking Deal Thrills Susan," *Los Angeles Times*, July 6, 1947, p. 23.

"Taking greasepaint away": Sheilah Graham, "A Little Thing Like Inability Can't Keep Susan Peters from Acting."

"I know they will come in to see how I look": Philip K. Scheurer, "Wheel-Chair Filmmaking Deal Thrills Susan."

"Plainly the story is claptrap": Bosley Crowther, "The Sign of the Ram, Marking Return of Susan Peters to Films, at Loew's State," *New York Times*, March 4, 1948, p. 30.

"It was one of those kinds of pictures": Charles Bennett to Ronald L. Davis, *Words Into Images: Screenwriters on the Studio System*.

Norman Lloyd: Norman Lloyd to CV, December 27, 2018.

"This divorce is her idea": Louella Parsons, "Romance Over Says Mate, Dick Quine," *Journal AM*, May 3, 1948.

"was entitled to a normal life": Louella Parsons, "Nina Foch Returning to Columbia," *San Francisco Examiner*, May 5, 1948, p. 13.

"grievous mental and physical suffering": Suzanne Carnahan Quine vs. Richard Harding Quine, D364355, Superior Court of the State of California, Los Angeles County, July 21, 1948.

"In view of Miss Peter's marked ability": "Miss Susan," *Billboard*, March 31, 1951, p. 13.

"How can I—I have no spinal cord": Bob Thomas, "Tragic Death of Susan Peters Saddens Many in Hollywood," *Asbury Park Press*, October 27, 1952, p. 10.

"She had to come live with me": Bob Carnahan to Dan Webster; Dan Webster, "Forgotten Star," *Spokesman-Review and Spokane Chronicle*, March 22, 1991, p. D6.

"terminal state": "Death in Visalia Ends Epic Fight of Susan Peters," *Fresno Bee*, October 24, 1952, p. 1.

"lost the will": "Final Rites Held for Susan Peters," *Spokane Chronicle*, October 27, 1952, p. 14.

"bronchopneumonia": Certificate of Death, Suzanne Carnahan Quine, County of Tulare, Visalia, California. This also mentions kidney infection and 2 months of starvation and dehydration.

Marni Nixon: Unsung Hero

"messenger girl": Robert Wahls, "Ghostess Goes East," *Daily News* (New York), May 31, 1964, p. 79.

"ghostess with the mostest": "Instant Voice," *Time*, February 7, 1964, pp. 81–82.

"I was torn": Marni Nixon, *I Could Have Sung All Night*.

"By doing this": Ibid.

"I would listen": Ibid.

Deborah Kerr… told a columnist: Earl Wilson, "Deborah Tells a Secret," *Mirror-News*, March 9, 1956, p. 4.

"forever synonymous": Marni Nixon, *I Could Have Sung All Night*.

"I was both very embarrassed": Ibid.

"He must": Manoah Bowman, *Natalie Wood: Reflections on a Legendary Life*.

"just a Broadway": Jack Warner, *My First Hundred Years in Hollywood: An Autobiography*.

Top-secret auditions: *My Fair Lady* Music Files, Folder #1, Warner Bros. Archive, USC.

"trying to imitate": Eliza's Voice Recordings at Burbank, May 16, 1963, Warner Bros. Archive, USC.

The role was hers: Contract between Warner Bros. and Marni Nixon, June 27, 1963, Warner Bros. Archive, USC.

the studio wanted one voice: Memo from Victor Blau to Hal Findlay, October 4, 1963, Warner Bros. Archive, USC.

"wicked behavior": Marni Nixon, *I Could Have Sung All Night.*

"She had the cutest old lady": Ibid.

"Since they fired": Ibid.

Dancing Queen of the Silver Screen

born without the hyphen: Vera E. Rohe, February 16, 1921, born in Hamilton, Ohio Birth Index.

wooden stool: "Cancer Claims Ohio Actress Vera-Ellen," *Lancaster-Eagle Gazette*, September 2, 1981, p. 3.

honor-roll student: Norwood High School Yearbook, 1935.

director of . . . band: "The Junior Band of the Norwood View School," *Cincinnati Enquirer*, July 15, 1928, p. 97.

"drawn a book worm": Wood Soanes, "Does Your Lawn Need Cutting? Movie Star Vera-Ellen Would Love to Do the Job for You," *Oakland Tribune*, April 2, 1950, p. 98.

"From then on ballet": Nancy Grace, "Vera-Hyphen-Ellen Takes in Our Town," *Courier-Journal* (Louisville, Kentucky), September 2, 1952, p. 21.

"iriology diet": David Soren, *Vera-Ellen: The Magic and the Mystery.*

Not a doctor: *Chicago Federation Bulletin*, Federation of State Medical Boards of the United States, vols. 7–9, January 1921; "Court: Eye Is a Radio Station, 'Professor' Tells Court Here about Iriology," *Atlanta Constitution*, June 9, 1938, p. 8; "Health Lecturer Is Indicted Here," *Atlanta Constitution*, May 14, 1938, p. 6.

"other colors": "The Eye As Radio Station of the Body," *Chillicothe Gazette*, July 24, 1926, p. 6.

change the color of 80% of all eyes: "Medicine: Eye Tinting," *Time*, January 28, 1929.

"any meat": "Blue Eyes Given Place of Honor," *Times Colonist*, August 5, 1926, p. 6.

"When I found out": John L. Scott, "'The Hyphen' Puts Best Dancing Toes Forward," *Los Angeles Times*, September 2, 1945.

stretching exercises: Bob Thomas, "Star Stretches into Good Roles," *South Bend Tribune*, June 27, 1946, p. 22.

Vera married: Marriage license dated January 21, 1941, Manhattan, New York; Marriage License Indexes.

"The neatest trick": *New York World Telegraph*, June 4, 1942.

"I wanted to be different": "Vera-Ellen's Hyphen Sparked Dream Dash," *Indianapolis Star*, March 16, 1952, p. 87.

"The Dash": Sheilah Graham, "Vera-Hyphen-Ellen's Career Got a Boost When She Put Sex Appeal into Her Dancing," *Courier-Journal*, February 5, 1950, p. 65.

"You're always worth more": David Soren, *Vera-Ellen: The Magic and the Mystery.*

"She didn't know how to walk": Samuel Goldwyn, "It's My Business," *Photoplay*, May 1947, p. 60.

"He had an overestimated": "Dancer Gets Decree on Plea Husband Was Too Conceited," *Los Angeles Times*, November 28, 1946.

"always used physical force": Ibid.

pawned it: "Husband Pawned Ring Vera-Ellen Complained," *Cincinnati Enquirer*, July 12, 1946, p. 14.

"Movie work is fun": Letter from Vera-Ellen to Claudia Franck, August 19, 1944, AMPAS.

"Vera-Ellen is a fine": "The Wonder Man," *Variety*, April 1945, p. 14.

"a pert and chic": Bosley Crowther, "On the Screen," *New York Times*, June 9, 1945, p. 17.

600 fan letters: Samuel Goldwyn Productions Fan Mail Report, August 28, 1947, AMPAS.

"I took stock": Edwin Schallert, "Vera-Ellen Gets Chance at Comedy," *Los Angeles Times*, September 25, 1949, pp. 89 and 91.

"just to show": Jack Holland, "No More Kidding Around," *Screenland*, September 1949, p. 65.

"I knew I could do the steps": Sheilah Graham, "Vera-Hyphen-Ellen's Career Got a Boost When She Put Sex Appeal into Her Dancing."

"I told her I was just thinking about the steps": Ibid.

"the greatest seven minutes": Ibid.

Love Happy. Love Happy Legal File, AMPAS.

"I'm so glad I've graduated": Sheilah Graham, "Vera-Hyphen-Ellen's Career Got a Boost When She Put Sex Appeal into Her Dancing."

"Vera-Ellen, with this picture": "Film Reviews (Three Little Words)," *Variety*, July 12, 1950, p. 6.

"Vera-Ellen was told that she was too fat": Debbie Reynolds, *Debbie: My Life.*

"It was her habit": David Soren, *Vera-Ellen: The Mystery and the Magic.*

"She did little socialization": Ibid.

"I like to feel fragile": Liza Wilson, "Candleflame Blonde," *Photoplay*, May, 1951, p. 113.

"Nobody knew what anorexia": AC Lyles to David Soren, *Vera-Ellen: The Mystery and the Magic.*

"there were no story conferences": Brent Phillips, *Charles Walters: The Director Who Made Hollywood Dance.*

"Honey, you have to eat": Mark Knowles, *The Man Who Made the Jailhouse Rock: Alex Romero, Hollywood Choreographer.*

"one of the greatest dance numbers": Donald O'Connor to David Soren, *Vera-Ellen: The Mystery and the Magic.*

"She was so nice": Ibid.

"Save Vera-Ellen Campaign": Aline Mosby, "Skinny Girls Are Defended by One of Them—Vera-Ellen," *Spokane Chronicle*, October 11, 1954, p. 18.

"Everybody was worried when I weighed 90": Ibid.

"I read it and I liked it": Vera-Ellen, "Vera-Ellen Changes Mind; Dancing Fine; Drama Finer!," *Kenosha News*, July 3, 1953, p. 12.

"She was disciplined": Rosemary Clooney Interview on Vera-Ellen. Retrieved on December 21, 2019 from https://www.youtube.com/watch?v=bZN3VIAFryw.

"men who saw the picture": "Aline Mosby, News—Notes from Hollywood," *Times Standard* (Eureka, California), October 18, 1954, p. 11.

"There's a sexiness about slimness": Aline Mosby, "Skinny Girls Are Defended by One of Them—Vera-Ellen."

"I think I get the energy from my diet": "Vera-Ellen Slated for Salt Lake City Visit," *Desert News*, November 10, 1954, p. 31.

"Nothing serious": Vic Rothschild to David Soren, *Vera-Ellen: The Magic and the Mystery.*

Victoria Ellen: California Birth Index, 1905-1995; California Death Index, 1940–1997.

"acute interstitial pneumonitis": Certificate of Death, Victoria Ellen Rothschild, June 20, 1963, Los Angeles County Registrar-Recorder/County Clerk.

"I think Vera just did not want to deal": Vic Rothschild to David Soren, *Vera-Ellen: The Magic and the Mystery.*

bitter divorce: Victor Bennett Rothschild vs. Vera-Ellen Rothschild, No. D695395.

"I still go [to dance class]": Dorothy Townsend, "Vera-Ellen, Former Star of Movie Musicals, Dies" *Los Angeles Times*, September 2, 1981, p. 34.

"a living skeleton": Jo Dennis to David Soren, *Vera-Ellen: The Magic and the Mystery.*

"claiming that it was not good for her diet!": Ibid.

Vera died alone: Certificate of Death, Vera-Ellen Rothschild aka Ellen, August 30, 1981, California Department of Health. Cause of death listed: cardiopulmonary arrest due to metastatic cancer.

Paul Newman's Unholy Grail

"Paul Newman Apologizes": Art Rayon, "Paul Newman Apologizes for First Film, Now on TV," *Los Angeles Times*, January 22, 1963, p. 21.

"community service": Phyllis Battelle, "Newman Cites Good in Movie on Evil," *Record* (Hackensack, New Jersey), May 14, 1963, p. 21.

"Everybody watched": Nancy Anderson, "All Actors Overpaid but . . . Newman Feels No Guilt Over Big Movie Earnings," *Boston Globe*, July 22, 1966, p. 10.

Warner spared no expense: *The Silver Chalice* Production Budget, April 8, 1954, Warner Bros. Archive, USC.

"What were Civil Guards": Victor Saville to Research Department, May 5, 1924, Warner Bros. Archive, USC.

"Did Romans": Howard Bristol to Research Department, June 24, 1954, Warner Bros. Archive, USC.

"Could swans": Boris Levan to Research Department, June 24, 1954, Warner Bros. Archive, USC.

June 1954: *The Silver Chalice*, Daily Progress Reports, Warner Bros. Archive, USC.

four in the morning: Ibid.

Paul Newman became ill: Ibid.

"Three weeks": Richard Warren Lewis, "Waiting for a Horse, Paul Newman Makes a Western," *New York Times*, November 6, 1966, p. 280.

"we need to see the people": Letter from Jack Warner to Victor Saville, July 3, 1954, Warner Bros. Archive, USC.

"some over-the-shoulder shots": Ibid.

"in small cuts": Ibid.

"filmdom's longest camera boom": "On the Set Production Notes," *Taylor Daily Press* (Taylor, Texas), May 1, 1955, p. 11.

"my cocktail dress": Richard Christiansen, "Paul Newman," *Chicago Tribune*, September 17, 1978, p.144.

"impressive as Simon": Roy Moseley (editor), *Evergreen: Victor Saville In His Own Words.*

"The only thing": ibid

August 26, 1954: *The Silver Chalice*, Daily Progress Reports, Warner Bros. Archive, USC.

Saranac Lake: "Saranac Lake to See Premiere for Yule Seal Sale Victory," *Elmira Star-Gazette*, December 10, 1954, p. 3.

"tremendous box office": Telegram from Pickman-Hendricks to Mort Blumenstock, Warner Bros. Studio, December 17, 1954, Warner Bros. Archive, USC.

"white carpet snow": Ibid.

"Show business": Helen Bower, "'Silver Chalice' Had Gala Premiere," *Detroit Free Press*, December 22, 1954, p. 10.

"I was horrified": Craig Modderno, "Paul Newman: An Exclusive Portrait," *Playgirl*, June 1980.

"a cumbersome": A.W., "Silver Chalice at the Paramount Among Features That Have Premieres: At the Paramount," *New York Times*, December 27, 1954, p. 22.

"Paul Newman . . . delivers": John McCarten, "The Current Cinema," *New Yorker*, Jan 15, 1955, p. 70.

"Paul Newman looks": Marjory Adams, "New Film," *Boston Globe*, December 28, 1954, p. 16.

"a poor man's Marlon Brando": Shawn Levy, *Paul Newman: A Life.*

"It was fun": John Skow, "Paul Newman: Verdict on a Superstar," *Time*, December 6, 1982.

"When I think about": Nancy Anderson, "All Actors Overpaid but . . . Newman Feels No Guilt Over Big Movie Earnings."

SELECTED BIBLIOGRAPHY

Books

Anderson, Joan Wester. *Forever Young: The Life, Loves and Enduring Faith of a Hollywood Legend.* Revised Edition. Joan Wester Anderson, 2012.

Arvidson, Linda. *When The Movies Were Young.* E. P. Dutton & company, 1925.

Astaire, Fred. *Steps in Time: An Autobiography.* (Reprint Edition). Harper Collins, 2008.

Bacall, Lauren. *By Myself and Then Some.* Headline, 2005.

Baker, Sarah. *Lucky Stars: Janet Gaynor & Charles Farrell.* BearManor Media, 2009.

Behlmer, Rudy (editor). *Memo from David O. Selznick.* Grove, 1972.

Berg, A. Scott. *Goldwyn: A Biography.* Knopf, 1989.

Birchard, Robert S. *Cecil B. DeMille's Hollywood.* University Press of Kentucky, 2004.

Black, Shirley Temple. *Child Star: An Autobiography.* McGraw-Hill, 1988.

Bogdanovich, Peter. *Who the Hell's In It: Conversations with Hollywood's Legendary Actors.* Ballantine Books, (Reprint Edition) 2005.

Bowman, Manoah. *Natalie Wood: Reflections On A Legendary Life.* Running Press, 2016.

Brownlow, Kevin. *Hollywood: The Pioneers.* Collins, 1979.

Brownlow, Kevin. *The Parade's Gone By.* University of California Press, 1976.

Burns, George. *Gracie: A Love Story.* G.P. Putnam's Sons, 1988.

Capra, Frank. *The Name Above the Title: An Autobiography.* Macmillan, 1971.

Chaplin, Charles. *My Autobiography.* Simon & Schuster, 1964.

Clarke, Gerald. *Get Happy: The Life of Judy Garland.* Random House, 2000.

Davis, Ronald L. *Words into Images: Screenwriters on the Studio System.* University Press of Mississippi, 2007.

DeMille, Cecil B.; Hayne, Donald. *The Autobiography of Cecil B. DeMille.* Prentice-Hall, 1959.

Duncan, Lee. *The Rin-Tin-Tin Book of Dog Care.* Prentice-Hall, 1958.

Ellenberger, Allan R. *The Valentino Mystique: The Death and Afterlife of the Silent Film Idol.* McFarland, 2005.

Elwood, Ann. *Rin-Tin-Tin: The Movie Star.* Amazon.com Services LLC, 2010.

Eyman, Scott. *Lion of Hollywood: The Life and Legend of Louis B. Mayer.* Simon & Schuster, 2012.

Eyman, Scott. *The Speed of Sound: Hollywood and the Talkie Revolution 1926-1930.* Simon & Schuster, 1997.

Fantle, David. *Hollywood Heyday: 75 Candid Interviews with Golden Age Legends.* McFarland, 2018.

Ford, Peter. *Glenn Ford: A Life.* University of Wisconsin Press, 2011.

Funk, Edward J. *Behind The Door: the Real Story of Loretta Young.* Edward Funk, 2015.

Goessel, Tracey. *First King of Hollywood: The Life of Douglas Fairbanks.* Chicago Review Press, 2015.

Haver, Ronald. *A Star Is Born: The Making of the 1954 Movie and Its 1983 Restoration.* Applause Theatre Book Publishers, 2002.

Hayakawa, Sessue; Bowen, Croswell (editor). *Zen Showed Me The Way.* Bobs-Merrill Company, 1960.

Hill, Constance Valis. *Brotherhood In Rhythm: The Jazz Tap Dancing of the Nicolas Brothers.* Cooper Square Press, 2002.

Hill, Laurance Landreth. *In the Valley of the Cahuengas: The Story of Hollywood.* Hollywood Branch of the Security Trust & Savings Bank, 1922.

Knowles, Mark. *The Man Who Made The Jailhouse Rock: Alex Romero, Hollywood Choreographer.* McFarland, 2013.

Kobal, John. *People Will Talk.* Knopf, 1986.

Kobal, John. *Rita Hayworth: Portrait of a Love Goddess.* Berkley, 1982.

Koszarski, Richard. *Fort Lee: The Film Town (1904-2004).* Indiana University Press, 2005.

Lambert, Gavin. *On Cukor: Conversations with George Cukor.* Capricorn Books, 1973.

Leaming, Barbara. *If This Was Happiness.* Viking Penguin, 1989.

Leider, Emily. *Dark Lover: The Life and Death of Rudolph Valentino.* Faber & Faber, 2003.

Levin, Alice B. *Eleanor Powell: First Lady of Dance.* Empire Publishing, 1998.

Lewis, Judy. *Uncommon Knowledge.* Pocket Books, 1994.

Lockwood, Charles. *Dream Palaces.* Viking-Adult, 1981.

Luft, Sid. *Judy and I: My Life with Judy Garland.* Chicago Review Press, 2017.

Marion, Fraces. *Off with Their Heads: A Serio-Comic Tale of Hollywood.* Macmillan, 1972.

McGrath, Patrick J. *John Garfield: The Illustrated Career in Films and on Stage.* McFarland, 2006.

Menjou, Adolphe; Musselman, M.M. *It Took Nine Tailors.* Whittlesey House, 1948.

Miyao, Daisuke. *Sessue Hayakawa: Silent Cinema and Transnational Stardom.* Duke University Press, 2007.

Moseley, Roy (editor). *Evergreen: Victor Saville In His Own Words.* Southern Illinois University Press, 2000.

Nixon, Marni; Cole, Stephen. *I Could Have Sung All Night.* Billboard Books, 2006.

Norden, Martin F (editor). *Lois Weber: Interviews.* University Press of Mississippi, 2019.

Nott, Robert. *He Ran All The Way.* Limelight Editions, 2003.

Parsons, Louella. *Tell it to Louella.* P.G. Putnam's Sons, 1961.

Peterson, Roger C. *Valentino: The Unforgotten.* Wetzel Publishing Company, 1937.

Phillips, Brent. *Charles Walters: The Director Who Made Hollywood Dance.* University Press of Kentucky, 2017.

Pickford, Mary. *Sunshine and Shadow.* Doubleday, 1955.

Reynolds, Debbie; Columbia, David Patrick. *Debbie: My Life.* William Morrow & Co., 1988.

Schmidt, Randy L. *Judy Garland on Judy Garland: Interviews and Encounters.* Chicago Review Press, 2014.

Selznick, Irene Mayer. *A Private View.* Knopf, 1983.

Shipman, David. *Judy Garland: The Secret Life of an American Legend.* Fourth Estate, 1992.

Skolsky, Sidney. *Don't Get Me Wrong- I Love Hollywood.* Penguin Adult, 1975.

Slide, Anthony. *Lois Weber: The Director Who Lost Her Way in History.* Greenwood, 1996.

Soren, David. *Vera-Ellen: The Magic and the Mystery.* Luminary Press, 2003.

Stamp, Shelley. *Lois Weber in Early Hollywood.* University of California Press, 2015.

Thomas, Bob. *King Cohn.* Barrie And Rockliff, 1967.

Thomas, Marlo. *Growing Up Laughing: My Story and the Story of Funny.* Hachette Books, 2011.

Thomson, David. *Showman: The Life of David O. Selznick.* Knopf, 1992.

Thompson, Frank T. *William A. Wellman.* Scarecrow Press, 1983.

Terhune, Tracy Ryan. *Valentino Forever: The History of the Valentino Memorial Services.* AuthorHouse, 2004.

Ullman, George. *Valentino: As I Knew Him.* Macy-Masius, 1926.

Vance, Jeffrey; Maietta, Tony. *Douglas Fairbanks.* University of California Press, 2008.

Vidor, King. *A Tree Is A Tree.* Harcourt, Brace & Company, 1953.

Warner, Jack. *My First Hundred Years in Hollywood: An Autobiography.* Random House, 1965.

Mason Wiley, Mason; Bona, Damien. *Inside Oscar: The Unofficial History of the Academy Awards.* Ballantine Books, 1986.

Williams, Gregory Paul. *The Story of Hollywood: An Illustrated History.* BL Press, 2011.

Newspapers and Periodicals

Akron Beacon Journal

Altoona Times

American Heritage

American Weekly

The Atlanta Constitution

The Baltimore Sun

Beatrice Daily Sun

Billboard

The Billings Gazette

Birmingham News

Boston Globe

Bulletin (AMPAS)

The Californian

The California Outlook

The Central New Jersey Home News

Chicago American

Chicago Tribune

Chillicothe Gazette

Cincinnati Enquirer

The Columbus Telegram

The Courier-Journal

The Courier-News (Bridgewater, New Jersey)

Current Opinion

The Daily Item (Sunbury-Pennsylvania)

Daily News (New York)

The Daily Mail (Hagerstown, Maryland)

The Daily Tribune

Deadline

Des Moines News

Des Moines Tribune

Detroit Free Press

Elmira Star-Gazette

El Paso Times

Entertainment Weekly

Esquire

The Evening Independent (St. Petersburg, FL)

Evening Star (Washington, D.C.)

The Evening Sun (Baltimore, M.D.)

Exhibitors Herald

Exhibitors Trade Review

The Film Mercury

Filmograph

The Fresno Bee

The Gazette (Cedar Rapids, Iowa)

Great Falls Tribune
Green Bay Press-Gazette
Greene County Democrat
The Greenville News
Hanford Morning Journal
The Hanford Sentinel
Hollywood
The Hollywood Reporter
Hollywood Vagabond
The Indianapolis Star
Lancaster-Eagle Gazette
Lansing State Journal
Liberty
LIFE
The Lincoln Star
Los Angeles Evening Express
Los Angeles Herald
Los Angeles Herald Examiner
Los Angeles Times
Marlborough Express
Marysville Journal-Tribune
McCalls
The Miami News
The Minneapolis Star
The Mirror
Mirror-News
Modern Screen
The Morning Herald
Motion Picture
The Motion Picture Director
Motion Picture News
Motion Picture World
Movie Classic
Movie Mirror
Movie Weekly
Moving Picture Weekly
Moving Picture World
Nanaimo Daily News
National Federation of Business and
Professional Women's Club
The Nebraska State Journal
The New Movie Magazine
The News-Herald
New York Daily News
New York Dramatic Mirror
New Yorker
New York Times
New York World-Telegram
Oakland Tribune
The Orlando Sentinel
The Ottawa Citizen
Pacific Stars And Stripes
The Palm Beach Post
People
Philadelphia Inquirer
Photoplay
The Pittsburgh Press
Playgirl
The Post-Star (Glens Falls, New York)
Quad-City Times
Reading Times
The Record (Hackensack, New Jersey)
Reel Life

Reno Evening Gazette
Rochester Democrat and Chronicle
Salt Lake Telegram
Salt Lake Tribune
San Bernardino County Sun
San Diego Evening Tribune
San Francisco Examiner
Santa Ana Register
Screenland
Show World
Sioux City Journal
The South Bend Tribune
The Springfield News
Spokane Chronicle
The Spokesman-Review And Spokane
Chronicle
Static Flashes
St. Louis Post-Dispatch
St. Louis Star and Times
St. Louis Times
Tampa Bay Times
Time
The Times-Heald (Port Huron, Michigan)
Toledo Blade
Tyler Morning Telegraph
Valley Times
The Vancouver Sun
Variety
Vidette-Messenger of Porter County
Visalia Times-Delta
W Magazine
The Waco News-Tribune
Washington Post
Wisconsin State Journal

Archives

ALABAMA

Center for Health Statistics-Vital Records

ARIZONA

Clerk's Office- Yuma

CALIFORNIA

Academy of Motion Pictures Arts and
Sciences, Beverly Hills
(Louise Hilton, Lizzie Youle, Libby Wertin,
Corliss Rauls)
American Film Institute, Los Angeles
California Department of Public Health-
Vital Records, Sacramento
Hollywood Forever Cemetery
Huntington Library
Los Angeles County Hall of Records
Los Angeles County Registrar-Recorder
Los Angeles Public Library
Natural History Museum of Los Angeles
County
Seaver Center for Western History
Research (John Cahoon and Betty Uyeda)
Santa Clara County Recorder's Office

Tulare County Recorder's Office, Visalia
University of California Los Angeles
Film & Television Archive (Maya Montañez
Smukler)
Oral History
University of Southern California
Warner Bros. Archive. (Brett Service)

COLORADO

Colorado Department of Health, Denver

CONNECTICUT

Department of Vital Records, Hartford

DISTRICT OF COLUMBIA

Department of Vital Records
Federal Bureau of Investigation
Freedom of Information Act
Library of Congress
National Archives
Ship Passenger Arrival Records
WW1 and WW2 Draft Cards
US Census

ILLINOIS

Cooks County Clerk's Office

MASSACHUSETTS

Registry of Vital Records and Statistics,
Boston

NEW JERSEY

Office of Vital Statistics and Registry

NEW YORK

Bureau of Vital Statistics, Manhattan
City Clerk's Office, Bronx
City Clerk's Office, Queens
County Clerk's Office, Manhattan
Liberty-Ellis Island Foundation
New York Public Library
New York State Archives

OHIO

Department of Vital Statistics, Columbus

PENNSYLVANIA

Pennsylvania State Records
Pennsylvania Vital Statistics

TEXAS

Department of Health, State Vital
Statistics, Austin
University of Texas at Austin
Harry Ransom Center (Cristina Meisner)

WASHINGTON STATE

King County Clerk's Office
McNeil Island Penitentiary Records
Washington State Archives
Washington Dept. of Health, Leavenworth,
Chelan

INTERNATIONAL

CANADA

Library & Archives Canada (LAC)

FRANCE

Cimetière des Chiens et Autres Animaux
Domestiques

ITALY

Archivio di Stato di Castellaneta / States
Archives in Castellaneta

UNITED KINGDOM

The National Archives of the UK

PHOTO CREDITS

INDEX

Page numbers in italics refer to photographs or their captions.

THIS WAS HOLLYWOOD

ACKNOWLEDGMENTS

★ ★ ★

I WOULD like to thank my husband Zack, first and foremost for not divorcing me during this crazy process, but more importantly for all his help and support in making this book a reality. Thank you to my mother and father for believing in me, and to my grandparents: Te quiero muchisimo! To my mother-in-law Naomi—I'd be in a gutter without you. Same goes for you Jake Abrams.

I would also like to thank:

Cora Sue Collins, Peter Ford, Julie Garfield, Linda Lewis, Norman Lloyd, William Wellman Jr., Richard C. Levin, Shannon Quine, Karie Bible, Chris Mitchum, and Janice Easterling, who all shared their stories with me for which I am deeply grateful.

The following institutions and individuals, who made much of my research possible: AMPAS (Louise Hilton, Lizzy Youle, Libby Wertin, Faye Thompson, Corliss Rauls); Harry Ransom Center, University of Texas at Austin (Cristina Meisner); Seaver Center for Western History Research (John Cahoon, Betty Uyeda); UCLA Film & Television Archive (Maya Montañez Smukler); USC Warner Bros. Archive (Brett Service).

The publication team: Running Press (Cindy Sipala, Jess Riordan, Diana Drew, Susan Van Horn, Jessica Schmidt, Seta Zink, Amy Cianfrone), Turner Classic Movies (John Malahy, Eileen Flanagan), Parham Santana (Aaron Spiegeland).

Others whose help was indispensable to navigating this wild adventure: David B. Oshinsky, Hannah Meyers, Rebecca Nagel, Robert Uhur, Darrell Rooney, Tai Babilonia, Michael Thomas Jr., Holly Hyman, Justin Humphreys, Beck Medina, Frank Couch, Emily Byron, Darren Sheely, Kendra Bean, Sophia D'Aurelio, Darby Miller.

I would also like to thank one of the best teachers in the world: Michael Williams from Montgomery County Public Schools. Thank you for teaching me that not all history is in the history books.

Many thanks to the Los Angeles freeways for allowing me to drive and sit (mostly sit) in countless hours of traffic to reach various archives across the city, without which none of this would be possible. Pieces of my soul are scattered across the 101 Freeway, and I wouldn't have it any other way.

And, last but certainly not least:

Thank you to all the followers of @thiswashollywood. This book never would have happened without you. This book is for you. I hope I did you proud!